Nikon® 1 J1/V1 FOR DUMMIES®

by Julie Adair King

John Wiley & Sons, Inc.

Nikon® 1 J1/V1 For Dummies®

Published by John Wiley & Sons, Inc. 111 River Street Hoboken, NJ 07030-5774 www.wiley.com

Copyright © 2012 by John Wiley & Sons, Inc., Hoboken, New Jersey

Published by John Wiley & Sons, Inc., Hoboken, New Jersey

Published simultaneously in Canada

No part of this publication may be reproduced, stored in a retrieval system or transmitted in any form or by any means, electronic, mechanical, photocopying, recording, scanning or otherwise, except as permitted under Sections 107 or 108 of the 1976 United States Copyright Act, without either the prior written permission of the Publisher, or authorization through payment of the appropriate per-copy fee to the Copyright Clearance Center, 222 Rosewood Drive, Danvers, MA 01923, (978) 750-8400, fax (978) 646-8600. Requests to the Publisher for permission should be addressed to the Permissions Department, John Wiley & Sons, Inc., 111 River Street, Hoboken, NJ 07030, (201) 748-6011, fax (201) 748-6008, or online at http://www.wiley.com/go/permissions.

Trademarks: Wiley, the Wiley logo, For Dummies, the Dummies Man logo, A Reference for the Rest of Us!, The Dummies Way, Dummies Daily, The Fun and Easy Way, Dummies.com, Making Everything Easier, and related trade dress are trademarks or registered trademarks of John Wiley & Sons, Inc. and/or its affiliates in the United States and other countries, and may not be used without written permission. Nikon is a registered trademark of Nikon Corporation. All other trademarks are the property of their respective owners. John Wiley & Sons, Inc. is not associated with any product or vendor mentioned in this book.

LIMIT OF LIABILITY/DISCLAIMER OF WARRANTY: THE PUBLISHER AND THE AUTHOR MAKE NO REPRESENTATIONS OR WARRANTIES WITH RESPECT TO THE ACCURACY OR COMPLETENESS OF THE CONTENTS OF THIS WORK AND SPECIFICALLY DISCLAIM ALL WARRANTIES, INCLUDING WITH-OUT LIMITATION WARRANTIES OF FITNESS FOR A PARTICULAR PURPOSE. NO WARRANTY MAY BE CREATED OR EXTENDED BY SALES OR PROMOTIONAL MATERIALS. THE ADVICE AND STRATEGIES CONTAINED HEREIN MAY NOT BE SUITABLE FOR EVERY SITUATION. THIS WORK IS SOLD WITH THE UNDERSTANDING THAT THE PUBLISHER IS NOT ENGAGED IN RENDERING LEGAL, ACCOUNTING, OR OTHER PROFESSIONAL SERVICES. IF PROFESSIONAL ASSISTANCE IS REQUIRED, THE SERVICES OF A COMPETENT PROFESSIONAL PERSON SHOULD BE SOUGHT. NEITHER THE PUBLISHER NOR THE AUTHOR SHALL BE LIABLE FOR DAMAGES ARISING HEREFROM. THE FACT THAT AN ORGANIZA-TION OR WEBSITE IS REFERRED TO IN THIS WORK AS A CITATION AND/OR A POTENTIAL SOURCE OF FURTHER INFORMATION DOES NOT MEAN THAT THE AUTHOR OR THE PUBLISHER ENDORSES THE INFORMATION THE ORGANIZATION OR WEBSITE MAY PROVIDE OR RECOMMENDATIONS IT MAY MAKE, FURTHER, READERS SHOULD BE AWARE THAT INTERNET WEBSITES LISTED IN THIS WORK MAY HAVE CHANGED OR DISAPPEARED BETWEEN WHEN THIS WORK WAS WRITTEN AND WHEN IT IS READ.

For general information on our other products and services, please contact our Customer Care Department within the U.S. at 877-762-2974, outside the U.S. at 317-572-3993, or fax 317-572-4002.

For technical support, please visit www.wiley.com/techsupport.

Wiley publishes in a variety of print and electronic formats and by print-on-demand. Some material included with standard print versions of this book may not be included in e-books or in print-on-demand. If this book refers to media such as a CD or DVD that is not included in the version you purchased, you may download this material at http://booksupport.wiley.com. For more information about Wiley products, visit www.wiley.com.

Library of Congress Control Number: 2012936423

ISBN 978-1-118-29947-0 (pbk); ISBN 978-1-118-39869-2 (ebk); ISBN 978-1-118-39870-8 (ebk); ISBN 978-1-118-39871-5 (ebk)

Manufactured in the United States of America

10 9 8 7 6 5 4 3 2 1

About the Author

Julie Adair King is the author of many books about digital photography and imaging, including the best-selling Digital Photography For Dummies. Her most recent titles include a series of For Dummies guides to popular Nikon, Canon, and Olympus cameras. Other works include Digital Photography Before & After Makeovers, Digital Photo Projects For Dummies, Julie King's Everyday Photoshop For Photographers, Julie King's Everyday Photoshop Elements, and Shoot Like a Pro!: Digital Photography Techniques. When not writing, King teaches digital photography at such locations as the Palm Beach Photographic Centre.

An Ohio native and graduate of Purdue University, she now resides in West Palm Beach, Florida.

Author's Acknowledgments

I am deeply grateful for the chance to work once again with the wonderful publishing team at John Wiley & Sons. Kim Darosett, Jennifer Webb, Steve Hayes, Barry Childs-Helton, and Patrick Redmond are just some of the talented editors and designers who helped make this book possible. And finally, I am also indebted to technical editor Dave Hall, without whose insights and expertise this book would not have been the same.

Publisher's Acknowledgments

We're proud of this book; please send us your comments at http://dummies.custhelp.com. For other comments, please contact our Customer Care Department within the U.S. at 877-762-2974, outside the U.S. at 317-572-3993, or fax 317-572-4002.

Some of the people who helped bring this book to market include the following:

Acquisitions and Editorial

Project Editor: Kim Darosett

Executive Editor: Steven Hayes

Senior Copy Editor: Barry Childs-Helton

Technical Editor: David Hall

Editorial Manager: Leah Cameron Editorial Assistant: Leslie Saxman

Sr. Editorial Assistant: Cherie Case

Cover Photo: © iStockphoto.com/Aldo Murillo

Cartoons: Rich Tennant

(www.the5thwave.com)

Composition Services

Project Coordinator: Patrick Redmond

Layout and Graphics: Melanee Habig,

Joyce Haughey

Proofreader: Linda Seifert **Indexer:** Estalita Slivoskey

Publishing and Editorial for Technology Dummies

Richard Swadley, Vice President and Executive Group Publisher

Andy Cummings, Vice President and Publisher

Mary Bednarek, Executive Acquisitions Director

Mary C. Corder, Editorial Director

Publishing for Consumer Dummies

Kathleen Nebenhaus, Vice President and Executive Publisher

Composition Services

Debbie Stailey, Director of Composition Services

Contents at a Glance

Introduction
Part 1: Fast Track to Super Snaps 5
Chapter 1: Getting the Lay of the Land7
Chapter 2: Choosing Basic Picture Settings31
Chapter 3: Taking Great Pictures, Automatically57
Chapter 4: Shooting Digital Movies and Motion Snapshots
Part 11: Working with Picture Files 103
Chapter 5: Playback Tricks: Viewing Your Photos and More
Chapter 6: Downloading, Printing, and Sharing Your Photos
Part III: Taking Creative Control 169
Chapter 7: Getting Creative with Exposure and Lighting
Chapter 8: Manipulating Focus and Color
Chapter 9: Putting It All Together245
Part 1V: The Part of Tens
Chapter 10: Top Ten Maintenance and Emergency Care Tips
Chapter 11: Ten Special-Purpose Features to Explore on a Rainy Day273
Index 291

Table of Contents

Introduction	1
A Quick Look at What's AheadIcons and Other Stuff to Note	
eCheat Sheet	
Practice, Be Patient, and Have Fun!	
	_
Part 1: Fast Track to Super Snaps	5
Chapter 1: Getting the Lay of the Land	7
Attaching and Using Lenses	7
Extending and collapsing the lens	9
Zooming in and out	
Using the Viewfinder	
Working with Memory Cards	
Exploring External Camera Controls	
Topside controls	
Back-of-the-body controls	
Front controls	
Hidden connections	
Ordering from Camera Menus	
Customizing the Monitor DisplayAdding the SB-N5 Flash	
Taking a Few Critical Setup Steps	
Restoring Default Settings	
Chapter 2: Choosing Basic Picture Settings	31
Choosing a Basic Shooting Mode	
Choosing a Still Image Exposure Mode	
Choosing the Release Mode	
Standard Release modes: Single Frame and Continuous	
Electronic (Hi) Release mode	38
Self-timer and remote-control shooting	
Taking Advantage of Vibration Reduction	
Choosing the Right Quality Settings	
Diagnosing quality problems	
Considering image size: How many pixels are enough?	
Understanding Image Quality options (JPEG or Raw)	
My take: Choose JPEG Fine or Raw (NEF)	
Setting Image Size and Quality	55

Chapter 3: Taking Great Pictures, Automaticall	у
Composing a Stronger Image	58
Following the rule of thirds	58
Creating movement through the frame	59
Working all the angles	
Editing out the clutter	62
Giving them room to move	
As Easy as It Gets: Using Scene Auto Selector M	Iode64
Setting up for automatic success	68
Taking a picture in Scene Auto Selector n	node72
Using Smart Photo Selector Mode	
Taking a picture in Smart Photo Selector	
Viewing and deleting Smart Photo Selector	or images78
Chapter 4: Shooting Digital Movies and Motion	Snapshots81
Getting Started with Movie Mode	
Recording Made Easy: Using the Default Setting	gs83
Digging Deeper into Movie Recording Options	
Understanding the Movie Settings option	85
Adjusting audio settings	
Controlling exposure and color	89
Controlling focusing in Movie mode	90
Adding a fade in/fade out transition	92
Shooting Still Pictures During Movie Recording	g93
Shooting a Slow-Motion Movie	
Creating a Motion Snapshot	
Screening Your Movies	
Trimming Movies	99
Part 11: Working with Picture Files	103
Chapter 5: Playback Tricks: Viewing Your Phot	os and More 105
Customizing Basic Playback Options	106
Adjusting playback timing	106
Enabling automatic picture rotation	
Viewing Images in Playback Mode	108
Switching to Thumbnail view	
Using Calendar view	
Zooming in for a closer view	
Viewing Picture Data	
Simple Photo Information display	
Detailed Photo Information display	
Rating Photos	120

Deleting Photos and Other Files	122
Deleting files one at a time	123
Deleting all files	123
Deleting a batch of selected files	
Protecting Files from Accidental Erasure	
Creating a Digital Slide Show	129
Viewing Your Photos on a Television	133
Chapter 6: Downloading, Printing, and Sharing Your Photos .	137
Choosing the Right Photo Software	
Three free photo programs	138
Advanced photo programs	139
Sending Pictures to the Computer	142
Connecting the camera and computer for picture downlo	
Starting the transfer process	144
Downloading using ViewNX 2	146
Processing Raw (NEF) Files	151
Planning for Perfect Prints	155
Check the pixel count before you print	156
Allow for different print proportions	159
Get print and monitor colors in sync	159
Preparing Pictures for E-Mail and Online Sharing	161
Prepping online photos using ViewNX 2Resizing pictures from the Playback menu	163
Part 111: Taking Creative Control	169
Chapter 7: Getting Creative with Exposure and Lighting	171
Introducing the Exposure Trio: Shutter Speed, Aperture, and IS	O 172
Understanding exposure-setting side effects	
Doing the exposure balancing act	
Exploring the Advanced Exposure Modes Reading the Exposure Meter	104
Setting Aperture, Shutter Speed, and ISO	106
Choosing a shutter type (mechanical or electronic)	197
Adjusting aperture and shutter speed	
Controlling ISO	
Choosing an Exposure Metering Mode	192
Sorting Through Your Camera's Exposure-Correction Tools	194
Applying Exposure Compensation	
Using autoexposure lock	197
Expanding tonal range with Active D-Lighting	
Investigating Advanced Flash Options	201
Choosing the right Flash mode	201
Adjusting flash output	208
Controlling flash output manually	210

•	anipulating Focus and Color	
Masterin	g the Focusing System	214
Aut	ofocusing using the default settings	214
Disa	abling Face-priority AF	217
	lerstanding the AF-Area mode setting	
	nging the Focus mode setting	
Cho	oosing the right autofocus combo	222
	ng autofocus lock	
Focusing	Manually	224
	ting Depth of Field	
	ng Color	
	recting colors with white balance	
	anging the White Balance setting	
FINE	e-tuning White Balance settings	
	ating a white balance presetLook at Picture Controls	
raking a	LOOK at 1 Icture Controls	240
Chapter 9: Pu	tting It All Together	245
Recappin	g Basic Picture Settings	245
	Still Portraits	
	turing action	
Cap	turing scenic vistas	255
Сар	turing dynamic close-ups	259
Part 1V: The Pa	art of Tens	261
Part 1V: The Part 10: The Part	op Ten Maintenance and Emergency Care Ti	<i>261</i> ps263
Part 1V: The Part 10: To Extend B	op Ten Maintenance and Emergency Care Ti	26 1 ps 263
Part 1V: The Po Chapter 10: To Extend Bo Clean the	op Ten Maintenance and Emergency Care Ti attery Life	 26 1 ps 263
Part IV: The Part	op Ten Maintenance and Emergency Care Ti attery Life Lens and LCD with Careour Firmware	 26 1 ps263 265 266
Chapter 10: To Extend Book Clean the Update Y Protect Y	op Ten Maintenance and Emergency Care Ti attery Life	 26 1 ps263 263 265 266 266
Chapter 10: To Extend Bo Clean the Update Y Protect Y Reduce D	op Ten Maintenance and Emergency Care Ti attery Life Lens and LCD with Care our Firmware our Camera from the Elements bisplay Flickering or Banding	261 ps263265266266266
Chapter 10: The Port IV: The Po	op Ten Maintenance and Emergency Care Ti attery Life	261 ps263263265266266268268
Chapter 10: The Po Chapter 10: To Extend Bo Clean the Update Y Protect Y Reduce D Clean the Run the F	op Ten Maintenance and Emergency Care Ti attery Life Lens and LCD with Care our Firmware Our Camera from the Elements Display Flickering or Banding Image Sensor Pixel Mapping Tool	261 ps263265266266268268268
Chapter 10: The Part IV: The Pa	op Ten Maintenance and Emergency Care Ti attery Life Lens and LCD with Care our Firmware Our Camera from the Elements Display Flickering or Banding Image Sensor Pixel Mapping Tool I Your Picture Files	261 ps263265266266268268269270
Chapter 10: The Po Chapter 10: To Extend Bo Clean the Update Y Protect Y Reduce Do Clean the Run the F Safeguard Use Imag	op Ten Maintenance and Emergency Care Ti attery Life Lens and LCD with Care our Firmware Our Camera from the Elements Elmage Sensor Pixel Mapping Tool I Your Picture Files e-Recovery Software to Rescue Lost Photos	261 ps263265266266268268269270
Chapter 10: The Part IV: The Pa	op Ten Maintenance and Emergency Care Ti attery Life Lens and LCD with Care our Firmware Our Camera from the Elements Display Flickering or Banding Image Sensor Pixel Mapping Tool I Your Picture Files	261 ps263265266266268268269270
Chapter 10: The Port IV: The Po	op Ten Maintenance and Emergency Care Ti attery Life Lens and LCD with Care our Firmware Our Camera from the Elements Display Flickering or Banding Image Sensor Pixel Mapping Tool I Your Picture Files	261 ps263263265266268268269271271
Chapter 10: The Port 10: The Port 10: The Extend Border 11: The Ex	op Ten Maintenance and Emergency Care Ti attery Life	26 1 ps 263 263 265 266 268 268 269 271 273
Chapter 10: The Part IV: The Pa	op Ten Maintenance and Emergency Care Ti attery Life	261 ps263265266266268269271271273

Using the Shutter Button to Lock Exposure and Focus	279
Trying Automated Time-Lapse Photography	
Changing the Color Space	
Customizing a Picture Control	
Saving a Custom Picture Control	
Printing Directly from Your Camera or Memory Card	
Getting Free Help and Creative Ideas	
Index	291

Introduction

ikon. The name has been associated with top-flight photography equipment for generations. And now, with the introduction of its V1 and J1 cameras, Nikon brings its stellar reputation to an entirely new breed of photographic tool: the Nikon 1 compact system camera. A photographer's dream, Nikon 1 models offer the flexibility of interchangeable lenses and superior image quality in a compact, lightweight body. Yet despite their small size, these cameras are big on power and control, providing all the features a photography enthusiast could want.

In fact, both cameras offer so *many* features that sorting them all out can be more than a little confusing, especially if you're new to digital photography. Dig through the camera manual, and you encounter all sorts of techie terms — *resolution, aperture, white balance,* and so on — on top of a seemingly endless array of camera buttons and menu items. If you're like many people, you may be so overwhelmed by it all that you haven't yet ventured beyond the fully automatic picture-taking mode, which is a shame because it's sort of like buying a Porsche and never actually taking it on the road.

Therein lies the point of *Nikon 1 J1/V1 For Dummies*. Through this book, you can discover not just what each bell and whistle on your camera does, but also when, where, why, and how to put it to best use. Unlike many photography books, this one doesn't require any previous knowledge of photography or digital imaging to make sense of things, either. In classic *For Dummies* style, everything is explained in easy-to-understand language, with lots of illustrations to help clear up any confusion.

In short, what you have in your hands is the paperback version of an in-depth photography workshop tailored specifically to your Nikon picture-taking powerhouse.

A Quick Look at What's Ahead

This book is organized into four parts, each devoted to a different aspect of using your camera. Although chapters flow in a sequence that's designed to take you from absolute beginner to experienced user, I've also tried to make each chapter as self-standing as possible so you can explore the topics that interest you in any order you please.

Here's a brief preview of what you can find in each part of the book:

Part I: Fast Track to Super Snaps: Part I contains four chapters to help you get up and running. Chapter 1 offers a tour of the external controls on your camera, shows you how to navigate camera menus, and walks you through initial camera setup. Chapter 2 explains basic picture-taking options, such as shutter-release mode and Image Quality settings, and Chapter 3 shows you how to use the camera's fully automatic exposure modes, the Scene Auto Selector and Smart Photo Selector modes. Chapter 4 explains the ins and outs of movie-making with the J1 and V1 and also introduces you to the Motion Snapshot exposure mode.

- ▶ Part II: Working with Picture Files: This part offers two chapters, both dedicated to after-the-shot topics. Chapter 5 explains how to review your pictures on the camera monitor, delete unwanted images, and protect your favorites from accidental erasure. Chapter 6 offers a look at some photo software options including Nikon ViewNX 2, which ships free with your camera and then guides you through the process of downloading pictures to your computer and preparing them for printing and online sharing.
- Part III: Taking Creative Control: Chapters in this part help you unleash the full creative power of your camera by moving into the advanced shooting modes (P, S, A, and M). Chapter 7 covers the critical topic of exposure, and Chapter 8 explains how to manipulate focus and color. Chapter 9 summarizes all the techniques explained in earlier chapters, providing a quick-reference guide to the camera settings and shooting strategies that produce the best results for portraits, action shots, land-scapes, and close-ups.
- ▶ Part IV: The Part of Tens: In the famous For Dummies tradition, the book concludes with two "top-ten" lists containing additional bits of information and advice. Chapter 10 provides ten camera maintenance and emergency repair tips, and Chapter 11 wraps up the book by detailing some camera features that, although not found on most "Top Ten Reasons I Bought My Nikon 1 camera" lists, are nonetheless interesting, useful on occasion, or a bit of both.

Icons and Other Stuff to Note

If this isn't your first *For Dummies* book, you may be familiar with the large, round icons that decorate its margins. If not, here's your very own icondecoder ring:

A Tip icon flags information that will save you time, effort, money, or some other valuable resource, including your sanity. Tips also point out techniques that help you get the best results from specific camera features.

When you see this icon, look alive. It indicates a potential danger zone that can result in much wailing and teeth-gnashing if ignored. In other words, this is stuff that you really don't want to learn the hard way.

Lots of information in this book is of a technical nature — digital photography is a technical animal, after all. But if I present a detail that is useful mainly for impressing your technology-geek friends, I mark it with this icon.

I apply this icon either to introduce information that is especially worth storing in your brain's long-term memory or to remind you of a fact that may have been displaced from that memory by some other pressing fact.

Most of the information in this book applies to both V1 and J1 cameras. But if a feature is available only on one model, I mark the paragraph with one of these two icons to let you know which camera I'm referencing.

Additionally, I need to point out these additional details that will help you use this book:

- Other margin art: Replicas of some of your camera's buttons and onscreen symbols also appear in the margins of some paragraphs. I include these to provide a quick reminder of the appearance of the button or feature being discussed.
- ✓ **Software menu commands:** In sections that cover software, a series of words connected by an arrow indicates commands that you choose from the program menus. For example, if a step tells you to "Choose Filec>Convert Files," click the File menu to unfurl it and then click the Convert Files command on the menu.
- Figures: Most figures in this book show menus and screens as they appear on the V1. Rest assured that things look the same on the J1 unless I specifically say otherwise. When a feature is provided only on the J1, I show the screens from that camera. You'll notice that the J1 screens are a little smaller than the V1 screens in the figures; the difference has to do with the way that I capture the video feed from the camera in order to create the figures. The J1 has only an HD (high-definition) video feed, which produces screens with a different aspect ratio than those taken from the V1, which I capture using the traditional, analog (A/V) video feed. Don't think too much about it I bring it up only so that readers who pay attention to such things won't be distracted with wondering why the screens are two different sizes.

Occasionally, we have updates to our technology books. If this book does have technical updates, they will be posted at www.dummies.com/go/nikon1j1v1updates.

eCheat Sheet

As a little added bonus, you can find an electronic version of the famous For Dummies Cheat Sheet at www.dummies.com/cheatsheet/nikon1j1v1. The Cheat Sheet contains a quick-reference guide to all the external controls and exposure modes on your camera. Log on, print it out, and tuck it in your camera bag for times when you don't want to carry this book with you.

Practice, Be Patient, and Have Fun!

To wrap up this preamble, I want to stress that if you initially think that digital photography is too confusing or too technical for you, you're in very good company. *Everyone* finds this stuff a little mind-boggling at first. So take it slowly, experimenting with just one or two new camera settings or techniques at first. Then, each time you go on a photo outing, make it a point to add one or two more shooting skills to your repertoire.

I know that it's hard to believe when you're just starting out, but it really won't be long before everything starts to come together. With some time, patience, and practice, you'll soon wield your camera like a pro, dialing in the necessary settings to capture your creative vision almost instinctively.

So without further ado, I invite you to grab your camera, a cup of whatever it is you prefer to sip while you read, and start exploring the rest of this book. Your Nikon 1 camera is the perfect partner for your photographic journey, and I thank you for allowing me, through this book, to serve as your tour guide.

Part I Fast Track to Super Snaps

In this part . . .

aking sense of all the controls on your camera isn't something you can do in an afternoon — heck, in a week, or maybe even a month. But that doesn't mean that you can't take great pictures today. By using your camera's Scene Auto Selector and Smart Photo Selector shooting modes, you can capture terrific images with very little effort. All you do is compose the scene, and the camera takes care of almost everything else.

The part shows you how to take best advantage of these two point-and-shoot exposure modes and also addresses some basic setup steps and gets you familiar with the camera menus, buttons, and other controls. In addition, chapters in this part explain how to obtain the very best picture quality, whether you shoot in an automatic or manual mode, and how to use your camera's Movie and Motion Snapshot shooting modes.

Getting the Lay of the Land

In This Chapter

- Familiarizing yourself with the monitor and lens
- Working with a memory card
- Exploring external controls and menus
- Customizing basic operations
- Restoring the camera's default settings

still remember the day that I bought my first interchangeable lens camera. I was excited to finally move up from my one-button point-and-shoot model, but I was a little anxious, too. My new pride and joy sported several unfamiliar buttons and dials, and the explanations in the camera manual clearly were written for someone with an engineering degree. And then there was the whole business of attaching the lens—what if I made a mistake and broke it before I even took any pictures?

If you're feeling similarly insecure, you're not alone — working with a new camera *is* a little intimidating. But the information in this chapter should banish any anxiety and help you get comfortable with your camera. I introduce you to each external camera control, explain how to navigate menus, and cover a few other important basics, such as how to work with lenses and memory cards. In no time at all, your camera will start to feel like a familiar friend.

Attaching and Using Lenses

Your camera has a lens mount that's classified as a Nikon 1 mount. As I write this, Nikon offers just a handful of 1-mount lenses, including the 10–30mm zoom lens featured in this book. However, you can buy the FT1 adapter (approximately \$249) that enables you to attach lenses that have an F mount

as well. If you attach an AF-S lens, autofocusing is supported, but in a limited way. For example, Face-priority AF, which automatically detects and focuses on faces, and Subject Tracking autofocusing, which tracks focus on a moving subject, are not supported. You can find more details about the lens adapter at the Nikon website.

The AF in AF-S stands for *autofocus*, and the S stands for *silent wave*, a Nikon autofocus technology.

When using a Nikon 1 lens, follow these steps to mount it on the camera body:

- 1. Turn off the camera and remove the cap that covers the lens mount on the front of the camera.
- 2. Remove the cap that covers the back of the lens.
- 3. Hold the lens in front of the camera so that the mounting index on the lens aligns with the one on the camera.

Figure 1-1 offers a look at the mounting index as it appears on the 10–30mm Nikon 1 lens. On other lenses, the mounting index may instead be a little white dot; check your lens manual for complete operating instructions. The mounting index on the camera body is marked with a white dot, as shown in the figure. (The figure shows the V1 camera; the mounting index on the J1 is identical.)

- 4. Keeping the mounting indexes aligned, position the lens on the camera's lens mount.
- 5. Turn the lens in a counterclockwise direction until the lens clicks into place.

To put it another way, turn the lens toward the side of the camera that sports the shutter button, as indicated by the red arrow in the figure.

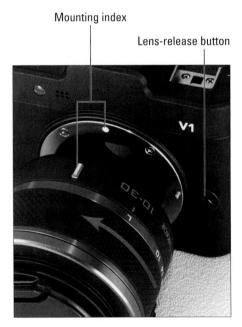

Figure 1-1: When attaching the lens, rotate it in the direction indicated by the arrow.

To remove a lens, first retract the lens, as outlined in the next section, if your lens offers that feature. Then press the lens-release button (labeled in Figure 1-1), and turn the lens toward that button — that is, the opposite of what the arrow indicates in the figure — until it detaches from the lens mount. Put the rear protective cap onto the back of the lens and, if you aren't putting another lens on the camera, cover the lens mount with its protective cap, too.

Always attach or switch lenses in a clean environment to reduce the risk of getting dust, dirt, and other contaminants inside the camera or lens. Changing lenses on a sandy beach, for example, isn't a good idea. For added safety, point the camera body slightly down when performing this maneuver; doing so helps prevent any flotsam in the air from being drawn into the camera by gravity.

Extending and collapsing the lens

The Nikon 1 10–30mm and 30–110mm lenses can be collapsed to make them even more petite. For example, Figure 1-2 shows the 10–30mm zoom lens in its retracted state (left side of the figure) and its extended position (right).

Lens retract/extend button

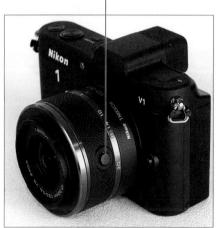

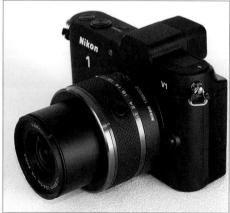

Figure 1-2: To extend and retract the lens, press the lens button while turning the zoom barrel.

To extend the lens, press the little button on the side of the lens while rotating the zoom barrel on the lens toward the shutter button side of the camera. (The zoom barrel is the movable ring that surrounds the button; refer to Figure 1-3.) To retract it, press the button while rotating the zoom barrel in the opposite direction. Always retract the lens before removing it from the camera.

Extending the lens also turns on the camera. Retracting the lens doesn't shut the camera off, however. If you turn on the camera while the lens is retracted, a message appears on the monitor asking you to extend the lens before shooting.

Things work a little differently for the 10–100 power zoom lens. This lens extends automatically when you turn the camera on. And unless you move the switch on the side of the lens from Off to Lock, the lens automatically retracts when you turn the camera off.

Zooming in and out

If you bought the Nikon 1 10–30mm or 30–110mm lens, it has a movable zoom barrel. The location of the zoom barrel on the 10–30mm lens is shown in Figure 1-3. To zoom in or out with these lenses, rotate the zoom barrel.

The numbers at the edge of the zoom barrel, by the way, represent *focal lengths*. If that term is new to you, Chapter 8 explains it fully. In the meantime, just know that when the kit lens is mounted on the camera, the little line labeled *focal length indicator* in Figure 1-3 represents the current focal length. In Figure 1-3, for example, the focal length is 10mm.

The 10–100mm Nikon 1 lens has a power zoom function; to zoom this lens, you press the zoom switch on the lens. (See the lens manual for

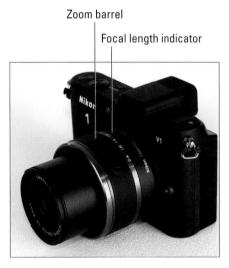

Figure 1-3: The focal length indicator tells you the current focal length of the zoom lens.

complete details about operating the power zoom.) This lens doesn't have the focal length markings that you see in Figure 1-3; instead, you see a zoom guide in the display. See "Customizing the Monitor Display," later in this chapter, for information about display modes.

Using the Viewfinder

With the V1, you can choose to use the electronic viewfinder, shown in Figure 1-4, to compose images rather than framing them using the monitor. But that's not all this viewfinder can do: You can also view your pictures and camera menus in the viewfinder.

Here's what you need to know about using the viewfinder:

Switching to the viewfinder:

The camera automatically turns off the monitor and turns on the viewfinder any time you put your eye up to the viewfinder. The secret to this automatic switching is the little eye sensor labeled in the figure. Whenever the sensor is covered — by your eye, face, whatever — the camera assumes that you want to use the viewfinder and so makes the switch for you.

Waking up the viewfinder: By

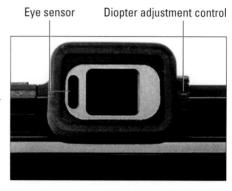

Figure 1-4: Use the diopter adjustment control to set the viewfinder focus for your eyesight.

- default, the viewfinder shuts off after 30 seconds of inactivity, as does the monitor. To bring the viewfinder back to life, just give the shutter button a quick half press and then release it. See the section "Taking a Few Critical Setup Steps" to find out how to adjust the automatic shutoff timing.
- Adjusting the viewfinder to your eyesight: Positioned on the right side of the rubber eyepiece is a tiny dial that enables you to adjust the focus of your viewfinder to accommodate your eyesight. Figure 1-4 offers a close-up look at the dial, which is officially known as the diopter adjustment control.

The Nikon manual warns you not to poke yourself in the eye as you adjust the viewfinder focus. This warning seems so obvious that I laugh every time I read it — which makes me feel doubly stupid the next time I poke myself in the eye as I perform this maneuver.

Working with Memory Cards

Instead of recording images on film, digital cameras store pictures on *memory cards*. Your camera uses a specific type of memory card — an *SD card* (for *Secure Digital*).

Most SD cards sold today carry the designation SDHC (for *High Capacity*) or SDXC (for *eXtended Capacity*), depending on how many gigabytes (GB) of data they hold. SDHC cards hold from 4GB to 32GB of data; the SDXC moniker is assigned to cards with capacities greater than 32GB.

Do you need high-speed memory cards?

Secure Digital (SD) memory cards are rated according to *speed classes*: Class 2, Class 4, Class 6, and Class 10, with the number indicating the minimum number of *megabytes* (units of computer data) that can be transferred per second. A Class 2 card, for example, has a minimum transfer speed of 2 megabytes, or MB, per second. In addition to these speed classes, The Powers That Be recently added a new category of speed rating, UHS, which stands for UltraHigh Speed. UHS cards also carry a number designation; at present, there is only one class of UHS card, UHS 1. These cards currently offer the fastest performance.

Of course, with the speed increase comes a price increase, which leads to the question: Do you really have a need for speed? The answer is "maybe." If you shoot a lot of movies, I recommend a Class 6 card at minimum — the faster data-transfer rate helps ensure smooth movierecording and playback performance. For still photography, users who shoot at the highest

resolution or prefer the NEF (Raw) file format may also gain from high-speed cards; both options increase file size and, thus, the time needed to store the picture on the card. (See Chapter 2 for details.)

As for picture downloading, how long it takes files to shuffle from card to computer depends not just on card speed, but also on the capabilities of your computer and, if you use a memory card reader to download files, on the speed of that device. (Chapter 6 covers the file-downloading process.)

Long story short, if you want to push your camera to its performance limits, a high-speed card is worth the expense, especially for video recording. But if you're primarily interested in still photography or you already own slower-speed cards, try using them first — you may find that they're more than adequate for most shooting scenarios.

The following list offers a primer in the care and feeding of your memory cards:

- ✓ **Inserting a card:** The slot for the card is found in the battery compartment on the bottom of the camera. To install a card, turn off the camera and then put the card in the card slot with the label facing the back of the camera, as shown in Figure 1-5. Push the card into the slot until it clicks into place. After the card is inserted, a tiny memory card access light blinks for a second to let you know the card is inserted properly. On the V1, the light is just below the Menu button; on the J1, it's just above the Disp button.
- ✓ **Formatting a card:** The first time you use a new memory card or insert a card that's been used in other devices (such as an MP3 player), you need to *format* it. Formatting ensures that the card is properly prepared to record your pictures. Here's what you need to know about this important housekeeping task:

• Formatting erases everything on your memory card. So before formatting, be sure that you have copied any pictures or other data to your computer.

• Format the card by using the Format Memory Card option on the Setup menu. (The upcoming section "Ordering from Camera Menus" explains how to use the menus, if you need help.) Some computer programs enable you to format cards as well, but it's not a good idea to go that route. Your camera is better equipped to format cards optimally.

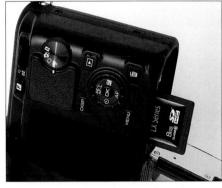

Figure 1-5: Insert the card with the label facing the camera back.

- The message "This memory card is not formatted; Format the card?" appears if the camera detects a card that needs formatting. Select Yes and press the OK button to start the formatting process. If you instead see the message "This memory card cannot be used," the camera is having trouble reading the card data. Formatting the card may help; just remember that you lose any data stored on the card if you format it.
- Removing a card: After making sure that the memory card access light is off, indicating that the camera has finished recording your most recent photo, turn off the camera. Open the battery chamber door, depress the memory card slightly until you hear a little click, and then

let go. The card pops halfway out of the slot, enabling you to grab it by the tail and remove it.

If you turn on the camera when no card is installed, the message *No memory card* appears. If you do have a card in the camera and you get this message, try taking the card out and reinserting it.

Handling cards: Don't touch the gold contacts on the back of the card. (See the left card in Figure 1-6.) When cards aren't in use, store them in the protective cases they came in or in a

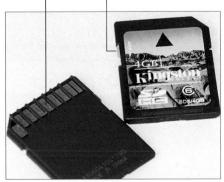

Figure 1-6: Avoid touching the gold contacts on the card.

memory-card wallet. Keep cards away from extreme heat and cold as well.

Locking cards: The tiny switch on the side of the card, labeled *lock* switch in Figure 1-6, enables you to lock your card, which prevents any data from being erased or recorded to the card. Press the switch toward the bottom of the card to lock the card contents; press it toward the top of the card to unlock the data. (If you insert a locked card into the camera, you see a message on the monitor alerting you to the fact.)

You also can protect individual images on a card from accidental erasure by using the camera's Protect feature, which I cover in Chapter 5.

Exploring External Camera Controls

Scattered across your camera's exterior are numerous controls that you use to change picture-taking settings, review your photos, and perform various other operations. In later chapters, I discuss all your camera's functions in detail and provide the exact steps to follow to access them. This section provides just a basic road map to the external controls plus a quick introduction to each.

Topside controls

Your virtual tour begins with the bird's-eye views shown in Figures 1-7 (J1) and 1-8 (V1). There are a number of controls of note here:

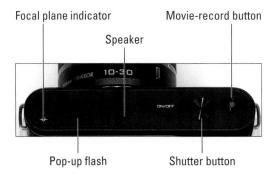

Figure 1-7: Here's the layout of the features on top of the J1.

✓ **On/Off switch:** You don't need me to explain the purpose of this one, of course. But do remember one fact about powering on the camera: Extending the lens barrel on the Nikon 1 10–30mm and 30–110mm lenses also turns on the camera; retracting the lens doesn't shut down the camera, however.

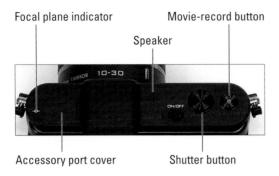

Figure 1-8: The V1 has an accessory port instead of a built-in flash.

- ➤ Shutter button: I'm pretty sure you already figured out this button, too. But you may not be aware that you need to press the shutter button in two stages: Press and hold the button halfway and wait for the camera to initiate exposure metering and, if you're using autofocusing, to set the focusing distance. Then press the button the rest of the way to take the picture.
- Movie-record button: As its name implies, you use this button to start and stop recording. With the J1, you must first set the Mode dial on the back of the camera to Movie mode. With the V1, you can record videos when the Mode dial is set either to Movie mode or Still Image mode. See Chapter 2 to find out about these two shooting modes, and visit Chapter 4 to find out how to adjust movie-recording settings.
- ✓ Built-in flash: The J1 has its own flash, which you pop up via the little
 flash button on the back of the camera.
- Multi accessory port: Here's where you attach the optional SB-N5 flash or the GP-N100 GPS unit to the V1. When not in use, the contacts on the port are protected by a little black cover (as shown in Figure 1-8); remove the cover to expose the contacts and attach the flash or GPS unit.

In addition to these two accessories, you can mount the Nikon ME-1 stereo microphone using the multi-accessory port. You attach the microphone cable to the microphone port on the side of the camera, however (see the upcoming section "Hidden connections.") The accessory port mount is just a way to keep the microphone in place atop the camera.

- ✓ **Speaker:** When you play movies that contain sound, the audio comes wafting through the holes labeled *Speaker* in Figures 1-7 and 1-8.
- ✓ Focal plane indicator: Should you need to know the exact distance between your subject and the camera, the focal plane indicator is key. The mark, labeled in Figures 1-7 and 1-8, indicates the plane at which

light coming through the lens is focused onto the negative in a film camera or the image sensor in a digital camera. Basing your measurement on this mark produces a more accurate camera-to-subject distance than using the end of the lens or some other external point on the camera body as your reference point.

Back-of-the-body controls

As you can see from Figure 1-9, the back of the Nikon J1 (left side of the figure) is nearly identical to the V1 (right side) with the exception of a slightly smaller size, the flash pop-up slider (J1), and the viewfinder and accessory port (V1). Figure 1-10 offers a close-up view of the remaining controls on both cameras. The one difference among this cluster of controls is that bottom button on the Multi Selector accesses flash modes on the J1 and the Focus mode setting on the V1 (more about that momentarily).

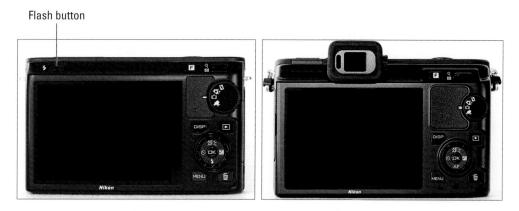

Figure 1-9: The J1 (left) and V1 (right) sport the same essential backside controls.

Starting at the top and working down, the various bits and pieces serve the following purposes:

✓ **F (Feature) button:** Pressing this button produces different results depending on what camera feature you're currently using. For example, in Movie mode, you use the button to choose from high-definition recording or slow-motion recording. And during picture playback, you press it to access a feature that lets you assign a rating to a picture — one star, two stars, and so on.

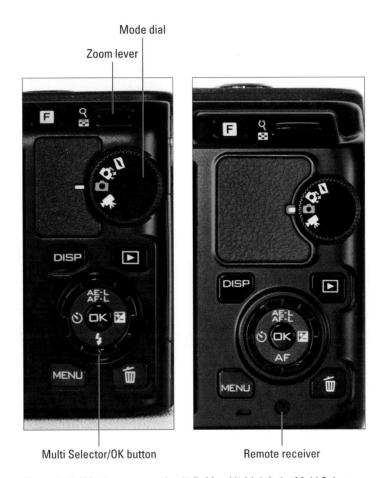

Figure 1-10: Whether you use the J1 (left) or V1 (right), the Multi Selector is key to navigating menus and choosing camera settings.

- **Zoom lever:** Labeled in Figure 1-10, this lever enables you to magnify pictures during playback or to switch from single-image view to index (thumbnails) view. During shooting, you use the lever to adjust certain settings. For example, if you shoot in aperture-priority autoexposure mode, you press the lever up or down to select the f-stop you want to use. (Chapter 7 explains this exposure mode and f-stops.) You also use the lever to set focusing distance when you focus manually with a Nikon 1 lens; see Chapter 8 for help with that option.
- ✓ Mode dial: You select a basic exposure mode via this dial, labeled in Figure 1-10. You can choose from Still Image mode, Motion Snapshot

 $\operatorname{mode},\operatorname{Smart}\operatorname{Photo}\operatorname{Selector}\operatorname{mode},\operatorname{or}\operatorname{Movie}\operatorname{mode}.\operatorname{Chapter}2\operatorname{introduces}$ you to all these modes.

✓ **Disp button:** Press this button to vary the type of information that appears on the monitor or, on the V1, to turn the monitor off altogether. (See the upcoming section "Customizing the Monitor Display) for details.)

On the V1, pressing the Disp button also changes the amount of information displayed in the electronic viewfinder. But you can't use the button to turn off the viewfinder display — it remains on until you take your eye away from the viewfinder.

- ✓ Playback button: Press this button to switch the camera into picture review mode. Chapter 5 details playback features.
- ✓ Multi Selector/OK button: This dual-natured control, labeled in Figure 1-10, plays a role in many camera functions. When navigating menus, you press the outer edges of the Multi Selector left, right, up, or down to scroll through menu options. You also use the Multi Selector buttons to scroll through pictures during playback. Alternatively, you can scroll by rotating the dial just run your thumb around the outside of the dial to rotate it.

When no menus are displayed, pressing the up/down/right/left buttons invoke the feature that's indicated by the button labels. Three of the buttons are identical on the V1 and J1; the bottom button serves different purposes on the two cameras. Here's the rundown:

- *Top button:* Press the top button to activate AE (autoexposure) lock, a feature covered in Chapter 7. By default, the button locks autofocus at the same time that autoexposure is locked, but you can change this behavior through an option covered in Chapter 11.
- *Right button:* This handy button enables you to apply Exposure Compensation, another exposure feature that I discuss in Chapter 7.
- Left button: You use this button to turn on Self-Timer shooting, covered in Chapter 2.
- Bottom button: On the V1, pressing the bottom button provides access to the Focus mode, which you can read about in Chapter 8.
- *Bottom button:* On the J1, pressing the bottom button enables you to select a Flash mode, as detailed in Chapters 2 and 7.
- ✓ Delete button: Sporting a trash-can icon, the universal symbol for delete, this button enables you to erase pictures from your memory card. Chapter 5 has specifics.

Menu button: Press this button to access menus of camera options. See the section "Ordering from Camera Menus," later in this chapter, for details on navigating menus.

✓ Remote receiver: The little round sensor labeled on the right side of Figure 1-10 is designed to pick up the signal from the optional wireless remote control. The front of the camera also has a sensor; see the next section for details. (The J1 has a front-side receiver only.)

Front controls

The front side of the J1 and V1 contain similar features, but arranged a little differently. Figure 1-11 shows the J1; Figure 1-12, the V1.

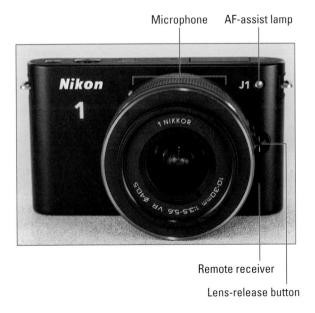

Figure 1-11: Here's a look at the front features of the J1.

Front-side features include the following:

✓ AF-assist lamp: In dim lighting, the camera may emit a beam of light from this lamp when you use autofocusing. The light helps the camera find its focusing target. If you're shooting in a setting where this light is distracting or otherwise annoying, you can disable it via the Built-In AF-Assist option on the Shooting menu. On the flip side, there are some situations in which the lamp is automatically disabled: It doesn't light during movie recording, for example.

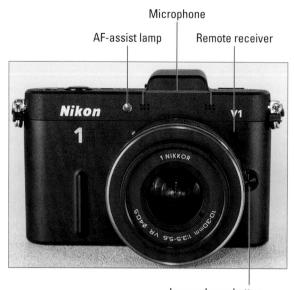

Lens-release button

Figure 1-12: The V1 has the same basic features but in a different arrangement.

The AF-assist lamp also shoots out light when you use red-eye reduction flash and the Self-Timer shutter-release mode, both covered in Chapter 2. You can't disable the lamp for these two functions.

- Lens-release button: Press this button to disengage the lens from the camera's lens mount so that you can remove the lens.
- ✓ Microphone: These little holes lead to the camera's internal microphone. See Chapter 4 to find out how to disable the microphone if you want to record silent movies.
- ✓ Remote receiver: If you purchase the optional wireless remote control, you aim it at the infrared receiver to send the remote signal to the camera. Note that the V1 also has a receiver on the back of the camera (refer to Figure 1-10).

Hidden connections

Hidden under little cover on the right side of the J1 and the left side of the V1, you find the connection ports shown in Figure 1-13:

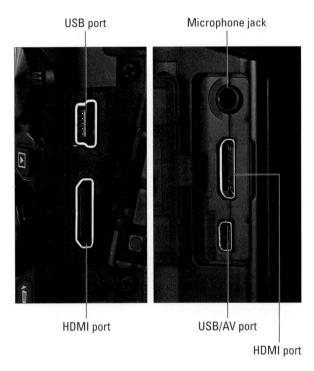

Figure 1-13: The J1 has USB and HDMI ports (left); the V1 adds a microphone jack (right), and the USB port also serves as the A/V out port.

✓ USB port: Through this port, you can connect your camera to your computer for picture downloading. Nikon supplies the cable you need in the camera box; see Chapter 6 for picture downloading help.

For the V1, you also use this port to connect the camera to a television set via a standard A/V connection (in other words, an analog connection). The cable you need is supplied with the camera; Chapter 5 explains the process of connecting the two devices.

- ✓ HDMI port: You can use this port to connect your camera to a high-definition TV, but you need to buy an HDMI cable to do so. Look for a Type C mini-pin cable. Chapter 5 offers more details on HD television playback.
- ✓ **Microphone jack:** If you're not happy with the audio quality provided by the internal microphone, you can plug in the optional ME-1 microphone here. (See Chapter 4 for all things movie-related.) The J1 lacks this feature; you can record sound only by using the built-in microphone.

If you turn the camera over, you find a tripod socket, which enables you to mount the camera on a tripod that uses a ¼-inch screw, plus the battery chamber and memory card slot.

Ordering from Camera Menus

Pressing the Menu button on your camera gives you access to a whole slew of options in addition to those you select via the external controls. When you press this button, you see a screen similar to the one shown in Figure 1-14. The icons along the left side of the screen represent the three menus: Setup, Shooting, and Playback. In the menu screens, the icon that's highlighted or appears in color is the active menu; options on that menu automatically appear to the right. In the figure, the Shooting menu is active.

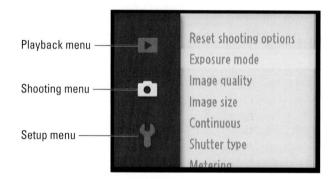

Figure 1-14: Highlight a menu in the left column to display its contents.

Note that the Shooting menu icon changes depending on the setting of the Mode dial. For normal, Still Image shooting, for example, the icon takes the same shape as the icon on the Mode dial (the green camera). When you choose a different Mode dial setting, the icon changes to reflect that setting. You see a movie-camera icon for Movie mode, for example. (Chapter 2 introduces you to all the modes.)

In addition, some menu items appear only when they're relevant. For example, on the V1, you don't see any flash-related menu items unless the SB-N5 accessory flash is attached and turned on. Ditto for the GPS unit — you see a GPS-related item on the Setup menu only when the unit is attached and turned on. And if you attach non-Nikon 1 lenses via the FT1 lens mount adapter, any menu options not supported by the attached lens don't appear.

I explain all the important menu options elsewhere in the book; for now, just familiarize yourself with the process of navigating menus and selecting options therein. The Multi Selector (refer to Figure 1-10) is the key to the game. You press the edges of the Multi Selector to navigate up, down, left, and right through the menus. Or you can rotate the dial to scroll from option to option.

In this book, the instruction "Press the Multi Selector left" simply means to press the left edge of the control. "Press the Multi Selector right" means to press the right edge, and so on. Additionally, menu screens show primarily the V1 menus. In most cases, the J1 menus are the same, so I chose not to waste space showing both. Where the possibility of confusion arises, I show both or spell out the differences in the text.

Here's a bit more detail about the process of navigating menus:

- ✓ **To select a different menu:** Press the Multi Selector left to jump to the column containing the menu icons. Then press up or down or rotate the dial to highlight the menu you want to display. Finally, press right to jump over to the options on the menu.
- To select and adjust a function on the current menu: Again, use the Multi Selector to scroll up or down the list of options to highlight the feature you want to adjust, and then press OK. Settings available for the selected item then appear. For example, if you select the Exposure Mode item from the Shooting menu, as shown on the left in Figure 1-15, and press OK, the available Exposure Mode options appear, as shown on the right in the figure. Repeat the old up-and-down scroll routine until the choice you prefer is highlighted. Then press OK to return to the previous screen.

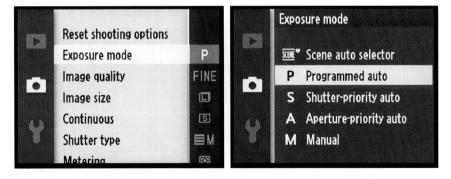

Figure 1-15: Select a menu item and press OK to display the available settings.

As an alternative to using the OK button, pressing the Multi Selector right displays available options. And when you're ready to leave the option screen, pressing left takes you back to the menu.

Customizing the Monitor Display

By default, the monitor displays icons or text representing critical picture-taking settings, as shown on the left in Figure 1-16. (The figure shows the V1 display; the J1 display is similar.) This display mode is called the Simplified display. By pressing the Disp button, you can switch to Detailed display mode and view even more shooting data, as shown on the right in the figure. Note that for the V1, your choice affects the viewfinder display as well.

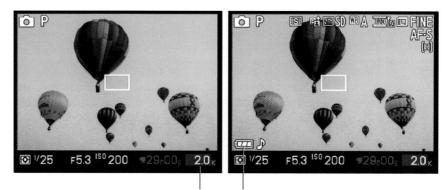

Shots remaining Battery status

Figure 1-16: Press the Disp button to change the amount of data displayed on the monitor.

To turn the monitor off on the V1, press Disp one more time. (The monitor eats up lots of battery power, so shutting it off while you're not using it is a good idea.) To bring the monitor back to life, press Disp again. Again, you can't turn off the viewfinder display on the V1 by using the Disp button; just take your eye away from the viewfinder, and the camera automatically turns off that display.

If what you see in Figure 1-16 looks like a confusing mess, don't worry. Many of the settings relate to options that won't mean anything to you until you make your way through later chapters and explore the advanced exposure modes. But do make note of the following bits of data that are helpful even when you shoot in the fully automatic modes:

- ✓ **Shots remaining:** Labeled on the left screen in Figure 1-16, this value indicates how many additional pictures you can store on the current memory card. If the number exceeds 999, the value is presented a little differently. The initial K appears with the value to indicate that the first value represents the picture count in thousands. For example, 1.0K means that you can store 1,000 more pictures (*K* being a universally accepted symbol indicating 1,000 units). The number is then rounded down to the nearest hundred. So if the card has room for, say, 1,230 more pictures, the value reads 1.2K.
- ✓ Battery status indicator: A full battery icon like the one shown on the right in Figure 1-16 shows that the battery is fully charged; if the icon appears empty, look for your battery charger. (Note that the icon is in a slightly different position on the J1, but still in the lower-left corner of the display.)

You can further customize the monitor display by adding a grid to the mix, as shown on the left in Figure 1-17. Turn it on by opening the Setup menu and setting the Grid Display option to On, as shown on the right. The grid is especially helpful when you're shooting landscapes — the horizontal lines make it easy to ensure that you've framed the shot with the horizon level.

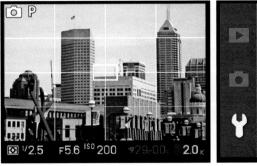

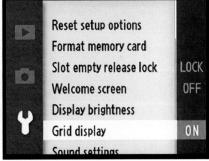

Figure 1-17: You can add a grid in the display via the Setup menu.

Adding the SB-N5 Flash

Rather than sporting a built-in flash like the J1, the V1 has an accessory port where you can attach the optional Speedlight SB-N5 flash, as shown in Figure 1-18. I strongly recommend taking Nikon up on this option, as you will no doubt encounter situations where you need to add extra light to a subject. At press time, the flash sells for about \$150.

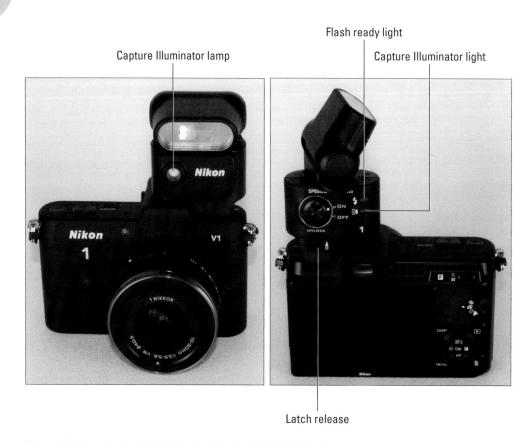

Figure 1-18: Here's a look at the front and back of the SB-N5 flash.

Later chapters explain in detail how to make best use of the flash, but here's an overview of the basics to get you started:

- ✓ Attaching the flash: Remove the accessory port cover tuck it away somewhere safe and then remove the cover that protects the bottom of the flash unit as well. Then slide the flash mounting foot into the accessory port until it clicks into place.
- ✓ **Turning on the flash:** To turn on the flash, rotate its On/Off switch to the On position. But note that the flash takes its power from the camera itself rather than using its own battery supply, so regardless of the position of the On/Off switch, the flash doesn't come to life unless the camera is also turned on.

Also remember that the flash will fire *only* in Still Image photography mode. It does not fire in Movie mode, Motion Snapshot mode, or Smart Photo Selector mode. See Chapter 2 for a review of these exposure modes, chosen via the Mode dial on the back of the camera.

Adjusting the flash head: To give you maximum lighting flexibility, the flash head can be rotated upward, as shown in the right image in Figure 1-18. This position enables you to use bounce lighting — the flash light travels up to the ceiling and then falls gently down on your subject — which provides more flattering lighting than straight-on flash. (See Chapter 9 for an example.) You also can swivel the flash head, as shown in the figure, so that you can light your subject from any angle. You can swivel the flash as far as 180 degrees, so that it faces the back of the camera, in fact. You can rotate the flash up as far as 90 degrees.

Be gentle about adjusting the flash head, and don't force the head past where you feel some resistance.

- Waiting for the flash-ready light: When the camera is set to Still Image photography mode, the flash-ready indicator light (labeled in Figure 1-18) glows red to let you know the flash is ready to fire. Between shots, the light turns off briefly to indicate that the flash is recharging. After 30 seconds of inactivity, the flash automatically turns itself off to save power; you can wake it up simply by pressing the shutter button halfway and releasing it.
- Using the Capture Illuminator light: If the flash is turned on when you use the Smart Photo Selector or Motion Snapshot exposure mode, the Capture Illuminator light on the front of the flash emits a bright light as soon as you press the shutter button halfway. This light, as its name suggests, is designed to add some extra light to your subject during the time the images are being recorded. When the light is ready to use, the Capture Illuminator lamp on the back of the flash glows green (see the right image in Figure 1-18).

Again, though, the flash itself doesn't fire in these modes, so no light comes through the main flash head. And the Capture Illuminator light has a limited time of operation — about six seconds — after which the monitor displays a message saying that the light is too exhausted to keep shining. See Chapter 3 for help using Smart Photo Selector mode; check out Chapter 4 to find out about Motion Snapshot recording.

If either the flash-ready lamp or Capture Illuminator lamp on the back of the camera blinks, the camera is alerting you to a potential flash problem. The number and speed of the blinks vary depending on the error; see the camera manual for a listing of all the possibilities.

✓ Removing the flash: Press up on the latch release (refer to Figure 1-18) while sliding the flash out of the accessory port. Replace the protective covers on the flash mounting foot and the accessory port and then place the flash head in its handy carrying bag for extra protection.

Taking a Few Critical Setup Steps

Your camera offers scads of options for customizing its performance. Later chapters explain settings related to actual picture taking, such as those that affect flash behavior and autofocusing. Chapter 11 explores a few options that are better left at their default settings until you really get to know your camera. That leaves just a handful of options that I recommend you consider at the get-go. They're found on the Setup menu, shown in Figure 1-19. Here's a rundown of these options:

✓ **Slot Empty Release Lock:** This cryptically named feature determines whether the camera lets you take a picture when no memory card is installed in the camera. If you set it to Enable Release, the camera no

longer warns you if a memory card isn't installed. You can take a temporary picture, which appears in the monitor with the words *Demo mode* but isn't recorded anywhere. The feature is provided mainly for use in camera stores, enabling salespeople to demonstrate the camera without having to keep a memory card installed. I can think of no good reason why anyone else would change the setting from the default, Release Locked.

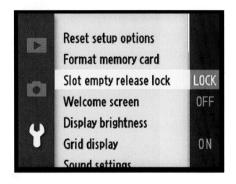

Figure 1-19: Visit the Setup menu to customize your camera's basic appearance and operation.

- Welcome Screen: When this option is set to On, the monitor displays an opening "title" screen that says Nikon 1 every time you turn on the camera. The screen disappears after a second or two. To make it permanently disappear, set this option to Off.
- ✓ **Display Brightness (V1) and Monitor Brightness (J1):** This option enables you to make the LCD display brighter or darker. On the V1, you also can separately adjust the brightness of the electronic viewfinder.

If you take this step, keep in mind that what you see on the display may not be an accurate rendition of the actual exposure of your image. Crank up the monitor brightness, for example, and an underexposed photo may look just fine. So I recommend that you keep the brightness at the default setting (0).

✓ **Sound Settings:** By default, the camera emits a little beep when autofocusing is complete — and also when you use the self-timer shutter release. Additionally, you hear the sound of a camera shutter when you press the shutter button and the electronic shutter is used. (The J1 has only an electronic shutter; on the V1, you can choose from manual or electronic shutter, as explored in Chapter 7.)

To disable these sound effects, choose Sound Settings, as shown on the left in Figure 1-20, and press OK to display the second screen in the figure. Highlight an option and press the Multi Selector right to remove the check from the adjacent box. The first option controls the autofocus and self-timer beep; the second, the electronic shutter sound. Note that on the J1, the shutter-sound control is labeled simply *Shutter* instead of Electronic Shutter.

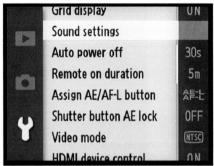

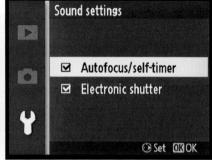

Figure 1-20: Disable sound effects to enjoy quieter shooting.

- Auto Power Off: By default, the camera automatically shuts off the monitor (and viewfinder, on the V1) after 30 seconds of inactivity. You can adjust the shutdown timing via this menu option. Just remember that the monitor is one of the biggest drains on the battery, so keeping it awake for long periods when you don't need to view it isn't a smart idea.
 - Regardless of the setting you choose for this menu option, the camera shuts itself off completely after approximately three minutes of inactivity.
- Reset File Numbering: The camera automatically numbers your picture files and creates a storage folder to house them. Each folder can contain 999 images. If you're a really prolific shooter, you may one day shoot enough pictures to fill up 999 folders, at which point the camera refuses to take any more pictures. (The same thing occurs if the folder contains an image numbered 9999.) The only solution is to choose this option, which resets file numbering back to 0001. You then need to be especially careful when downloading pics so that you don't overwrite existing images that have the same numbers.
- ✓ **Time Zone and Date:** When you turn on your camera for the very first time, it automatically displays this option and asks you to set the current date and time. Keeping the date and time accurate is important because that information is recorded as part of the image file. In your photo browser, you can then see when you shot an image and, equally handy, search for images by the date they were taken.

- Language: You're asked to specify a language along with the date and time when you fire up your camera for the first time. Your choice determines the language of text on the camera monitor.
- ✓ Battery Info: Choose this option and press OK to display a screen that shows you how much charge is left in the battery and the age of the battery. When the age reported is 4, it's time to start thinking about replacing the battery.

For information on the Firmware Version and Pixel Mapping options at the bottom of the Setup menu, see Chapter 10. And again, refer to Chapter 11 for a few additional Setup menu options.

Restoring Default Settings

Should you ever want to return your camera to its original, out-of-the-box state, the camera manual contains a complete list of most of the default settings. Look on the pages that introduce each of the menus.

You can also partially restore default settings by taking these steps:

- Reset all Shooting Menu options: Open the Shooting menu, choose Reset Shooting Menu, and press OK.
- ✓ Reset all Setup Menu options: Choose the Reset Setup Menu option at the top of the Setup menu.

Choosing Basic Picture Settings

In This Chapter

- Spinning the Mode dial
- Choosing a Still Image exposure mode
- Changing the shutter-release mode
- Enabling and disabling Vibration Reduction
- ▶ Choosing the right Image Size (resolution) setting
- ▶ Understanding the Image Quality setting: JPEG or Raw?

very camera manufacturer strives to provide a good *out-of-box* experience — that is, to ensure that your initial encounter with the camera is a happy one. To that end, the camera's default settings are carefully selected to make it as easy as possible for you to take a good picture the first time you press the shutter button. On your Nikon 1 camera, the default settings are designed to let you take a picture the same way you do with automatic, point-and-shoot cameras: Just compose the shot, press the shutter button halfway to set focus and exposure, and then press the button the rest of the way to record the image.

Although the default settings deliver nice pictures in many cases, they don't produce optimal results in every shooting situation. You may be able to take a decent portrait using the default setup, for example, but probably need to tweak a few settings to capture action. In fact, adjusting a few settings can help turn that decent portrait into a stunning one, too.

So that you can start fine-tuning camera settings to your subject, this chapter explains the most basic picture-taking options, such as the exposure mode, shutter-release mode, and the image size and quality. They're not the most exciting options to explore (don't think I didn't notice you stifling a yawn), but they make a big difference in how easily you can capture the photo you have in mind.

Choosing a Basic Shooting Mode

The first picture-taking setting to consider is the basic shooting mode, which you select via the Mode dial, shown in Figure 2-1. You have four choices:

- Fill Image mode: This is the "normal, still photo" mode. But it's actually five modes in one. After you set the dial to Still Image, you can choose from five still-photography modes. You can stick with the default, Scene Auto Selector mode, which provides fully automatic shooting, or choose from four advanced exposure modes that give you more control over the camera. See the next section for details.
- Movie mode: As you probably guessed, you set the Mode dial to the little movie camera icon when you want to record HD videos. You can then start and stop recording by pressing the red Movie-record button on top of the camera.

With the V1, you also can record movies in Still Image mode — just press the Movierecord button as usual. But if you go this route, you lose control over certain recording settings. See Chapter 4 for complete information about all things movie-related, including how to take still photos during movie recording.

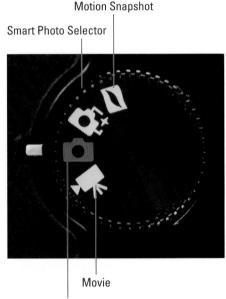

Figure 2-1: Choose Still Image mode for regular photography.

Still Image

Auto Selector mode). The camera captures about 20 images in rapid succession, starting recording as soon as you press the shutter button halfway and continuing for a few frames *after* you press the button the rest of the way. Then it analyzes the images and chooses what it considers the five best frames. You can review those images and select your own best shot, and you can choose to delete all but the winning frame. Chapter 3 gives you step-by-step instructions for taking advantage of this special shooting mode.

✓ **Motion Snapshot mode:** This mode produces a short, slow-motion video that ends with a still photo — all set to one of four built-in music tracks. Chapter 4 provides the how-to's for using this feature.

Choosing a Still Image Exposure Mode

After setting the Mode dial to Still Image mode, you can choose one of five different exposure modes, each of which gives you a different level of control over two critical exposure settings: aperture and shutter speed, both explained fully in Chapter 7. Make your selection via the Exposure Mode option on the Shooting menu, as illustrated in Figure 2 2.

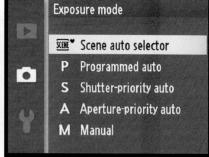

Figure 2-2: You can choose from five Still Image exposure modes.

Your choices are as follows:

✓ **Scene Auto Selector mode:** For people who haven't yet explored photography concepts like aperture and shutter speed — or who just aren't interested in "going there" — this mode offers fully automatic shooting.

The name refers to the fact that the camera automatically selects from different "scene types" — portraits, landscapes, close-ups, or night portraits — and then dials in camera settings that are designed to produce the traditional look of that kind of photo. If you're shooting portraits, for example, the camera chooses settings that attempt to blur the background, which is a traditional creative choice for people pics. If your subject doesn't fall into one of the scene categories, the camera uses general, all-purpose settings.

Again, remember that because this mode is designed to make picture-taking simple, it prevents you from accessing many of the camera's features. Options that are off limits appear dimmed in the camera menus. And if you press a camera button that leads to an advanced setting, nothing happens.

✓ P (Programmed autoexposure) mode: In this mode — one of four advanced shooting modes — the camera selects the aperture and shutter speed necessary to ensure a good exposure. But you can choose from different combinations of the two to vary the creative results. For example, shutter speed affects whether moving objects appear blurry or sharp. So you might use a fast shutter speed to freeze action, or you

might go the other direction, choosing a shutter speed slow enough to blur the action, creating a heightened sense of motion.

This mode provides the closest thing to fully automatic operation while still giving you access to all the camera's features. So if you're locked out of a setting in Scene Auto Selector mode, give P mode a whirl.

- ✓ **S (Shutter-priority autoexposure):** You select the shutter speed, and the camera selects the proper aperture to properly expose the image. This mode is ideal for capturing sports or other moving subjects because it gives you direct control over shutter speed.
- ✓ A (Aperture-priority autoexposure): In this mode, you choose the aperture, and the camera automatically chooses a shutter speed to properly expose the image. Because aperture affects *depth of field*, or the distance over which objects in a scene remain in sharp focus, this setting is great for portraits because you can select an aperture that results in a blurred background, putting the emphasis on your subject. For landscape shots, on the other hand, you might choose an aperture that keeps the entire scene sharply focused so that both near and distant objects have equal visual weight.
- ✓ M (Manual exposure): In this mode, you select both the aperture and shutter speed. But the camera still offers an assist by displaying an exposure meter to help you dial in the right settings.

To sum up, you get one fully automatic exposure mode, three semi-automatic modes (P, A, and S), and, for complete exposure control, manual mode. Chapter 3 provides details about shooting in Scene Auto Selector mode; when you're ready to dig into exposure issues and try the more advanced exposure modes, head for Chapter 7.

Choosing the Release Mode

By default, the camera captures a single image each time you press the shutter button. But by changing the Release mode setting, you can vary this behavior. For example, you can set the camera to Self-Timer mode so that you can press the shutter button and then run in front of the camera and be part of the picture. Or you can switch to Continuous mode, which records a burst of images as long as you hold down the shutter button — a great feature for photographing a fast-moving subject.

Now for the confusing part: On your camera, there is no menu option called Release mode, although the camera manual refers to the setting by that name. Inexplicably, the menu item is instead called Continuous, which is the name of one possible Release mode. Furthermore, you access Self-Timer and Remote Control Release modes not via the menu option, but through the left Multi Selector button. The next three sections clarify things and show you how to select each of the available Release modes.

Hey, my shutter button isn't working!

You press the shutter button . . . and press it, and press it — and yet nothing happens. Don't panic: First, make sure that a memory card is installed in the camera. If it is, the error is most likely related to autofocusing. You see, when you use certain autofocus modes, including the default ones, the camera insists on achieving focus before it releases the shutter to take a picture. You can press the shutter button all day, and the camera just ignores you if it can't set focus.

Try backing away from your subject a little — the focusing issue may be occurring because you've exceeded the minimum focusing distance of the lens. If that doesn't work, the subject itself just may not be conducive to autofocusing. Highly reflective objects, scenes with very little contrast, and subjects behind fences are some of the troublemakers. The easiest solution? Switch to manual focusing and set focus yourself. See Chapter 8 for information on manual focusing as well as a complete rundown of autofocusing options.

Standard Release modes: Single Frame and Continuous

For Still Image shooting, you can choose from two standard Release modes, which are represented in the menus by the icons you see in the margins here. In Detailed display mode, the monitor also displays the icon for the currently selected mode; Figure 2-3 shows you where to look. (Press the Disp button to cycle from Simplified display mode to Detailed mode.)

Here's a rundown on these Release modes:

Single Frame: This is the default setting, resulting in one picture each time you press the shutter button. In other words, this is normal-photography mode. The only other thing you need to know is that you must press the shutter button in two stages for autoexposure and autofocusing to work correctly: Press the button halfway, pause to let the camera set focus and exposure, and then press the rest of the way to take the picture.

Continuous: Sometimes known as *burst mode*, this mode records a continuous series of images as long as you hold down the shutter button, making it easier to capture action. The camera can record as many as five frames per second in this mode.

A few critical details:

• Continuous shooting is disabled when you use flash.
You can't use flash in
Continuous mode because the time that the flash needs to recycle between shots slows down the capture rate too much. If you try to use flash when Continuous mode is selected, you see a little lightning bolt symbol plus a red warning dot to the left of the Release mode icon on the monitor. And the

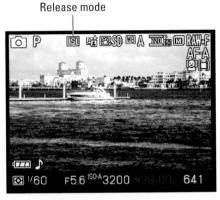

Figure 2-3: The icon representing the current Release mode appears here.

camera takes only one picture with each shutter-button press, just as it does in Single Frame mode.

- Continuous mode is unavailable in Smart Photo Selector exposure mode. In fact, the Continuous menu option disappears altogether as soon as you set the Mode dial to Smart Photo Selector mode. That makes sense, since the camera is already capturing a burst of images in that mode. (Again, see Chapter 3 for details.)
- Images are stored temporarily in the memory buffer. The camera has a little bit of internal memory a buffer where it stores picture data until it has time to record the images to the memory card. The number of pictures the buffer can hold depends on certain camera settings, such as resolution and file type (JPEG or Raw). The monitor displays an estimate of how many pictures will fit in the buffer; see the sidebar "What does r24 mean?" later in this chapter, for details.

After shooting a burst of images, wait for the memory card access light on the back of the camera to go out before turning off the camera. That's your signal that the camera has successfully moved all data from the buffer to the memory card. Turning off the camera before that happens may corrupt the image files.

• Your mileage may vary. The maximum number of frames per second is an approximation. The actual number of frames you can capture depends on a number of factors, including your shutter speed. (See Chapter 7 for an explanation of shutter speed.) Additionally, although you can capture as many as 100 frames in a single burst, the frame rate can drop if the buffer gets full.

How you select these Release modes depends on which Nikon 1 model you use:

✓ **J1:** For fastest results, press the F (Feature button), which displays the selection screen shown on the left in Figure 2-4. Use the Multi Selector to highlight your choice and press OK to hide the selection screen. Again, this option isn't available in Smart Photo Selector mode, so pressing the button in that mode does absolutely nothing.

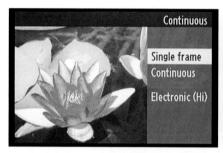

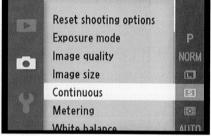

Figure 2-4: On the J1, press the F button to display the Release mode choices (left) or select the Continuous item on the Shooting menu (right).

Alternatively, you can select the mode via the Continuous option on the Shooting menu, highlighted on the right in the figure. And yes, the menu item is named Continuous even when Single Frame is the selected setting. (Argh!)

✓ V1: On the V1, the F button plays a different role, enabling you to quickly change the shutter type in Still Image mode. So the only way to access these two release modes is via the Shooting menu, as illustrated in Figure 2-5.

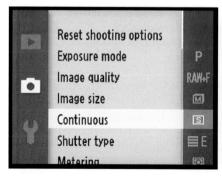

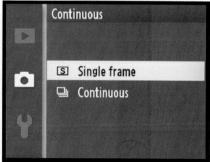

Figure 2-5: On the V1, use the Shooting menu option to switch between Single Frame and Continuous shooting.

Electronic (Hi) Release mode

■F^{HI} This specialty Release mode, available only for Still Image mode shooting, permits a higher frames-per-second capture rate than the regular Continuous mode. At the default Electronic (Hi) setting, the camera records about 10 frames per second, but you can up the rate to 30 and even 60 frames per second.

Wow, you're thinking, why wouldn't you always use Electronic Hi instead of Continuous? Well, there some serious tradeoffs you make for the more advanced frame rate:

- ✓ At the 10 frames per second setting, the camera can adjust focus between frames, but it always focuses on the center of the frame. Facedetection autofocusing (covered in Chapter 8) is not available.
- ✓ At 30 and 60 frames per second, focus and exposure are locked at the settings used for the first frame in the series. Face detection is available to help you lock that initial focus point, however.
- Flash isn't available regardless of which frames-per-second value you select.
- After you enable Electronic Hi shooting, several critical picture-taking settings, including the exposure mode, become unavailable. The camera automatically uses P (Programmed auto) mode, but you can't choose from different combinations of aperture and shutter speed as you normally can. Nor do you have any control over autofocusing settings, Exposure Compensation, Metering mode, or ISO Sensitivity. (Part III explains these settings.)

It's also important to consider that even at 10 frames per second, you're recording a lot of images. And unless your subject is moving really, really fast, you're not going to see much difference between the shots. That means that you fill up your memory card at a rapid pace, with little benefit to show for it. And with the 30 and 60 frames-per-second rates, where focus and exposure are locked from the first frame, many of those frames may be poorly exposed, out of focus shots if you're shooting subjects that are moving away from or toward the camera or into and out of the light.

That said, if you want to try out Electronic (Hi), be sure that the Mode dial is set to Still Image — again, Electronic (Hi) is off limits when any other mode is selected. Then access the setting as follows:

✓ J1: Open the Shooting menu, select Continuous, and press OK to display the screen shown on the left in Figure 2-8. Choose Electronic (Hi) and press the Multi Selector right to display the screen shown on the right. Select the desired frames per second rate and press OK.

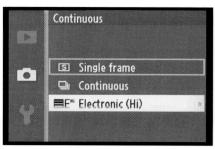

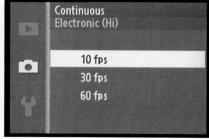

Figure 2-6: On the J1, choose Electronic (Hi) and then press the Multi Selector right to display the available frames per second options.

You also can press the F button to display the Release mode choices (refer to Figure 2-4). Selecting Electronic (Hi) results in whatever frame rate was last chosen from the Shooting menu.

✓ V1: To access the Electronic (Hi) setting on the V1, choose Shutter Type from the Shooting menu and then choose Electronic (Hi), as shown on the left in Figure 2-7. Press the Multi Selector right to display the available frames-per-second options, as shown on the right in the figure. Highlight your choice and press OK. Note that choosing this option disables the regular, mechanical shutter and engages the electronic one. See Chapter 7 for the complete story on the two shutter types.

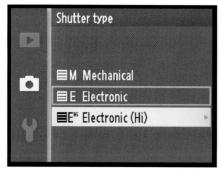

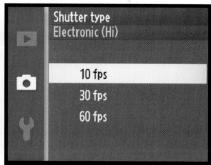

Figure 2-7: On the V1, set the Electronic (Hi) frame rate via the Shutter Type item on the Shooting menu.

As with the J1, you also can press the F button to enable Electronic (Hi) shooting at the currently selected frame rate. But in this case, the screen that appears lists the same choices as on the Shutter Type item on the Shooting menu: Mechanical, Electronic, and Electronic (Hi). The camera uses whatever frame rate you last chose from the Shooting menu.

Self-timer and remote-control shooting

You access self-timer and remote-control shutter-release options by pressing the left button on the Multi Selector, labeled in Figure 2-8. Note, however, that the button doesn't work if the Electronic (Hi) Release mode is active — you must select either the Single Frame or Continuous mode first.

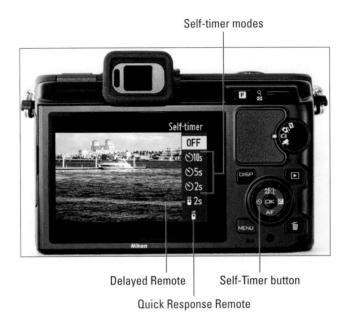

Figure 2-8: Press the Multi Selector left to access the Self-Timer and Remote Control Release modes.

You can choose from the following options:

Three Self-Timer modes: You're no doubt familiar with the Self-Timer Release mode, which delays the shutter release for a few seconds after you press the shutter button, giving you time to dash into the picture. Here's how it works on your camera: After you press the shutter button, the AF-assist lamp on the front of the camera starts to blink, and the camera emits a series of beeps (assuming that you didn't disable its voice, a setting I cover in Chapter 1). A few seconds later, the camera captures the image.

You can select a delay time of 2 seconds, 5 seconds, or 10 seconds by choosing the corresponding setting from the list of options, represented by the icons you see here and labeled in Figure 2-8.

ॐ2s **ॐ**5s

Note one important factoid about all three settings: Your self-timer setting is good only for one shot. After you take the picture, the self-timer function is automatically set to Off, and you return to either Single Frame or Continuous shooting, depending on which you selected last.

Additionally, you can't use self-timer shooting in Smart Photo Selector shooting mode; the camera insists on using Single Frame release mode. Nor is the self-timer function available for recording a motion snapshot. But — and here's a surprise — you can use Self-Timer mode to delay the start of movie recording. Just press the Movie-record button instead of the shutter button to trigger the timer.

✓ Two wireless Remote Control modes: The final two Release mode settings, also available for both Still Image and Movie shooting modes only, relate to the optional Nikon ML-L3 wireless remote-control unit. You can choose from a Delayed Remote mode, in which case the camera takes the picture about two seconds after you press the shutter-release button on the remote unit. If you instead choose the Quick Response setting, the image is captured immediately.

Remember that in order for the remote control to work, you must aim it at the infrared sensor on the camera. See Chapter 1 for a look at the sensor; the J1 has one on the front of the camera, and the V1 has one on the front and on the back.

Normally, the camera cancels out of the remote control modes if it doesn't receive a signal from the remote after about five minutes. You can adjust this timing through the Remote On Duration option on the Setup menu and featured in Figure 2-9. The maximum delay time is 15 minutes; keep in mind that a shorter delay time saves battery life. After the delay time expires, the camera resets itself to either Single Frame or Continuous mode, depending on which mode you last used. The Release mode is also reset to one of those modes if you turn the camera off.

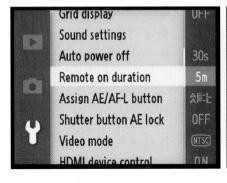

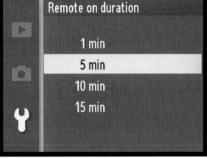

Figure 2-9: Set preferences for wireless-remote shutter release via this menu option.

What does r24 mean?

Normally, the number of shots remaining appears in the lower-right corner of the display. But as soon as you press the shutter button halfway, which kicks the autofocus and exposure mechanisms into action, that value changes to show you how many pictures can fit in the camera's memory buffer. For example, the value r24 tells you that 24 pictures can fit in the buffer.

So what's the *buffer?* It's a temporary storage tank where the camera stores picture data until it has time to fully record that data onto the camera memory card. This system exists so that you can take a continuous series of pictures without waiting between shots until each image is fully written to the memory card. When the buffer is full, the camera automatically disables the shutter button until it catches up on its recording work.

Taking Advantage of Vibration Reduction

Three of the four lenses in the initial Nikon 1 lineup — the 10–30mm zoom, 30–110mm zoom, and 10–100mm power zoom — offer *Vibration Reduction*, indicated by the initials VR in the lens name. Vibration Reduction attempts to compensate for small amounts of camera shake that are common when photographers handhold their cameras and use a slow shutter speed (long exposure time), a lens with a long focal length (telephoto lens), or both. That camera movement during the exposure can produce blurry images. Although Vibration Reduction can't work miracles, it enables most people to capture sharper handheld shots in many situations than they otherwise could.

When using one of the aforementioned lenses, you control the feature via the Vibration Reduction option on the Shooting menu, as shown in Figure 2-10. You get two "on" settings: Active and Normal. Active is designed for situations in which you expect a lot of camera movement — shooting pictures while riding in a speedboat or car, for example. Normal is designed for, well, normal shooting situations where you're standing still (or close to it) and taking the shot.

For some reason, Nikon made Active the default setting. And although that may sound like a good thing, it's not. When the camera tries to compensate for movement that's not actually occurring, the result can be a blurrier, rather than sharper, photo. So set this option to Normal unless you're really going to be on the move while shooting. When you use a tripod, you should turn off the feature altogether, for the same reason. (This assumes that

the tripod head is locked down so that no camera movement is possible.) Remember, too, that if you restore the Shooting menu's default settings, the Vibration Reduction option gets reset to Active.

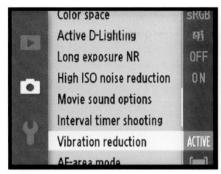

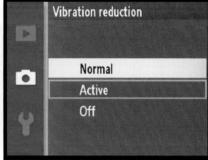

Figure 2-10: Normal is the best setting for regular handheld photography.

If you use other lenses, check the lens manual to find out whether your lens offers a similar feature and, if so, how to implement it. (With most lenses, the Vibration Reduction option disappears from the Shooting menu, and you activate the feature with a switch on the lens itself.) On non-Nikon lenses, Vibration Reduction may go by another name: *image stabilization, optical stabilization, anti-shake, vibration compensation,* and so on.

Choosing the Right Quality Settings

Almost every review of the Nikon 1 cameras contains positive reports about picture quality. As you've no doubt discovered, those reviews are true: These cameras can create large, beautiful images.

What you may *not* have discovered is that Nikon's default Image Quality setting isn't the highest that the cameras offer. Why, you ask, would Nikon do such a thing? Why not set up the cameras to produce the best images right out of the box? The answer is that using the top setting has some downsides. Nikon's default choice represents a compromise between avoiding those disadvantages while still producing images that will please most photographers.

Whether that compromise is right for you, however, depends on your photographic needs. To help you decide, the rest of this chapter explains the Image Quality setting, along with the Image Size setting, which is also critical to the quality of images that you print. Just in case you're having quality problems related to other issues, though, the next section provides a handy quality-defect diagnosis guide.

If you already know what settings you want to use and just need some help finding out how to select the options, skip to the very last section of the chapter.

Diagnosing quality problems

When I use the term *picture quality,* I'm not talking about the composition, exposure, or other traditional characteristics of a photograph. Instead, I mean how finely the image is rendered in the digital sense.

Figure 2-11 illustrates the concept: The first example is a high-quality image, with clear details and smooth color transitions. The other examples show five common digital-image defects.

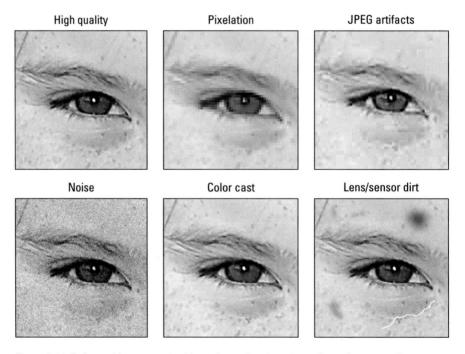

Figure 2-11: Refer to this symptom guide to determine the cause of poor image quality.

Each of these defects is related to a different issue, and only one is affected by the Image Quality setting. So if you aren't happy with your image quality, first compare your photos to those in the figure to properly diagnose the problem. Then try these remedies:

- ✓ Pixelation: When an image doesn't have enough *pixels* (the colored tiles used to create digital images), details aren't clear, and curved and diagonal lines appear jagged. The fix is to increase image resolution, which you do via the Image Size control. See the next section, "Considering image size: How many pixels are enough?" for details.
- JPEG artifacts: The "parquet tile" texture and random color defects that mar the third image in Figure 2-11 can occur in photos captured in the JPEG (jay-peg) file format, which is why these flaws are referred to as JPEG artifacts. This defect is related to the Image Quality setting; see "Understanding Image Quality options (JPEG or Raw)," later in this chapter, to find out more.
- Noise: This defect gives your image a speckled look, as shown in the lower-left example in Figure 2-11. Noise can occur with very long exposure times or when you choose a high ISO Sensitivity setting on your camera. You can explore both issues in Chapter 7.
- ✓ **Color cast:** If your colors are seriously out of whack, as shown in the lower-middle example in the figure, try adjusting the camera's White Balance setting. Chapter 8 covers this control and other color issues.
- Lens/sensor dirt: A dirty lens is the first possible cause of the kind of defects you see in the last example in the figure. If cleaning your lens doesn't solve the problem, dust or dirt may have made its way onto the camera's image sensor. See Chapter 10 for advice about cleaning your lens and sensor.

When diagnosing image problems, you may want to open the photos in ViewNX 2 or some other photo software and zoom in for a close-up inspection. Some defects, especially pixelation and JPEG artifacts, have a similar appearance until you see them at a magnified view. (See Part II for information about using ViewNX 2.)

I should also tell you that I used a little digital enhancement to exaggerate the flaws in my example images to make the symptoms easier to see. With the exception of an unwanted color cast or a big blob of lens or sensor dirt, these defects may not even be noticeable unless you print or view your image at a very large size. And the subject matter of your image may camouflage some flaws; most people probably wouldn't detect a little JPEG artifacting in a photograph of a densely wooded forest, for example.

In other words, don't consider Figure 2-11 as an indication that your camera is suspect in the image-quality department. First, *any* digital camera can produce these defects under the right circumstances. Second, if you follow the guidelines in this chapter and the noise and color recommendations that I explore in other chapters, you can resolve any quality issues that you may encounter.

Considering image size: How many pixels are enough?

Pixels are the little square tiles from which all digital images are made. You can see some pixels close up in the right image in Figure 2-12, which shows a greatly magnified view of the eye area in the left image.

Figure 2-12: Pixels are the building blocks of digital photos.

Pixel is short for *picture element*. The number of pixels in an image is referred to as *resolution*. You can define resolution either in terms of the *pixel dimensions* — the number of horizontal pixels and vertical pixels — or total resolution, which you get by multiplying those two values. This number is usually stated in *megapixels*, or MP for short, with 1 megapixel equal to 1 million pixels. For example, both the J1 and V1 offer a maximum resolution of 3872 x 2592 pixels, which translates to about 10 megapixels.

You control resolution via the Image Size setting. You can choose from three settings: Large, Medium, and Small; Table 2-1 lists the resolution values for each setting. (Megapixel values are rounded off.)

Table 2-1	Standard (3:2) Image Sizes
Setting	Resolution
Large	3872 x 2592 (10 MP)
Medium	2896 x 1944 (5.6 MP)
Small	1936 x 1296 (2.5 MP)

Note that if you select Raw (NEF) as your file format, all images are captured at the Large setting. You can vary the resolution only when choosing JPEG as the file format. The upcoming section "Understanding Image Quality options (JPEG or Raw)" explains file formats.

Also note that the resolutions shown in Table 2-1 apply to photos that you shoot in Still Image and Smart Photo Selector shooting modes. Still photos that you capture in Movie mode have different pixel dimensions because they have a 16:9 aspect ratio, whereas Still Image and Smart Photo Selector photos have a 3:2 aspect ratio. For photos taken in Movie mode, the still-image resolution is tied to the Movie Settings option, which controls the video resolution. Table 2-2 lists the still photo sizes that are produced at each movie setting. Chapter 4 provides complete details about recording movies and capturing still images during recording.

Table 2-2	Movie Mode (16:9) Image Sizes
Movie Settings Option	Still Image Resolution
1080/60i	3840 x 2160 (8.3 MP)
1080/30p	1920 x 1080 (2 MP)
720/60p	1280 x 720 (0.9 MP)

Whatever the aspect ratio of your photo, you need to understand the three ways that pixel count affects your pictures:

✓ Print size: Pixel count determines the size at which you can produce a high-quality print. If you don't have enough pixels, your prints may exhibit the defects you see in the pixelation example in Figure 2-11, or worse, you may be able to see the individual pixels, as in the right example in Figure 2-12. Depending on your photo printer, you typically need anywhere from 200 to 300 pixels per linear inch, or *ppi*, of the print. To produce an 8 x 10 print at 200 ppi, for example, you need a pixel count of 1600 x 2000, or just less than 2 megapixels.

Even though many photo-editing programs enable you to add pixels to an existing image, doing so isn't a good idea. For reasons I won't bore you with, adding pixels — known as *upsampling* — doesn't enable you to successfully enlarge your photo. In fact, upsampling typically makes matters worse. The printing discussion in Chapter 6 includes some example images that illustrate this issue.

✓ Screen display size: Resolution doesn't affect the quality of images viewed on a monitor, television, or other screen device the way it does for printed photos. Instead, resolution determines the *size* at which the image appears. This issue is one of the most misunderstood aspects of digital photography, so I explain it thoroughly in Chapter 6. For now,

just know that you need *way* fewer pixels for onscreen photos than you do for printed photos. In fact, even the Small resolution setting on your camera creates a picture too big to be viewed in its entirety in some e-mail programs.

✓ File size: Every additional pixel increases the amount of data required to create a digital picture file. So a higher-resolution image has a larger file size than a low-resolution image.

Large files present several problems:

- You can store fewer images on your memory card, on your computer's hard drive, and on removable storage media, such as a DVD.
- The camera needs more time to process and store the image data on the memory card after you press the shutter button. This extra time can hamper fast-action shooting.
- When you share photos online, larger files take longer to upload and download.
- When you edit your photos in your photo software, your computer needs more resources and time to process large files.

As you can see, resolution is a bit of a sticky wicket. What if you aren't sure how large you want to print your images? What if you want to print your photos *and* share them online?

I take the better-safe-than-sorry route, which leads to the following recommendations about which Image Size setting to use when you're shooting in Still Image mode or Smart Photo Selector mode (as opposed to capturing a single frame while recording a movie):

Always shoot at a resolution suitable for print. You then can create a low-resolution copy of the image in your photo editor for use online. In fact, your camera offers a built-in resizing option; Chapter 6 shows you how to use it.

- Again, you *can't* go in the opposite direction, adding pixels to a low-resolution original in your photo editor to create a good, large print. Even with the very best software, adding pixels doesn't improve the print quality of a low-resolution image.
- ✓ For everyday images, Medium is a good choice. I find the Large setting (10 MP) to be overkill for most casual shooting, which means that you're creating huge files for no good reason. Keep in mind that even at the Small setting, your pixel count (1936 x 1296) is more than what you need to produce a 5 x 7-inch print at 200 ppi.

- Choose Large for an image that you plan to crop, print very large, or both. The benefit of maxing out resolution is that you have the flexibility to crop your photo and still generate a decent-sized print of the remaining image. Figures 2-13 and 2-14 offer an example. When I was shooting this photograph, I couldn't get close enough to fill the frame with my main interest the two juvenile herons at the center of the scene. But because I had the resolution cranked up to Large, I could later crop the shot to the composition you see in Figure 2-14 and still produce a great print. In fact, I could have printed the cropped image at a much larger size than fits here.
- ✓ Reduce resolution if shooting speed is paramount. If you're shooting action and the shot-to-shot capture time is slower than you want that is, the camera takes too long after you take one shot before it lets you take another dialing down the resolution may help.

After you decide which resolution setting is right for your picture, visit the section "Setting Image Size and Quality," at the end of this chapter, for details on how to select that setting when shooting in Still Image or Smart Photo Selector mode.

Again, for stills that you capture during movie recording, the image size is determined by the Movie Setting option, which I detail in Chapter 4. If you can't find a setting that answers both your video and still-image needs, simply switch back to one of the Still Image exposure modes to capture your still frames.

Figure 2-13: I couldn't get close enough to fill the frame with the two juvenile herons, so I captured this image at the Large resolution setting.

Figure 2-14: A high-resolution original enabled me to crop the photo tightly and still have enough pixels to produce a quality print.

Understanding Image Quality options (IPEG or Raw)

If I had my druthers, the Image Quality option would instead be called File Type because that's what the setting controls.

Here's the deal: The file type, sometimes also known as a file *format*, determines how your picture data is recorded and stored. Your choice does impact picture quality, but so do other factors, as outlined in the earlier section "Diagnosing quality problems." In addition, your choice of file type has ramifications beyond picture quality.

At any rate, your camera offers the two file types common on most digital cameras: JPEG and Camera Raw, or just Raw for short, which goes by the specific moniker NEF (*Nikon Electronic Format*) on Nikon cameras. The next sections explain the pros and cons of each format. If your mind is already made up, skip ahead to "Setting Image Size and Quality," near the end of this chapter, to find out how to make your selection.

Don't confuse *file format* with the Format Memory Card option on the Setup menu. That option erases all data on your memory card; see Chapter 1 for details.

Also note that you can choose from JPEG and Raw only for photos that you shoot in Still Image and Smart Photo Selector mode. Stills that you capture in Movie mode are always saved in the JPEG format.

JPEG: The imaging (and web) standard

Pronounced *jay-peg*, this format is the default setting on your camera, as it is for most digital cameras. JPEG is popular for two main reasons:

- Immediate usability: All web browsers and e-mail programs can display JPEG files, so you can share them online immediately after you shoot them. The same can't be said for Raw (NEF) files, which must be processed and converted to JPEG files before you can share them online. And although you can view and print your camera's Raw files in Nikon ViewNX 2 without converting them, many third-party photo programs don't enable you to do that. You can read more about the conversion process in the upcoming section "Raw (NEF): The purist's choice."
- ✓ Small files: JPEG files are smaller than Raw files. And smaller files consume less room on your camera memory card and in your computer's storage tank.

The downside — you knew there had to be one — is that JPEG creates smaller files by applying *lossy compression*. This process actually throws away some image data. Too much compression leads to the defects you see in the JPEG artifacts example in Figure 2-11.

Fortunately, your camera enables you to specify how much compression you're willing to accept. You can choose from three JPEG settings, which produce the following results:

- ✓ **JPEG Fine:** At this setting, the compression ratio is 1:4 that is, the file is four times smaller than it would otherwise be. In plain English, that means very little compression is applied, so you shouldn't see many compression artifacts, if any.
- ✓ JPEG Normal: Switch to Normal, and the compression ratio rises to 1:8.
 The chance of seeing some artifacting increases as well.
- ✓ JPEG Basic: Shift to this setting, and the compression ratio jumps to 1:16. That's a substantial amount of compression and brings with it a lot more risk of artifacting.

Again, though, you get this level of control only in Still Image and Smart Photo Selector shooting modes. All still photos that you capture in Movie mode are saved at the JPEG Fine setting.

Also understand that even the JPEG Basic setting doesn't result in anywhere near the level of artifacting that you see in my example in Figure 2-11. Again, that example is exaggerated to help you be able to recognize artifacting defects and understand how they differ from other image-quality issues. In fact, if you keep your image print or display size small, you aren't likely to notice a great deal of quality difference between the Fine, Normal, and Basic compression levels, although details in the Fine and Normal versions may appear slightly crisper than the Basic one. It's only when you greatly enlarge a photo that the differences become apparent.

Given that the differences between the compression settings aren't that easy to spot until you enlarge the photo, is it okay to stick with the default setting — Normal — or even drop down to Basic in order to capture smaller files? Well, only you can decide what level of quality your pictures demand. For me, the added file sizes produced by the Fine setting aren't a huge concern, given that the prices of memory cards fall all the time. Long-term storage is more of an issue; the larger your files, the faster you fill your computer's hard drive and the more DVDs or CDs you need for archiving purposes. But in the end, I prefer to take the storage hit in exchange for the lower compression level of the Fine setting. You never know when a casual snapshot is going to be so great that you want to print or display it large enough that even minor quality loss becomes a concern. And of all the defects that you can correct in a photo editor, artifacting is one of the hardest to remove.

To make the best decision, do your own test shots, carefully inspect the results in your photo editor, and make your own judgment about what level of artifacting you can accept. Artifacting is often much easier to spot when you view images onscreen. It's difficult to reproduce artifacting here in print because the printing press obscures some of the tiny defects caused by compression. Your inkjet prints are more likely to reveal these defects.

If you don't want *any* risk of artifacting, bypass JPEG altogether and change the file type to Raw (NEF). Or consider your other option, which is to record two versions of each file, one Raw and one JPEG. The next section offers details.

Raw (NEF): The purist's choice

The other picture file type you can create when shooting in Still Image or Smart Photo Selector mode is *Camera Raw*, or just *Raw* (as in uncooked) for short.

Each manufacturer has its own flavor of Raw. Nikon's is NEF, for *Nikon Electronic Format*, so you see the three-letter extension NEF at the end of Raw filenames.

Raw is popular with advanced, very demanding photographers, for three reasons:

- ✓ **Greater creative control:** With JPEG, internal camera software tweaks your images, adjusting color, exposure, and sharpness as needed to produce the results that Nikon believes its customers prefer. With Raw, the camera simply records the original, unprocessed image data. The photographer then copies the image file to the computer and uses special software known as a *Raw converter* to produce the actual image, making decisions about color, exposure, and so on at that point. The upshot is that "shooting Raw" enables you, not the camera, to have the final say on the visual characteristics of your image.
- ✓ **Higher bit depth:** *Bit depth* is a measure of how many distinct color values an image file can contain. JPEG files restrict you to 8 bits each for the red, blue, and green color components, or *channels*, that make up a digital image, for a total of 24 bits. That translates to roughly 16.7 million possible colors. On your camera, a Raw file delivers a higher bit count, collecting 12 bits per channel. (Chapter 8 provides more information about the red-green-blue makeup of digital images.)
 - Although jumping from 8 to 12 bits sounds like a huge difference, you may not really ever notice any difference in your photos that 8-bit palette of 16.7 million values is more than enough for superb images. Where having the extra bits can come in handy is if you really need to adjust exposure, contrast, or color after the shot in your photo-editing program. In cases where you apply extreme adjustments, having the extra original bits sometimes helps avoid a problem known as *banding* or *posterization*, which creates abrupt color breaks where you should see smooth, seamless transitions. (A higher bit depth doesn't always prevent the problem, however, so don't expect miracles.)
- ✓ Best picture quality: Because Raw doesn't apply the destructive compression associated with JPEG, you don't run the risk of the artifacting that can occur with JPEG.

But of course, as with most things in life, Raw isn't without its disadvantages. To wit:

✓ You can't do much with your pictures until you process them in a Raw converter. You can't share them online, for example, or put them into a text document or multimedia presentation. You can view and print them immediately if you use the free Nikon ViewNX 2 software, but most other photo programs require you to convert the Raw files to a standard format first. Ditto for retail photo printing. So when you shoot Raw, you add to the time you must spend in front of the computer instead of behind the camera lens. Chapter 6 shows you how to process your Raw files using Nikon ViewNX 2.

Raw files are larger than JPEGs. Unlike JPEG, Raw doesn't apply lossy compression to shrink files. In addition, Raw files are always captured at the maximum resolution available on your camera, even if you don't really need all those pixels. For both reasons, Raw files are significantly larger than JPEGs, so they take up more room on your memory card and on your computer's hard drive or other picture-storage device.

✓ To get the full benefit of Raw, you need software other than Nikon ViewNX 2. The ViewNX 2 software that ships free with your camera does have a command that enables you to convert Raw files to JPEG or to TIFF, another standard imaging format (Chapter 6 has details). However, this free tool gives you limited control over how your original data is translated in terms of color, exposure, and other characteristics — which defeats one of the primary purposes of shooting Raw. The same is true for the Raw converter built into the camera.

Nikon Capture NX 2 offers a sophisticated Raw converter, but it costs about \$180. (Sadly, if you already own Capture NX, you need to upgrade to version 2 to open the Raw files from your camera.) If you own Adobe Photoshop or Photoshop Elements, however, you're set; both include the converter that most people consider one of the best in the industry. Watch the sale ads, and you can pick up Elements for well below \$100. You may need to download an update from the Adobe website (www.adobe.com) to get the converter to work with your Nikon 1 files. For additional software options, see Chapter 6.

Whether the upside of Raw outweighs the down is a decision that you need to ponder based on your photographic needs, your schedule, and your computer-comfort level. If you do decide to try Raw shooting, you can select from the following two Image Quality options:

- ✓ Raw: This setting produces a single Raw file at the maximum resolution (10 megapixels).
- ✓ Raw+JPEG Fine: This setting produces two files: the standard Raw file plus a JPEG version saved at the Fine Image Quality setting. The Raw file is captured at the Large resolution setting; the JPEG size is determined by the Image Size setting.

I often choose the Raw+JPEG Fine option when I'm shooting pictures I want to share right away with people who don't have software for viewing Raw files. I upload the JPEGs to a photo-sharing site where everyone can view them, and then I process the Raw versions when I have time. Having the JPEG version

also enables you to display your photos on a DVD player or TV that has a slot for an SD memory card — most can't display Raw files but can handle JPEGs. Ditto for portable media players and digital photo frames.

My take: Choose JPEG Fine or Raw (NEF)

At this point, you may be finding all this technical goop a bit much — I recognize that panicked look in your eyes — so allow me to simplify things for you. Until you have time or energy to completely digest all the ramifications of JPEG versus Raw, here's a quick summary of my thoughts on the matter:

- ✓ If you require the absolute best image quality and have the time and interest to do the Raw conversion, shoot Raw. See Chapter 6 for more information on the conversion process.
- ✓ If great photo quality is good enough for you, you don't have wads of spare time, or you aren't that comfortable with the computer, stick with JPEG Fine.
- If you don't mind the added file-storage space requirement and want the flexibility of both formats, choose Raw+JPEG Fine.
- If you go with JPEG only, stay away from JPEG Normal and Basic. The tradeoff for smaller files isn't, in my opinion, worth the risk of compression artifacts. As with my recommendations on image size, this fits the "better safe than sorry" formula: You never know when you may capture a spectacular, enlargement-worthy subject, and it would be a shame to have the photo spoiled by compression defects.

Setting Image Size and Quality

To sum up this chapter:

- ✓ The Image Size and Image Quality options both affect the quality of your pictures and also play a large role in image-file size.
- Choose a high Image Quality setting Raw (NEF) or JPEG Fine and the maximum Image Size setting (Large), and you get top-quality pictures and large file sizes.
- Combining the lowest Quality setting (JPEG Basic) with the lowest Size setting (Small) greatly shrinks files, enabling you to fit lots more pictures on your memory card; however, it also increases the chances that you'll be disappointed with the quality of those pictures, especially if you make large prints.

One more important reminder: You can set the Image Size and Image Quality *only* for photos that you capture in Still Image or Smart Photo Selector shooting mode. For stills that you capture during movie recording, the image size is dependent on the movie-quality settings you select (via the Movie Settings menu option). And all stills are saved at the JPEG Fine setting.

In Still Image or Smart Photo Selector mode, you can view the current Image Size and Image Quality settings in the upper right corner of the display in Detailed display mode. (Press the Disp button to change the display mode.) Figure 2-15 shows you where to look.

To adjust the settings, just visit the Shooting menu. The two options live next door to each other near the top of the menu, as shown in Figure 2-16.

Remember that when you choose the Raw (NEF) option, you don't need to worry about the Image Size setting. For that format, all pictures are automatically captured at the Large resolution, and you can't choose a lower resolution setting.

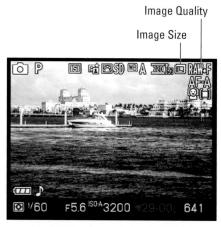

Figure 2-15: The current Image Quality and Image Size settings appear here.

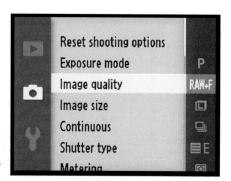

Figure 2-16: Set the Image Size and Image Quality options via the Shooting menu.

Taking Great Pictures, Automatically

In This Chapter

- ▶ Reviewing the basics of good composition
- Choosing the best options for automatic photography
- ▶ Understanding the pros and cons of Scene Auto Selector mode
- Shooting your first pictures
- Taking advantage of Smart Photo Selector mode

art III of this book explains how to take complete control over exposure, focus, and color, which is important to becoming a masterful photographer. Problem is, it takes a while to digest all that information and even longer to put everything you learn into practice. As I tell my students, "There's a *reason* you can get a master's degree in photography — there's a *lot* to learn."

Don't get discouraged, though: Just because digital photography has a bit of a learning curve doesn't mean that you can't start taking better pictures right away. First off, one of the biggest steps you can take toward improving your photos has nothing to do with learning all your camera's bells and whistles. Rather, it's understanding a few basics of composition, which the first part of this chapter presents. After all, you can be the most technically knowledgeable photographer in the world, but if your composition is poor, your pictures still fall flat.

Second, your camera offers two fully automatic photography modes, Scene Auto Selector and Smart Photo Selector, both of which let the camera do the heavy lifting so that you can simply compose, point, and shoot. The second half of this chapter explains these modes. They're both fairly simple to use,

but there are a few tips I can share that will help you get the best results when you take advantage of them.

Composing a Stronger Image

You don't have to be an art major to understand that your camera angle and distance, as well as how you position elements of a scene, can make the difference between a well-composed image and one that elicits yawns. Of course, not everyone agrees on the best ways to compose an image — art being in the eye of the beholder and all that. For every composition rule, you can find an incredible image that proves the exception. That said, the next sections offer five basic compositional tips that can help you create images that rise above the ho-hum mark on the "visual interest" meter. Be sure to also visit Chapter 9 for more tips on taking specific types of pictures.

Following the rule of thirds

For maximum impact, don't place your subject smack in the center of the frame. Instead, mentally divide the frame into thirds like a tic-tac-toe game, as illustrated in Figure 3-1. Then position the main subject elements at spots where the dividing lines intersect. In the sample image, the point of interest, the bee in the large daisy, falls at that placement, for example.

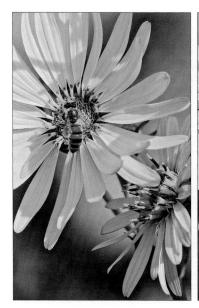

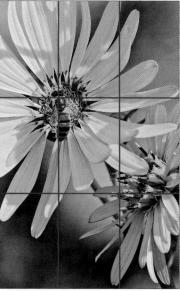

Figure 3-1: One rule of composition is to divide the frame into thirds and position the main subject at one of the intersection points.

Figure 3-2 offers another example of how following the rule of thirds can improve a picture. In the first image, putting the horizon line at dead center makes for a boring shot, even though the sunset is beautiful. Reframing to shift the horizon line down to the bottom third of the frame creates the more dynamic composition shown on the right.

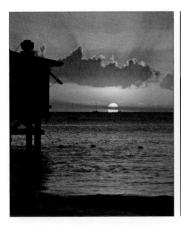

Figure 3-2: Putting the horizon line at dead center makes for a dull image (left); reframing to follow the rule of thirds leads to a more dynamic shot.

Creating movement through the frame

To add life to your images, compose the scene so that the viewer's eye is naturally led from one edge of the frame to the other. For example, in Figure 3-3, the winding canal takes the eye from the boat in the foreground all the way to the back of the frame, while in Figure 3-4, the strong diagonal lines of the walkway and the curving arches that frame it do the trick. You can also create movement through the frame by finding repeating patterns of color, as shown in Figure 3-5, or with patterns of light and shadow, as in Figure 3-6.

Figure 3-3: Here the winding canal leads the eye vertically through the frame.

Working all the angles

Resist taking the predictable shot: the front-and-center view of the monument, the shot looking down at the top of the birthday cake, the front-facing portrait of two people standing side by side and saying "cheese." Instead, spend some time studying your subject *before* you even pick up your camera. What's the most interesting viewpoint to capture? As an example, see Figure 3-7. This image accurately represents the statue. But the picture is hardly as captivating as the images in Figure 3-8, which show the same subject from more unusual angles.

Professional photographers "work the angles," experimenting with shooting their subject from above, below, from the side, and so on. Only by moving around and really seeing your subject from all sides can you find the most interesting viewpoint. And doing that bit of extra work is what can separate your photos from those taken by 99 percent of the other people photographing the same subject.

Figure 3-4: The strong diagonals in the walkway, framed by the curved archways, create movement in this shot.

Figure 3-5: In this photo, the repeating pattern of blue leads the eye from one corner to the other.

Figure 3-6: The strong contrast between the dark background and the bright foreground emphasize the curves of the calla lily.

Figure 3-7: The standard-issue front-and-center view equals "yawn."

Figure 3-8: Looking at the statue from different angles reveals more interesting shots.

Editing out the clutter

Know that claustrophobic feeling you get when you walk in a store that is jam-packed to the rafters with goods — so cluttered that you can't even move through the aisles? That's the same reaction most people have when looking at a photo like the one in Figure 3-9. There's simply too much going on. The eye doesn't know where to look, except away.

Figure 3-9: This shot looks chaotic because there's too much going on for the eye to land on any one subject.

As a photographer, you must decide what you want your main subject to be — and then try to frame the shot so that distracting elements aren't visible. For example, in Figure 3-10, reframing the shot to include just a portion of the ride creates a much better image. All the energy of the fair is captured in the whirling chairs, and the composition is such that the eye moves around the curve of the frame to take it all in. To add an even greater sense of motion, I used a shutter speed slow enough to slightly blur the whirling riders while keeping the rest of the ride sharp. (Chapter 7 explains how to use shutter speed to control motion blur.)

Being aware of the subject's surroundings is especially critical in portraits. If you're not paying attention, you can wind up with "plant on the head" syndrome, as illustrated in Figure 3-11. The window blinds and computer monitor

Figure 3-10: Concentrating just on a small portion of the ride captures its energy without all the distracting background.

further distract from the subject's beautiful face in this picture.

Long story short: Pick a subject — a *single subject* — and then work to find a composition that eliminates unwanted clutter from the background. If you can't move the subject, move your feet and keep looking until you find the best angle to flatter that subject. If all else fails, see Chapter 8 to find out how to blur the background so that it's less distracting.

Giving them room to move

For pictures that portray movement, don't

frame your images so tightly that your subject looks cramped. For example, suppose you're shooting a cyclist racing along a street course. Frame the image with extra margin in the direction the biker is riding, as shown in Figure 3-12. Otherwise, it appears that there's nowhere for the subject to go. Similarly, when shooting animals or people in profile, leave extra padding in the direction that the subjects' eyes are focused, as shown in Figure 3-13. This helps the eye follow the focus of the subjects across the frame and then causes the viewer to imagine what is just out of sight.

One note regarding this compositional point: As you look through this book or browse through other photography books and magazines, you'll see lots of examples of very tightly framed images that work very well. But in many cases, the images were originally framed loosely and then cropped to the final composition. Why not just frame tightly to begin with? Because if you want to print your images later on at traditional frame sizes— 4 x 6, 5 x 7, 8 x 10, and so on — you may be out of luck.

Figure 3-11: Scan the background for distracting objects to avoid "plant on the head" syndrome in portraits.

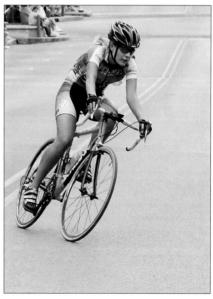

Figure 3-12: Give moving subjects somewhere to go in the frame.

Nancy Nauman

Figure 3-13: Leaving extra space on the right causes the viewer to follow the bears' glance across the frame.

Here's the deal: Your camera creates originals with a 3:2 aspect ratio. A 3:2 original translates perfectly to a 4 x 6-inch snapshot print, but at any other frame size, you have to crop out some of the image to fit the proportions of the print. For example, in the left photo in Figure 3-14, the red outline shows you how much of the 3:2 original would fit into a 5 x 7-inch frame; the one in the right photo, an 8 x 10-inch frame. Had I composed the original with a very tight frame, I wouldn't have been able to crop to a different frame size without cutting off important parts of the picture. So especially when I'm shooting portraits, I always leave some extra padding around the edges of the frame. (Some people refer to this margin area as *head room* when discussing portraits.)

Don't be put off by the idea of having to crop your picture, either — it's not a difficult task. You can do the job easily in Nikon View NX 2, the free software that ships with your camera. In fact, you don't even have to go that far to find a crop tool: The Playback menu on your camera has a tool that you can use to create a cropped copy of your original image. (Chapter 11 shows you how to use it.) In addition, most retail printing sites and in-store print kiosks offer tools that enable you to crop your images before printing.

As Easy as It Gets: Using Scene Auto Selector Mode

Scene Auto Selector is the name given to your camera's normal, fully automatic photography mode. (Smart Photo Selector mode, discussed later in

this chapter, is also fully automatic but is a special-use mode.) Why Scene Auto Selector? Well, in this mode, the camera analyzes the subject and then automatically selects one of four scene modes: Portrait, Landscape, Night Portrait (for portrait subjects set against dark backgrounds), or Close-up. These scene modes are designed to choose camera settings that deliver the best results for these types of pictures. For example, portraits usually look best with a softly focused background, so in Portrait mode, the camera chooses settings that produce that effect. Color and sharpness are also tweaked to produce soft, pleasing skin tones. If your subject doesn't fit any of the four scene types, the camera uses all-purpose settings that capture most subjects in a pleasing fashion.

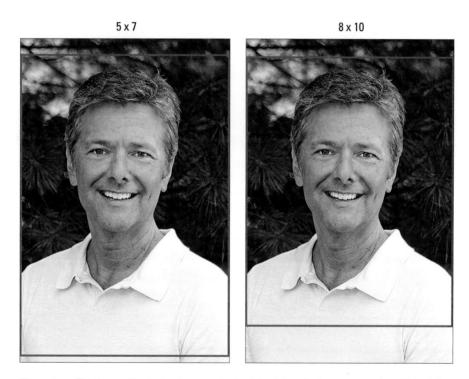

Figure 3-14: This image illustrates how much of a 3:2 original fits in a 5 x 7- and 8 x 10-inch frame.

If you've used other digital cameras, you may be familiar with these scene modes. Normally, you select the scene yourself via a dial or menu option. But on the Nikon 1, the camera makes the choice for you, and it all happens in an instant. You're alerted to which scene mode the camera selected by an icon that appears in the display. Try it out:

- 1. Set the Mode dial to Still Image mode, as shown in Figure 3-15.
- 2. Display the Shooting menu and select Exposure Mode, as shown on the left in Figure 3-16.

This is the menu option that lets you set the camera to Scene Auto Selector or to one of the advanced exposure modes (P, S, A, or M, all covered in Chapter 7).

- 3. Press OK to display the options shown on the right in Figure 3-16.
- 4. Select Scene Auto Selector and press OK.
- 5. Press the shutter button halfway and release it to return to Shooting mode.

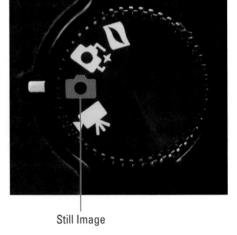

Figure 3-15: The first step in using Scene Auto Selector mode is to set the Mode dial to Still Image mode.

In the upper-left corner of the display, you see the icon representing Still Image mode next to one that indicates which scene mode Scene Auto Selector chose, as shown in Figure 3-17. For example, in the figure, the camera selected Close-Up mode, indicated by a flower icon.

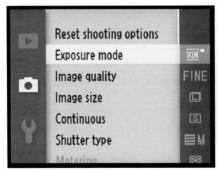

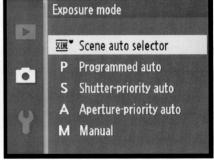

Figure 3-16: Then set the Exposure Mode item on the Shooting menu to Scene Auto Selector.

Table 3-1 offers a look at all the scene type icons; here's a review of the results that the four special scene types are designed to produce:

Table 3-1	Scene Auto Selector Scene Modes	
	Scene mode	What it does
Ž *	Portrait	Softens backgrounds; warms and softens skin tones
••	Landscape	Keeps both near and distant objects in sharp focus; emphasizes blues and greens
<u>•</u> *	Night Portrait	Uses slow shutter speed to capture more ambient light in dark settings (use a tripod to avoid camera shake)
# "	Close-up	Softens backgrounds but keeps colors natural
AUTO♥	Auto	Uses all-purpose settings to capture subjects that don't fit other scene types

Exposure mode

- ✓ Portrait: This mode is selected when the camera detects people. It results in settings that blur the background and soften and warm skin tones, producing the traditional portrait look.
- ✓ Landscape: Almost the opposite of Portrait mode, this mode is geared to keep both foreground and background objects sharp. In the tradition of landscape photography, colors are also adjusted to boost blues and greens.
- Night Portrait: The camera chooses this mode if it detects people set against a dark background (or in generally dim lighting conditions). As with Portrait mode, this mode tries to achieve a blurry background and a ceft warm.

Scene mode

1/60 F5.3 129-00: 1.7 K

Figure 3-17: These icons indicate the exposure mode (Scene Auto Selector) and the scene mode that the camera selected.

blurry background and a soft, warm rendering of the skin. The difference

is that in this mode, the camera uses a slow shutter speed so that it can soak up more ambient light, resulting in brighter backgrounds. Even so, you may need to use flash to light your subject properly.

A slow shutter speed increases the chances of camera shake during the exposure, which can blur the image, so use a tripod for good results. Also ask your subjects to remain as still as possible, as any movement on their part may also be blurred at a slow shutter speed.

✓ Close-up: When your subject is near the camera lens, the camera chooses this mode. The background is blurred to draw attention to the subject, but unlike Portrait mode, Close-up mode doesn't manipulate colors.

It's important to understand that these modes achieve their blurry back-grounds (Portrait, Night Portrait, and Close-up) or large zone of sharp focus (Landscape mode) by varying an exposure control called the *aperture*, or *f-stop*. However, the range of apertures the camera can select varies depending on the light. In dim lighting, an open aperture (which results in back-ground blurring) is needed to properly expose the picture; in bright light, a small aperture (which results in a large zone of sharp focus) may be required to avoid overexposing the picture. Additionally, the range of available aperture settings varies from lens to lens, and the amount of background blurring also increases as the distance between your subject and the background grows. So how much *depth of field* (the zone of sharp focus) you get from any of these scene modes varies from shot to shot. (For more about apertures and f-stops, see Chapter 7; for a look at all the ways to control depth of field, see Chapter 8.)

The upcoming section "Taking pictures in Scene Auto Selector mode" walks you through the steps of framing and capturing your photo. But first, you may want to check out the next section, which discusses a few camera settings that you should check before you shoot.

Setting up for automatic success

Scene Auto Selector mode is designed for people without any knowledge of photography. You just frame the shot and press the shutter button. But you still have a few ways to control the camera's behavior, and it's a good idea to review these settings before you start shooting.

Here's a quick rundown of the options you can control:

✓ Vibration Reduction: When enabled, this feature helps produce sharper images by compensating for camera movement that can occur when you

handhold the camera. Enable and disable it via the Shooting menu. For normal photography, choose Normal; if you're really going to be moving as you shoot, try Active. For tripod shooting, disable the feature.

- ✓ Flash: Unlike most cameras, your Nikon 1 model doesn't control the flash, even in this fully automatic shooting mode. Instead, if you want to use flash on the V1, attach the optional flash unit and set the power switch to On. (Chapter 1 has details.) On the J1, raise the flash head by sliding the Flash switch on the back of the camera, as shown in Figure 3-18.
- Flash mode: If you enable flash, you can choose from two flash modes: Fill Flash, which is the

photos.

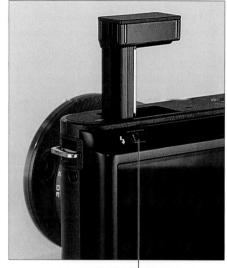

Flash switch

Figure 3-18: To raise the J1's flash, slide the

modes: Fill Flash, which is the normal flash mode (it gets its name from the fact that it's designed to fill in shadows in the scene); and Red-Eye Reduction flash, which is designed to help avoid those glowing red eyes that often plague flash

When you use Red-Eye Reduction flash, the AF-assist lamp on the front of the camera emits a brief burst of light before the flash fires — the idea being that the prelight will constrict the subject's pupils, which helps reduce the chances of red-eye. Warn your subject to wait until after the flash to stop smiling.

Chapter 7 provides complete details about these and other flash settings; here's a quick intro:

• Checking the current Flash mode: A symbol representing the current Flash mode appears in the display. On the J1, the symbol appears in the upper-left corner, as shown on the left in Figure 3-19; on the V1, it's in the bottom-right corner, as shown in the right image in the figure. A single lightning bolt, as in the figures, means that the flash is set to Fill Flash mode, which is the normal flash mode. In Red-Eye Reduction mode, a little eyeball appears next to the lightning bolt.

J1 Flash mode icon

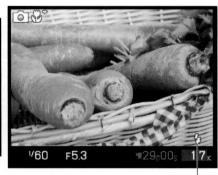

V1 Flash mode icon

Figure 3-19: Here's where you find the icon representing the Flash mode on the J1 (left) and the V1 (right).

Changing the Flash mode:
 The process for changing the flash mode varies depending on which Nikon 1 model you use.

On the J1, pressing the down button on the Multi Selector — marked with the little lightning bolt symbol — displays the available Flash modes on the screen, as shown in Figure 3-20. Highlight your choice and press OK to lock

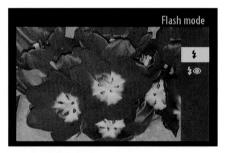

Figure 3-20: On the J1, press the Multi Selector down to access the Flash mode options.

in the setting and hide the Flash mode screen.

On the V1, visit the Shooting menu and look for the Flash mode option, shown in Figure 3-21. Note that this menu option disappears when no flash is attached to the camera or when the flash is attached but turned off.

✓ **Shutter-release mode:** This setting determines the number of images that are recorded with each press of the shutter button and the timing of each shot. Chapter 2 details your options and explains how to select the mode you want to use. The menu option in question is named Continuous. By pressing the Multi Selector right, you can access self-timer and remote-control modes as well.

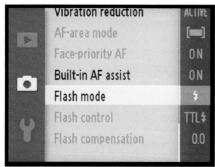

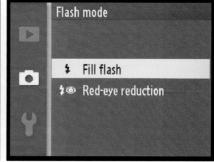

Figure 3-21: On the V1, the Shooting menu offers the Flash mode options — but only when the flash is attached and turned on.

- ✓ Image Quality and Image Size: By default, pictures are recorded at the Large Image Size setting, producing a 10MP (megapixel) image, and the Normal Image Quality setting, which creates a JPEG picture file with a moderate amount of compression. Chapter 2 explains both options and offers advice on when you may want to stray from the default settings.
- ➤ Shutter type: On the V1, you can use either the mechanical or electronic shutter. Stick with the default, Mechanical, until you explore the differences between the two shutter types in Chapter 7. You can adjust this setting via the F button or the Shooting menu.
- Advanced Shooting menu options: You also can control the following more advanced Shooting menu options:
 - *Color Space*: Again, stick with the default setting, sRGB, until you delve into this advanced color issue, covered in Chapter 11.
 - *High ISO NR (Noise Reduction) and Long Exposure NR*: These features try to compensate for image defects that can occur when you use a high ISO setting or a long exposure time, respectively. Chapter 7 explains the pros and cons of enabling the features.
 - Custom Picture Control: This option enables you to edit, save, and load personalized Picture Control settings. Ignore it the camera always uses the Standard Picture Control in Scene Auto Selector mode. See Chapter 11 for details on how to create a custom Picture Control.

If you're not up to sorting through any of the options in the preceding list, just leave them all at their default settings and skip to the next section to get step-by-step help with taking your first pictures. Remember, you can restore

the defaults by choosing Reset Shooting Options from the top of the Shooting menu. The only default that you probably don't want to use is the one selected for the Vibration Reduction option: Active is chosen by default, and Normal is a better choice unless you're running while shooting or otherwise expect a heavy amount of camera shake.

Taking a picture in Scene Auto Selector mode

Remember, to use Scene Auto Selector mode, you first set the Mode dial to Still Image mode (the green camera icon) and then set the Exposure Mode option on the Shooting menu to Scene Auto Selector. Take these steps to shoot your pictures:

1. If you want to use flash, raise it (J1) or attach it and switch it on (V1). Set the Flash mode as outlined in the preceding section.

2. Frame your image in the display.

The camera's Face-priority AF (autofocus) feature is enabled, so if you're shooting a portrait and a face is detected, you see a yellow focusing box around the face, as shown in Figure 3-22. If you're shooting a group of people, up to five faces may be highlighted. The box that has the inner-corner markings, as in the figure, is the one that the camera will use to establish focus. Usually, the closest person is selected. Note that the face-detection feature only works if your subject is facing forward — if the subject is in pro-

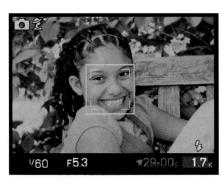

Figure 3-22: The yellow box indicates that the camera detected a face and will set focus on that person.

file or looking away from the camera, it's typically unsuccessful.

3. Press and hold the shutter button halfway down.

The camera's autofocus system begins to do its thing. In dim light, a little lamp located on the front of the camera may shoot out a beam of light. That lamp, the *autofocus-assist illuminator*, or *AF-assist lamp* for short, helps the camera measure the distance between your subject and the lens so that it can better establish focus.

If the camera can focus successfully, it lets you know by briefly displaying one or more green focus rectangles, as shown in Figure 3-23, to indicate which areas are now in focus. In situations where the camera

detected a face, the facedetection box (refer to Figure 3-22) turns green instead.

For still subjects, you also hear a beep; for moving subjects, the beep may not sound, however. If focus can't be achieved, the tocus rectangles or face-detection box turns red.

If flash is enabled, a red dot lights near the Flash mode icon to let you know that the flash is ready to fire, as shown in the figure. (The figure shows the V1 monitor; on the J1, the symbol appears in the top-left corner of the display.)

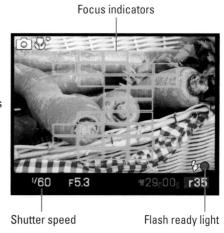

Figure 3-23: When focus is achieved, green rectangles appear over the areas that are now in focus.

4. Press the shutter button the rest of the way down to record the image.

While the camera sends the image data to the camera memory card, the memory card access lamp on the back of the camera lights. Don't turn off the camera or remove the memory card while the lamp is lit, or you may damage both camera and card.

When the recording process is finished, the picture appears briefly on the camera monitor. If you want to take a longer look at the image, see Chapter 5, which covers picture playback.

Here are a few important points about working in Scene Auto Selector mode:

➤ Exposure: In Scene Auto Selector mode, the camera sets the three critical exposure settings: f-stop, shutter speed, and ISO. Chapter 7 explains all three, but for now, the critical setting to monitor is shutter speed, which appears at the bottom of the display, as shown in Figure 3-23. (On the J1, the shutter speed appears over the live image rather than using the black-bar design of the V1.)

In dim lighting, the shutter speed may drop very low, which means that if you're handholding the camera, you run the risk of camera shake blurring your image. The camera doesn't warn you about this possibility, so in Step 2, be sure to glance at the shutter speed the camera selects. Most people get in the danger zone of camera shake when the shutter speed falls below 1/60 second, but this varies from person to person and

also depends on the lens you're using. For reasons I won't get into here, a lens with a longer focal length exacerbates camera shake problems.

When the light gets so dim that an exposure time greater than one second is needed, you see the word Lo instead of a shutter speed. This is another clue that you need to use a tripod or add some additional light to the scene.

Note that the camera monitors the light continuously up to the time you take the shot, so it may adjust the initial shutter speed if the light changes or you reframe the subject before you take the shot.

Focusing: Manual focusing with a Nikon 1 lens is not available in Scene Auto Selector mode; autofocusing is your only option. You need to be aware of two autofocusing settings: First, the camera uses the AF-A Focus mode, which means that focus is locked as long as you hold the shutter button halfway down unless the camera senses motion, in which case it adjusts focus as needed to track your subject up to the time you fully depress the shutter button.

For the second autofocusing option, AF-Area mode, the camera uses the Auto Area setting. In that mode, the camera selects which autofocus points to use when establishing focus. Typically, focus is set on the closest object. Chapter 8 explains both of these focus settings in more detail, but you can modify this behavior — or use manual focusing — only if you shift out of Scene Auto Selector mode.

✓ Recording movies: On the V1, you can start recording a movie at any time simply by pressing the red Movie-record button on top of the camera. Press again to stop recording. The movie is recorded using the default settings; see Chapter 4 for more about adjusting the settings and other aspects of movie recording. This instant movie-recording feature isn't available on the J1.

Using Smart Photo Selector Mode

How many times have you looked at a photo and thought, "If I had pressed the shutter button just an *instant* later, that would have been the *perfect* shot!" Had you timed the capture just a little differently, your portrait subject's eyes would have been open instead of just-blinked-shut, or you might have frozen the exact moment that the baby stopped crying and flashed a tiny smile.

Preventing these "if only" timing errors is the idea behind the Smart Photo Selector shooting mode, which is a variation of Scene Auto Selector mode. As in that mode, the camera analyzes your subject and then sets the camera to one of the four scene modes (Portrait, Landscape, Night Portrait, or Close-up) or to the standard Auto mode. But in Smart Photo Selector mode, the camera records as many as 20 images in rapid succession, starting the captures when you press the shutter button halfway and continuing for several frames after you press the button the rest of the way. Then it analyzes all the shots and saves what it considers to be the five best to the camera memory card. During playback, you can review the five shots and decide whether you agree with the camera or think one of the other four is a better photo.

Although it sounds like a miracle solution for capturing the most fleeting of moments, Smart Photo Selector has a couple important limitations:

✓ Flash is disabled. Because the camera is capturing a burst of images, you can't use flash — there wouldn't be time for the flash to recharge between frames. That makes Smart Photo Selector mode a bust for shots where you need extra light to capture your subject.

If you attach the SB-N5 flash to the V1, however, you can get a little artificial light support. When you press the shutter button halfway, the Capture Illuminator lamp on the front of the flash throws some light on your subject. But you get only about six seconds of light, after which the light not only shuts off, but the camera stops recording frames and a message appears on the display to tell you that you've exceeded the Capture Illuminator's life span. (You can resume capturing frames by releasing the shutter button and pressing it halfway again.) In addition, the reach of the Capture Illuminator beam isn't as great as that of the actual flash. So although it's better than nothing, the Capture Illuminator lamp often isn't an adequate substitute for flash.

✓ You have little control over capture settings. Like Scene Auto Selector mode, Smart Photo Selector is a fully automatic exposure mode. That means you have no control over exposure settings, focusing, color, or most other capture options, including the shutter-release mode. Autofocusing and exposure work as outlined in the bullet points in the preceding section.

One serious downside I experienced with Smart Photo Selector mode has to do with shutter speed: If you're shooting a moving subject, be aware that the camera often doesn't select a shutter speed fast enough to freeze the action, leaving the subject blurry. If you encounter the same result, my best advice is to switch to shutter-priority autoexposure mode so that you can control shutter speed. You can set the Release mode to Continuous so that you can still capture a burst of frames as you do in Smart Photo Selector mode. Chapter 7 shows you how to use shutter-priority autoexposure mode and the other advanced exposure modes; Chapter 2 explains the Continuous Release mode.

- Movie recording is disabled. Whereas Scene Auto Selector mode lets V1 users record movies by simply pressing the Movie-Record button, this function is disabled in Smart Photo Selector mode. Again, see Chapter 4 for the complete story on recording movies.
- Only Nikon 1 lenses are compatible with this mode. If you attach lenses via the FT1 adapter, you give up the option of using Smart Photo Selector mode.

Because of these limitations, my guess is that after you make your way through Part III and get a handle on the exposure modes that give you more control, you'll abandon Smart Photo Selector mode. Still, it's worth playing around with, and you can always turn to it as a possible solution when you hand your camera to a newbie to take your photo. So the next section details the steps involved in taking a picture in this mode; following that, I show you how to review the five best frames and select the one you like best.

Taking a picture in Smart Photo Selector mode

To try out Smart Photo Selector mode, take these steps:

1. Set the Mode dial to Smart Photo Selector mode, as shown in Figure 3-24.

As soon as you move the Mode dial to the Smart Photo Selector position, you see four little brackets around the center portion of the display, as shown in Figure 3-25. These brackets indicate the autofocusing area and so are officially called *AF-area brackets*. Also, as in Scene Auto Selector mode, you see an icon representing the scene mode that the camera thinks best matches your subject. (In the figure, for example, the camera chose the Auto scene mode.)

2. Frame your subject so that it's within the AF-area brackets.

Smart Photo Selector mode

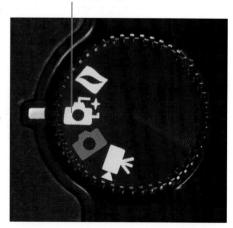

Figure 3-24: Smart Photo Selector mode records up to 20 frames and then saves the five best to the memory card.

Face-priority AF (automatic face detection) is enabled, so if the camera detects a face, it displays a yellow box around that face, as in Scene Auto Selector mode.

3. Press and hold the shutter button halfway down.

The autofocusing system comes alive and hunts for the correct focusing distance. When focus is achieved, green focus rectangles appear on the display to show you the area that's in focus, just as in Scene Auto Selector mode. Or, if you're shooting portraits, the face-detection box turns from yellow to green momentarily instead. If the camera can't find a focus point, the rectangles or face-detection box appear red; release the shutter button and try Figure 3-25: Frame your subject within the again.

After focus is achieved, the camera begins to capture frames but doesn't yet record any images to the memory card. Instead, images are saved in the camera's internal memory, or buffer. To let you know that frames are being captured, an icon that features tiny moving bars appears in the upper-left corner of the display, as shown in Figure 3-26. If necessary, the camera continually adjusts focus to account for any change in the subject-to-camera distance. The camera can keep capturing frames for about 90 seconds.

Exposure mode Scene mode AF-area brackets /60 F5.6

AF-area brackets.

Images being recorded to buffer

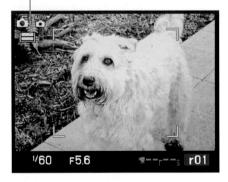

Figure 3-26: This icon tells you that frames are being captured and stored in the camera's internal memory.

4. Press the shutter button the rest of the way down.

The camera continues to record additional frames to the buffer for a few seconds after the shutter button is fully depressed. Then a little blinking grid appears on the display as the camera reviews all the images and saves its five favorites to the memory card. The winning image then appears for a few seconds in the display, just as when you take pictures in other exposure modes. See the next section for help viewing that image and the other four best-shot contenders.

Viewing and deleting Smart Photo Selector images

Chapter 5 details picture playback, but some things work a little differently for images that you capture in Smart Photo Selector mode. First, only the frame that the camera chose as the best of the five recorded shots initially appears on the monitor. Second, after reviewing the five frames, you can choose to designate a different frame as the best shot. And finally, you can either save all five frames, save just the winner and delete the other four, or delete all five.

Follow these steps to inspect the leading frame and the other four captured frames:

1. Press the Playback button to switch to Playback mode.

The image selected by the camera as the winning shot appears in the display. (If another image is visible, press the Multi Selector right or left to scroll through your pictures to find the Smart Photo Selector frame.)

A couple things tell you that you're looking at a Smart Photo Selector image: You see the Smart Photo Selector icon in the upper-left corner, as shown in Figure 3-27. Also, the words OK View appear at the bottom of the

Smart Photo Selector icon

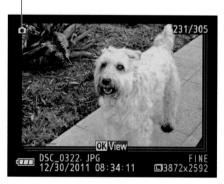

Figure 3-27: This icon indicates an image taken in Smart Photo Selector mode.

image. If your screen doesn't look similar to the one in the figure, press the Disp button to cycle through the available playback display modes until it does. (Keep in mind that the figures here show the V1 playback; the J1 playback screens have the same data but sometimes display that data laid over the image a little differently.)

2. To see the other four frames the camera captured, press OK.

The display changes to look similar to what you see on the left in Figure 3-28, with the shot the camera selected surrounded by a thick yellow highlight. The frame number appears in the upper-left corner; for example, the left image in the figure shows frame 3 out of 5.

3. To scroll through the frames, press the Multi Selector left or right.

As during normal playback, you can zoom in on an image to inspect the details by pressing the Zoom lever up (next to the F button, top-right corner of the camera). Press the Multi Selector up, down, right, or left to scroll the display to inspect a different area of the image. And press the Zoom lever down to zoom out or press OK to return to normal magnification. See Chapter 5 for the whole story on this playback function.

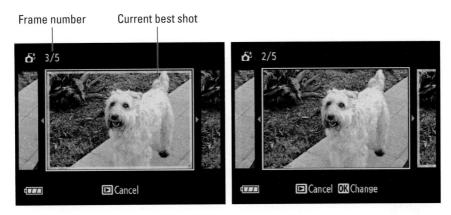

Figure 3-28: The frame the camera selected is surrounded by a thick yellow border (left); to scroll to other frames, press the Multi Selector right or left (right).

After reviewing the five frames, you can choose a different picture as the best shot, delete pictures, and return to normal Playback mode as follows:

Choose a different frame as the winning image: In frames that the camera didn't select as the best shot, you see the words OK Change at the bottom of the display, as shown on the right in Figure 3-28. If you like one of those frames better, press OK. The camera displays a confirmation screen asking if you want to replace the best shot with the current frame; highlight Yes and press OK to do so. Now you just see the word Cancel under the frame, indicating that it's the number-one picture.

✓ Delete frames: Press the Delete button to display the screen you see in Figure 3-29. From this screen, you can delete the current frame or all but the best frame. Highlight your choice and press OK.

✓ Return to normal Playback mode: Press the Playback button. (The button icon appears next to the word Cancel at the bottom of the screen to remind you of this function.)

If you want to erase all five frames, return to regular Playback mode before pressing the Delete button. You

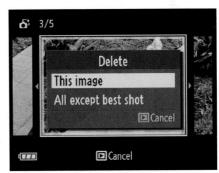

Figure 3-29: While reviewing your five images, press the Delete button to display this screen and erase the current image or all but the winning shot.

then see a confirmation screen asking whether you want to erase the images; press Delete again to do so. Although there's no indication that you're erasing five frames, they all get zapped together.

Shooting Digital Movies and Motion Snapshots

In This Chapter

- Taking the easy path to HD recording
- Controlling movie-recording settings
- Taking still photos during a recording
- Recording a slow-motion movie
- Experimenting with Motion Snapshot mode
- Playing and trimming movies

ot content to serve only as a stellar still-photography performer, your Nikon 1 also can record digital movies — in high-def, no less. This chapter explains everything you need to know to become a Nikon 1 cinematographer, from choosing recording settings to trimming off unwanted footage from the start or end of a movie. You can also find out about recording slow-motion movies and Motion Snapshot exposure mode, which enables you to record a brief, slow-motion clip that ends with a still photo.

Getting Started with Movie Mode

To start exploring Movie mode, just rotate the Mode dial on the back of the camera to the little movie-camera icon, as shown in Figure 4-1. After you take this step, a couple things happen:

The display changes to include shooting data related to movie recording. As is the case for still photography, you can choose from Detailed display mode, shown in Figure 4-2, or Simplified display mode, which hides some of the shooting data. Just press the Disp button to cycle between the display modes. (On the V1, press Disp again to turn off the monitor.)

I explain all the settings labeled in the figure later in the chapter; for now, the important bit of data to note is the maximum recording-time value, which tells you the length of the movie that you can record on your current memory card. All movies have a maximum length of either 29 minutes or 20 minutes, depending on the movie quality settings you choose. (See "Understanding the Movie Settings option.) Of course, if you have the room on your memory card, you can simply end one recording and start another.

✓ The aspect ratio of the live image changes. Normally, all movies have an aspect ratio of 16:9, as opposed to the 3:2 aspect ratio of still photos. The exception is when you use the slow-motion recording option, which records clips with an 8:3

Figure 4-1: To access movie-recording features, set the Mode dial to this symbol.

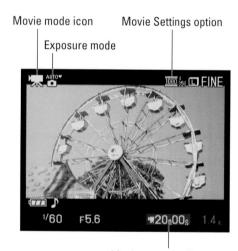

Maximum recording time

Figure 4-2: In Movie mode, the Detailed display mode includes movie recording settings.

aspect ratio. Either way, the black borders on the display indicate the boundaries of the movie frame.

New options appear on the Shooting menu. Notice that the little menu icon that indicates the Shooting menu changes to a movie-camera symbol, as shown in Figure 4-3. The menu also displays settings related to moviemaking that are hidden in Still Image exposure mode and the other exposure modes.

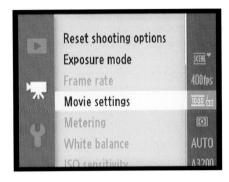

Recording Made Easy: Using the Default Settings

Figure 4-3: Movie-recording options appear on the Shooting menu only when the Mode dial is set to Movie mode.

In the next sections, I explain all the recording settings that you can adjust while in Movie mode. But frankly, some of them can get a little obscure, and I wouldn't blame you a bit if you wanted to keep things simple and just stick with the manufacturer's defaults. (Choose Reset Shooting Options at the top of the Shooting menu to restore the defaults.) At the default settings, you get a Full HD movie with sound recording enabled. The camera continuously adjusts autofocus as you shoot, tracks faces in scenes containing people, and chooses all exposure settings for you. In other words, you get a pretty slick recording without all the fuss.

Knowing a few things about the process can make life easier, though, so here's the drill:

1. Set the camera to Movie mode.

- 2. Press the Feature button to display the screen shown in Figure 4-4.
- 3. Select HD Movie and press OK.

The other option records slowmotion movies. The HD option should be selected by default but it pays to double-check.

4. Frame your opening shot so that the subject is in the center of the frame.

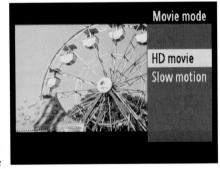

Figure 4-4: For regular movies, select HD movie.

Just as in Still Image mode, the camera uses the Scene Auto Selector exposure mode and automatically selects a scene type for you — Portrait, Landscape, Night Portrait, Close-Up, or Auto. (For more about Scene Auto Selector, see Chapter 3.) You can see the current scene type along with the exposure mode icon in the top-left corner of the screen (refer to Figure 4-2).

Press the red Movie-record button on top of the camera to start recording.

A red recording light appears in the upper-left corner of the display, as shown in Figure 4-5, and the elapsed recording time appears just below. The nearby microphone symbol lets you know the status of audio recording — in this case, that audio is being recorded and the microphone level is being automatically adjusted. At the bottom of the screen, you can see how much recording time remains.

6. To stop recording, press the Movie-record button again.

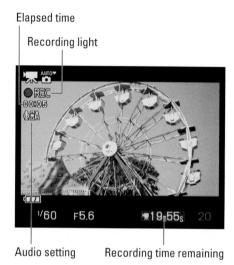

Figure 4-5: The red light signals that the camera is recording video.

7. To view your movie, press the Playback button and then press the OK button.

The section "Screening Your Movies," later in the chapter, talks more about movie playback.

One quick aside for V1 owners: You don't actually need to switch to Movie mode to record movies — you can start and stop movie recording by pressing the Movie-record button while in Still Image mode as well. Just remember that you won't be able to access any menu options related to movies while in Still Image mode. And if you go this route, movies are recorded in Standard HD rather than Full HD, using the 720/60p Movie Setting option. (See the next section for information on this recording option.) Finally, and perhaps more critically, you don't see the 16:9 aspect ratio borders, making it difficult to know that your subject remains in the movie frame.

Digging Deeper into Movie Recording Options

When you're ready to take more control over your movie recordings, the next several sections detail the options available to you. Remember, these options don't show up on the Shooting menu until you set the Mode dial to Movie.

Understanding the Movie Settings option

The first recording option to consider is the Movie Settings option on the Shooting menu, featured in Figure 4-6. This option controls several factors that affect the quality of the movie.

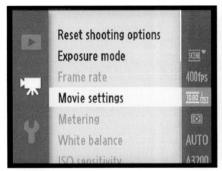

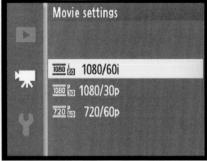

Figure 4-6: The Movie Settings option determines the resolution and frame rate of the recording.

The first thing to know is that there are two ways to record the lines of pixels that create a frame of digital video. With the first technology, *interlaced video*, a single frame of video is split into odd and even *fields*, or lines of pixels. The picture data from the odd lines is recorded first, followed very rapidly by the data from the even lines — so rapidly, in fact, that the picture appears seamless to the viewer during playback. With the second technology, *progressive video*, all the lines are pulled out of the magic video hat in sequential order, in a single pass. The Nikon 1 video can capture both interlaced and progressive video, with the letter *i* or *p* in the Movies Settings option names indicating which type you're getting.

Which is better? Well, progressive is the newer of the two technologies and tends to deliver smoother, cleaner footage, especially if you're shooting fast motion or panning the camera (moving it to follow the subject through the frame). Interlaced video was developed for older, analog sets, and sometimes results in a little flickering of fast-paced action. But an HDTV should be able to play both types of video. Also, if you plan to combine footage that you shoot with your Nikon 1 with existing interlaced footage, it's best to use the interlaced setting so that all your video clips use the same technology.

There's more to video quality than the progressive vs. interlaced issue, however. You also need to consider these two factors:

Frame rate: The speed at which the video is recorded, measured in frames per second (*fps*), frame rate plays a role in how smoothly the video plays. On your camera, you can opt for 30 fps, which is the standard for television in North America and other countries that follow the NTSC video standard, or you can double that value and get 60 frames

- per second. That high frame rate is sometimes preferred by people who want to create slow-motion effects because with more frames per second, the video maintains its clarity better when playback is slowed. But a higher frame rate also tends to give a "crisper" look overall (which some people prefer and other people think is a little *too* crisp).
- Picture resolution: The quality of the image, picture resolution is measured in pixels. As with a still photo, the higher the resolution, the better the picture quality. In the world of HDTV, a resolution of 1920 x 1080 pixels is considered Full HD meaning the best possible (at the moment, anyway) while 1280 x 720 is known as Standard HD, which still looks a lot better than the video we watched before high-def came along. But a higher resolution also translates into a larger file size, which means you can fit fewer recorded minutes on your memory card. Nikon estimates that a 16GB memory card will hold about an hour and a half of Full HD footage captured by the Nikon 1; at the Standard HD setting, you get about two hours and 10 minutes. Note, however and this is important that the maximum recording time for each individual clip is much shorter: For Full HD movies, the maximum recording time is 20 minutes; for Standard HD, 29 minutes.

So, returning to the Movie Settings menu (shown on the right in Figure 4-6), you have three combinations of these three factors to choose from:

- ✓ 1080/60i: This setting produces a Full HD movie with a frame size of 1920 x 1080 pixels, using 60 interlaced fields to generate a final frame rate of 30 fps. (Remember, an interlaced frame is created by two passes, so your 60 fields combine to produce the 30-fps rate.) This is the default recording setting.
- ✓ 1080/30p: This setting also produces Full HD video at 30 fps but uses progressive video.
- 720/60p: This setting gives you a Standard HD movie with a frame size of 1280 x 720, a frame rate of 60 frames per second, and progressive video. On the V1, this setting is used when you record movies while in Still Image mode.

One more little wrinkle to note: If you take a still picture during recording, the Movie Settings option determines the resolution of that still photo. The 1080/60i setting delivers the highest still photo resolution, 3840×2160 pixels. At 1080/30p, the resolution drops to 1920×1080 pixels; at 720/60p, you get only 1280×720 pixels. See "Shooting Still Pictures During Movie Recording" for more on this feature.

Whatever option you choose, you can view the current setting in the upperright corner of the display when you engage the Detailed display mode, as shown in Figure 4-7. (Press the Disp button to change the display mode.) Right next door, you can see the current setting for the Image Size and Image Quality settings, which come into play only if you take a still picture during recording.

Adjusting audio settings

Your sound recording options vary depending on your Nikon 1 model:

Figure 4-7: In Detailed display mode, you can view the selected Movie Setting option here.

- ✓ **J1:** The internal microphone captures the sound collected through the two little holes on the front of the camera (labeled in Figure 4-8).
- ✓ V1: You can use the built-in microphone (labeled on the left in Figure 4-9) or attach an external microphone into the microphone jack located under the door on the left side of the camera, as shown on the right side of the figure.

Figure 4-8: On the J1, these two holes lead to the built-in microphone.

Figure 4-9: On the V1, you can use the built-in mike (left) or attach an external one (right).

Either way, to enable sound recording and adjust the microphone sensitivity, select Movie Sound Options on the Shooting menu, as shown on the left in Figure 4-10. You then gain access to two sound options, as shown on the right:

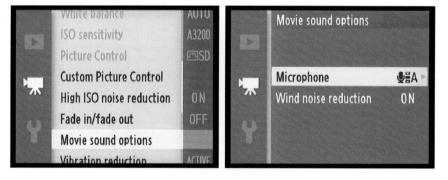

Figure 4-10: Set audio recording options through this menu item.

✓ **Microphone:** Select this option and press the Multi Selector right to display the options shown in Figure 4-11. If you choose the Auto Sensitivity option, the camera automatically adjusts the volume according to the level of the ambient noise. Or you can choose one of the other settings

to control the microphone sensitivity yourself. Choose Microphone Off to record a silent movie. When you begin recording, an icon that mirrors the one you selected on the menu appears in the upper-left corner of the display, near the red Recording light.

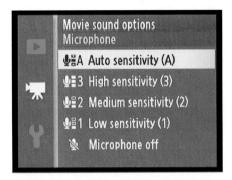

Figure 4-11: Adjust microphone sensitivity or disable audio here.

Wind Noise Reduction: This setting, when enabled, uses an audio filter to try to minimize the sound that wind makes when blowing over the microphone. Other, similar sounds may also be affected, so it pays to do a short test recording to see which setting works best for the current environment.

When using the built-in microphone, make sure that you don't inadvertently cover up the little holes that lead to it. And keep in mind that anything *you* say will be picked up by the mike along with any other audio present in the scene.

Controlling exposure and color

By default, the camera uses the Scene Auto Selector exposure mode and automatically sets exposure, using *matrix metering* (whole-frame metering) to choose the proper aperture, shutter speed, and ISO Sensitivity setting. The camera also takes the reins of color-related options. But by changing the exposure mode (via the Exposure Mode option on the Shooting menu), you can take advantage of the following exposure and color controls:

✓ **Aperture and shutter speed:** You can adjust f-stop before recording if you set the exposure mode to A (aperture-priority autoexposure). This option enables you to control depth of field in your movies; Chapter 7

explains the aperture setting's role in depth of field. In A mode, press the Zoom lever up or down to change the f-stop.

If you set the exposure mode to S, you can use the Zoom lever to control shutter speed. Of course, if you select the M exposure mode, you can control both aperture and shutter speed. Use the Zoom lever to control shutter speed and rotate the Multi Selector to adjust the aperture. However, know that setting the shutter speed for movie recording involves different considerations than for still photography, so this is an option outside the scope of this book and best left to experienced videographers.

- **Exposure Compensation:** Exposure Compensation enables you to override the camera's autoexposure decisions and specify that you want a brighter or darker picture than the camera thinks is appropriate You can apply this adjustment for movies when the Exposure Mode option is set to P, S, or A. See Chapter 7 to find out more about this feature. To adjust the setting, press the Multi Selector right to display the Exposure Compensation scale, press up or down to set the value, and then press OK.
- ✓ **ISO:** In P, S, A, and M modes, you can control ISO Sensitivity just as in Still Image exposure modes. Access the control via the Shooting menu.

- ✓ **Autoexposure lock:** In A, S, and P modes, you can lock exposure at the current settings by pressing and holding the AE-L/AF-L button that's the top Multi Selector button. Chapter 7 also tells you more about autoexposure lock.
- ✓ White Balance and Picture Control: The colors in your movie are rendered according to the current White Balance and Picture Control settings. Chapter 8 explains how to adjust these settings, but you have control over the options only when the Mode dial is set to P, S, A, or M.

Want to record a black-and-white movie? Open the Shooting menu, choose Set Picture Control, and select Monochrome. Instant *film noir*.

Controlling focusing in Movie mode

In the P, S, A, and M exposure modes, you can choose auto or manual focusing and control autofocusing behavior via these settings:

- ✓ Focus mode: You can choose from three options, which you access on the V1 by pressing the AF button on the Multi Selector (the down button) and on the J1 via the Shooting menu. The settings work like so:
 - AF-F, full time autofocusing, is the default. The camera starts focusing immediately and continues adjusting focus to follow the subject through the frame. This option typically works well, but on occasion, the camera can miss its focusing target and have to "hunt" for focus. You also may sometimes be able to hear the

autofocusing motor doing its thing in the soundtrack. Possible solutions are to try the next autofocus option and, on the V1, attach an external microphone and position it away from the camera.

- AF-S, for single-frame autofocusing, locks focus when you press the shutter button halfway. One or more green rectangles appear to show you where focus was achieved, and focus remains locked at that point even if you take your finger off the shutter button. You can reset focus at any time by pressing the shutter button halfway again.
- MF, for manual focusing, disables the autofocus system. Press OK to magnify the display and then use the Multi Selector to scroll the display if needed until you can view your subject. Then rotate the Multi Selector until the subject is in focus and press OK again. Obviously, this method is a little cumbersome for movie shooting if your subject is on the move at all it's hard to keep going through the focusing procedure during the recording.

All these details assume that you're using a Nikon 1 lens; if you attach another lens via the FT1 lens adapter, you may not have access to all three options. Any settings that aren't compatible with your lens disappear from the menu.

In the Detailed display mode, you can view the current Focus mode setting in the upper-right corner of the monitor, as shown in Figure 4-12.

- ✓ **AF-Area mode:** This option, set through the Shooting menu, determines how the camera chooses its focus point. You get the same options as for still photography. Chapter 8 details these settings, but here's a quick preview:
 - Auto-Area mode: The camera chooses the focus point, usually aiming for the closest subject.
 - Single point: This option lets you choose the focus point.
 The camera displays a single focus rectangle; press OK to display four little triangles at the edges of that

P S) B A 6 5 F F E A F F S C F

Face-priority AF enabled

AF-Area mode

Focus mode

Figure 4-12: In Detailed display mode, you can view the current Focus mode along with symbols that indicate the status of the Face-priority AF and AF-Area mode options.

- rectangle and then use the Multi Selector to move the rectangle over your subject. Press OK again to return to shooting.
- Subject tracking: This setting attempts to track a single subject moving through the frame. You see a white focusing box on the display; press OK to display positioning arrows around the frame and then use the Multi Selector to move the frame over your subject. Press OK again, and the box turns yellow, indicating that the camera is now tracking the subject. Press OK one more time to turn off tracking.

You can view an icon representing the current setting in the location indicated in Figure 4-12 (you must enable the Detailed display mode). The icon in the figure represents the Auto-Area mode.

- Face-priority AF: By default, face recognition is turned on, and the camera displays yellow focusing rectangles if it detects faces, making it easy to find your focusing target. In P, S, A, and M exposure modes, you can choose to do away with this feature by disabling the option, found on the Shooting menu. When the feature is turned on, you see the little face icon in the area indicated in Figure 4-12.
- ✓ **Vibration Reduction:** In any exposure mode, you can choose to enable or disable Vibration Reduction via the Shooting menu. For handheld shots, the feature typically helps you avoid the blur that is created by camera shake, but when you use a tripod, you should turn it off. See Chapter 2 for more about Vibration Reduction.

Adding a fade in/fade out transition

Here's an option that can make your movies appear a little more elegant: When you enable the Fade In/Fade Out option on the Shooting menu (as shown in Figure 4-13), the camera adds a second or two of black screen or white screen, depending on your preference, to the beginning and end of the movie clip. As the name suggests, your movies then fade in from black (or white) and fade back out to the same color at the end. The default setting is Off.

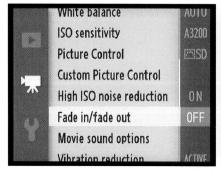

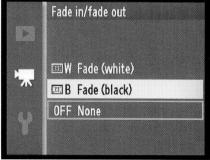

Figure 4-13: When you enable this option, movies fade in from black (or white) and then fade out again at the end.

Shooting Still Pictures During Movie Recording

At any time during movie recording, you can press the shutter button all the way down to record a still photo. On the J1, you can shoot as many as 15 still frames during a recording; on the V1, the number rises to 20 still frames.

There are a couple important things to know about this feature:

- ✓ You don't hear the normal shutter sound that occurs when you take a picture in Still Image mode. Because the operation is silent, you may initially think the feature isn't working. But if you look at the lower-right corner of the display, a tiny camera symbol appears to let you know when your still frame is being snapped.
- ✓ The resolution of the still photo depends on the Movie Settings option on the Shooting menu. Here are the still-photo resolutions produced by each of the three movie settings:
 - 1080/60i: 3840 x 2160 pixels
 - 1080/30p: 1920 x 1080 pixels
 - 720/60p: 1280 x 720 pixels

Chapter 2 spells out the implications of pixel count fully, but in a nutshell, remember that to produce a good print, you need at least 200 pixels per linear inch of the print. So at the highest movie setting, you get enough pixels to produce a print that's roughly 19×10 inches, but at the lowest movie setting, you have only enough for about a 6.5×3.5 print.

✓ The photo has an aspect ratio of 16:9. Again, the normal still-photo aspect ratio is 3:2. You do have the option of using the Trim function on the Playback menu to crop the 16:9 frame to a 1:1, 4:3, or 3:2 aspect ratio. (Chapter 11 has details.)

Shooting a Slow-Motion Movie

If you've always wanted to make one of those dreamy romantic movies where hero and heroine run into each other's arms in slow motion, good news! You can create short slo-mo clips on your Nikon 1. (Finding the hero and heroine . . . that's up to you.) A slow-motion recording is also a good way to let budding athletes analyze their form. And a slow-motion video of your dad snoring on the couch, well, that's always a hit at the family reunions.

Whatever subject your creative heart has in mind, you need to know a few pesky technical details:

The movie aspect ratio is different from HD movies. Slow-motion movies have an aspect ratio of 8:3, while HD movies have an aspect ratio of 16:9.

- ✓ No audio is recorded. Sorry, but you'll have to add the romantic reunion music or snoring sounds in post-production.
- ✓ You can capture movies at 400 frames per second or 1200 frames per second. Why so many? Well the camera has to record zillions of frames so that when you play it back in slow motion, the video remains smooth. (Movies are played back at 30 frames per second.) The tradeoff for using the higher frames-per-second recording rate is a lower resolution. At 400 frames per second, the resolution is 640 x 240 pixels; at 1200 frames per second, it's 320 x 120 pixels. In other words, neither setting gives you a high-definition picture. Additionally, to achieve the high frame rate, the camera has to use a very high shutter speed, which can make creating slow-motion movies in dim lighting difficult. (If you see the word Lo appear in the area where the shutter speed normally appears in the lower-left corner of the display you need to add more light to the scene.)
- ✓ You can record up to five seconds of action at a time. That sounds like a brief time, but remember that you'll be shooting a ton of frames in those five seconds and, of course, that when you play the movie, the playing time will be longer than five seconds. A five-second clip captured at 400 frames per second takes just over one minute to play; captured at 1200 frames per second, the playing time is three minutes and 20 seconds.
- ✓ You can't take still photos during slow-motion recording. Don't sweat it you don't really want a still photo captured at the low resolution that the slow-motion recording requires. Besides, you'd have to be pretty fast to capture that frame with only five seconds of recording time.

With those preliminaries out of the way, take these steps to record a slowmotion movie:

1. Set the Mode dial to Movie mode.

- 2. Press the Feature button to display the screen shown in Figure 4-14.
- 3. Choose Slow Motion and press OK.

The display changes to indicate that you're now working with an 8:3 aspect ratio, as shown in Figure 4-15. Again, note the high shutter speed the camera selected — 1/400 second, in the figure.

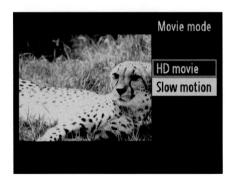

Figure 4-14: Press the Feature button to access this screen and set the camera to slow-motion recording mode.

4. Set the frames-per-second rate via the Frame Rate option on the Shooting menu, as shown in Figure 4-16.

Note that this menu option doesn't become available until after you set the movie recording mode to Slow Motion. (Therefore be sure to take Step 3 before you take Step 4.)

5. Choose an exposure mode (optional) and exposure and color settings.

For slow-motion recording, the camera uses the P (programmed autoexposure) mode instead of

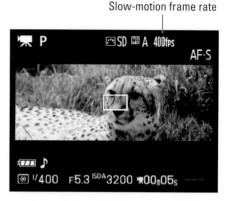

Figure 4-15: Slow-motion movies have an aspect ratio of 8:3.

the usual Scene Auto Selector mode used by default for normal recording. If you're new to exposure modes, stick with P — the camera will choose the main exposure settings for you, just like in the automatic mode. But if you want to play with exposure, you can also set the exposure mode to A, S, or M via that Exposure Mode option on the Shooting menu.

In any of the four exposure modes, you have access to the almost the same exposure and color settings as during regular movie recording. These include White Balance, ISO Sensitivity, Picture Control, and Exposure Compensation. For details, see the earlier section "Controlling exposure and color."

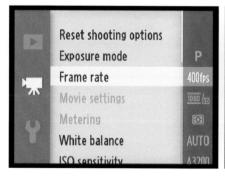

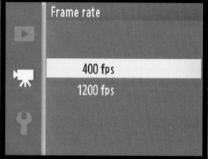

Figure 4-16: A higher frame rate means smoother playback but a smaller frame size.

6. Choose the Focus mode (optional).

Focusing options are more limited than during normal movie recording. You don't have access to face detection autofocus or the AF-Area mode setting; the camera's autofocusing system focuses on the object at the center of the screen, and that's your only option unless you want to use manual focusing. To do so, change the Focus mode setting from AF-S (the default) for slow-motion autofocus to MF (for manual). On the V1, press the Multi Selector down to access the setting; on the J1, change it via the Shooting menu. In either case, the continous autofocusing setting, AF-F, isn't available.

Manual focusing works the same as outlined in the earlier section "Controlling focusing in Movie mode" except that the display isn't magnified to help you nail down focus.

7. Press the red Movie record button on top of the camera.

You see the normal red recording light along with the elapsed time in the top-left corner of the display; the remaining time appears in the lower-right corner.

8. Press the Movie record button again to stop recording.

Or just wait until five seconds pass, at which time the camera will end the recording automatically.

Creating a Motion Snapshot

A motion snapshot is a short, slow-motion video clip that ends with a still photograph. The camera records about one second of video along with the still image. The resulting slow-motion video clip lasts about two and a half seconds before your picture appears. The camera even adds background music for you; you can choose from four built-in musical themes. (Note that the music plays with the clip only on the camera or when you view the clip in Nikon ViewNX 2.)

To create a Motion Snapshot using the default settings, take these steps:

1. Set the Mode dial to the Motion Snapshot symbol, as shown in Figure 4-17.

Motion Snapshot mode

Figure 4-17: Motion Snapshot mode creates a short, slow-motion video clip that ends with a still photo.

The display shows the Motion Snapshot symbol in the upper-left corner, and displays 1 second as the maximum movie recording time in the lower-right corner, as shown in Figure 4-18.

2. To choose the soundtrack, press the Feature button to display the screen shown in Figure 4-19.

You can select from four clips. Highlight your choice and press OK. Note that no other audio is recorded, and when you play the clip, the audio will last about 10 seconds (so some music plays over the display of your still photo).

Press the shutter button halfway to set focus and begin sending video to the camera's memory buffer.

The *buffer* is the camera's internal data-storage tank. A few blinking bars appear in the upper-left corner of the display to let you know that buffering is occurring. Buffering will stop after 90 seconds if you don't let up on the shutter button.

4. Press the shutter button the rest of the way to take the still photo.

The camera continues to buffer a bit more video after you take the shot, and then creates your Motion Snapshot, using one second of the buffered video in the finished product.

I suspect that you'll find Motion Snapshots to be a little gimmicky and not something you'll use on a regular basis, but they're fun to try, anyway. Just a couple more notes about the feature:

Exposure mode: By default, the camera uses the Scene Auto Selector exposure mode and handles all exposure, color, and focus decisions for you. But you can switch to P, S, A, or M mode (via the Exposure Mode option on the Shooting menu) if you choose to gain more control. See Part III for more about those exposure modes.

Motion Snapshot icon

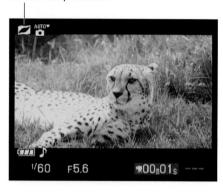

Figure 4-18: The camera records up to one second of video per snapshot.

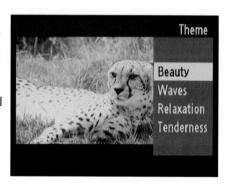

Figure 4-19: Press the Feature button to select a music theme for the snapshot.

✓ Flash: Flash is disabled in Motion Snapshot mode. But if you use the optional SB-N5 flash for the V1, the Capture Illuminator on the front of the flash unit lights for a short period of time to help light your subject. See Chapter 1 for more details about the flash unit.

Screening Your Movies

Playing a movie or Motion Snapshot involves most of the same tricks as viewing still photos in Playback mode, which I detail in the next chapter. First, press the Playback button. Then press the Disp button to cycle between three playback display modes: The default, Simple Photo Information mode, which displays the data shown in Figure 4-20; Detailed Information mode, which displays some additional data plus a brightness histogram; and a third mode, which hides all the shooting data.

Assuming that you don't hide the shooting data, you can spot a movie file in single-image playback mode by looking for the little movie-camera icon in the top-left corner of the screen, as shown in Figure 4-20. For a

Movie length

291/295

000914

DSC_0482_MOV 1080/60 i 01/23/2012 13:03:43

Movie Settings data

Figure 4-20: The little movie-camera symbol tells you you're looking at a movie file.

Motion Snapshot, you see the Motion Snapshot symbol (the same one that's on the Mode dial) instead. Either way, press OK to start playback.

In the Thumbnail and Calendar playback modes, you see little filmstrip dots along the edges of movie files. Motion Snapshots are indicated by gray borders along the top and bottom of the frame. Either way, press OK twice: once to shift to single-image view and again to start movie playback.

After you begin playback of a regular movie, the data in the top-right corner shows you how many seconds of the movie have played so far, along with the total length of the movie, as labeled in Figure 4-21. In addition, little playback control icons appear at the bottom of the screen to remind you that you can use the Multi Selector and Zoom lever to control playback, as follows:

- **✓ Stop playback:** Press the Multi Selector up.
- Pause/resume playback: Press down to pause playback; press OK to resume playback.

- ✓ Fast forward/rewind: Press the Multi Selector right or left to fast-forward or rewind the movie. Press again to double the fast-forward or rewind speed; keep pressing to increase the speed to as much as 15 times normal. Hold the button down to fast-forward or rewind all the way to the end or beginning of the movie.
- Advance frame by frame: First, press the Multi Selector down to pause playback. Then press the Multi Selector right to advance one frame; press left to go back one frame. Or rotate the Multi Selector to advance or go back frame by frame when the movie is paused.

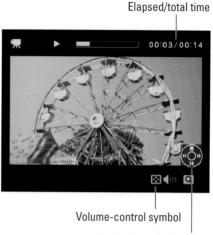

Playback-control symbol

Figure 4-21: These little icons remind you to use the Multi Selector to control movie playback and the Zoom lever to adjust volume.

Adjust playback volume: See the little markings labeled "volume-control symbol" in Figure 4-21? They remind you that you can press the Zoom lever up to increase playback volume. For a quieter playback, press the Zoom lever down.

For a Motion Snapshot, the elapsed/total time data doesn't appear. Nor does the playback-control symbol appear; you can't pause, stop, or fast forward or rewind motion snapshots. You can, however, use the Zoom lever to adjust playback volume.

One more technical point: Movies and Motion Snapshots are created in the MOV format, which means you can play them on your computer using most movie-playback programs. You also can view movies in Nikon View NX2, the free software provided with your camera. If you want to view your movies on a TV, you can connect the camera to the TV, as I explain in Chapter 5. Or — if you have the necessary computer software — you can convert the MOV file to a format that a standard DVD player can recognize, and then burn the converted file to a DVD disc. You also can edit your movie in a program that can work with MOV files. In fact, Nikon ViewNX 2 has a simple movie editing tool; look in the program's Help system for details about using it.

Trimming Movies

You can do some limited movie editing in camera. I emphasize: *limited* editing. You can trim frames from the start of a movie and clip off frames from the end, and that's it.

To eliminate frames from the beginning of the movie, take these steps:

1. Display the Playback menu and select Edit Movie, as shown on the left in Figure 4-22.

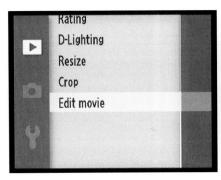

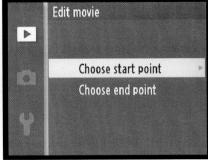

Figure 4-22: The Edit Movie option lets you trim frames from the start or end of a movie.

- 2. Press OK to display the second screen in the figure.
- 3. Select Choose Start Point and press the Multi Selector right.

Trim symbol

You see thumbnails of your movies.

4. Highlight the movie you want to edit and press OK.

The movie appears in a playback screen, as shown in Figure 4-23, but with a little scissors icon in the upper-left corner to indicate that you're about to trim frames from the movie.

- 5. Press OK to play the movie and then press the Multi Selector down to pause playback on the frame that will become the new opening shot.
- 6. Press the Multi Selector up to trim the footage that comes before the current frame.

ΧĽ 00:01/00:14 ■ Cancel (**)

Figure 4-23: After pausing the movie, press the Multi Selector up to trim frames.

Notice that the up button on the Multi Selector is marked with scissors to remind you of the Trim function. After you press the button, you get a confirmation screen asking for permission to proceed.

7. Highlight Yes and press OK.

A message appears, telling you that the trimmed movie is being saved as a new file, preserving your original. Your trimmed movie then appears onscreen, ready for playback.

If you prefer instead to trim footage from the end of a film, take the same steps, but this time select Choose End Point in Step 3 and pause playback on the last frame that you want to keep.

Part II Working with Picture Files

"That's a lovely scanned image of your sister's portrait. Now take it off the body of that pit viper before she comes in the room."

In this part . . .

ou have a memory card full of pictures. Now what? Now you turn to the first chapter in this part, Chapter 5, which explains all your camera's picture-playback features, including options that help you evaluate exposure and zoom the display so that you can check small details. The same chapter shows you how to delete lousy pictures and protect great ones from accidental erasure.

When you're ready to move pictures from the camera to your computer, Chapter 6 shows you the best ways to get the job done. In addition, Chapter 6 offers step-by-step guidance on printing your pictures and preparing them for online sharing.

Playback Tricks: Viewing Your Photos and More

In This Chapter

- Exploring picture playback functions
- Deciphering the picture-information displays
- Understanding histograms
- Rating photos
- Deleting bad pictures and protecting great ones
- Creating an in-camera slide show
- ▶ Viewing pictures (and movies) on a television

ithout question, my favorite thing about digital photography is being able to view my pictures on the monitor the instant after I shoot them. No more guessing whether I captured the image I wanted or I need to try again; no more wasting money on developing and printing film pictures that stink. In fact, this feature alone was reason enough for me to turn my back forever on my closetful of film-photography hardware and all the unexposed film remaining from my predigital days.

But seeing your pictures is just the start of the things you can do when you switch your camera to playback mode. You also can review all the camera settings you used to take the picture, display a graphic that alerts you to serious exposure problems, assign ratings to pictures, and add file markers that protect the pictures from accidental erasure. This chapter tells you how to use all these playback features and also explains how to connect your camera to a television so that you can view your photos and movies on a bigger screen.

A couple notes before you dig in:

- Some picture-display information presented in this chapter relates only to photos that you capture using Still Image mode. Some playback functions work a little differently for movies, motion snapshots, and pictures taken using Smart Photo Selector mode. Chapter 4 details playback of movies and motion snapshots; Chapter 3 shows you how to view Smart Photo Selector images.
- ✓ Figures feature screens from the V1, but things work the same on the J1. The only difference is that on the J1, picture data displayed during playback appears directly on the image rather than atop a black border as on the V1.
- V Sections related to rating, protecting, and deleting images also apply to movies, motion snapshots, and pictures taken using Smart Photo Selector mode. You use the same techniques regardless of the type of file. However, note that with Smart Photo Selector photos, all five of the images the camera captured are treated as a single unit. For example, if you delete the best shot the one that's visible initially during playback you also delete the four runners-up. See the end of Chapter 3 for information on viewing and deleting the individual frames in the group. (You can't protect or rate individual frames.)

Customizing Basic Playback Options

You can control many aspects of picture playback on your camera. Later sections show you how to choose what type of data appears with your pictures, how to display multiple images at a time, and how to magnify an image for a close-up look. But first, the next two sections explain options that affect overall playback performance, including how long your pictures appear onscreen and how they're oriented on the monitor.

Adjusting playback timing

By default, the camera displays your photo for a few seconds immediately after the image is captured and then returns to shooting mode. You can't disable or adjust this instant-review period.

In playback mode, the monitor turns off after 30 seconds of inactivity to save battery power, as it does during shooting. If you're viewing pictures and need a longer time to inspect your work, you can adjust the shutdown timing through the Auto Power Off option, found on the Setup menu. You can increase the shutdown interval to as much as 10 minutes or, on the flip side, reduce it to 15 seconds to conserve even more battery power than the

default 30-second delay allows. Just remember that your choice affects monitor shutoff during shooting as well as during picture playback.

Enabling automatic picture rotation

When you take a picture, the camera can record the image *orientation* — whether you held the camera normally, creating a horizontally oriented image, or turned the camera on its side to shoot a vertically oriented photo. During playback, the camera can then read the orientation data and automatically rotate the image so that it appears in the upright position, as shown on the left in Figure 5-1. The image is also automatically rotated when you view it in Nikon ViewNX 2, Capture NX 2, and other photo programs that can interpret the data. If you disable rotation, vertically oriented pictures appear sideways, as shown on the right in Figure 5-1. This playback feature applies to pictures that you take in Smart Photo Selector mode as well as to those shot in Still Image mode. Movies and motion snapshots aren't rotated.

Figure 5-1: You can display vertically oriented pictures in their upright position (left) or sideways (right).

Official photo lingo uses the term *portrait orientation* to refer to vertically oriented pictures and *landscape orientation* to refer to horizontally oriented pictures. The terms stem from the traditional way that people and places are captured in paintings and photographs — portraits, vertically; landscapes, horizontally.

Set up your rotation wishes through the following two menu options, both shown in Figure 5-2:

✓ **Auto Image Rotation:** This option, on the Setup menu, determines whether the orientation data is included in the picture file. The default setting is On; select Off to leave out the data.

Figure 5-2: Visit the Setup and Playback menus to enable or disable image rotation.

✓ Rotate Tall: Found on the Playback menu, this option controls whether the camera pays attention to the orientation data. The default setting is On. Select Off if you don't want the camera to rotate the image during playback.

Regardless of these settings, your pictures aren't rotated during the instantreview period. Also, be aware that shooting with the lens pointing directly up or down sometimes confuses the camera, causing it to record the wrong data in the file.

Viewing Images in Playback Mode

To review your photos in playback mode, take these steps:

1. Press the Playback button, labeled in Figure 5-3.

By default, the camera displays the last picture, movie, or motion snapshot you took, along with some picture data, such as the filename of the photo and the date it was taken, as shown in Figure 5-3. To find out how to interpret the picture information and specify what data you want to see, see the upcoming section "Viewing Picture Data."

Note that Figure 5-3 shows the data that appears with photographs taken in Still Image mode. For information on details that appear with movies and motion snapshots, see Chapter 4. Check out Chapter 3 for help with playback of photos taken in Smart Photo Selector mode.

2. To scroll through your image files, press the Multi Selector right or left.

Just as a reminder: The Multi Selector is the four-way rocker pad that surrounds the OK button. I labeled it in Figure 5-3. You also can scroll

through your pictures by rotating the Multi Selector. Just run your thumb around the edge of the Multi Selector to spin it.

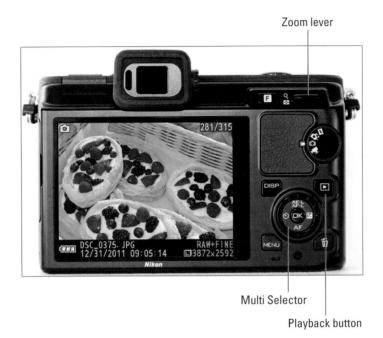

Figure 5-3: These buttons play the largest roles in picture playback.

You can magnify the view of photos taken in Still Image mode by pressing the Zoom lever up (refer to Figure 5-3). See the upcoming section "Zooming in for a closer view" for details.

3. To return to picture-taking mode, press the Playback button again or press the shutter button halfway and then release it.

These steps assume that the camera is currently set to display a single image, movie, or motion snapshot in full-frame view, as shown in Figure 5-3. You can also display thumbnails of multiple files at a time, as explained next.

Switching to Thumbnail view

Along with viewing images, movies, and motion snapshots one at a time, you can display 4 or 9 thumbnails, as shown in Figure 5-4, or even a whopping 72 thumbnails. Here's how to take advantage of this playback option:

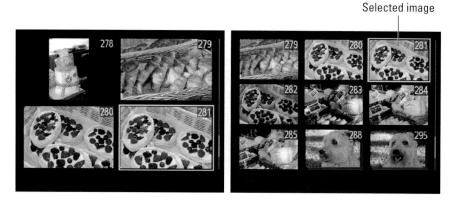

Figure 5-4: You can view multiple image thumbnails at a time.

Movie files are indicated by little "sprocket holes" along the edges of the thumbnail. Again, Chapter 4 provides details on playing movies.

✓ **Display thumbnails.** The key to shifting to Thumbnail view is the Zoom lever, labeled in Figure 5-3. Press the lever down to cycle from full-frame

✓ **Display fewer thumbnails.** Pressing the Zoom lever up takes you from Calendar view back to the standard thumbnails display or, if you're already in that display, reduces the number of thumbnails so you can see each one at a larger size. Again, your first press takes you from 72 thumbnails to 9, your second press to 4 thumbnails, and your third press returns you to full-frame view.

Notice the labels to the left of the Zoom lever: The top one is a magnifying glass, the universal symbol for zoom-in, reminding you to press up to display larger thumbnails. And the lower one is a little grid that resembles a screen full of thumbnails, reminding you to press down to shift from single-image view to Thumbnail view.

- Scroll the display. Press the Multi Selector up and down to scroll to the top or bottom thumbnail on the current screen, then press again to scroll to the next or previous screen of thumbnails. You can also scroll by rotating the Multi Selector.
- Select a thumbnail. To perform certain playback functions while in Thumbnail view, you first need to select a thumbnail. A yellow box surrounds the currently selected thumbnail, as shown in Figure 5-4. To select a different thumbnail, use the Multi Selector to move the highlight box over it. You can press up, down, right, or left or simply rotate the Multi Selector to shift the box.

Jump from any thumbnail display to full-frame view. Instead of pressing the Zoom lever up multiple times, you can just press OK to display the selected thumbnail in full-frame view.

Using Calendar view

In Calendar view, you see a little calendar on the screen, as shown in Figure 5-5. By selecting a date on the calendar, you can quickly navigate to all the pictures, movies, and motion snapshots you took on that day. A thumbnail-free date indicates that your memory card doesn't contain any files from that day.

The key to navigating Calendar view is the Zoom lever (refer to Figure 5-3):

1. Press the Zoom lever down as needed to cycle through the thumbnail display modes until you reach Calendar view.

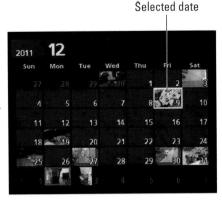

Figure 5-5: Calendar view makes it easy to view all photos shot on a particular day.

If you're currently in full-frame view, for example, you need to press the lever down four times to get to Calendar view.

2. Using the Multi Selector, move the yellow highlight box over a date that contains a thumbnail preview.

In Figure 5-5, the 9th day of December is selected, for example. (The number of the month appears in the top-left corner of the screen.)

3. Press OK to shift to full-frame view and see the first photo, movie, or motion snapshot taken on that day.

To return to Calendar view, repeat these steps.

Zooming in for a closer view

After displaying a photo in single-frame view, as shown on the left in Figure 5-6, you can magnify it to get a close-up look at important details, as shown on the right. This feature, however, works only for pictures taken in Still Image mode and Smart Photo Selector mode. For Smart Photo Selector pictures, you must first press OK to get to the individual frames the camera captured. (Again, see Chapter 3 for complete details on Smart Photo Selector playback.)

Magnified area

Figure 5-6: When viewing images in single-frame view (left), press the Zoom lever up to magnify the picture (right).

Use these techniques to zoom in and out on your photos:

- **Zoom in.** Press the Zoom lever up to magnify the image. Keep pressing the lever up to increase the magnification.
- **Zoom out.** To zoom out to a reduced magnification, press the Zoom lever down.
- View another part of the magnified picture. When an image is magnified, a little navigation thumbnail showing the entire image appears briefly in the lower-right corner of the monitor, as shown on the right in Figure 5-6. The yellow outline in this picture-in-picture image indicates the area that's currently consuming the rest of the monitor space. Use the Multi Selector to scroll the yellow box and display a different portion of the image. After a few seconds, the navigation thumbnail disappears; just press the Multi Selector in any direction to redisplay it.
- Inspect faces. Try this trick to inspect each face in a group shot: Press the Zoom lever up once to magnify the image slightly. The picture-in-picture thumbnail then displays a white border around each detected face, as shown in Figure 5-7. (Typically, subjects must be facing the camera for faces to be detected.) Now rotate the Multi Selector to jump from face to face and examine each one at a magnified view.

Figure 5-7: The Face Detection feature enables you to quickly inspect faces.

✓ Return to full-frame view. When you're ready to return to the normal magnification level, you don't need to keep pressing the Zoom lever down until you're all the way zoomed out. Instead, just press OK.

Viewing Picture Data

In full-frame playback view, you can choose from the three display modes shown in Figure 5-8. To cycle from one to the other, press the Disp button.

The next sections explain exactly what details you can glean from the default display mode, Simple Photo Information mode, and the more complex mode, Detailed Photo Information mode.

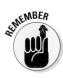

Figures and information presented here mostly apply to pictures taken in Still Image mode, although much of the data shown in the figures also appears when you view movies, motion snapshots, and photos taken in Smart Photo Selector mode. In those modes, as for regular photos, you can choose from the three display styles shown in Figure 5-8, but you may also see some additional onscreen data related just to the type of file you're viewing.

Simple Photo Information

Detail Photo Information

No Information

Figure 5-8: Press the Disp button to cycle from one display style to the next.

Simple Photo Information display

In the Simple Photo Information display mode, the monitor displays the data shown in Figure 5-9. Here's the key to what information appears, starting at the top of the screen and working down:

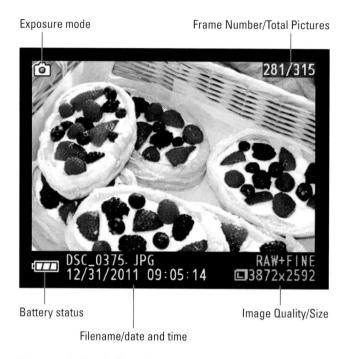

Figure 5-9: In Simple Photo Information display mode, you can view these bits of data.

- Exposure mode: The icon shown in the upper-left corner of Figure 5-8 appears for photos taken using Still Image exposure mode. For files taken using the other exposure modes (Movie, Smart Photo Selector, or Motion Snapshot), the icon mirrors the corresponding icon on the Mode dial.
- Frame Number/Total Pictures: The first value here indicates the frame number of the currently displayed photo; the second tells you the total number of pictures in the same folder. In Figure 5-8, for example, the image is number 281 out of 315.
- ✓ Battery status: The little battery icon reports the level of juice left in your battery. When you see three stripes in the battery, as shown in the

Filename: The camera also automatically names your files. Filenames end with a three-letter code that represents the file format, which is either JPG (for JPEG) or NEF (for Raw) for still photos. Chapter 2 discusses these formats. If you record a movie or motion snapshot, the file extension is MOV, which represents a digital-movie file format.

The first four characters of filenames also vary. Here's what the possible codes indicate:

- *DSC_*: This code means you used the default Color Space setting, sRGB. You can investigate this option in Chapter 11.
- _DSC: If you change the Color Space setting to Adobe RGB, the underscore character comes first.
- CSC_: When you create an edited copy of a photo by using the Playback menu's Resize, Crop, or D-Lighting feature, the copy's filename begins with these characters. If the underscore precedes the letters, you captured the original in the Adobe RGB color space. See the next chapter for information about the Resize option; head to Chapter 11 for details about the Crop and D-Lighting features.
- NMS_: This file prefix indicates a motion snapshot.

Each file is also assigned a four-digit file number, starting with 0001. When you reach file 9999, the file numbering restarts at 0001, and the new files go into a new folder to prevent any possibility of overwriting the existing files. For more information about file numbering, see the Chapter 1 section that discusses the Reset File Numbering option on the Setup menu.

- ✓ Date and time: Just below the filename, you see the date and time that you recorded the file. Of course, the accuracy of this data depends on whether you set the camera's date and time values correctly, which you do via the Setup menu. Chapter 1 has details.
- ✓ Image Quality: Here you can see which Image Quality setting you used when taking a still photo. Again, Chapter 2 has details, but the short story is this: Fine, Normal, and Basic are the three JPEG recording options, with Fine representing the highest JPEG quality. Raw refers to the Nikon Raw format, NEF (for Nikon Electronic Format).
- ✓ Image Size: This value tells you the image resolution, or pixel count. See Chapter 2 to find out about resolution.

You also may see one of the following symbols, labeled in Figure 5-10:

- **✓ Protected symbol:** A little key icon indicates that you used the file-protection feature to prevent the image from being erased when you use the camera's Delete function. See "Protecting Files from Accidental Erasure." later in this chapter, to find out more. (Note: Formatting your memory card, a topic discussed in Chapter 1, does erase even protected pictures.) This area of the display appears empty if you didn't apply protection.
- **Rating stars:** Using the Rating you assigned to the picture. option on the Playback menu, you can award a picture from one to five stars or you can mark it as worthy only of the trash bin. If you rate a photo, the rating appears at the bottom of the screen, just above the filename. See "Rating Photos," also later in this chapter, for details about this feature.

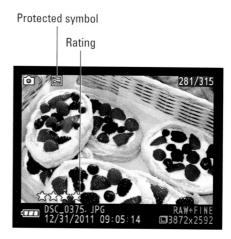

tected photo; the stars indicate the rating

Figure 5-10: The key symbol indicates a pro-

Detailed Photo Information display

In this mode, the playback screen contains a small image thumbnail along with scads of shooting data plus a little graph known as a brightness histogram, as shown in Figure 5-11. (The sidebar "Reading a Brightness histogram," later in this chapter, tells you what to make of that part of the screen.)

In case you forget what camera you're using, the model name appears in the upper-right corner of the display. And as in Simple Photo Information mode, the Frame Number/Total Pictures data appears at the upper-right corner of the image thumbnail, while the icon representing the exposure mode

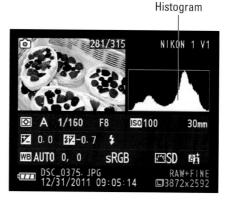

Figure 5-11: In Detailed Photo Information display mode, you can view the major camera settings you used to take the picture.

appears in the upper-left corner. For details on that data, see the preceding section.

To sort out the maze of other information, the following list breaks down things into the five rows that appear under the image thumbnail and histogram. In the accompanying figures as well as in Figure 5-10, I include all possible data simply for the purpose of illustration; if any of the items don't appear on your screen, it simply means that the relevant feature wasn't enabled when you captured the shot.

✓ Row 1: This row shows the exposure-related settings labeled in Figure 5-12, along with the focal length of the lens you used to take the shot. Chapter 7 details the exposure settings; Chapter 8 introduces you to focal length.

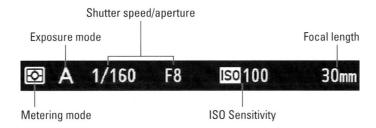

Figure 5-12: Here you can inspect major exposure settings along with the lens focal length.

One note about the exposure-mode icon: If you shot the image in Scene Auto Selector mode, you see an icon representing the specific scene type the camera chose: Portrait, Landscape, Night Portrait, Close-up, or Auto.

✓ Row 2: This row contains a few additional exposure settings, labeled in Figure 5-13.

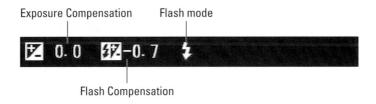

Figure 5-13: This row contains additional exposure information.

Row 3: The first three items on this row, labeled in Figure 5-14, relate to color options explored in Chapters 8 and 11. The second White Balance value shows the amount of blue-to-amber fine-tuning adjustment; and

the third, the amount of green-to-magenta adjustment (both values are 0 in the figure). The last item indicates the Active D-Lighting setting, another exposure option discussed in Chapter 7.

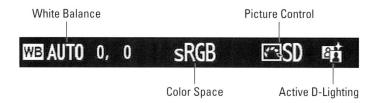

Figure 5-14: Look at this row for details about advanced color settings.

✓ Rows 4 and 5: The final two rows of data (refer to Figure 5-11) show the same information you get in Simple Photo Information display mode, explained in the preceding section.

In addition to this data, you may also see the two symbols labeled in Figure 5-15. The little key symbol indicates that you protected the photo by using the Protect feature on the Playback menu; the Retouch symbol indicates that you created an edited copy of the original image by using the Resize, Crop, or D-Lighting feature on the Playback menu. (The fact that the filename begins with CSC also indicates a retouched image, as outlined in the preceding section.) See the section "Protecting Photos from Accidental Erasure," later in this chapter, for more about protecting photos. To find out about the Resize option, visit Chapter 6, and to get help with the Crop and D-Lighting features, check out Chapter 11.

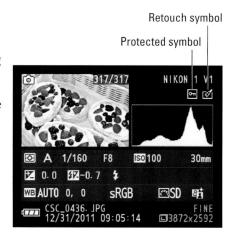

Figure 5-15: These two symbols let you know you're looking at a protected image and an edited version of the original.

Reading a brightness histogram

In Detailed Photo Information display mode, the playback screen includes an exposure tool called a *histogram*, which is a chart that plots out the brightness values of all pixels in the photo. You can see a sample histogram, along with the photo it represents, in the figures here.

The horizontal axis of the chart displays brightness values, with shadows on the left and highlights on the right. The vertical axis represents the number of pixels at each brightness value. So a spike at any point indicates that you have lots of pixels at that particular brightness value.

By reading the histogram, you can quickly see whether your picture may be underexposed or overexposed. Why not just see how the picture looks in the monitor, you ask? Because depending on the ambient light in which you view the picture and on the inherent brightness of the monitor itself, the photo may look brighter or darker than it actually is. A histogram, on the other hand, is a scientific measurement of the actual image brightness.

Normally, a histogram that resembles a bell-shaped curve, or something that looks close to it, is good because well-exposed photos typically contain more *midtones* (areas of medium brightness) accented by highlights and shadows. This isn't true exclusively, of course, and sometimes you may want more shadows or highlights in an image depending on your subject. You wouldn't expect to see lots of shadows, for example, in a photo of a polar bear walking on a snowy landscape.

However, if you look at your camera's histogram and it has a big spike to the left, it may be that your photo is too dark, in which case you need to adjust your exposure settings or add a flash. If it's spiked to the right, your photo may be too bright. It's normal to have a few odd spikes here and there, though; don't demand that every image be a perfect curve. In other words, a histogram is a general guideline and reference tool, not an absolute determining factor for how your image needs to be adjusted.

Shadows

Highlights

Rating Photos

By using the Rating feature, you can assign your photos from one to five stars to rate them as awful, awesome, or somewhere in between. And for pictures that don't even rate one star, you can assign a discard rating to mark it as destined for the trash bin. You also can rate movies, motion snapshots, and pictures that you took using Smart Photo Selector mode.

Taking the time to rate your picture, movie, and snapshot files pays off in a few ways:

- ✓ You can easily locate and erase specific files. After tagging files with the discard rating, you can delete them all in one easy step by choosing the Delete function on the Playback menu and then selecting the Discard option. See "Deleting a batch of selected photos," later in this chapter, for details.
- Vou can prevent specific files from being displayed in slide shows. When you use the Slide Show function, also explained later in this chapter, you can tell the camera to display only files that received a specific star rating. This option saves you the embarrassment of having everyone see your so-so work.
- ✓ After downloading files, you can display and organize them by rating. In ViewNX 2, the free photo software that ships with your camera, you can tell the program to display files in order by rating. Just choose View➪ Sort Thumbnails By➪Rating. You also can choose to display just those images that received a particular star rating: First choose View➪Filter➪ Use Filters to enable picture filtering, and then choose View➪Filter➪By Rating and set the star threshold that pictures must meet to be displayed.

Being able to easily call up all your best work makes it easy to gather up all the files for archiving to DVD or other storage medium, while displaying just your one-star files simplifies the job of weeding out clunkers from your storage bin.

Note that some other photo programs, including Nikon Capture NX2, can also read the star ratings that you assign.

The upcoming steps walk you through the process of rating a file. But first, I need to mention a few issues:

- ✓ You can't rate protected files. If you apply protection, as outlined in the later section "Protecting Files from Accidental Erasure," the file is locked, so the camera can't add the rating data.
- ✓ You can't rate the individual files in a group recorded in Smart Photo Selector mode. Instead, only the shot currently selected as the best of the five recorded shots gets the rating. For more about Smart Photo Selector mode, see the end of Chapter 3.

With those two details out of the way, take these steps to rate a file:

1. Put the camera in Playback mode.

All you have to do is press the Playback button.

2. Display the picture, movie, or snapshot in full-frame view.

If you're currently in thumbnails or Calendar view, just press OK to display the selected file in full-frame view.

3. Press the F (Feature) button.

A rating scale appears in the lower-left corner of the display, as shown on the left in Figure 5-16. The figure shows the display as it appears in the Simple Photo Information display mode, but you can rate photos in any display mode. In Detailed Photo Information mode, the rating scale appears over the image thumbnail.

Rating scale

Figure 5-16: Press the F button to display the rating scale (left); rotate the Multi Selector to assign a rating.

4. Rotate the Multi Selector right to assign a star rating.

Rotate right to highlight the stars one by one. For example, in the right image in Figure 5-16, I assigned a four-star rating to the picture.

The little symbol to the right of the rating stars represents the Multi Selector, by the way — it's there to remind you to rotate the Multi Selector to adjust the rating. If the symbol's missing and rotating the Multi Selector has no effect, the image is protected; you must remove the protection to access the rating feature. (You can protect the file again after rating it.)

- 5. To assign the discard tag, rotate the Multi Selector left to highlight the symbol labeled in Figure 5-17.
- 6. To rate another picture, press the Multi Selector right or left to scroll to that photo.

Then repeat Steps 4 and 5.

symbol.

7. To return to normal playback mode, press the F button again.

The assigned star rating now appears during playback.

To remove the rating tag, repeat these steps and then rotate the Multi Figure 5-17: Selecting this symbol assigns the discard tag to the photo.

2011 17:48:09

Selector until you remove the highlight from all the stars or the discard

Discard symbol

You can also access the rating feature by selecting Rating from the Playback menu. When you do, you see thumbnails of your files; highlight the one you want to rate and then press the Multi Selector up to add stars; press down to assign the discard tag. To rate another file, press the Multi Selector right or left or rotate the Multi Selector to highlight the file's thumbnail. Press OK when you finish rating all your files.

Deleting Photos and Other Files

You have three options for erasing pictures, movies, and motion snapshots from a memory card when it's in your camera. The next sections give you the lowdown.

For photos captured in the Smart Photo Selector mode, the deleting techniques outlined in this section erase not just the best shot — the one visible in the display — but also the four additional shots the camera stored on the memory card when you took the photo. See the end of Chapter 3 to find out how to instead keep the winning shot but delete the other four.

Also, deleting images using these techniques has no effect on files that you safeguard by applying protected status. See the later section "Protecting Files from Accidental Erasure" for more about this feature.

Deleting versus formatting: What's the diff?

Chapter 1 introduces the Format Memory Card command, which lives on the Setup menu and erases everything on your memory card. What's the difference between erasing photos by formatting and by choosing Delete from the Playback menu and then selecting the All option?

Well, if you happen to have stored other data on the card, such as, say, a music file or a picture

taken on another type of camera, you need to format the card to erase those files. You can't use Delete to get rid of them.

In addition, although using the Protect feature (explained elsewhere in this chapter) prevents the Delete function from erasing a picture, formatting erases all pictures, protected or not.

Deleting files one at a time

The Delete button is key to erasing single images. But the process varies a little depending on which playback display mode you use, as follows:

- ✓ In single-image view, erase the current file by pressing the Delete button.
- ✓ In Thumbnail view (displaying 4, 9, or 72 thumbnails), use the Multi Selector to highlight the file you want to erase and then press the Delete button.
- In Calendar view, highlight the date that contains the file. Then press OK to jump to the first image, movie, or motion snapshot taken on that date, use the Multi Selector to scroll to the one you want to trash, and then press the Delete button.

See the earlier section, "Viewing Images in Playback Mode," for more details about Thumbnail and Calendar views.

After you press Delete, you see a message asking whether you really want to erase the picture. If you do, press the Delete button again. Or, to cancel out of the process, press the Playback button.

Remember, if the selected image was captured using Smart Photo Selector mode, you delete the visible photo plus the four other versions that the camera recorded. To find out how to delete only the four shots that weren't deemed best, see the end of Chapter 3.

Deleting all files

To erase all pictures, take these steps:

1. Display the Playback menu and highlight Delete, as shown in the left image in Figure 5-18.

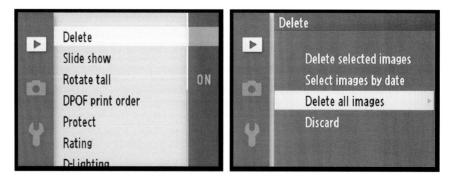

Figure 5-18: To delete all photos, use the Delete option on the Playback menu.

- 2. Press OK to display the second screen in the figure.
- 3. Select Delete All Images and press the Multi Selector right or press OK.

You see a screen that asks you to verify that you want to delete all your images, as shown on the right in the figure.

4. Select Yes and press OK.

All files on the memory card are erased with the exception of any files that you protected using the Protect option on the Playback menu. See "Protecting Files from Accidental Erasure" for more on that feature.

Deleting a batch of selected files

When you want to get rid of more than a few files — but not erase all files on the card — don't waste time erasing each file, one at a time. Instead, you can tag multiple files for deletion and then take them all out to the trash at one time.

You can accomplish this task in two ways:

✓ Rate and delete: First, assign the photos the discard rating, as outlined in the earlier section "Rating Photos." Then choose Delete from the Playback menu, as shown on the left in Figure 5-19, press OK, and choose Discard, as shown on the right. Press OK; you see a confirmation screen asking for the go-ahead to delete the files. Highlight Yes and press OK.

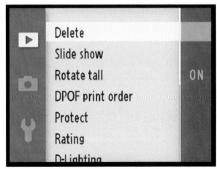

Figure 5-19: The Discard option deletes all photos that you rated with the discard tag.

- ✓ **Select and delete:** You also can tag files for erasure directly from the Delete menu. You have two options for specifying which ones you want to erase:
 - Select individual files. Use this option if the files you want to delete weren't all taken on the same day. After choosing Delete from the Playback menu and pressing OK, highlight Delete Selected Images, as shown on the left in Figure 5-20, and press the Multi Selector right or press OK to display a screen of thumbnails, as shown on the right. Rotate the Multi Selector to place the yellow highlight box over the first file you want to delete and then press the Multi Selector up. A little trash can icon, the universal symbol for delete, appears beneath the thumbnail, as shown in the figure. The file is then tagged as no longer worthy of taking up space on your memory card.

Delete symbol

Figure 5-20: Press the Multi Selector up to tag the selected photo, movie, or motion snapshot with the trash can icon; press down to remove the tag.

If you change your mind, press the Multi Selector down to remove the Delete tag. To remove the tag from all selected files, press the Playback button.

For a closer look at the selected file, press and hold the Zoom lever up. When you release the lever, the display returns to normal thumbnails view.

• Erase all photos taken on a specific date. This time, choose Select Images by Date from the main Delete screen, as shown on the left in Figure 5-21. Press the Multi Selector right to display a list of dates on which you took the pictures on the memory card, as shown on the right in the figure.

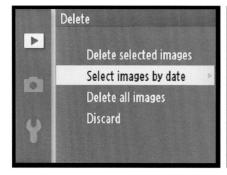

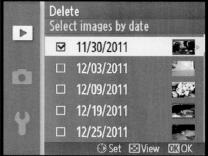

Figure 5-21: With the Select Date option, you can quickly erase all photos taken on a specific date.

Next, highlight a date and press the Multi Selector right. A little check mark appears in the box next to the date, as shown on the right in Figure 5-21, tagging all files taken on that day for deletion. To remove the check mark and save the files from the digital dumpster, press the Multi Selector right again.

Can't remember what photos, movies, or motion snapshots are associated with the selected date? To display thumbnails of all of them, press the Zoom lever down. To temporarily view the selected thumbnail at full-frame view, press and hold the Zoom lever up; release the lever to return to the thumbnail display. To return to the date list, press the Zoom lever down again.

After tagging individual files for deletion or specifying a shooting date to delete, press OK. You see a confirmation screen asking permission to destroy the files; select Yes and press OK. The camera trashes the files and returns you to the Playback menu.

You have one alternative way to quickly erase all files recorded on a specific date: In the Calendar display mode, you can highlight the date in question and then press the Delete button instead of going through the Playback menu. You get the standard confirmation screen that asks you whether you want to go forward. Press the Delete button again to dump the files. Visit the section "Displaying photos in Calendar view," earlier in this chapter, for the scoop on that display option.

Again, if the file you selected represents the best shot in a group taken in Smart Photo Selector mode, you erase all of the images, not just the one that's visible. See Chapter 3 for more about Smart Photo Selector mode, including how to erase all but the winning shot.

Protecting Files from Accidental Erasure

Using the Delete function explained in the preceding section, you can erase unwanted photos, movies, and motion snapshots from your memory card. If you're worried that you might accidentally erase a keeper instead, you can use the Protect feature to safeguard it. After you take this step, the camera doesn't allow you to delete the picture, movie, or snapshot file using the Delete button or the Delete option on the Playback menu.

I also use the Protect feature when I want to keep a handful of files on the card but delete the rest. Normally, you can't delete a batch of files without either assigning them the discard rating or selecting them one by one using the options on the Delete menu. If you have a large number of files to erase, doing all that tagging can take time. Instead, you can simply protect the handful you want to preserve and then set the Delete menu option to All. The protected files are left intact, and the rest are dumped.

Formatting your memory card, however, *does* erase even protected files. In addition, when you protect a file, it shows up as a read-only file when you transfer it to your computer. Files that have that read-only status can't be altered until you unlock them in your photo software. In Nikon ViewNX 2, you can do this by clicking the image thumbnail and then choosing File\$\to\$Protect Files\$\to\$Unprotect.

Protecting a file is easy:

1. Display the Playback menu and select Protect, as shown on the left in Figure 5-22.

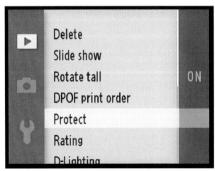

Figure 5-22: Protecting a picture prevents it from being erased when you use the Delete functions

- 2. Press OK to display the screen shown on the right in the figure.
- 3. Highlight Select/Set and press the Multi Selector right or press OK.

You see a screen of thumbnails, as shown in Figure 5-23.

Protected symbol

- 4. Rotate the Multi Selector to put the yellow highlight box around the picture, movie, or motion snapshot you want to protect.
- 5. Press the Multi Selector up.

A little key symbol appears under the thumbnail, indicating that the file is locked and untouchable by the normal Delete function. (Again, formatting the card *will* erase even protected photos.)

Figure 5-23: Press the Multi Selector up to turn on file protection; press down to turn it off.

You can magnify the photo temporarily by pressing and holding the Zoom lever up. When you release the lever, the thumbnails return.

6. To protect additional photos, repeat Steps 4 and 5.

7. Press OK.

A message appears to tell you that the protection status for the selected files has been updated.

To remove protection, choose one of these paths:

- ✓ Remove protection from a single image: Repeat Steps 1 through 3, high-lighted the protected photo in Step 4, and then press the Multi Selector down in Step 5. The little key symbol disappears from beneath the thumbnail, indicating that the file is now unlocked. Continue through the rest of the steps to wrap up.
- ✓ Remove protection from all images on the memory card: Choose Protect from the Playback menu, press OK, and then choose Reset on the next screen that appears. (Refer to the right screen in Figure 5-22.) Press the Multi Selector right or press OK. On the confirmation screen that appears, highlight Yes and press OK.

One potential glitch with respect to protecting photos captured using Smart Photo Selector mode: Using the delete techniques outlined in this chapter leaves all five images the camera recorded intact. But if you use the delete technique outlined at the end of Chapter 3, the protection status applies only to the shot selected as the best of the five, and the other four can be deleted.

Creating a Digital Slide Show

Many photo-editing and cataloging programs offer a tool for creating digital slide shows that can be viewed on a computer or, if copied to a DVD, on a DVD player. You can even add music, captions, graphics, special effects, and the like to jazz up your presentations.

But if you want to create a simple slide show — that is, one that simply displays the photos on the camera memory card one by one — you can create and run the show right on your camera by using the Slide Show function on the Playback menu. And by connecting your camera to a television, as outlined in the last section of this chapter, you can present your show to a whole roomful of people.

Follow these steps to present a slide show:

1. Display the Playback menu and highlight Slide Show, as shown on the left in Figure 5-24.

Figure 5-24: Choose Slide Show to set up automatic playback of all pictures on your memory card.

2. Press OK to display the initial slide-show setup screen, shown on the right in Figure 5-24.

This screen lists options that limit the type of files to be included in the slide show.

3. Select the type of files you want to include.

You can choose from the following options:

- *All Images:* Include all photos, movies, and motion snapshots. *Note:* For photos taken in the Smart Photo Selector mode, only the image chosen as the best shot is displayed; the other four are hidden. (See Chapter 3 for more on this shooting mode.)
- *Still Images:* Include still photographs only. Again, only the best Smart Photo Selector image appears.
- Movies: Include movies only.
- Motion Snapshot: Include motion snapshots only. Note: Only the movie portion of the file plays during the slide show. The still photo recorded at the end of the snapshot doesn't appear.
- Select Images by Date: Include files recorded on a specific date. If you choose this option, press the Multi Selector right to display a calendar and then highlight the date in question.
- Selected Scene: Display only photos of a specific scene type recorded in Scene Auto Selector mode: Auto, Portrait, Landscape, Night Portrait, or Close-up. Press right to display the list of scenes and highlight your choice.
- By Rating: Display only files that you assigned a specific rating.
 After highlighting this option, as shown on the left in Figure 5-25, press right to display the screen shown on the right. Highlight a star rating and press the Multi Selector right to put a check in the

box and include pictures with that rating in the show. For example, in the right image in Figure 5-25, I specified that I wanted four- and five-star files to be included.

 Face Priority: Include only images in which the camera detected faces.

Figure 5-25: You can limit the slide show to displaying only files that you tagged with a specific star rating.

4. Press OK.

You then see the screen shown in Figure 5-26. (For some options selected in Step 3, you may first see the message that the camera is preparing the show.)

5. Set the frame interval.

This option determines how long each still image is displayed. To make your choice, highlight Frame Interval and press the Multi Selector right. On the next screen, you can specify how long you want each image to be displayed. You can set the interval

Figure 5-26: Set the frame interval, movie playback duration, and audio options here.

to 2, 3, 5, or 10 seconds. Press OK after making your choice to return to the screen shown in Figure 5-26.

6. If your show includes movies, set the movie playback time.

To do so, highlight Movie Playback Time, as shown on the left in Figure 5-27, and press OK. You see the screen shown on the right in the figure. Choose from the following options:

Figure 5-27: For movies, choose whether you want to play just the start of the movie or the entire clip.

- Same as Frame Interval: The movie will play for the length of time you selected for the frame interval in Step 5. Then the next file in the slide show will be displayed.
- 10 Seconds: Plays the first 10 seconds of the movie only.
- 15 Seconds: Plays the first 15 seconds.
- All (No Limit): Plays the entire movie.

After selecting your choice, press OK.

7. Set the audio options.

Highlight Audio, as shown on the left in Figure 5-28, and press OK to display your options, as shown on the right. Select Mute for no audio track; choose one of the three provided background tracks; or choose Movie Sound Tracks to play only the audio recorded with movies (still photos and motion snapshots are played with no audio).

Figure 5-28: You can choose from three background tracks, disable audio, or play sound recorded with movies only.

The first provided background track is a relaxing piano melody and tracks 2 and 3 have a jazzier beat.

Press OK after making your choice.

8. To start the show, highlight Start and press OK.

When the show ends, you see a screen offering several options. You can choose to restart the show (select the Resume option), adjust the playback options, or select Exit to return to the initial slide-show setup screen. Highlight your choice and press OK. Or, to return to regular playback mode, press the Playback button; to return to shooting mode, press the shutter button halfway, and release it.

During the show, you can control playback as follows:

- Adjust audio volume: Press the Zoom lever up to increase the volume; press down to lower it.
- ✓ Pause the show. Press OK. You see the same screen that appears at the end of a show. To restart playback, select Resume and press OK. You also can adjust the playback options of choose Exit to return to the initial slide-show setup screen.
- Skip to the next/previous image manually. Press the Multi Selector right or left.
- ✓ Change the information displayed with the image. Press the Disp button to cycle between the three playback display modes and change the amount of shooting data that appears on the screen. See the section "Viewing Picture Data" for help with understanding the various modes.
- **Exit the show.** You have three options:
 - To return to regular playback, press the Playback button.
 - To return to the Playback menu, press the Menu button.
 - To return to picture-taking mode, press the shutter button halfway.

Viewing Your Photos on a Television

Your camera is equipped with a feature that allows you to play your pictures and movies on a television screen. Here's what you need to know:

✓ Regular (standard-definition) video playback: Haven't made the leap yet to HDTV? No worries: You can set the V1 to send a regular standarddefinition audio and video signal to the TV. The cable you need is even provided in the camera box. (Look for the cable that has a yellow plug and a white plug at one end.)

- One hang-up to note about this option: For movies, the audio playback is monaural, even if you recorded sound using an external stereo microphone.
- ✓ HDMI playback: For this option the only one available on the J1 you need an HDTV along with an HDMI cable to connect the camera and television. You need a Type C mini-pin HD cable; prices start at about \$20. Nikon doesn't make its own cable, so just look for a quality third-party version.
- For HDMI CEC TV sets: If your television is compatible with HDMI CEC, you can use the buttons on the TV's remote control to perform the functions of the OK button, Multi Selector, and Playback buttons during picture playback and slide shows. To make this feature work, set the HDMI Device Control option on the Setup menu to On, as shown in Figure 5-29. After you connect the camera to the TV, a remotecontrol guide appears on screen to tell you which buttons do what.

Figure 5-29: Enable this option to use a compatible HDTV remote control to run your show.

You need to make one final preflight check before connecting the V1 to a television: Verify the status of the Video Mode setting, located just above the HDMI Device Control option on the Setup menu. You have just two options: NTSC and PAL. Select the video mode used by your part of the world. (In the United States, Canada, and Mexico, NTSC is the standard.) The mode should've been set at the factory to the right option for the country in which you bought your camera, but it never hurts to check. (The J1 outputs video in the NTSC format only.)

After you select the necessary options, grab your video cable, turn off the camera, and open the little rubber door found on the left side of the V1 and the right side of the J1. On the J1, connect the cable to the HDMI port, labeled on the left in Figure 5-30. On the V1, you find two ports: one for the supplied standard audio/video (A/V) cable and one for the HDMI cable, as shown on the right in the figure.

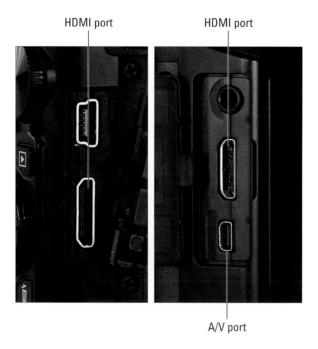

Figure 5-30: The video-out ports are under the little rubber door on the side of the camera.

For standard A/V connection — again, available on the V1 only — the smaller plug on the cable attaches to the camera. The yellow plug goes into your TV's video jack, and the white one goes into your TV's audio jack. For HDMI playback, a single plug goes to the TV.

At this point, I need to point you to your specific TV manual to find out exactly which jacks to use to connect your camera. You also need to consult your manual to find out which channel to select for playback of signals from auxiliary input devices. Then just turn on your camera to send the signal to the TV set. If you don't have the latest and greatest HDMI CEC capability (or lost your remote), control playback using the same techniques as you normally do to view pictures on your camera monitor. You can also run a slide show by following the steps outlined in the preceding section.

Downloading, Printing, and Sharing Your Photos

In This Chapter

- Choosing photo software
- Transferring pictures to your computer using Nikon ViewNX 2
- Processing Raw (NEF) files
- Taking steps to ensure great print quality
- Preparing your photos for online sharing

or many novice digital photographers, the task of moving pictures to the computer is one of the more confusing aspects of the art form. Unfortunately, providing you with detailed downloading instructions is impossible because the steps vary widely depending on which computer software you use to do the job.

To give you as much help as I can, however, this chapter starts with a quick review of photo software, in case you aren't happy with your current solution. Following that, you can find information about downloading images, converting pictures that you shoot in the Raw format to a standard format, and preparing your pictures for print and online sharing.

Choosing the Right Photo Software

Programs for downloading, archiving, and editing digital photos abound, ranging from entry-level software designed for beginners to high-end options geared to professionals. The good news is that if you don't need serious photo-editing capabilities, you may find a free program that serves your needs — in fact, your camera ships with one free program: Nikon ViewNX 2.

The next section offers a look at Nikon ViewNX 2, along with two other freebies; following that, I offer some advice on a few popular programs to consider when the free options don't meet your needs.

Three free photo programs

If you don't plan on doing a lot of retouching or other manipulation of your photos but simply want a tool for downloading and organizing your pictures, one of the following free programs may be a good solution:

✓ Nikon ViewNX 2: This program is on the CD that shipped in your camera box. (You also can download the program from the support section of the Nikon website.) As the name implies, the program provides a simple photo organizer and viewer, plus a few basic photo-editing features, including red-eye removal and exposure and color adjustment filters. You also can use the program to download pictures and to convert Raw files to a standard format. (See Chapter 2 for a primer on file formats.) I show you how to accomplish both tasks later in this chapter.

Figure 6-1 offers a look at the ViewNX 2 window as it appears when you use the Thumbnail Grid view mode, one of three display options available from the View menu.

S. ViewWith 2 - Collison Library Strip Picture within Transfer 2005

File Edit Transport

Fil

Click to hide/display Metadata panel

Figure 6-1: Nikon ViewNX 2 offers a basic photo viewer and some limited editing functions.

After you download your photos, you can view camera *metadata* — extra (*meta*) data that specifies the camera settings you used to take the picture — in ViewNX 2. Just display the Metadata panel, located on the right side of the program window, as shown in Figure 6-1. (If the panel is hidden, click the little triangle on the far right side of the window and then click the triangle at the top of the panel. I labeled both controls in the figure.) To view the maximum amount of metadata, select All from the menu at the top of the panel.

Many other photo programs also display metadata, but sometimes can't reveal data that's very camera specific, such as the Picture Control setting. Every camera manufacturer records metadata differently, and the Raw data structure may vary even among cameras from the same manufacturer, so it's a little difficult for software companies to keep up with each new model.

Also note that because Nikon supplies ViewNX 2 for cameras other than Nikon 1 models, some features don't apply to your camera. If a feature doesn't seem to work, it's likely because it isn't compatible with a Nikon 1 camera.

- ✓ **Apple iPhoto:** Most Mac users are very familiar with this photo browser, built in to the Mac operating system. Apple provides some great tutorials on using iPhoto at its website (www.apple.com) to help you get started.
- Windows Live Photo Gallery: Some versions of Microsoft Windows also offer a free photo downloader and browser, Windows Live Photo Gallery (the name varies, depending on your version of Windows).

Advanced photo programs

Programs mentioned in the preceding section can handle simple photo downloading and organizing tasks. But if you're interested in serious photo retouching or digital-imaging artistry, you need to step up to a full-fledged photo-editing program.

As with software in the free category, you have many choices; the following list describes just the most-widely-known programs.

✓ Adobe Photoshop Elements: Elements has been the best-selling consumer-level photo-editing program for some time, and for good reason. With a full complement of retouching tools, onscreen guidance for beginners, and an assortment of templates for creating photo projects like scrapbooks, Elements offers all the features that most consumers need. Figure 6-2 shows the Elements editing window with some of the photo-creativity tools displayed to the right of the photo. The program includes a photo organizer as well, along with built-in tools to help you print your photos and upload them to photo-sharing sites. (www.adobe.com, about \$100)

Figure 6-2: Adobe Photoshop Elements offers good retouching tools plus templates for creating scrapbooks, greeting cards, and other photo gifts.

- Nikon Capture NX 2: Shown in Figure 6-3, this Nikon program offers an image browser/organizer plus a wealth of photo-editing tools, including a sophisticated tool for processing Raw images. But as you can see from the figure, it's not exactly geared to casual photographers or novice photo editors, so expect a bit of a learning curve. Nor does this program offer the sort of photo-creativity tools you find in a program like Photoshop Elements; the same is true for the other advanced tools described in this list. (www.nikon.com, about \$180)
- ✓ **Apple Aperture:** Aperture is geared more to shooters who need to organize and process lots of images but typically do only light retouching work wedding photographers and school-portrait photographers, for example. (www.apple.com, about \$80 when purchased through Mac App store.)
- Adobe Photoshop Lightroom: Lightroom is the Adobe counterpart to Aperture, although in its latest version, it offers some fairly powerful retouching tools as well. Many pro photographers rely on this program for all their work, in fact. (www.adobe.com, about \$300)

Figure 6-3: Nikon Capture NX 2 may appeal to photographers who need more robust image-editing tools than are found in ViewNX 2.

Installing Nikon ViewNX 2

If you want to use the free Nikon software, Nikon ViewNX 2, to download, view, and organize your photos, first check your computer system specifications. In order to run the program successfully, Nikon suggests that you use one of the following computer operating systems:

- Windows 7, Vista with Service Pack 2, or XP with Service Pack 3 (Home or Professional Editions). The program runs as a 32-bit application in 64-bit installations of Windows 7 and Windows Vista.
- Mac OS X 10.5.8 or 10.6.7

If you use another OS (operating system, for the nongeeks in the crowd), check the support

pages on the Nikon website (www.nikon.com) for the latest news about any updates to system compatibility. You can always simply transfer images with a card reader, too.

Also note that this book features Nikon ViewNX 2 version 2.3.0. If you own an earlier version of the program, visit the Nikon website to install the updates. (To find out what version you have installed, open the program. Then, in Windows, choose Helpthabout. On a Mac, choose the About ViewNX 2 command from the ViewNX 2 menu.) You also may be able to use the builtin software updater, depending on the age of your software. Open the program and choose Helpthabout Check for Updates to give it a go.

✓ Adobe Photoshop: The granddaddy of photo editors, Photoshop offers the industry's most powerful, sophisticated retouching tools, including tools for producing HDR (high dynamic range) and 3D images. In fact, you probably won't use even a quarter of the tools in the Photoshop shed unless you're a digital imaging professional who uses the program on a daily basis — even then, some tools may never see the light of day. (www.adobe.com, about \$700)

Not sure which tool you need, if any? Good news: You can download free trials of all these programs from the manufacturers' websites.

Sending Pictures to the Computer

Whatever photo software you choose, you can take the following approaches to downloading images to your computer:

- Connect the camera to the computer via a USB cable. The USB cable you need is supplied in the camera box.
- ✓ Use a memory card reader. With a card reader, you simply pop the memory card out of your camera and into the card reader instead of hooking the camera to the computer. Many computers and printers now have card readers, and you also can buy standalone readers for less than \$30. Note: If you use SDHC (Secure Digital High Capacity), SDXC (Secure Digital eXtended Capacity), or UHS (Ultra High Speed) memory cards, be sure that your card reader supports that type of card.

For most people, I recommend a card reader. Sending pictures directly from the camera requires that the camera be turned on during the entire download process, wasting battery power. That said, I include information about cable transfer in the next section in case you don't have a card reader. To use a card reader, skip ahead to "Starting the transfer process," in this chapter.

Connecting the camera and computer for picture download

With the USB cable that shipped with your camera, you can connect the camera to your computer and then transfer images directly to the computer's hard drive.

The next section explains the actual transfer process; the steps here just walk you through the process of connecting the two devices. You need to follow a specific set of steps when connecting the camera to your computer. Otherwise you can damage the camera or the memory card.

With that preamble out of the way, here are the steps to link your computer and camera:

1. Check the level of the camera battery.

- If the battery is low, charge it before continuing. Running out of battery power during the transfer process can cause problems, including lost picture data. Alternatively, if you purchased the optional AC adapter, use that to power the camera during picture transfers.
- 2. Turn on the computer and give it time to finish its normal startup routine.
- 3. Turn off the camera.
- 4. Insert the smaller of the two plugs on the USB cable into the USB port on the side of the camera.

Look under the rubber door on the side of the camera for this port. Figure 6-4 identifies the USB port as it appears on the J1 (left) and V1 (right).

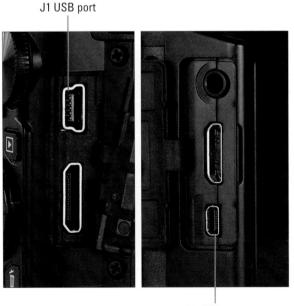

V1 USB port

Figure 6-4: The USB slot is hidden under the rubber door on the side of the camera.

5. Plug the other end of the cable into the computer's USB port.

If possible, plug the cable into a port that's built in to the computer, as opposed to one that's on your keyboard or part of an external USB hub. Those accessory-type connections can sometimes foul up the transfer process.

6. Turn on the camera.

What happens now depends on your computer operating system and what photo software you have installed on that system. The next section explains the possibilities and how to proceed with the image transfer process.

7. When the download is complete, turn off the camera and then disconnect it from the computer.

Starting the transfer process

After you connect the camera to the computer or insert a memory card into your card reader, your next step depends, again, on the software installed on your computer and the computer operating system.

Here are the most common possibilities and how to move forward:

✓ On a computer running Windows 7, a Windows message box similar to the one in Figure 6-5 appears. Again, the figure shows the dialog box as it appears on a computer running Windows 7. By default, clicking the Import Pictures and Videos icon starts image transfer using Windows picture-transfer utility, but you can click the Change Program link under the icon to choose Nikon ViewNX 2 or some other program as your preferred transfer tool.

In older versions of Windows, you typically see a dialog box listing all the installed programs that can handle the transfer; click the one you want to use.

An installed photo program automatically displays a photo-download wizard. For example, the Nikon Transfer 2 downloader or a downloader associated with Adobe Photoshop Elements, iPhoto, or some other photo software may leap to the forefront. Usually, the downloader that appears is associated with the software that you installed most recently. Each new program that you add to your system tries to wrestle control over your image downloads away from the previous program.

Figure 6-5: Windows 7 may display this initial boxful of transfer options.

If you don't want a program's auto-downloader to launch whenever you insert a memory card or connect your camera, you can turn off that feature. Check the software manual to find out how to disable the auto launch.

Nothing happens. Don't panic; assuming that your card reader or camera is properly connected, all is probably well. Someone simply may have disabled all the automatic downloaders on your system. Just launch your photo software and then transfer your pictures using whatever command starts that process.

As another option, you can use Windows Explorer or the Mac Finder to drag and drop files from your memory card to your computer's hard drive. If you connect the card through a card reader, the computer sees the card as just another drive on the system. Windows Explorer also shows the camera as a storage device when you cable the camera directly to the computer. So the process of transferring files is exactly the same as when you move any other file from a CD, DVD, or other storage device onto your hard drive. (Current versions of the Mac Finder don't recognize cameras in this way.)

In the next section, I provide details on using Nikon ViewNX 2 to download your files. If you use some other software, the concepts are the same, but check your program manual to get the small details. In most programs, you also can find lots of information by simply clicking open the Help menu.

Downloading using ViewNX 2

Built in to ViewNX 2 is a handy image-downloading tool called Nikon Transfer 2. A couple tips about using this software:

- ViewNX 2 is the best option for camera-to-computer transfers on a Mac. The Mac operating system doesn't recognize the camera when you attach the two devices via USB cable, but if you install ViewNX 2, the transfer utility does detect the camera. In fact, during program installation, you can ask Nikon Transfer 2 to spring to life as soon as you connect and power up the camera or insert a card into your card reader.
- You can use Nikon ViewNX 2 to download your photos and still use any photo-editing or image-management software you prefer. And to do your editing, you don't need to download photos a second time after you transfer photos to your computer, you can access them from any program, just as you can any file that you put on your system. With some programs, however, you must first take the step of *importing* or *cataloging* the photo files, which enables the program to build thumbnails and, in some cases, working copies of your pictures.

With that preamble out of the way, the following steps walk you through the process of downloading via Nikon ViewNX 2:

1. Attach your camera to the computer or insert a memory card into your card reader, as outlined in the first part of this chapter.

Depending on what software you have installed on your system, you may see a dialog box asking you how to download your photos. If the window that appears is the Nikon Transfer 2 window, shown in Figure 6-6, skip to Step 3.

Similarly, if you see a Windows dialog box that contains the Nikon Transfer 2 option, click that option and skip to Step 3.

If nothing happens, don't worry — just travel to Step 2, which shows you how to launch the Nikon Transfer 2 software if it didn't appear automatically.

2. Launch Nikon Transfer 2, if it isn't already open.

To access the transfer tool, open Nikon ViewNX 2 and then choose Filer⇒Launch Transfer or click the Transfer button at the top of the window. The window shown in Figure 6-6 appears. (If you use a Mac, the window decor is slightly different, but the main controls and features are the same.)

Figure 6-6: Select the check boxes of the images that you want to download.

3. Display the Source tab to view thumbnails of your pictures, as shown in the figure.

Don't see any tabs? Click the little Options triangle, located near the topleft corner of the window and labeled in Figure 6-6, to display them. Then click the Source tab. The icon representing your camera or memory card should be selected, as shown in the figure. If not, click the icon. Thumbnails of your images appear in the bottom half of the dialog box. If you don't see the thumbnails, click the arrow labeled in Figure 6-6 to open the thumbnails area.

4. Select the images that you want to download.

A check mark in the little box under a thumbnail tells the program that you want to download the image. Click the box to toggle the check mark on and off.

Here are a few tips to speed up this part of the process:

- Select protected images only: If you used the in-camera function to protect pictures (see Chapter 5), you can select just those images by clicking the Select Protected icon, labeled in Figure 6-6.
- Select all images: Just click the Select All icon, also labeled in the figure.
- Select a group of images: To select a batch of consecutive images, click the first one in the group and then hold down the Shift key as you click the last one. All the thumbnails become selected, and checking or unchecking the box under one thumbnail affects the entire group.

To select a batch of images that aren't consecutive, click the first one and then Ctrl+click (Windows) or \(\mathbb{H}\)-click (Mac) the others. That is, hold down the Ctrl or \(\mathbb{H}\) key as you click a thumbnail.

5. Click the Primary Destination tab at the top of the window.

When you click the tab, the top of the transfer window offers options that enable you to specify where and how you want the images to be stored on your computer. Figure 6-7 offers a look.

Choose a storage folder

Figure 6-7: Specify the folder where you want to put the downloaded images.

6. Choose the folder where you want to store the images from the Primary Destination Folder drop-down list.

The list is labeled in Figure 6-7. If the folder you want to use isn't in the list, open the drop-down list, choose Browse from the bottom of the list, and then track down the folder and select it.

By default, the program puts images in a Nikon Transfer 2 folder, which is housed inside the My Pictures folder in Windows XP and Pictures in Windows 7, Windows Vista, and on a Mac. That My Pictures or Pictures folder is housed inside a folder that your system creates automatically for each registered user of the computer.

You don't have to stick with this default location — you can put your pictures anywhere you please. But because most photo programs look for pictures in these standard folders automatically, putting your pictures there simplifies things a little down the road. You can always move your pictures into other folders after you download them if needed, too.

Specify whether you want the pictures to be placed inside a new subfolder.

If you select the Create Subfolder for Each Transfer option, the program creates a new folder inside the storage folder you selected in Step 6. Then it puts all the pictures from the current download session into that new subfolder. You can either use the numerical subfolder name the program suggests or click the Edit button to set up your own naming system. You might find it helpful to go with a folder name that includes the date that the batch of photos was taken, for example. You can reorganize your pictures into this type of setup after download, however.

8. Tell the program whether you want to rename the picture files during the download process.

If you do, select the Rename Files during Transfer check box. Then click the Edit button to display a dialog box where you can set up your new filenaming scheme. Click OK after you do so to close the dialog box.

9. Click the Preferences tab to set the rest of the transfer options.

The tab shown in Figure 6-8 takes over the top of the program window. Here you find a number of options that enable you to control how the program operates, as follows:

• Add Additional Information to Files: Through this option, you can embed XMP/IPTC data in the file. IPTC refers to text data that press photographers are often required to tag on to their picture files, such as captions and copyright information. XMP refers to a data format developed by Adobe to enable that kind of data to be added to the file. IPTC stands for International Press Telecommunications Council; XMP stands for Extensible Metadata Platform. Click the Edit button beneath the option to create and store a preset that contains the data you want to add. On your next visit to the dialog box, you can choose the preset from the drop-down list above the Edit button.

- Embed ICC Color Profile during Transfer: This option relates to the Color Space option on the Shooting menu. Nikon recommends that you enable this option if you capture images using the Adobe RGB color space instead of the default, sRGB space. Otherwise some photo programs may simply assume that the files are in the sRGB space. Chapter 11 explains the Color Space setting.
- Always use ratings applied on original files: If you rated your photos using the feature explained in Chapter 5, check this box to ensure that the ratings are retained during transfer.
- *Transfer New Files Only:* This option, when selected, ensures that you don't waste time downloading images that you've already transferred but are still on the memory card.
- Synchronize Camera Date and Time . . . : If you connect your camera to the computer via USB cable, selecting this option tells the camera to reset its internal clock to match the date and time of the computer.
- Disconnect Automatically after Transfer: Choose this option to tell the transfer tool to disconnect the memory-card reader or camera automatically when the download is complete. (Depending on your operating system, the device may not be officially disconnected, however; it may still be visible via the system's file-management tool.)
- Delete Original Files after Transfer: Turn off this option, as shown in Figure 6-8. Otherwise, your pictures are automatically erased from your memory card when the transfer is complete. Always make sure the pictures really made it to the computer before you delete them from your memory card. (See Chapter 5 to find out how to use the Delete function on your camera.)

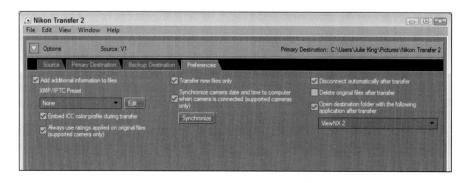

Figure 6-8: Control other aspects of the program's behavior via the Preferences tab.

• Open Destination Folder with the Following Application after Transfer: You can tell the program to immediately open your photo program after the transfer is complete. Choose ViewNX 2, as shown in the figure, to view, organize, and edit your photos using that program. To choose another program, open the drop-down list, choose Browse, and select the program from the dialog box that appears. Click OK after doing so.

Your choices remain in force for any subsequent download sessions, so you don't have to revisit this tab unless you want the program to behave differently.

10. When you're ready to start the download, click the Start Transfer button.

It's located in the lower-right corner of the program window. (Refer to Figure 6-6.) After you click the button, the Process bar in the lower-left corner indicates how the transfer is progressing. Again, what happens when the transfer completes depends on the choices you made in Step 9; if you selected Nikon ViewNX 2 as the photo program, it opens and displays the folder that contains your just-downloaded images.

Processing Raw (NEF) Files

Chapter 2 introduces you to the Raw file format. The advantage of capturing Raw files, or NEF files on Nikon cameras, is that you make the decisions about how to translate the original picture data into an actual photograph. You can specify attributes such as color intensity, image sharpening, contrast, and so on — which are all handled automatically by the camera if you use its other file format, JPEG. You take these steps by using a software tool known as a *Raw converter*.

The bad news: Until you convert your NEF files into a standard file format, you can't share them online or print them from most programs other than Nikon ViewNX 2. You also can't get prints from most retail outlets or open them in many photo-editing programs.

Fortunately, ViewNX 2 has a tool that offers a Raw processing feature. The controls for setting picture characteristics are a little more limited than in a more advanced photo editing program such as Adobe Photoshop or Nikon Capture NX 2, but you do get a solid group of basic options. Follow these steps to try it out:

1. Open ViewNX 2 and click the thumbnail of the image that you want to process.

You may want to set the program to Image Viewer mode, as shown in Figure 6-9, so that you can see a larger preview of your image. Just choose Viewer larger Viewer to switch to this display mode. To give the

photo even more room, also hide the Browser panel, which normally occupies the left third of the window, and the Filmstrip panel that usually runs across the bottom of the window. Choose Window Browser and Window Filmstrip to toggle those window elements on and off.

2. Display the Adjustments panel on the right side of the program window.

You can see the panel in Figure 6-9. Show and hide this panel and the Metadata panel by choosing Window ⇒ Edit or by clicking the triangle on the far-right side of the window. You can then display and collapse the individual panels by clicking the triangles to the left of their names. (I labeled the triangles in the figure.) To allow the maximum space for the Raw conversion adjustments, collapse the Metadata panel, as shown in the figure. If necessary, drag the vertical bar between the image window and the Adjustments panel to adjust the width of the panel.

Click to hide/display Adjustments panel

ViewNX 2 - D:\mages\Raw Dumps\October 2011 123456789 ◎ 亩★★★

Reset button

Save button

Figure 6-9: Display the Adjustments panel to tweak Raw images before conversion.

3. To display all available image settings, choose All from the Adjustments drop-down list at the top of the panel, as shown in the figure.

Unless you use a large monitor, you may need to use the scroll bar on the right side of the panel to scroll the display to see all the options.

4. Use the panel controls to adjust your image.

The preview you see in the image window reflects the default conversion settings chosen by Nikon. But you can play with any of the settings as you see fit. If you need help understanding any of the options, open the built-in help system (via the Help menu), where you can find descriptions of how each adjustment affects your image.

To return to the original image settings, click the Reset button at the bottom of the panel, labeled in Figure 6-9.

5. Click the Save button at the bottom of the panel (refer to Figure 6-9).

This step stores your conversion settings as part of the image file but doesn't actually create your processed image file. Don't worry — your original Raw data remains intact; all that's saved with the file is a "recipe" for processing the image, which you can change at any time.

6. To save the processed file, choose File⇔Convert Files.

Or just click the Convert Files button on the toolbar at the top of the program window. Either way, you see the Convert Files dialog box, as shown in Figure 6-10.

7. Choose TIFF(8 Bit) from the File Format drop-down list.

TIFF (tagged image file format) is the best format because it retains your processed file at the highest image quality. (This format has long been the preferred format for print publication.) Don't choose JPEG; as explained in Chapter 2, the JPEG format applies lossy compression, thereby sacrificing some image quality. If you need a JPEG copy of your processed Raw image for online sharing — TIFF files won't work for that use — you can easily create one from your TIFF version by following the steps laid out near the end of this chapter.

As for the 8 Bit part of the option name: A *bit* is a unit of computer data; the more bits you have, the more colors your image can contain. Although you can create 16-bit TIFF files in the converter, some photoediting programs either can't open them or limit you to a few editing tools, so I suggest you stick with the standard, 8-bit image option. Your image will contain more than enough colors, and you'll avoid potential conflicts caused by so-called *high-bit* images.

8. Deselect the Use LZW Compression option, as shown in the figure.

Although LZW compression reduces the file size somewhat and does not cause any quality loss, some programs can't open files that were saved with this option enabled. So turn it off.

Figure 6-10: To retain the best image quality, save processed Raw files in the TIFF format.

9. Deselect the Change the Image Size check box.

This step ensures that you retain all the original pixels in your image, which gives you the most flexibility in terms of generating quality prints at large sizes. For details on this issue, check out Chapter 2.

10. Deselect each of the three Remove check boxes.

If you select the check boxes, you strip image *metadata* — the extra text data that's stored by the camera — from the file. Unless you have some specific reason to do so, clear all three check boxes so that you can continue to access the metadata when you view your processed image in programs that know how to display metadata.

The first check box relates to data that you can view on the Metadata panel in ViewNX; the first section of the chapter gives you the lowdown. The second box refers to the XMP/IPTC data that you can embed during file transfer; see the section "Downloading photos with Nikon ViewNX 2" for a discussion of that issue. The ICC profile item refers to the image *color space*, which is either sRGB or Adobe RGB. Chapter 11 explains the difference.

11. Select a storage location for the processed TIFF file.

You do this in the Save In area of the dialog box. Select the top option to save your processed file in the same folder as the original Raw file. Or, to put the file in a different folder, click the Specified Folder button. The name of the currently selected alternative folder appears below the button, as shown in Figure 6-10. You can change the storage destination by clicking the Browse button and then selecting the drive and folder where you want to put the file.

By selecting the Create a New Subfolder for Each File Conversion check box, you can put your TIFF file into a separate folder within the destination folder. If you select the box, click the Naming Options button and then specify how you want to name the subfolder.

12. Specify whether you want to give the processed TIFF a different filename from the original Raw image.

To do so, select the Change File Names check box, click the Naming Options button, and enter the name you want to use.

If you don't change the filename, the program gives the file the same name as the original Raw file. But you don't overwrite that Raw file because you're storing the copy in a different file format (TIFF). In Windows, the filename of the processed TIFF image has the three-letter extension TIF.

13. Click the Convert button.

A window appears to show you the progress of the conversion process. When the window disappears, your TIFF image appears in the storage location you selected in Step 11.

One neat thing about working with Raw images is that you can easily create as many variations of your photo as you want. For example, you might choose one set of options when processing your Raw file the first time and then use an entirely different set to create another version of the photo. Just be sure to give each processed file a unique name so that your second and later versions of the image don't overwrite the first TIFF file you create.

Here's Tip #2: In a pinch, you can use the Resize option on the camera's Playback menu to create a JPEG version of a Raw image — but only at a lower resolution (smaller size) than the original. See the section "Resizing pictures from the Playback menu" for details.

Planning for Perfect Prints

Images from your Nikon 1 can produce dynamic prints, and getting those prints made is easy and economical, thanks to an abundance of digital printing services in stores and online. For home printing, today's printers are

better and less expensive than ever, too. That said, getting the best prints from your picture files requires a little bit of knowledge and prep work on your part, whether you decide to do the job yourself or use a retail lab. To that end, the next three sections offer tips to help you avoid the most common causes of printing problems.

Check the pixel count before you print

Resolution — the number of pixels in your digital image — plays a huge role in how large you can print your photos and still maintain good picture quality. You can get the complete story on resolution in Chapter 2, but here's a quick recap as it relates to printing:

Choose the right resolution before you shoot: Set resolution via the Image Size option, found on the Shooting menu.

You must select the size *before* you capture an image, which means that you need some idea of the ultimate print size before you shoot. When you do the resolution math, remember to take any cropping you plan to do into account.

✓ Aim for a minimum of 200 pixels per inch (ppi): You'll get a wide range of recommendations on this issue, even among professionals. But in general, if you aim for a resolution in the neighborhood of 200 ppi, you should be pleased with your results. If you want a 4-x-6-inch print, for example, you need at least 800 x 1200 pixels.

Depending on your printer, you may get even better results at a slightly lower resolution. On the other hand, some printers do their best work when fed 300 ppi, and a few request 360 ppi as the optimum resolution. Note, however, that using a resolution higher than 360 ppi typically doesn't produce any better prints.

Unfortunately, because most printer manuals don't bother to tell you what image resolution produces the best results, finding the right pixel level is a matter of experimentation.

Don't confuse *ppi* with the manual's statements related to the printer's dpi. *Dots per inch (dpi)* refers to the number of dots of color the printer can lay down per inch; many printers use multiple dots to reproduce one image pixel.

If you're printing photos at a retail kiosk or at an online site, the software you use to order prints should determine the resolution of your files and then suggest appropriate print sizes. If you're printing on a home printer, though, you need to be the resolution cop.

What do you do if you don't have enough pixels for the print size you have in mind? You have the following two choices, neither of which provides a good outcome:

- ✓ Keep the existing pixel count and accept lowered photo quality. In this case, the pixels simply get bigger to fill the requested print size. When pixels grow too large, they produce a defect known as pixelation: The picture starts to appear jagged, or stairstepped, along curved or oblique lines. Or, at worst, your eye can make out the individual pixels, and your photo begins to look more like a mosaic than, well, like a photograph.
- Add more pixels and accept lowered photo quality. In some photo programs, you can add pixels to an image (the technical term for this process is *resampling*). Some other photo programs even resample the photo automatically for you, depending on the print settings you choose.

Just to hammer home the point and remind you again of the impact of resolution picture quality, Figures 6-11 through 6-13 show you the same image as it appears at 300 ppi (the resolution required by the publisher of this book), at 50 ppi, and then resampled from 50 ppi to 300 ppi. As you can see, there's just no way around the rule: If you want the best-quality prints, you need the right pixel count from the get-go.

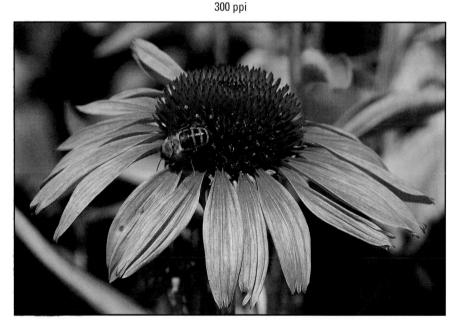

Figure 6-11: A high-quality print depends on a high-resolution original.

EMEMBER

50 ppi

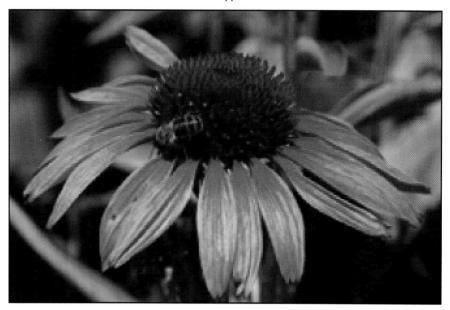

Figure 6-12: At 50 ppi, the image has a jagged, pixelated look.

50 ppi resampled to 300 ppi

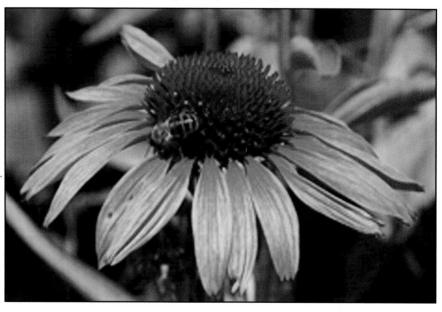

Figure 6-13: Adding pixels in a photo editor doesn't rescue a low-resolution original.

Allow for different print proportions

Your camera produces images that have a 3:2 aspect ratio, which matches the proportions of a 4-x-6-inch print. To print your photo at other traditional sizes — 5×7 , 8×10 , and so on — you need to crop the photo to match those proportions. Alternatively, you can reduce the photo size slightly and leave an empty margin along the edges of the print as needed.

Chapter 11 shows you how to crop your image using the Crop option on the Playback menu. However, this in-camera cropping tool lets you crop only to an aspect ratio of 3:2, 4:3, 1:1, or 16:9. So to crop to other frame sizes, you can use the Crop tool in ViewNX 2 — it's found on the same Adjustments panel that you use when processing your Raw images, as outlined earlier in this chapter. You also can usually crop your photo using the software provided at online printing sites and at retail print kiosks. If you plan to simply drop off your memory card for printing at a lab, be sure to find out whether the printer automatically crops the image without your input. If so, use your photo software to crop the photo, save the cropped image to your memory card, and deliver that version of the file to the printer.

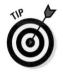

To allow yourself some printing flexibility, leave at least a little margin of background around your subject when you shoot. That way, you don't clip off the edges of the subject, no matter what print size you choose. (Some people refer to this margin padding as *head room*, especially when describing portrait composition.) Chapter 3 offers some examples in the section related to composition.

Get print and monitor colors in sync

Ah, your photo colors look perfect on your computer monitor. But when you print the picture, the image is too dark, is too light, or has a nasty color tint. This problem, which is probably the most prevalent printing issue, can occur because of any or all the following factors:

Your monitor needs to be calibrated. When print colors don't match the ones you see on your monitor, the most likely culprit is the monitor, not the printer. If the monitor isn't accurately calibrated, the colors it displays aren't a true reflection of your image colors. The same caveat applies to monitor brightness: You can't accurately gauge the exposure of a photo if the brightness of the monitor is cranked way up or down. It's worth noting that many of today's new monitors are very bright, providing ideal conditions for web browsing and watching movies but not necessarily for photo editing. So you may need to turn the brightness way, way down to get to a true indication of image exposure.

To ensure that your monitor displays photos on a neutral canvas, you can start with a software-based *calibration utility*, which is just a small program that guides you through the process of adjusting your monitor.

The program displays various color swatches and other graphics, and then asks you to provide feedback about the colors you see onscreen.

If you use a Mac, its operating system (OS) offers a built-in calibration utility, the Display Calibrator Assistant; Windows 7 offers a similar tool: Display Color Calibration. You also can find free calibration software for both Mac and Windows systems online; just enter the term *free monitor calibration software* into your favorite search engine.

Software-based tools, however, depend on your eyes to make decisions during the calibration process. For a more reliable calibration, invest in a hardware solution, such as the huey PRO (about \$100, www.pantone.com) or the Spyder4Express (about \$120, www.datacolor.com). These products use a device known as a *colorimeter* to accurately measure display colors.

Whichever route you take, the calibration process produces a monitor *profile*, which is simply a data file that tells your computer how to adjust the display to compensate for any monitor color casts or brightness and contrast issues. Your Windows or Mac operating system loads this file automatically when you start your computer. Your only responsibility is to perform the calibration every month or so because monitor colors drift over time.

One of your printer cartridges is empty or clogged. If your prints look great one day but are way off the next, the number-one suspect is an empty ink cartridge or a clogged print nozzle or head. Check your manual to find out how to perform the necessary maintenance to keep the nozzles or print heads in good shape.

If black-and-white prints have a color tint, a logical assumption is that your black ink cartridge is to blame, if your printer has one. But the truth is that images from a printer that doesn't use multiple black or gray cartridges typically have a slight color tint even when all the ink cartridges are fine. Why? Because a printer has to create gray by mixing yellow, magenta, and cyan ink in perfectly equal amounts — and that's a difficult feat for the typical inkjet printer to pull off. If your black-and-white prints have a strong color tint, however, a color cartridge might be empty, and replacing it may help somewhat. Long story short: Unless your printer is marketed for producing good black-and-white prints, you'll probably save yourself some grief by simply having your black-and-whites printed at a retail lab.

When you buy replacement ink, by the way, keep in mind that third-party brands (though perhaps cheaper) may not deliver the same performance as cartridges from your printer manufacturer. A lot of science goes into getting ink formulas to mesh with the printer's ink-delivery system, and the printer manufacturer obviously knows most about that delivery system.

- ✓ You chose the wrong paper setting in your printer software. When you set up a print job, be sure to select the right setting from the paper type option glossy or matte, for example. This setting affects the way the printer lays down ink on the paper.
- Your photo paper is low-quality. Sad but true: Cheap, store-brand photo papers usually don't render colors as well as the higher-priced, name-brand papers. For best results, try papers from your printer manufacturer; again, those papers are engineered to provide top performance with the printer's specific inks and ink-delivery system.

Some paper manufacturers, especially those that sell fine-art papers, offer downloadable *printer profiles*, which are simply little bits of software that tell your printer how to manage color for the paper. Refer to the manufacturer's website for information on how to install and use the profiles. And note that a profile mismatch can also cause incorrect colors in your prints, including the color tint in black-and-white prints alluded to earlier.

Your printer and photo software fight over color-management duties. Some photo programs offer *color-management* tools, which enable you to control how colors are handled as an image passes from camera to monitor to printer. Most printer software also offers color management features. The problem is, if you enable color management controls in both your photo software and printer software, you can create conflicts that lead to wacky colors. Check your photo software and printer manuals for color management options and ways to turn them on and off.

Even if all the aforementioned issues are resolved, however, don't expect perfect color matching between printer and monitor. Printers simply can't reproduce the entire spectrum of colors that a monitor can display. In addition, monitor colors always appear brighter because they are, after all, generated with light.

Finally, be sure to evaluate print colors and monitor colors in the same ambient light — daylight, office light, whatever — because that light source has its own influence on the colors you see. Also allow your prints to dry for 15 minutes or so before you make any final judgments.

Preparing Pictures for E-Mail and Online Sharing

How many times have you received an e-mail message that looks like the one in Figure 6-14? Some well-meaning friend or relative sent you a digital photo that's so large you can't view the whole thing on your monitor.

Figure 6-14: The attached image has too many pixels to be viewed without scrolling.

The problem is that computer monitors can display only a limited number of pixels. The exact number depends on the monitor's resolution setting and the capabilities of the computer's video card, but suffice it to say that the average photo from one of today's digital cameras has a pixel count in excess of what the monitor can handle.

Thankfully, newer e-mail programs often have picture-viewing tools that can display large images at a reduced size. And some programs can even upload photos to an online storage site instead of dumping the files directly into the recipient's mailbox — the recipient can then choose to view and download the files from the online storage. But if you send pictures to someone who uses an older e-mail program, chances are that your large files come through as shown in Figure 6-14. Not only do you make it difficult for people to view your files, but you're asking them to download and store large files — remember, every pixel in the photo adds to the file size, and thus, the file download time and storage requirements.

In general, a good rule is to limit e-mail photos to no more than 640 pixels at their longest dimension. That ensures that people who use the older e-mail programs can view your entire picture without scrolling, as in Figure 6-15. This image measures 640×424 pixels.

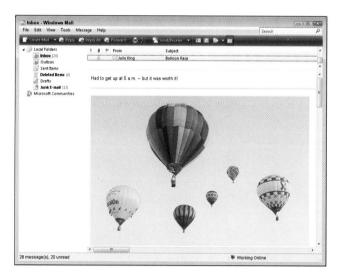

Figure 6-15: Keep e-mail pictures to no larger than 640 pixels wide or tall

This size recommendation means that even if you shoot at your camera's lowest Image Size setting (1936 x 1296), you wind up with more pixels than you need for onscreen viewing. Some new e-mail programs have a photoupload feature that creates a temporary low-res version for you, but if not, creating your own copy is easy. (Details later.) If you're posting to an online photo-sharing site, you may be able to upload all your original pixels, but many sites have resolution limits.

In addition to resizing high-resolution images, check their file types; if the photos are in the Raw (NEF) or TIFF format, you need to create a JPEG copy for online use. Web browsers and e-mail programs can't display Raw or TIFF files.

You can tackle both bits of photo prep in ViewNX 2 or by using the Resize option in your camera. The next two sections explain both methods.

Prepping online photos using ViewNX 2

For pictures that you already downloaded to the computer, you can create a small-sized JPEG copy for online sharing using ViewNX 2. Just click the image thumbnail and then choose the Convert Files command, found on the File menu. When the Convert Files dialog box appears, set up things as follows:

✓ **Select JPEG as the file format.** Make your choice from the File Format drop-down list, as shown in Figure 6-16.

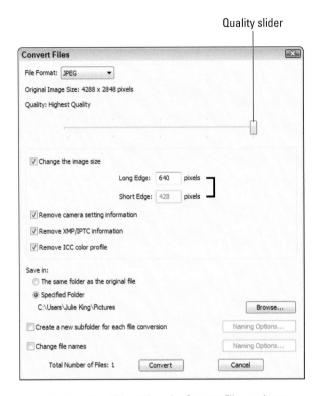

Figure 6-16: In ViewNX 2, select the Convert Files option to create a JPEG version of a Raw or TIFF photo.

- Set the picture-quality level. Use the Quality slider, labeled in the figure, to set the picture quality, which is controlled by how much JPEG compression is applied when the file is saved. For best quality, drag the slider all the way to the right, but remember the tradeoff: As you raise the quality, less compression occurs, which results in a larger file size. (See Chapter 2 for more information about JPEG compression.)
- ✓ **Set the image size (number of pixels).** To resize the photo, select the Change the Image Size check box and then enter a value (in pixels) for the longest dimension of the photo. The program automatically fills in the other value.

For pictures that you want to share online, also select all three of the Remove check boxes, as shown in the figure, to eliminate adding to file sizes unnecessarily.

The rest of the options work just as they do during Raw conversion; see the "Processing Raw Files," earlier in this chapter, for details. If you're resizing a JPEG original, be sure to give the small version a new name to avoid overwrlting that original.

Resizing pictures from the Playback menu

The in-camera resizing tool, found on the Playback menu, works on both JPEG and Raw images. With both types of files, your resized copy is saved in the JPEG format.

To use this tool, take these steps:

- 1. Display the Playback menu.
- 2. Select the Resize option, as shown on the left in Figure 6-17, and press OK.

You see the screen shown on the right in Figure 6-17.

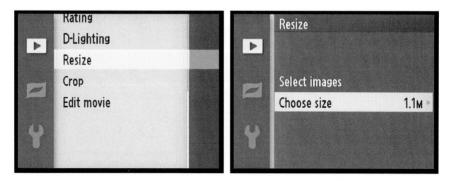

Figure 6-17: Use the Resize option to create a low-resolution version of a picture on your memory card.

3. Select Choose Size and press the Multi Selector right.

You see the screen shown in Figure 6-18, listing the possible image sizes, stated in megapixels. The options result in the following pixel dimensions for your small copy:

- 1.1M: 1280 x 856 pixels
- 0.6M: 960 x 640 pixels
- 0.3M: 640 x 424 pixels
- 4. Highlight the size you want to use for your copy and press OK.

You're returned to the main Resize menu.

5. Choose Select Images and press the Multi Selector right to display thumbnails of your pictures, as shown in Figure 6-19.

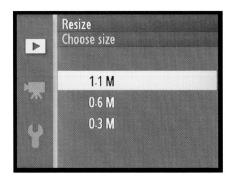

Figure 6-18: Set the size for your small copies here.

6. Rotate the Multi Selector to move the yellow highlight box over a thumbnail; then press the Multi Selector up to "tag" the photo for copying.

You see a little icon under the thumbnail, as shown in Figure 6-19. Press Multi Selector down to remove the tag if you change your mind.

A couple notes here: First, a little yellow box with an *x* through it, as shown on the right in Figure 6-19, indicates that the file can't be resized. You can't resize movie files and motion snapshots, and you can't resize a resized copy. For pictures taken in Smart Photo Selector mode, you can use the Resize option to make a small copy of the best photo in the group only.

Resize

Select images
Choose size

0.6M

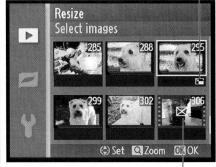

Can't resize

Resize symbol

Figure 6-19: Press the Multi Selector up to tag a picture for resizing.

7. After selecting all your pictures, press OK.

A screen appears asking you for permission to make small copies of the selected photos.

8. Highlight Yes and press OK.

The camera duplicates the selected images and *downsamples* (eliminates pixels from) the copies to achieve the size you specified. The small copies are saved in the JPEG file format, using the same Image Quality setting (Fine, Normal, or Basic) as the original. If you resize a Raw original, the copy is saved using the JPEG Fine setting. Either way, your original picture files remain untouched.

When you view small-size copies on the camera monitor, they appear with a Resize icon next to the file size, as shown in Figure 6-20. The filename of the resized image begins with CSC_ (or _CSC, if the original was captured using the Adobe RGB Color Space). And if you're viewing the photo in Detailed Photo Information display mode, the Retouch icon — a little paintbrush symbol — appears just above the histogram. (See Chapter 5 for details about playback display modes.)

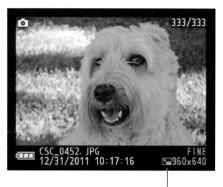

Resized symbol

Figure 6-20: The Resize icon indicates a small-size copy.

Part III Taking Creative Control

In this part . . .

Auto Selector or Smart Photo Selector mode and let the camera handle most of the photographic decisions, I encourage you to take creative control and explore the advanced Still Image exposure modes (P, S, A, and M). In these modes, you can make your own decisions about the exposure, focus, and color characteristics of your photo, which are key to capturing a compelling image as you see it in your mind's eye. And don't think that you have to be a genius or spend years to be successful — adding just a few simple techniques to your photographic repertoire can make a huge difference in the quality of the pictures you take.

thing you need to know to do just that, providing both some necessary photography fundamentals as well as details about using the advanced exposure modes. Following that, Chapter 9 helps you draw together all the information presented earlier in the book, summarizing the best camera settings and other tactics to use when capturing portraits, action shots, landscapes, and close-up shots. In short, this part helps you get the most out of your camera, which results in your becoming a better photographer.

The first two chapters in this part explain every-

Getting Creative with Exposure and Lighting

In This Chapter

- Understanding the basics of exposure
- Exploring advanced exposure modes: P, S, A, or M?
- Choosing an exposure metering mode
- ▶ Tweaking autoexposure with Exposure Compensation
- Taking advantage of Active D-Lighting
- Using advanced flash features

nderstanding exposure is one of the most intimidating challenges for the new photographer. Discussions of the topic are loaded with technical terms — aperture, metering, shutter speed, ISO, and the like. Add the fact that your camera offers many exposure controls, all sporting equally foreign names, and it's no wonder that most people throw up their hands and decide that their best option is to simply stick with Scene Auto Selector mode and let the camera take care of all exposure decisions.

You can, of course, turn out good shots in that mode. And I fully relate to the exposure confusion you may be feeling — I've been there. But I can also promise that when you take things nice and slow, digesting just a piece of the exposure pie at a time, the topic is not nearly as complicated as it seems on the surface. And I guarantee that the payoff will be well worth your time and brain energy. You'll not only gain the power to resolve just about any exposure problem, but also discover ways to use exposure to put your own creative stamp on a scene.

To that end, this chapter provides everything you need to know to really exploit your camera's exposure options, from a primer in exposure science (it's not as bad as it sounds) to explanations of all the camera's exposure controls. In addition, because some controls aren't accessible in Scene Auto Selector mode (or in Smart Photo Selector mode, for that matter), this chapter also provides more details about the four advanced Still Image modes, P, S, A, and M.

Introducing the Exposure Trio: Shutter Speed, Aperture, and 150

Any photograph, whether taken with a film or digital camera, is created by focusing light through a lens onto a light-sensitive recording medium. In a film camera, the film negative serves as that medium; in a digital camera, it's the *image sensor*, which is an array of light-responsive computer chips.

The exposure, or brightness, of the image that results when light hits the sensor depends on three settings: *shutter speed, aperture*, and *ISO*. This three-part exposure formula works as follows:

✓ Shutter speed (controls duration of light): The shutter speed determines exposure time, or how long the light is recorded by the sensor. Shutter speed is measured in seconds: 1/60 second, 1/250 second, 2 seconds, and so on.

Shutter refers to a mechanical light barrier that sits between the lens and image sensor. Figure 7-1 gives you an idea of the traditional lens, shutter, and sensor placement. When you take a picture, the shutter opens to allow the light to reach the sensor and then closes to end the exposure.

This traditional setup isn't quite the way things work on your camera, however. First, the J1 doesn't have a physical shutter like the one shown in the figure. Instead, it uses an *electronic shutter*. With this setup, pressing the shutter

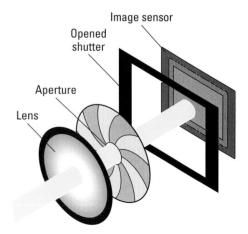

Figure 7-1: Here's a look at the traditional aperture, shutter, and image-sensor setup.

button tells the camera to begin recording the light that's striking the sensor. Recording stops at the end of the exposure time.

The V1, on the other hand, offers both a mechanical and electronic shutter. (See the section "Choosing a shutter type (mechanical or electronic)" for details on choosing between the two.) But even when you use the mechanical shutter, it actually stays open between exposures — that's required in order to generate the live scene on the camera display. When you press the shutter button, the shutter actually closes, opens for the duration of the exposure, and closes again briefly before opening to enable the live display again.

Available shutter speeds depending on your camera:

- *J1*: You can choose speeds ranging from 1/16000 second to 30 seconds when not using flash. If you do enable the flash, the fastest possible shutter speed is 1/60 second.
- VI: When you use the mechanical shutter, shutter speeds range from 1/4000 second to 30 seconds; with the electronic shutter, you can set the shutter speed as high as 1/16000 second. If you add flash, however, the fastest shutter speed for the mechanical shutter is 1/250 second, and the top speed for the electronic shutter is 1/60 second.

Should you want a shutter speed longer than 30 seconds, manual (M) exposure mode also provides a feature called *bulb* exposure on both cameras. At this setting, the shutter stays open indefinitely as long as you press the shutter button.

Aperture (controls amount of light): The *aperture* is an adjustable hole in a diaphragm in the lens. By changing the size of the aperture, you control the size of the light beam that can enter the camera. Aperture settings are stated as *f-stop numbers*, or simply *f-stops*, and are expressed with the letter *f* followed by a number: f/2, f/5.6, f/16, and so on. The lower the f-stop number, the larger the aperture, and the more light is permitted into the camera, as illustrated by Figure 7-2. To put it another way, the higher the number, the more the light is restricted.

The range of possible f-stops depends on your lens and, if you use a zoom lens, on the zoom position (focal length) of the lens. When you use the 10--30mm lens featured in this book, you can select apertures from f/3.5–f/16 when zoomed all the way out to the shortest focal length, 10mm. When you zoom in to the maximum focal length, 30mm, the aperture range is f/5.6–f/16. (See Chapter 8 for a discussion of focal lengths.)

✓ ISO (controls light sensitivity): ISO, which is a digital function rather than a mechanical structure on the camera, enables you to adjust how responsive the image sensor is to light. The term ISO is a holdover from film days, when an international standards organization rated each film stock according to light sensitivity: ISO 200, ISO 400, ISO 800, and so on.

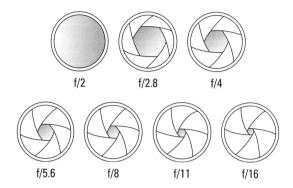

Figure 7-2: A lower f-stop number means a larger aperture, allowing more light into the camera.

On a digital camera, the sensor itself doesn't actually get more or less sensitive when you change the ISO — rather, the light "signal" that hits the sensor is either amplified or dampened through electronics wizardry, which is sort of like how raising the volume on a radio boosts the audio signal. But the upshot is the same as changing to a more light-reactive film stock: A higher ISO means that less light is needed to produce the image, enabling you to use a smaller aperture, faster shutter speed, or both. (In other words, from now on, don't worry about the technicalities and just remember that ISO equals light sensitivity.)

Normal ISO settings on both the V1 and J1 range from ISO 100 to 3200. But if you really need to push things, you can extend that range all the way to ISO 6400. (This über-high setting goes by the name Hi 1.) High ISO settings have a downside that you can explore in the upcoming section "ISO affects image noise."

Distilled to its essence, the image-exposure formula is just this simple:

- ✓ Aperture and shutter speed together determine the quantity of light that strikes the image sensor during the exposure.
- ✓ ISO determines how much the sensor reacts to that light and, therefore, how much light you need to expose the picture.

The tricky part of the equation is that aperture, shutter speed, and ISO settings affect your pictures in ways that go *beyond* exposure. You need to be aware of these side effects, explained in the next section, to determine which combination of the three exposure settings will work best for your picture.

Understanding exposure-setting side effects

You can create the same exposure with many combinations of aperture, shutter speed, and ISO. You're limited only by the aperture range allowed by the lens and the shutter speeds and ISO range offered by the camera.

But the settings you select impact your image beyond mere exposure, as follows:

- ✓ Aperture affects *depth of field*, or the distance over which focus appears sharp.
- Shutter speed determines whether moving objects appear blurry or sharply focused.
- ✓ ISO affects the amount of image *noise*, which is a defect that looks like tiny specks of sand.

As you can imagine, understanding how aperture, shutter speed, and ISO affect your image enables you to have much more creative control over your photographs — and, in the case of ISO, to ensure the quality of your images. (Chapter 2 discusses other factors that affect image quality.)

The next three sections explore the details of each exposure side effect.

Aperture affects depth of field

The aperture setting, or f-stop, affects *depth of field*, which is the distance over which sharp focus extends in your image. With a shallow depth of field, your subject appears more sharply focused than objects that are positioned farther from or nearer to the lens; with a large depth of field, the sharp-focus zone spreads over a greater distance.

As you reduce the aperture size — or *stop down the aperture*, in photo lingo — by choosing a higher f-stop number, you increase depth of field. As an example, take a look at the two images in Figure 7-3. For both shots, I established focus on the flower in the foreground. Notice that the grassy background in the first image, taken at an aperture setting of f/5.6, is softer than in the right example, taken at f/16. Aperture is just one contributor to depth of field, however; the focal length of your lens and the distance between that lens and your subject also affect how much of the scene stays in focus. See Chapter 8 for the complete story, including more examples of how changing the f-stop affects depth of field.

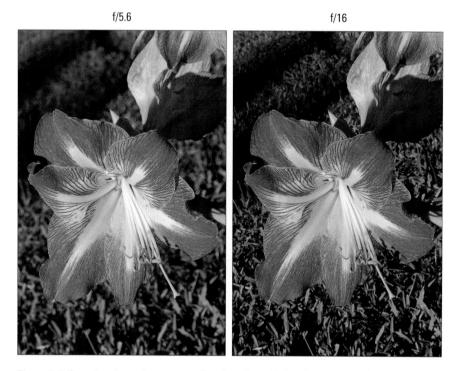

Figure 7-3: Stopping down the aperture (by choosing a higher f-stop number) increases depth of field, or the distance over which focus appears sharp.

One way to remember the relationship between f-stop and depth of field is to think of the f as standing for focus. A higher f-stop number produces a larger depth of field, so if you want to extend the zone of sharp focus to cover a greater distance from your subject, you set the aperture to a higher f-stop. Higher f-stop number, greater zone of sharp focus. (Please don't share this tip with photography elites, who will roll their eyes and inform you that the f in f-stop most certainly does not stand for focus but for the ratio between the aperture size and lens focal length — as if that's helpful to know if you're not an optical engineer. Again, Chapter 8 explains focal length, which is helpful to know.)

Shutter speed affects motion blur

At a slow shutter speed, moving objects appear blurry, whereas a fast shutter speed captures motion cleanly. This phenomenon has nothing to do with the actual focus point of the camera but rather on the movement occurring — and being recorded by the camera — during the time that the shutter is open.

Compare the photos in Figure 7-4, for example. A shutter speed of 1/100 second left the jumping children blurry; raising the speed to 1/300 second froze the action. How high a shutter speed you need to freeze action depends on the speed of your subject.

If your picture suffers from overall blur, as shown in Figure 7-5, where even stationary objects appear out of focus, the camera Itself moved during the exposure, which is always a danger when you handhold the camera. The slower the shutter speed, the longer the exposure time and the longer you have to hold the camera still to avoid the blur that's caused by camera shake.

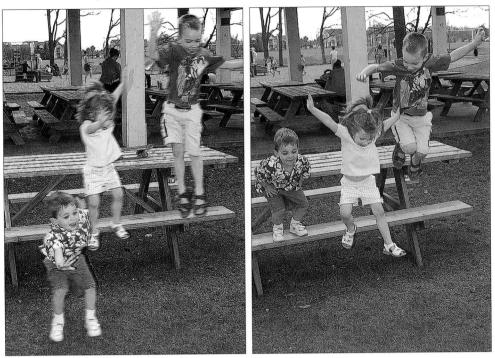

Figure 7-4: At slow shutter speeds, moving objects appear blurry (left); for this subject, a shutter speed of 1/300 froze the action (right).

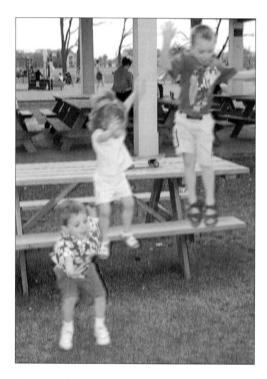

Figure 7-5: Allover blur is a symptom of camera shake during the exposure.

Keep in mind that freezing action isn't the only way to use shutter speed to creative effect. When shooting waterfalls, for example, most photographers use a very slow shutter speed to give the water a misty, romantic look. With colorful moving subjects, a slow shutter can produce some cool abstract effects and create a heightened sense of motion. Chapter 9 offers examples of both effects.

150 affects image noise

As ISO increases, making the image sensor more reactive to light, you increase the risk of producing noise. *Noise* is a defect that looks like sprinkles of sand and is similar in appearance to film *grain*, a defect that often mars pictures taken with high-ISO film. Figure 7-6 offers an example.

Ideally, then, you should always use the lowest ISO setting on your camera to ensure top image quality. But sometimes the lighting conditions simply don't

permit you to do so and still use the aperture and shutter speeds you need. Take my rose image as an example. When I shot these pictures, I didn't have a tripod, so I needed a shutter speed fast enough to allow a sharp handheld image. I opened the aperture to f/5.6, which was the maximum on the lens I was using, to allow as much light as possible into the camera. At ISO 100, I needed a shutter speed of 1/40 second to expose the picture, and that shutter speed wasn't fast enough for a successful handheld shot. By raising the ISO to 200, I was able to use a shutter speed of 1/80 second, which enabled me to capture the flower cleanly, as shown in Figure 7-7.

Handholding the camera: How low can you go?

My students often ask how slow they can set the shutter speed and still handhold the camera instead of using a tripod. Unfortunately, there's no one-size-fits-all answer to this question.

The slow-shutter safety limit varies depending on a couple factors, including your physical capabilities and your lens — the heavier the lens, the harder it is to hold steady. For reasons that are too technical to get into, camera shake also affects your picture more when you shoot with a lens that has a long focal length. (Chapter 8 explains focal length, if the term is new to you.)

A traditional photography rule is to use the inverse of the lens focal length as the minimum handheld shutter speed. For example, with a 50mm lens, use a shutter speed no slower than 1/50 second. But that rule was developed before the advent of today's modern lenses, which tend to be significantly lighter and smaller than older lenses, as do cameras themselves. (Case in point: the Nikon 1 lenses.)

So the best idea is to do your own tests to see where your handholding limit lies. Start with a slow shutter speed — say, in the 1/40 second

neighborhood, and then click off multiple shots, increasing the shutter speed for each picture. If you have a zoom lens, run the test first at the minimum focal length (widest angle) and then zoom to the maximum focal length for another series of shots. Then it's simply a matter of comparing the images in your photo-editing program. (You may not be able to judge the amount of blur accurately on the camera monitor.) See Chapter 6 to find out how to see the shutter speed you used for each picture when you view your images. That information, along with other camera settings, appears in each image file's metadata, which you can display in Nikon ViewNX 2 and many other programs.

Remember, too, that enabling Vibration Reduction can compensate for small amounts of camera shake, enabling you to capture sharp images at slightly slower shutter speeds than normal when handholding the camera. Again, your mileage may vary, but most people can expect to go at least one or two notches down the shutter-speed ramp. See Chapter 2 for more information about this feature.

Figure 7-6: Caused by a very high ISO or long exposure time, noise becomes more visible as you enlarge the image.

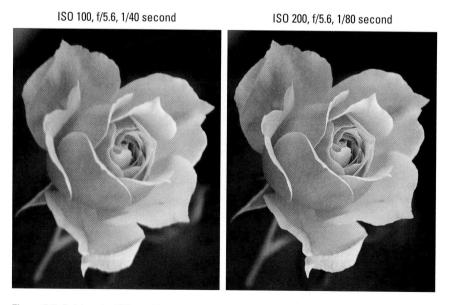

Figure 7-7: Raising the ISO enabled me to bump up the shutter speed enough to permit a blur-free handheld shot.

Fortunately, you don't encounter serious noise on either the J1 or V1 until you really crank up the ISO. In fact, you may even be able to get away with a fairly high ISO if you keep your print or display size small. Some people probably wouldn't even notice the noise in the left image in Figure 7-6 unless they were looking for it, for example. But as with other image defects, noise becomes more apparent as you enlarge the photo, as shown on the right in that same figure. Noise is also easier to spot in shadow areas of your picture and in large areas of solid color.

How much noise is acceptable — therefore how high an ISO is safe — is a personal choice. Even a little noise isn't acceptable for pictures that require the highest quality, such as images for a product catalog or a travel shot that you want to blow up to poster size.

It's also important to know that a high ISO isn't the only cause of noise: A long exposure time (slow shutter speed) can also produce the defect. So how high you can raise the ISO before the image gets ugly varies depending on shutter speed. I can pretty much guarantee, though, that your pictures will exhibit visible noise at the camera's highest ISO setting, which produces sensitivity equivalent to ISO 6400. In fact, that's why Nikon gave this setting its special label, Hi 1 — it's a way to let you know that you should use this setting only if the light is so bad that you have no other way to get the shot.

Doing the exposure balancing act

As you change any of the three exposure settings — aperture, shutter speed, and ISO — one or both of the others must also shift in order to maintain the same image brightness. Say that you're shooting a soccer game, for example, and you notice that although the overall exposure looks great, the players appear slightly blurry at your current shutter speed. If you raise the shutter speed, you have to compensate with either a larger aperture, to allow in more light during the shorter exposure, or a higher ISO setting, to make the camera more sensitive to the light — or both.

As the previous sections explain, changing these settings impacts your image in ways beyond exposure. As a quick reminder:

- Aperture affects depth of field, with a higher f-stop number producing a greater zone of sharp focus.
- ✓ Shutter speed affects whether motion of the subject or camera results in a blurry photo. A faster shutter "freezes" action and also helps safeguard against allover blur that can result from camera shake when you're handholding the camera.
- ✓ ISO affects the camera's sensitivity to light. A higher ISO makes the camera more responsive to light but also increases the chance of image noise.

So when you boost that shutter speed to capture your soccer subjects, you have to decide whether you prefer the shorter depth of field that comes with a larger aperture or the increased risk of noise that accompanies a higher ISO.

Everyone has a favorite approach to finding the right combination of aperture, shutter speed, and ISO, and you'll no doubt develop your own system as you become more practiced at using the advanced exposure modes. In the meantime, here's how I handle things:

- ✓ I always use the lowest possible ISO setting unless the lighting conditions are so poor that I can't use the aperture and shutter speed I want without raising the ISO.
- If my subject is moving (or might move, as with a squiggly toddler or antsy pet), I give shutter speed the next highest priority in my exposure decision. I might choose a fast shutter speed to ensure a blur-free photo or, on the flip side, select a slow shutter to blur that moving object intentionally, an effect that can create a heightened sense of motion.
- For images of non-moving subjects, I make aperture a priority over shutter speed, setting the aperture according to the depth of field I have in mind. For portraits, for example, I use the largest aperture (the lowest f-stop number, known as shooting *wide open*, in photographer-speak) so that I get a short depth of field, creating a soft background for my subject. For landscapes, I usually go the opposite direction, stopping down the aperture as much as possible to capture the subject at the greatest depth of field.

I know that keeping all this straight is a little overwhelming at first, but the more you work with your camera, the more the whole exposure equation will make sense to you. You can find tips for choosing exposure settings for specific types of pictures in Chapter 9; keep moving through this chapter for details on how to actually monitor and adjust aperture, shutter speed, and ISO settings on your camera.

Exploring the Advanced Exposure Modes

In the automatic modes described in Chapter 3 — Scene Auto Selector and Smart Photo Selector — you have very little control over exposure. You may be able to choose from one or two Flash modes, but that's it. To gain full control over exposure options, set the Mode dial to Still Image mode and then open the Shooting menu and set the Exposure Mode option to one of the four advanced Still Image modes, P, S, A, or M, as shown in Figure 7-8. You also need to shoot in these modes to use certain other features, such as manual white balancing, a color control that you can explore in Chapter 8.

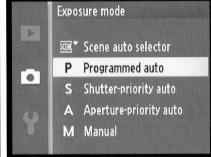

Figure 7-8: You can control exposure and certain other picture properties fully only in P, S, A, or M mode.

The major difference among the four advanced modes is the level of control over aperture and shutter speed, as follows:

- ✓ P (programmed autoexposure): In this mode, the camera selects both aperture and shutter speed. But you can choose from different combinations of the two for creative flexibility.
- ✓ **S (shutter-priority autoexposure):** In this mode, you select a shutter speed, and the camera chooses the aperture setting that produces a good exposure at your selected ISO setting.
- ✓ A (aperture-priority autoexposure): The opposite of shutter-priority autoexposure, this mode asks you to select the aperture setting. The camera then selects the appropriate shutter speed to properly expose the picture.
- ✓ M (manual exposure): In this mode, you specify both shutter speed and aperture.

To sum up, the first three modes are semi-automatic exposure modes that are designed to help you get a good exposure while still providing you with some photographic flexibility. You can even modify the autoexposure results by using features such as Exposure Compensation, explained later in this chapter. But it's important to note that in extreme lighting conditions, the camera may not be able to select settings that will produce a good exposure, and it doesn't stop you from taking a poorly exposed photo. Dim lighting may also cause the camera to select a very slow shutter speed in P and A modes, and the camera is perfectly happy to do so without giving you any warning, a hazard that can lead to blurry shots due to camera shake or movement of your subject.

Manual mode puts all exposure control in your hands. If you're a longtime photographer who comes from the days when manual exposure was the only game in town, you may prefer to stick with this mode. (If it ain't broke, don't fix it, as they say.) And in some ways, manual mode is simpler than the semi-auto modes because if you're not happy with the exposure, you just change the aperture, shutter speed, or ISO setting and shoot again. You don't have to fiddle with features that enable you to modify your autoexposure results — although again, the lighting conditions determine whether a good exposure is possible at any combination of settings.

My own personal choice is to use aperture-priority autoexposure when I'm shooting still subjects and want to control depth of field — aperture is my *priority* — and to switch to shutter-priority autoexposure when I'm shooting a moving subject and so I'm most concerned with controlling shutter speed. Frankly, my brain is taxed enough by all the other issues involved in taking pictures — what my White Balance setting is, what resolution I need, where I'm going for lunch as soon as I get this shot — that I just appreciate having the camera do some of the work.

However, when I know exactly what aperture and shutter speed I want to use, or I'm after an out-of-the-ordinary exposure, I use manual exposure. For example, sometimes when I'm doing a still life in my studio, I want to create a certain mood by underexposing a subject or even shooting it in silhouette. The camera is always going to fight you on that result in the P, S, and A modes because it so dearly wants to provide a good exposure. Rather than dialing in all the autoexposure tweaks that could eventually force the result I want, I simply set the mode to M, adjust the shutter speed and aperture directly, and give the autoexposure system the afternoon off.

But even in manual mode, you're never really flying without a net because the camera assists you by displaying the exposure meter, explained next.

Reading the Exposure Meter

To help you determine whether your exposure settings are on cue in M (manual) exposure mode, the camera displays an *exposure meter*. On the J1, the meter appears in vertical orientation on the right side of the display, as shown on the left in Figure 7-9. On the V1, the meter appears in horizontal orientation at the bottom of the display, as shown on the right in the figure.

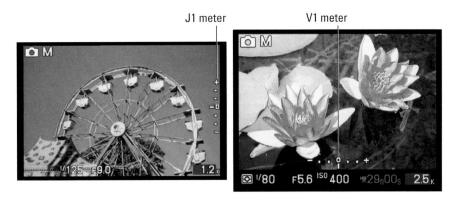

Figure 7-9: In M exposure mode, the exposure meter appears in the display.

Figure 7-10 offers a close-up illustration of the meter. The minus-sign end of the meter represents underexposure; the plus sign, overexposure. So if the little notches on the meter fall to the left of 0 on the V1, as shown in the first example in Figure 7-10, or, on the J1, below the 0, the image will be underexposed. If the indicator moves to the right of 0, as shown in the second example (or above the 0, on the J1), the image will be overexposed. The farther the indicator moves toward the plus or minus sign, the greater the potential problem. If you see a triangle at the end of the meter notches, the amount of over- or underexposure has exceeded the range of the meter. When the meter shows a balanced exposure, as in the third example, you're good to go.

In the P, S, and A exposure modes, you don't see a meter but instead see the word Lo or Hi if the camera anticipates an exposure problem. The Lo/Hi warning takes the place of the shutter speed or aperture, depending on which exposure mode you're using. For example, in shutter-priority auto-exposure, the warning appears in the space usually taken by the f-stop, as shown in Figure 7-11.

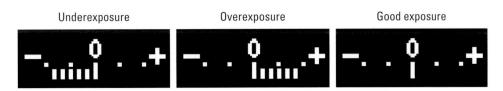

Figure 7-10: The meter indicates whether your exposure settings are on target.

What's a stop?

In photography, the term *stop* refers to an increment of exposure. To increase exposure by one stop means to adjust the aperture or shutter speed to allow twice as much light into

the camera as the current settings permit. To reduce exposure a stop, you use settings that allow half as much light. Doubling or halving the ISO value also adjusts exposure by one stop.

One word of caution: You're not likely to see this warning in aperture-priority autoexposure or program autoexposure mode because the camera has such a wide range of shutter speeds from which to choose. That's usually not a problem at the high end of the shutter-speed range — there's no downside to a faster exposure. But on the slow end of the range, the camera may choose a shutter speed as slow as 30 seconds, and it won't warn you when the speed falls below what you can handhold or what can freeze a moving subject. Long story short: Even if you're working in A or P mode. you still have to keep an eye on the shutter speed.

Exposure warning

Figure 7-11: In P, S, and A modes, the camera warns of exposure problems by displaying the word Lo (underexposure) or Hi (overexposure).

Also keep in mind that the camera's suggestion on exposure may not always be the one you want to follow. For example, you may want to shoot a backlit subject in silhouette, in which case you *want* that subject to be underexposed. In other words, the meter and the Hi/Lo warnings are guides, not dictators. In addition, remember that the exposure information the camera reports is based on the *exposure metering mode*, which determines which part of the frame the camera considers when calculating exposure. At the default setting, exposure is based on the entire frame, but you can select two other metering modes. See the upcoming section "Choosing an Exposure Metering Mode" for details.

Setting Aperture, Shutter Speed, and 150

The next sections detail how to view and adjust these three critical exposure settings as well as how to switch from the mechanical to electronic shutter on the V1. Remember, to control aperture (f-stop), shutter speed, and ISO, you

must switch to one of the four advanced Still Image exposure modes (P, S, A, or M), which you select via the Exposure Mode option on the Shooting menu.

Choosing a shutter type (mechanical or electronic)

By default, the mechanical shutter is engaged on the V1, but you have the option of switching to an electronic shutter. Doing so has a couple advantages: The top shutter speed leaps to 1/16000 second, versus 1/4000 second for the mechanical shutter. Will you ever shoot anything that requires a shutter speed faster than 1/4000? Well, it's unlikely, but it's nice to know you have the option to go beyond 1/4000 if the occasion ever arises. The other benefit of the electronic shutter is that you can disable the sound of the shutter (via the Sound Settings option on the Setup menu), which means you can be a "silent shooter" in settings where even a little noise may be disruptive.

Using the electronic shutter does have a significant downside, however: It limits the fastest shutter speed for flash photography to 1/60 second, versus 1/250 second when you use the mechanical shutter. At the slower shutter speed, you may overexpose the image when you use flash outdoors during daylight. (See the upcoming discussion on fill-flash photography for information about why you may want to use flash in that situation.)

For this reason, I recommend that you stick with the mechanical shutter unless you encounter a situation that specifically calls for the extra high-speed shutter or silent camera operation.

To choose the shutter type, you can go one of two routes:

- Feature button: Make sure that the Mode dial is set to Still Image (the little green camera symbol) and then press the Feature button to display the selection screen, as shown in Figure 7-12. Choose Mechanical or Electronic and press OK. The third option, Electronic (Hi), is a shutter-release mode that you can read about in Chapter 2.
- Shooting menu: You can access the same three settings shown in Figure 7-12 via the Shutter Type option on the Shooting menu.

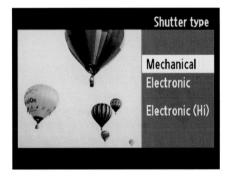

Figure 7-12: In Still Image mode, press the Feature button to access V1 shutter-type options quickly.

Adjusting aperture and shutter speed

You can view the current aperture (f-stop) and shutter speed in the display, as shown in Figure 7-13. The figure features the V1 display; on the J1, the two

values appear in the same spot but directly on the live image instead of on a black bar.

When the shutter speed slows to one second or more, quote marks appear after the number — 1" indicates a shutter speed of one second, 4" means four seconds, and so on.

To select aperture and shutter speed, start by pressing the shutter button half-way to kick the exposure system into gear. You can then release the button if you want. The next step depends on the exposure mode, as follows:

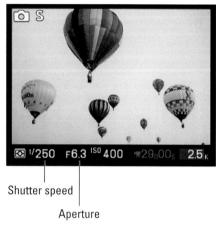

Figure 7-13: Look for the current f-stop and shutter speed here.

P (programmed autoexposure):

In this mode, the camera shows you its recommended f-stop and shutter speed when you press the shutter button halfway. But you can press the Zoom lever up and down to view different combinations of settings. The number of possible combinations depends upon the aperture settings the camera can select, which depends on your lens, as well as on the available light.

An asterisk (*) appears next to the P exposure mode symbol in the upper-left corner of the display if you press the Zoom lever to adjust the aperture/shutter speed settings. To get back to the initial combo of shutter speed and aperture, press the lever until the asterisk disappears.

- ✓ S (shutter-priority autoexposure): In this mode, you select the shutter speed. Just press the Zoom lever up for a faster shutter speed or press down for a slower speed. The camera automatically adjusts the aperture as needed to maintain proper exposure. Remember that as the aperture shifts, so does depth of field so even though you're working in shutter-priority mode, keep an eye on the f-stop, too, if depth of field is important to your photo. Also note that in extreme lighting conditions, the camera may not be able to adjust the aperture enough to produce a good exposure at your current shutter speed (again, possible aperture settings depend on your lens). If that occurs, you see the word Hi or Lo in place of the f-stop setting. The upshot is that you may need to compromise on shutter speed or ISO.
- ✓ A (aperture-priority autoexposure): In this mode, you control aperture, and the camera adjusts shutter speed automatically. To raise the f-stop to a higher number, press the Zoom lever up; to lower it, press down.

When you raise the f-stop value, be careful that the shutter speed doesn't drop so low that you risk camera shake if you handhold the camera. And if your scene contains moving objects, make sure that the shutter speed that the camera selects is fast enough to stop action (or

slow enough to blur it, if that's your creative goal). These same warnings apply when you use P mode.

- M (manual exposure): In this mode, you select both aperture and shutter speed, like so:
 - To adjust shutter speed: Press the Zoom lever up for a faster shutter speed, press down for a slower speed.

Go one notch past the slowest speed (30 seconds) to access the Bulb setting, which keeps the shutter open as long as the shutter button is pressed, up to a two-minute exposure. Be sure to set the shutter-release mode to Single Frame, as discussed in Chapter 2, for bulb shooting. If you attach the optional ML-L3 remote, you also see a Time shutter-speed setting. At this setting, you press the remote's shutter button once to begin the exposure and a second time to end it; maximum exposure time is two minutes. For this feature, choose one of the remote-control shutter-release options covered in Chapter 2.

• *To adjust aperture:* Rotate the Multi Selector. Rotate to the right to raise the f-stop number; rotate left to lower it.

Keep in mind that when you use P, S, or A mode, the settings that the camera selects are based on what it thinks is the proper exposure. If you don't agree with the camera, you can switch to manual exposure mode and dial in the aperture and shutter speed that deliver the exposure you want — or, if you want to stay in P, S, or A mode, you can tweak exposure using the features explained in the section "Sorting through Your Camera's Exposure-Correction Tools," later in this chapter.

When you view the f-stop and shutter speed display, by the way, remember that the camera continues to meter and, in P, S, and A modes, to adjust exposure up to the time you take the shot. (The exception is when you use the autoexposure lock feature, explained later in this chapter.) So if you frame the shot and then move the camera to better see the display, the exposure settings no longer reflect the ones the camera chose for your subject — instead, they show the settings for whatever is now in front of the lens. And if you (like most people) hold the camera with the lens pointing down to view the monitor, the camera begins calculating the correct settings to use to photograph the ground.

Controlling 150

The ISO setting, introduced at the start of this chapter, adjusts the camera's sensitivity to light. At a higher ISO, you can use a faster shutter speed or a smaller aperture (higher f-stop number) because less light is needed to expose the image. But remember that a higher ISO also increases the possibility of noise, as illustrated in Figure 7-6. (Be sure to check out the upcoming sidebar "Dampening noise" for features that may help calm noise somewhat.)

To adjust ISO, first set the exposure mode to P, S, A, or M — you can control the setting only in those modes. Then open the Shooting menu and select ISO Sensitivity, as shown on the left in Figure 7-14. Press OK to display the list of options, as shown on the right in the figure.

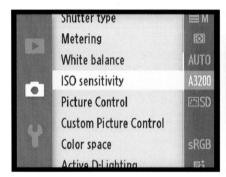

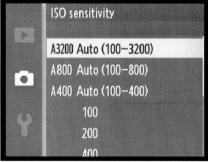

Figure 7-14: Adjust ISO through the Shooting menu.

In addition to choosing specific ISO values ranging from 100 to Hi 1, which is equivalent to ISO 6400, you can select one of three Auto ISO modes. In these modes, the camera adjusts ISO automatically as needed to properly expose the picture at the current f-stop and shutter speed. The Auto setting you choose determines how high the camera can raise the ISO; at the A400 Auto setting, for example, the top ISO setting the camera will select is ISO 400. These settings enable you to let the camera do some of the exposure work for you but still control the top ISO — thus, the amount of noise — that you're willing to accept.

On the V1, you can view the current ISO Setting at the bottom center of the display, as shown in Figure 7-15. On the J1, the data appears at the same place, but you must use the Detailed display mode to view it (press the Disp button to change the display mode). On both cameras, you see ISO-A along with the value, as in the figure, when one of the three automatic ISO settings is selected. For example, in the figure, the A800 Auto ISO option is enabled, meaning that the camera may raise the ISO as high as 800 if necessary. (You won't be able Figure 7-15: The current ISO Sensitivity setto tell what ISO the camera actually selected until you view the ISO value

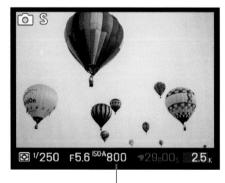

ISO Sensitivity setting

ting appears here.

during playback. See Chapter 5 to find out how.)

Dampening noise

High ISO settings can result in *noise*, the digital defect that gives your pictures a speckled look. (Refer to Figure 7-6.) Long exposure times (slow shutter speeds) also create a noise potential. To help solve these problems, your camera offers two noise-removal filters: *Long Exposure Noise Reduction*, which dampens the type of noise that occurs during long exposures; and *High ISO Noise Reduction*, designed to reduce the appearance of ISO-related noise. When the camera is set to Still Image mode, you can enable both filters through the Shooting menu, as shown in the figure below. In the other shooting modes — Smart Photo Selector, Movie, and Motion Snapshot — you can access High ISO Noise Reduction only.

If you turn on Long Exposure Noise Reduction (it's disabled by default), the camera applies the filter to pictures taken at shutter speeds of longer than one second. When you turn on High ISO Noise Reduction, the camera applies noise removal to all photos; this setting is the default. If you turn the feature off, the camera actually still applies a tiny amount of noise removal, but only at high ISO settings.

Before you enable noise reduction, be aware that doing so has a few disadvantages. First, the filters are applied after you take the picture, as the camera processes the image data. While the Long Exposure Noise Reduction filter is being applied, a warning message appears in the display reminding you of that fact, and you can't take another picture until the noise-removal job is done. The time needed to apply this filter can significantly slow down your shooting speed — in fact, it can double the time the camera needs to record the file to the memory card.

Second, although filters that go after long-exposure noise work fairly well, those that attack high ISO noise work primarily by applying a slight blur to the image. Don't expect this process to totally eliminate noise; do expect some softness in the resulting image. You may be able to get better results by using the blur tools or noise-removal filters found in many photo editors because you can blur just the parts of the image where noise is most noticeable — usually in areas of flat color or little detail, such as skies.

	Color space	SKOR
68	Active D-Lighting	19 <u>5</u>
	Long exposure NR	OFF
	High ISO noise reduction	ON
	Movie sound options	
	Interval timer shooting	
	Vibration reduction	ACTIVE
	AF-area mode	[]

	Color space	skoR
	Active D-Lighting	E i
	Long exposure NR	0FF
	High ISO noise reduction	ON
	Movie sound options	
	Interval timer shooting	
	Vibration reduction	ACTIVE
	AF-area mode	[1

Choosing an Exposure Metering Mode

To fully interpret what your exposure meter tells you, you need to know which *metering mode* is active. The metering mode determines which part of the frame the camera analyzes to calculate the proper exposure. The metering mode affects the exposure-meter reading as well as the exposure settings that the camera chooses when you use autoexposure modes.

Your camera offers three metering modes, described in the following list and represented by the icons you see in the margins:

Matrix: This setting is the default. The camera analyzes the entire frame and then selects an exposure that's designed to produce a balanced exposure.

Center-weighted: The camera bases exposure on the entire frame but puts extra emphasis — or weight — on the center of the frame.

- ✓ **Spot:** In this mode, the camera bases exposure entirely on a circular area that's about 2mm in diameter. The exact location used for this pinpoint metering depends on an autofocusing option called the AF-Area mode. Detailed in Chapter 8, this option determines which of the camera's focus points the autofocusing system uses to establish focus. Here's how the setting affects exposure:
 - If you choose the Auto Area mode, in which the camera chooses the focus point for you, exposure is based on the center focus point. The exception is when you also have Face-priority AF enabled; in that case, the camera bases exposure on the focus point nearest to the center of the face that's selected for focusing.
 - If you use the Single Point or Subject Tracking AF-Area mode, which enables you to select a specific focus point, the camera bases exposure on that point.

Because of this autofocus/autoexposure relationship, it's best to switch to an AF-Area mode that allows focus-point selection when you want to use spot metering. In the Auto Area mode, exposure may be incorrect if you compose your shot so that the subject isn't at the center of the frame or the camera can't detect a face (as is usually the case unless your subject is looking directly at the camera).

As an example of how metering mode affects exposure, Figure 7-16 shows the same image captured at each mode. In the matrix example, the bright background caused the camera to select an exposure that left the statue quite dark. Switching to center-weighted metering helped somewhat, but didn't quite bring the statue out of the shadows. Spot metering produced the best result as far as the statue goes, although the resulting increase in exposure left the sky a little washed out.

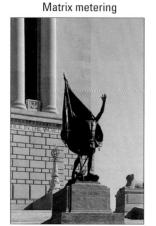

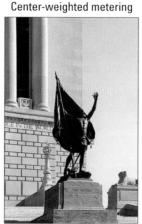

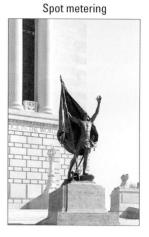

Figure 7-16: The metering mode determines which area of the frame the camera considers when calculating exposure.

As with most other exposure controls, you can change the metering mode only in the P, S, A, and M exposure modes. Make your selection via the Metering option on the Shooting menu, as shown in Figure 7-17. The icon in the lower-left corner of the display reflects your choice, as shown in Figure 7-18. The figure features the V1 display. On the J1, the metering icon is in the same general area but appears only in Detailed display mode. (Press the Disp button to change the display mode.)

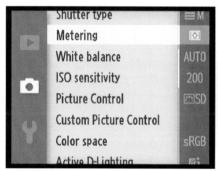

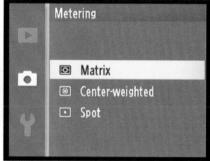

Figure 7-17: Adjust the metering mode via the Shooting menu.

In theory, the best practice is to check the metering mode before you shoot and choose the one that best matches your exposure goals. But in practice, that's a bit of a pain, not just in terms of having to adjust yet one more capture setting but in terms of having to remember to adjust one more capture setting. So here's my advice: Until you're really comfortable with all the other controls on your camera, just stick with the default setting, which is matrix metering. That mode produces good results in most situations, and after all, you can see in the monitor whether you disagree with how the camera metered or exposed the image

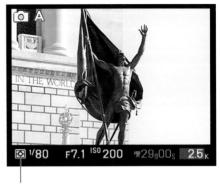

Metering mode symbol

Figure 7-18: A symbol representing the current metering mode appears here.

and simply reshoot after adjusting the exposure settings to your liking. This option, in my mind, makes the whole metering mode issue a lot less critical than it is when you shoot with film.

The one exception to this advice might be when you're shooting a series of images in which a significant contrast in lighting exists between subject and background, as in Figure 7-16. Then switching to center-weighted metering or spot metering may save you the time of having to adjust the exposure for each image.

Sorting Through Your Camera's Exposure-Correction Tools

In addition to the normal controls over aperture, shutter speed, and ISO, your camera offers a few tools that enable you to solve tricky exposure problems. The next several sections give you the lowdown on these features.

Applying Exposure Compensation

When you set your camera to the P, S, or A mode, you can enjoy autoexposure support but still retain some control over the final exposure. If you think that the image the camera produced is too dark or too light, you can use *Exposure Compensation*. This feature enables you to tell the camera to produce a darker or lighter exposure than what its autoexposure mechanism thinks is appropriate.

Here's what you need to know to take advantage of it:

- ✓ Exposure Compensation settings are stated in terms of EV numbers, as in EV +2.0. Possible values range from EV +3.0 to EV -3.0. (EV stands for exposure value.)
 - Each full number on the EV scale represents an exposure shift of one *stop*. If you're new to this terminology, see the sidebar "What's a *stop?*"
- ✓ A setting of EV 0.0 results in no exposure adjustment.
- ✓ For a brighter image, raise the Exposure Compensation value. The higher you go, the brighter the image becomes.
- For a darker image, lower the EV.

As an example, take a look at the first image in Figure 7-19. The initial exposure selected by the camera left the balloon a tad too dark for my taste. So I just amped the Exposure Compensation setting to EV \pm 1.0, which produced the brighter exposure on the right.

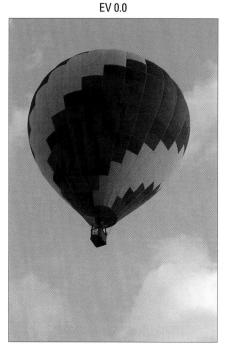

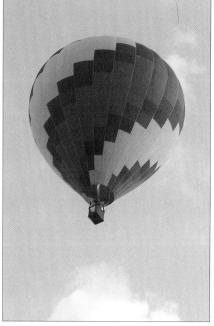

Figure 7-19: For a brighter exposure, raise the Exposure Compensation value.

To change the setting, press the Multi Selector right. In other words, press the button marked with the little plus/ minus sign. An Exposure Compensation scale then appears on the right side of the display, as shown in Figure 7-20. Press the Multi Selector up to raise the value, press down to lower it. For example, in the right image in the figure, Lset the value to +1.0. Press OK to finalize the setting and return to shooting. Immediately, the display shows you the result of the adjustment — a neat feature of the Nikon 1 cameras. If you went too far — or not far enough — just repeat the process. To disable Exposure Compensation, set the value back to 0.

When Exposure Compensation is in force, you see the value at the bottom of the image display. On the V1, the value appears in the center of the display, as shown in Figure 7-21. On the J1, the value appears in the lower-right corner, just above the shots remaining value.

In P, S, and A exposure modes, your Exposure Compensation setting remains in force until you change it, even if you power off the camera. So you may want to make a habit of checking the setting before each shoot — or always setting the value back to EV 0.0 after taking the last shot for which you want to apply compensation.

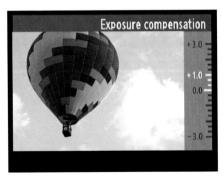

Figure 7-20: Press the Multi Selector right to access the Exposure Compensation setting; then press up or down to adjust the setting.

Exposure Compensation amount

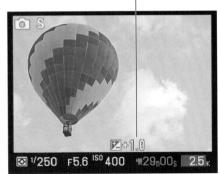

Figure 7-21: The Exposure Compensation value appears only when you select a setting other than 0.

Just a couple other tips on this feature:

- How the camera arrives at the brighter or darker image you request through your Exposure Compensation setting depends on the exposure mode:
 - *In A (aperture-priority autoexposure) mode*, the camera adjusts the shutter speed but leaves your selected f-stop in force. Be sure

to check the resulting shutter speed to make sure it isn't so slow that you have problems with camera shake or blur from moving objects.

- In S (shutter-priority autoexposure) mode, the camera opens or stops down the aperture.
- *In P (programmed autoexposure) mode*, the camera decides whether to adjust aperture, shutter speed, or both.
- In all three modes, the camera may also (or instead) adjust ISO if you have one of the three Auto ISO settings enabled.

Keep in mind that the camera can adjust f-stop only so much, according to the aperture range of your lens. And the range of shutter speeds, too, is limited by the camera itself. So if you reach the ends of those ranges, you either have to compromise on shutter speed or aperture or adjust ISO.

If you don't want to fiddle with Exposure Compensation, just switch to manual exposure mode and select whatever aperture, shutter-speed, and ISO settings produce the exposure you're after.

Using autoexposure lock

To help ensure a proper exposure, your camera continually meters the light until the moment you depress the shutter button fully. In autoexposure modes, it also keeps adjusting exposure settings as needed to maintain a good exposure.

For most situations, this approach works great, resulting in the right settings for the light that's striking your subject at the moment you capture the image. But on occasion, you may want to lock in a certain combination of exposure settings. For example, perhaps you want your subject to appear at the far edge of the frame. If you were to use the normal shooting technique, you'd place the subject under a focus point, press the shutter button halfway to lock focus and set the initial exposure, and then reframe to your desired composition to take the shot. The problem is that exposure is then recalculated, based on the new framing — which can leave your subject under- or overexposed.

The easiest way to lock in exposure settings is to switch to M (manual) exposure mode and use the f-stop, shutter speed, and ISO settings that work best for your subject. But if you prefer to stay with P, S, or A mode, you can press the AE-L/AF-L button to lock exposure before you reframe. This feature is known as *autoexposure lock*, or AE Lock for short.

Here's the technique I recommend for using AE Lock:

1. Set the metering mode to spot metering.

Select the option via the Metering option on the Shooting menu.

2. If autofocusing, set the Focus mode to AF-S and the AF-Area mode to Single Point.

On the V1, access the Focus mode setting by pressing the Multi Selector down (the button is labeled AF). On the J1, adjust the setting via the Shooting menu. On both cameras, change the AF-Area mode setting via the Shooting menu.

3. Select the center focus point.

The little white rectangle on the screen reflects the focus point. If the point isn't in the center of the screen, press OK and then use the Multi Selector to move the point. Press OK again to finish.

In spot-metering mode, the focus point determines the area used to calculate exposure, so this step is critical whether you use autofocusing or manual focusing.

4. Frame your subject so that it's under the center focus point.

If you're focusing manually, go ahead and set focus now; Chapter 8 explains how to do it.

5. Press and hold the shutter button halfway down.

The camera sets the initial exposure settings. If you're using autofocusing, focus is also set at this point.

6. Press and hold the Multi Selector up (it's the button labeled AE-L/AF-L).

While the button is pressed, the letters AE-L appear in the display to remind you that exposure lock is applied. On the V1, the letters appear just to the right of the f-stop; on the J1, they appear to the left of the shutter speed.

7. Reframe the shot as desired and take the photo.

Be sure to keep holding the AE-L/AF-L button until you release the shutter button! And if you want to use the same focus and exposure settings for your next shot, just keep the AE-L/AF-L button pressed.

By default, the AE-L/AF-L button locks both focus and exposure; see Chapter 11 to find out how to modify this setting so that it locks only one or the other.

Expanding tonal range with Active D-Lighting

A scene like the one in Figure 7-22 presents the classic photographer's challenge: Choosing exposure settings that capture the darkest parts of the subject appropriately causes the brightest areas to be overexposed. And if

you instead *expose for the highlights* — that is, set the exposure settings to capture the brightest regions properly — the darker areas are underexposed.

In the past, you had to choose between favoring the highlights or the shadows. But with the Nikon 1, you can expand the possible *tonal range* — that's photo-speak for the range of brightness values in an image — through Active D-Lighting. This teature is designed to give you a better chance of keeping your highlights intact while better exposing the darkest areas.

The *D* in Active D-Lighting is a reference to the term *dynamic range*, which is used to describe the range of brightness values that an imaging device can capture. By turning on this feature, you enable to camera to produce an image with a slightly greater dynamic range than usual.

In my seal scene, turning on Active D-Lighting produced a brighter rendition of the darkest parts of the rocks and the seals, for example, and yet the color in the sky didn't get blown out as it did when I captured the image with Active D-Lighting turned off. The highlights in the seal and in the rocks on the lower-right corner of the image also are toned down a tad in the Active D-Lighting version.

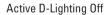

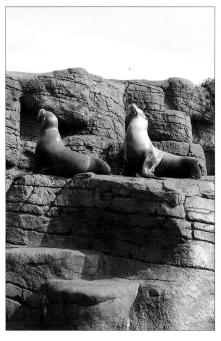

Active D-Lighting On

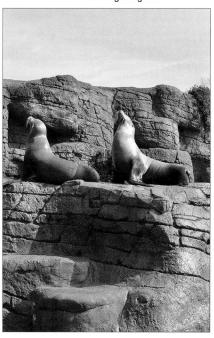

Figure 7-22: Active D-Lighting captured the shadows without blowing out the highlights.

Active D-Lighting actually does its thing in two stages. First, it selects exposure settings that result in a slightly darker exposure than normal. This half of the equation guarantees that you retain details in your highlights. After you snap the photo, the camera brightens the darkest areas of the image. This adjustment rescues shadow detail.

Active D-Lighting is enabled by default; in Scene Auto Selector mode, you can't change the setting. But in the P, S, A, and M modes, you can turn the feature on and off via the Shooting menu, as shown in Figure 7-23. When the feature is enabled, you see the icon labeled in Figure 7-24 at the top of the screen, but only if you use Detailed display mode. (Again, press the Disp button to cycle through the available display modes.)

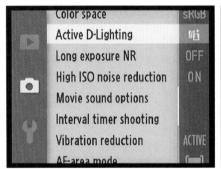

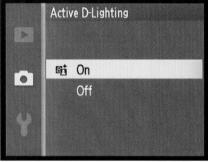

Figure 7-23: Enable or disable Active D-Lighting through the Shooting menu.

A couple of pointers:

- You get the best Active D-Lighting results in matrix metering mode.
- In the M exposure mode, the camera doesn't change your shutter speed or f-stop to achieve the darker exposure it needs for Active D-Lighting to work; instead, the meter readout guides you to select the right settings unless you've enabled automatic ISO override. In that case, the camera may adjust ISO instead to manipulate the exposure.

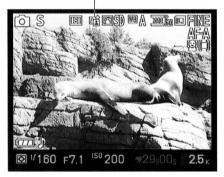

Figure 7-24: This symbol tells you that Active D-Lighting is turned on

If you opt out of Active D-Lighting, remember that the Playback menu offers a D-Lighting filter that applies a similar adjustment to existing pictures. (See Chapter 11 for help.) Some

photo-editing programs, including Nikon ViewNX 2, also have good shadow and highlight recovery filters. (In ViewNX 2, investigate the D-Lighting HS, Shadow Protection, and Highlight Protection filters; the program's Help system explains how to use them.) In any case, when you shoot with Active D-Lighting disabled, you're better off setting the initial exposure settings to record the highlights as you want them. It's very difficult to bring back lost highlight detail after the fact, but typically you can unearth at least a little bit of detail from the darkest areas of the image.

Investigating Advanced Flash Options

Sometimes, no amount of fiddling with aperture, shutter speed, and ISO produces a bright-enough exposure — in which case, you simply have to add more light. On the J1, the built-in flash offers the most convenient solution; just slide the Flash button on the back of the camera to raise the flash. The V1 has no built-in flash, but you can attach the optional SB-N5 flash unit to the camera for extra lighting. (Chapter 1 gives you a primer on using that flash.)

How much flash control you have depends on your exposure mode. Flash is off limits when you use Smart Photo Selector, Motion Snapshot, or Movie mode. In Scene Auto Selector mode, you have access to two flash modes, Fill Flash and Red-Eye Reduction mode, but that's it. In P, S, A, and M modes, you not only can choose from additional flash modes but can also adjust the amount of light the flash emits.

Chapter 3 offers assistance with using the flash in Scene Auto Selector mode; the rest of this chapter digs into features available in the advanced exposure modes. Like everything else on Nikon 1 cameras, those features range from fairly simple to fairly not. Unfortunately, to keep this book from being exorbitantly large (and expensive), I can cover only the basics here. So here are two of my favorite resources for delving more deeply into flash photography:

- Nikon's United States website (www.nikonusa.com) offers some great tutorials on flash photography (as well as other subjects). Start in the Learn & Explore section of the site.
- ✓ A website completely dedicated to flash photography, www.strobist. com, enables you to learn from and share with other photographers.

In addition, Chapter 9 of this book offers flash and lighting tips related to portraits and other specific types of photographs.

Choosing the right Flash mode

Chapter 3 details the art of setting the Flash mode, but here's a quick repeat so that you don't have to go flipping back to that chapter. First, remember

that you can view the current mode in the display, in the areas labeled in Figure 7-25. The symbol shown in the figures represents the Fill Flash mode, described next

Figure 7-25: The current Flash mode appears in the Shooting Info display.

How you set the Flash mode depends on which Nikon 1 camera you use:

- ✓ **J1:** Press the Multi Selector down (the button face wears a flash symbol) to display the mode selection screen, shown in Figure 7-26. Highlight your choice and press OK.
- ✓ V1: Change the setting via the Flash Mode option on the Shooting menu, shown in Figure 7-27. Note that this option appears on the menu only when the SB-N5 flash is attached and turned on.

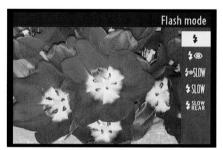

Figure 7-26: On the J1, press the Multi Selector down to access the Flash mode setting.

In either case, the Flash mode options that appear depend on your exposure mode.

For P, S, A, and M exposure modes, your Flash mode choices break down into three basic categories, described in the next sections: Fill Flash; Red-Eye Reduction; and the sync modes, Slow-Sync and Rear-Sync, which are special-purpose flash options.

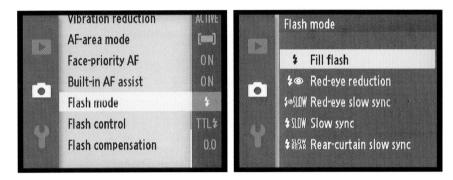

Figure 7-27: On the V1, the Flash Mode option appears on the Shooting menu if the optional SB-N5 flash is attached and turned on.

Fill Flash

The Fill Flash setting is represented by the plain-old lightning-bolt symbol you see in the margin here. You can think of this setting as "normal flash" — at least in the way that most people think of using a flash, which is to fill in shadows in a scene.

Although you may think of flash only as a nighttime or indoor lighting tool, it can often be beneficial to outdoor photos, even when the sun is bright. After all, your main light source — the sun — is overhead, so although the top of the subject may be adequately lit, the front typically needs some additional illumination. As an example, Figure 7-28 shows a floral image taken both with and without a flash. The small pop of light provided by the built-in flash is also extremely beneficial when shooting subjects that happen to be slightly shaded, such as the carousel horses featured in the "Adjusting flash output" section. For outdoor portraits, a flash is even more important; the section on shooting still portraits in Chapter 9 discusses that subject and offers a look at the difference a flash can make.

You do need to beware, however, of a couple complications with using flash in bright light:

Colors may need tweaking when you mix light sources. When you combine multiple light sources, such as flash with daylight, colors may appear warmer or cooler than neutral. In Figure 7-28, colors became warmer with the addition of flash. For outdoor portraits, the warming effect is usually flattering, and I usually like the result with nature shots as well. But if you prefer a neutral color rendition, see the Chapter 8 section related to the White Balance control to find out how to address this issue. You can adjust white balance only in P, S, A, and M exposure modes.

No Flash

Fill Flash

Figure 7-28: Adding flash resulted in better illumination and a slight warming effect.

- Consider shutter speed. Because of the way the camera needs to synchronize the firing of the flash with the opening of the shutter, you face some shutter speed limitations when you use flash, as follows:
 - The fastest shutter speed you can use with the J1 or with the V1 and the electronic shutter is 1/60 second. With the V1's mechanical shutter, the fastest shutter speed is 1/250 second.

At the relatively slow shutter speed of 1/60 — and even at 1/250 second, on occasion — you may need to stop down the aperture significantly or lower ISO, if possible, to avoid overexposing the image when shooting in bright light. As another option, you can place a *neutral-density filter* over your lens; this accessory reduces the light that comes through the lens without affecting colors. Of course, if possible, you can simply move your subject into the shade.

Remember, too, that a slow shutter speed also means trouble if you're shooting a moving subject.

• The slowest shutter speed depends on the exposure mode. In Scene Auto Selector mode, the camera may choose a shutter speed as

slow as 1 second. In S and M modes, you can choose a shutter speed as slow as 30 seconds to create what are known as *slow-sync effects*. (See the upcoming section "Slow-Sync and Rear-Sync flash" for examples.) If you use M mode with Bulb shutter speed, you can exceed even that slow limit. In P and A modes, the slowest possible shutter speed is 1/60 second in Fill Flash mode. However, you can use some special modes to achieve the slow-sync look — again, the aforementioned section tells all.

Of course, in S and M modes, you control the shutter speed, so you can be careful to choose one that's not so slow that it doesn't leave a moving subject blurry or leave you at risk of camera shake. But when you use the P and A modes, the camera takes the shutter speed's reins, so pay attention.

If you're paying attention to this text, by the way, it may have occurred to you that on the J1 (or V1, with electronic shutter), that if the top shutter speed is 1/60 second, and the slowest shutter speed in P and A modes is also 1/60 second, then shutter speed is pretty much locked at 1/60 second. Try adjusting the f-stop, and you won't see the shutter-speed change in response as you do when you're not using flash.

For close-ups, you may need to reduce flash power to avoid overexposing the subject. I find that at the default flash power, the built-in flash is almost always too strong. No worries — you can dial down the flash output with Flash Compensation, as explained later in this chapter.

Red-Eye Reduction flash

Red-eye is caused when flash light bounces off a subject's retinas and is reflected back to the camera lens. Red-eye is a human phenomenon, though; with animals, the reflected light usually glows yellow, white, or green, producing an image that looks like your pet is possessed by some demon.

Man or beast, this issue isn't nearly the problem with the type of pop-up flash found on the J1 or the accessory flash available for the V1. The flash units are positioned in such a way that the flash light usually doesn't hit a subject's eyes straight on, which lessens the chances of red-eye. However, red-eye may still be an issue when you use a lens with a long focal length (a telephoto lens) or you shoot subjects from a distance. Even then, the problem usually crops up only in dark settings — in outdoor shots and other brightly lit scenes, the pupils constrict in reaction to the light, lessening the chance of red-eye. And because of the bright light, the flash power needed to expose the picture is lessened, also helping eliminate red-eye.

If you do notice red-eye, you can try the Red-Eye Reduction mode, represented by the icon shown in the margin here. In this mode, the AF-assist lamp on the front of the camera lights up briefly before the flash fires. The subject's pupils constrict in response to the light, allowing less flash light to enter the eye and cause that glowing red reflection. Be sure to warn your subjects to wait for the flash, or they may step out of the frame or stop posing after they see the light from the AF-assist lamp.

All the tips and warnings about shutter speed that I presented for Fill Flash in the preceding section also apply to Red-Eye Reduction flash, by the way.

Slow-Sync and Rear-Sync flash

In Fill Flash and Red-Eye Reduction Flash modes, the flash and shutter are synchronized so that the flash fires at the exact moment the shutter opens.

Technical types refer to this flash arrangement as *front-curtain sync*, which refers to how the flash is synchronized with the opening of the shutter. Here's the deal: On cameras that use a traditional mechanical shutter design, the action of the shutter involves two curtains moving across the frame each time you press and release the shutter button. When you press the shutter button, the first curtain opens, allowing light through to the sensor. At the end of the exposure, the second curtain draws across the frame to once again shield the sensor from light. With front-curtain sync, the flash fires at the moment the front curtain opens.

Your camera also offers four special sync modes, which work as follows:

SLOW \$

✓ **Slow-Sync:** This mode, available only in the P and A exposure modes, also uses front-curtain sync but allows a shutter speed slower than the 1/60 second that's permissible when you use Fill Flash and Red-Eye Reduction flash.

The benefit of this longer exposure is that the camera has time to absorb more ambient light, which in turn has two effects: Background areas that are beyond the reach of the flash appear brighter; and less flash power is needed, resulting in softer lighting.

The downside of the slow shutter speed is, well, the slow shutter speed. As discussed earlier in this chapter, the longer the exposure time, the more you have to worry about blur caused by movement of your subject or your camera. A tripod is essential to a good outcome, as are subjects that can hold very, very still. I find that the best practical use for this mode is shooting nighttime still-life subjects like the one you see in Figure 7-29. However, if you're shooting a nighttime portrait and you have a subject that *can* maintain a motionless pose, slow-sync flash can produce softer, more flattering light.

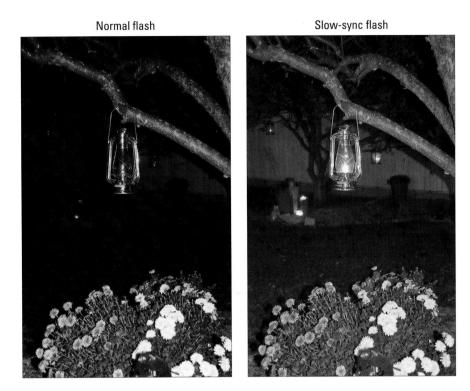

Figure 7-29: Slow-sync flash produces softer, more even lighting than normal flash in nighttime pictures.

Some photographers, on the other hand, turn the downside of slow-sync flash to an upside, using it to purposely blur their subjects. The idea is to use the blur to emphasize motion.

Note that even though the official Slow-Sync mode appears only in the P and A exposure modes, you can get the same result in the M and S modes by simply using a slow shutter speed and the normal, Fill Flash mode. You can use a shutter speed as slow as 30 seconds when using flash in those modes or, in Manual mode with a Bulb exposure, go even slower. In fact, I prefer those modes when I want the slow-sync look because I can directly control shutter speed.

Rear-Curtain Sync: In this mode, available only in shutter-priority auto-exposure (S) and manual (M) exposure modes, the flash fires at the very end of the exposure, just before the shutter closes. The classic use of this mode is to combine the flash with a slow shutter speed to create trailing-light effects like the one you see in Figure 7-30. With Rear-Curtain

Sync, the light trails extend behind the moving object (my hand and the match, in this case), which makes visual sense. If instead you use slow-sync flash, the light trails appear in front of the moving object.

On the V1, you can set the shutter speed as low as 30 seconds and as high as 1/250 second in this Flash mode. On the J1, possible shutter speeds range from 1/60 second to 30 seconds. You also can use a Bulb exposure in Manual mode to exceed the 30-second limit.

Rear-Curtain Slow-Sync: Hey, not confusing enough for you yet? This mode enables you to produce the same motion-trail effects as with Rear-Curtain Sync, but in the P and A exposure modes. The camera automatically chooses a

Figure 7-30: I used rear-curtain sync flash to create this candle-lighting image.

slower shutter speed than normal after you set the f-stop, just as with regular Slow-Sync mode.

Red-Eye Slow-Sync: In P and A exposure modes, you can also combine a slow-sync flash with the red-eye-reduction feature. Given the potential for blur that comes with a slow shutter, plus the potential for subjects to mistake the prelight from the AF-assist lamp for the real flash and walk out of the frame before the image is actually recorded, I vote this Flash mode as the most difficult to pull off successfully.

All these modes are somewhat tricky to use successfully, however. So have fun playing around, but at the same time, don't feel too bad if you don't have time right now to master these modes plus all the other exposure options presented to you in this chapter. In the meantime, search the web for slow-sync and rear-sync image examples if you want to get a better idea of the special effects that other photographers create with these Flash modes.

Adjusting flash output

When you shoot with flash, the camera attempts to adjust the flash output as needed to produce a good exposure. But if you shoot in the P, S, A, or M exposure modes and you want a little more or less flash light than the camera thinks is appropriate, you can adjust the flash output by using *Flash Compensation*.

This feature works just like Exposure Compensation, discussed earlier in the chapter, except that it enables you to override the camera's flash-power decision instead of its autoexposure decision. As with Exposure Compensation, the Flash Compensation settings are stated in terms of EV (exposure value) numbers. A setting of 0.0 indicates no flash adjustment; you can increase the flash power to EV +1.0 or decrease it to EV -3.0.

As an example of the benefit of this feature, look at the carousel images in Figure 7-31. The first image shows you a flash-free shot. Clearly, I needed a flash to compensate for the fact that the horses were shadowed by the roof of the carousel. But at normal flash power, as shown in the middle image, the flash was too strong, creating glare in some spots and blowing out the highlights in the white mane. By dialing the flash power down to EV –0.7, I got a softer flash that straddled the line perfectly between no flash and too much flash.

Flash EV 0.0

Flash EV -0.7

Figure 7-31: When normal flash output is too strong, dial in a lower Flash Compensation setting.

As for boosting the flash output, well, you may find it necessary on some occasions, but don't expect miracles, even at a Flash Compensation of +1.0. The built-in flash on the J1 has a flash range of only about 16 feet; light from the V1's SB-N5 flash reaches about 66 feet. In other words, don't even try taking flash pictures of a darkened recital hall from your seat in the balcony — all you'll wind up doing is annoying everyone.

To set the Flash Compensation amount, head for the Shooting menu, as shown in Figure 7-32. When compensation is set at any value but 0, you see a Flash Compensation symbol on the display, as shown in Figure 7-33. The figure shows the V1 display; on the J1, the symbol appears at the right edge of the display. Either way, don't confuse the setting with the Exposure Compensation setting, which appears nearby if that adjustment is enabled. The flash symbol in the Flash Compensation icon is the key reminder of which setting does what; see the earlier section "Applying Exposure Compensation" to get a look at that icon.

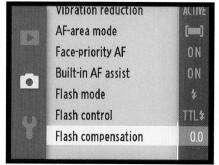

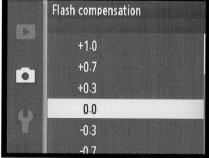

Figure 7-32: The Flash Compensation setting lives on the Shooting menu.

As with Exposure Compensation, any flash-power adjustment you make remains in force, even if you turn off the camera, until you reset the control. So be sure to check the setting before you next use your flash.

Controlling flash output manually

If you're experienced in the way of the flash, you can manually set the flash output on the V1 instead of letting the camera dictate the right amount of flash light. Open the Shooting menu,

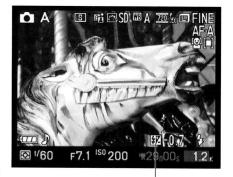

Flash Compensation symbol

Figure 7-33: When Flash Compensation is in effect, this symbol appears on the display.

select Flash Control, and press OK to screen shown on the left in Figure 7-34. Then choose Manual and press OK to reveal the possible flash-power settings, as shown on the right. Your options are from Full power to 1/32 power.

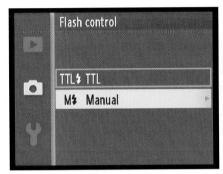

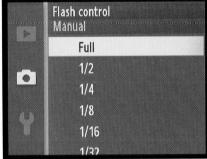

Figure 7-34: Through this option, you can control the flash output manually.

The TTL setting shown on the left in Figure 7-34 is the default flash setting, in which the camera sets the proper flash power for you. *TTL* stands for *through the lens*.

While manual flash control is enabled, an icon that looks like the Flash Compensation icon (a lightning bolt with a plus-minus sign) blinks in the display.

Manipulating Focus and Color

In This Chapter

- Adjusting the camera's autofocusing performance
- ▶ Perfecting your manual focusing technique
- Understanding focal lengths, depth of field, and other focus factors
- Exploring white balance and its effect on color
- Taking a quick tour of Picture Controls

o many people, the word *focus* has just one interpretation when applied to a photograph: Either the subject is in focus or it's blurry. And although it's true that this characteristic of your photographs is an important one, an artful photographer knows that there's more to focus than simply getting a sharp image of a subject. You also need to consider *depth* of *field*, or the distance over which sharp focus is maintained.

This chapter explains all the ways to control depth of field and also explains how to use your camera's advanced focusing options. Note, however, that the autofocusing features covered here relate to normal, Still Image mode photography; things work a little differently in Smart Photo Selector mode, covered in Chapter 3, and Movie and Motion Snapshot mode, both covered in Chapter 4. Also, this chapter concentrates on focusing with Nikon 1 lenses. If you attach another type of lens via the FT1 lens-mount adapter, please see the adapter's and lens' instruction sheets for information on what focusing features are available to you and what focusing techniques you need to use, as they vary depending on the lens.

Following the discussion, this chapter dives into the topic of color, explaining your camera's White Balance control, which compensates for the varying color casts created by different light sources. You also can get my take on another color feature, Picture Controls, in this chapter.

Mastering the Focusing System

Nikon 1 cameras offer a fast and trustworthy autofocusing system — you can rely on it for tack-sharp images 99 percent of the time, in my experience. But to get the best autofocusing performance, you need to understand how the system works so that you can choose the right settings for your subject.

You have three avenues of control over the autofocusing system:

- Face-priority AF (autofocus): This feature, when enabled, tells the camera to scan the frame for faces and, if it finds one, to base focus on that area automatically.
- ✓ AF-Area mode: This setting determines which focus points are used to establish focus when you use autofocusing. You can tell the camera to select the autofocus point for you or to base focus on a point that you select.
- Focus mode: You can set the camera to lock focus when you press the shutter button halfway or to adjust focus continually up to the moment you depress the button fully to take the picture. If you prefer, you can ask the camera to make the decision as to which option is best. Or you can disable autofocusing altogether and take advantage of manual focusing.

There's a hitch, however: You can control the AF-Area mode and Focus mode only in the P, S, A, and M exposure modes. You can turn Face-priority AF on or off in all modes. And again, if you aren't using a Nikon 1 lens — that is, you attached a different type of lens via the FT1 lens-mount adapter — all auto-focusing features and settings may not be available. Any features that aren't compatible with your lens simply don't show up in the menus or option-selection screens. (The rest of this chapter assumes that you're using a Nikon 1 lens.)

The next several sections provide the background you need to master these options and other aspects of the focusing system.

Autofocusing using the default settings

By default, the camera uses the Auto Area AF-Area mode and the AF-A Focus mode. Simply put, that means that the camera picks the autofocus point for you and decides whether to lock focus at the moment you press the shutter button halfway or to continually adjust focus until you take the picture. Additionally, Face-priority AF is enabled.

In case you're not ready to dig into the later sections that explain how and when you may want to modify these settings — or you haven't yet moved beyond Scene Auto Selector mode, which doesn't let you touch any setting

but the Face-priority AF option — the following steps show you how to focus using these defaults.

These steps apply to P, S, A, and M Still Image exposure modes as well as Scene Auto Selector mode, but not to pictures you take in Smart Photo Selector Mode, Movie mode, or Motion Snapshot mode. You need to use a specific focusing technique in those modes; see Chapters 3 and 4 for details.

1. Frame your subject in the display.

If the camera sees a face, it surrounds it with a yellow box to let you know that focus will be based on that area. In a group shot, as many as five detected faces get a box, and the box that has the little corner markings, as shown in Figure 8-1, indicates the face selected for focusing — the camera typically awards that honor to the closest person. Be aware that if your subject isn't directly facing the camera, the face-detection feature may not be successful.

Figure 8-1: The yellow box that has the corner markings indicates the face selected for focusing.

2. Press and hold the shutter button halfway down to initiate focusing.

Depending on the lighting conditions, the AF-assist lamp on the front of the camera may emit a beam to help the autofocus system find its target. (You can disable the light via the Built-in AF Assist option on the Shooting menu if you're shooting in a setting where it's problematic.)

With your half-press of the shutter button, the exposure metering system kicks into gear, and the shots remaining value in the viewfinder changes to show the number of frames that will fit in the camera's buffer. For more on exposure, travel to Chapter 7; information about the buffer awaits in Chapter 2.

With respect to autofocusing, one of two things happens:

- *If face detection was successful:* The selected face-detection box briefly turns green to let you know focus was set on the face, as shown on the left in Figure 8-2.
- *If no faces were found:* You see one or more green rectangles on the display, as shown on the right in Figure 8-2. The rectangles indicate the portion of the frame used to establish focus. Anything under

one of those green boxes should now be in focus. Note, though, that sometimes boxes don't light up for all objects that are in focus — so just know that anything that's the same distance from the camera as the objects that are marked will also be sharp.

Figure 8-2: Green indicates that focus has been successfully set on the selected face (left) or at the distance indicated by the rectangles (right).

If you're shooting a stationary subject, you also hear a tiny beep to indicate that focus has been achieved. For moving subjects, the been may not sound.

What happens next depends on whether you're shooting a still subject or a moving subject:

- For stationary subjects: Focus is now locked as long as you keep the shutter button depressed halfway. That means that you can reframe the picture if desired and still retain focus on the subject.
- For moving subjects: If the camera detects movement, it sets the initial focus point and then adjusts focus as needed if the subject moves out of the selected point.

If focusing is unsuccessful, the face-detection frame or focus boxes turn red instead of green. Try moving a bit further from your subject; exceeding the lens' close-focusing distance is a common cause of focus miscues. But some subjects are just hard for an autofocusing system to handle; reflective objects, subjects behind fences, and low-contrast scenes are just some troublesome subjects. See the section on manual focusing, later in this chapter, to take the focusing reins if the autofocus system hiccups.

Now that you understand how things work at the default settings, the next several sections explain how to modify the settings to best suit your subject.

Shutter speed and blurry photos

A poorly focused photo isn't always related to the issues discussed in this chapter. Any movement of the camera or subject can also cause blur. Both of these problems are related to shutter

speed. an exposure control that I cover in Chapter 7. Be sure to also visit Chapter 9, which provides some additional tips for capturing moving objects without blur.

Disabling Face-priority AF

Face detection is a cool feature, but after you're comfortable with focusing, having face-detection boxes pop up over the scene can be distracting. And there's no way to control which face the camera picks out in a group shot, so you may sometimes be forced to focus on a face that isn't your main interest. Additionally, sometimes the system sees faces where there aren't any — for example, if the leaves in a tree create a face-shaped pattern.

No worries: In P, S, A, and M exposure modes, you can disable the feature at any time. Just head for the Shooting menu and turn the Face-priority AF option off, as shown in Figure 8-3.

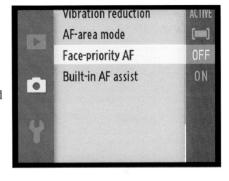

Figure 8-3: In the advanced exposure modes (P, S, A, and M), you can disable the face-detection feature.

Face-priority AF enabled

In Detailed display mode, you see a little face icon in the area labeled in Figure 8-4 when Face-priority AF is enabled in P, S, A, or M exposure mode. You don't see the icon in Scene Auto Selector mode even though the feature is enabled in that mode.

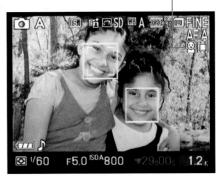

Figure 8-4: The little face symbol tells you that the Face-priority AF is enabled (but only in P, S, A, and M exposure modes).

Understanding the AF-Area mode setting

The AF-Area mode option determines which focusing points the camera uses to establish focus. (*AF* stands for *autofocus*.)

In P, S, A, and M exposure modes, you can choose from three settings via the AF-Area Mode option on the Shooting menu, as shown in Figure 8-5. If you enable Detailed display mode (press the Disp button until you get there), you can view an icon representing the current mode in the area labeled in Figure 8-6. (Note, though, that you lose control over this option if you use the Electronic (Hi) shutter release mode, covered in Chapter 2.)

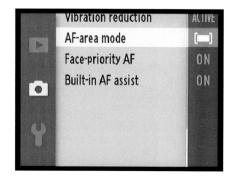

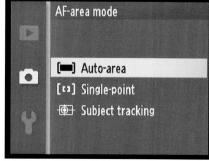

Figure 8-5: In P, S, A, and M exposure modes, you can select from three AF-Area modes.

Your choices are described in the following list and are represented in the display by the margin icons shown here:

✓ Auto Area: This setting is the default and makes use of 41 focus areas spread throughout the frame. The camera analyzes the objects under all 41 autofocus points and selects the one it deems most appropriate — usually the one that covers the object closest to the camera. When you press the shutter button halfway, green rectangles appear over the area (or areas) that were used to establish focus.

AF-Area mode symbol

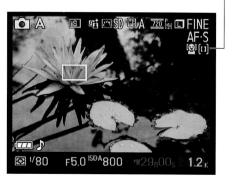

Figure 8-6: An icon representing the selected mode appears in Detailed display mode.

[(1)]

✓ **Single Point:** This mode enables you to select a specific focus point rather than relying on the camera to do it for you. And there's another benefit: Whereas Auto Area selects from 41 focus points, Single Point gives you 135 focus points from which to choose.

When you select this option, a white rectangle appears at the center of the display, as shown on the left in Figure 8-7. This rectangle represents the focusing point. To reposition it, press OK to display positioning arrows around the perimeter, as shown on the right in the figure. Use the Multi Selector to move the focus point over your subject and then press OK again to lock in that focus point and hide the positioning arrows. Press the shutter button halfway to initiate autofocusing; the focus point turns green when focus is achieved.

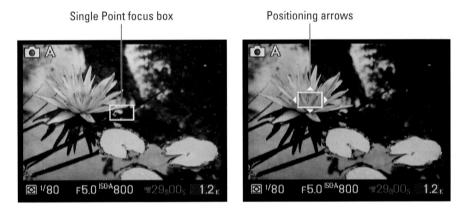

Figure 8-7: In Single Point mode, you see a single focus point (left); press OK to display positioning arrows and then move the point over your subject (right).

Subject Tracking: This option is designed to focus on moving subjects. Here's how it works: When you enable the option, you see a white focus box on the display, as shown on the left in Figure 8-8. Press OK; you then see the positioning arrows as with the Single Point focus option. Use the Multi Selector to move the box over your subject, as shown on the right in the figure, and press OK again. The focus box turns yellow, and the camera starts tracking your subject, with the box following the subject around the frame. When you press the shutter button halfway, focus will be set on the object under that box, and the box briefly turns green to let you know that focus is set. After you get the shot, press OK one more time to turn off tracking.

The only problem with Subject Tracking is that the way the camera detects your subject is by analyzing the colors of the object under your selected focus point. If not much difference exists between the subject

and other objects in the frame, the camera can get fooled. And if your subject moves out of the frame, you must release the shutter button, reframe and reset focus again. According to the Nikon manual, the feature also has problems with subjects that are too large, too small, too bright, too dark . . . you get the idea. When it works, it works smashingly — just don't expect it to work with all subjects.

Subject Tracking focus box

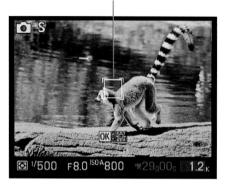

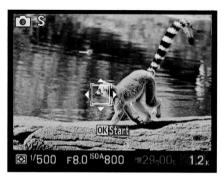

Figure 8-8: In Subject Tracking mode, move the box over your subject and press OK to start focus tracking.

For the most part, I stick with Single Point mode. Not only does it let me (and not the camera) choose the focusing target, but with more available focusing points, it allows a greater degree of precision. But spend some time practicing with Subject Tracking mode, too, so that you get a feel for what types of subjects it can handle well. Again, when it's presented with the right subject matter, it can make focusing on a quickly moving target easier.

Changing the Focus mode setting

The Focus mode setting offers three options for tweaking autofocusing behavior and one option that tells the camera that you prefer to focus manually. Here's a rundown of your choices.

✓ AF-A (auto-select autofocus): This mode is the default setting. The camera analyzes the scene and, if it detects motion, continues to adjust focusing up to the time you fully depress the shutter button. If the camera instead believes you're shooting a stationary object, it locks focus at the time you press the shutter button halfway.

This mode works pretty well, but it can get confused sometimes. For example, if your subject is motionless but other people are moving in the background, the camera may mistakenly switch to continuous

autofocus. By the same token, if the subject is moving only slightly, the camera may not make the switch. So my best advice is to choose one of the next two Focus mode options, which enable you to make the call yourself.

✓ AF-S (single autofocus): With this option, the camera locks focus when you depress the shutter button halfway. It's designed for shooting stationary subjects.

Use this mode if you want to frame your subject so that it doesn't fall under an autofocus point: Compose the scene initially to put the subject under a focus point, press the shutter button halfway to lock focus, and then reframe to the composition you have in mind. As long as you keep the button pressed halfway, focus remains set on your subject. Remember, though, that exposure is adjusted up to the time you take the picture. See Chapter 7 to find out how to use the AE-L/AF-L button to lock exposure at the same time you lock focus.

One other critical point about AF-S mode: When this mode is selected, the camera won't release the shutter to take a picture until focus is achieved. If you can't get the camera to lock onto your focusing target, switching to manual focusing is the easiest solution. Also be sure that you're not too close to your subject; if you exceed the minimum focusing distance of the lens, you can't focus manually either.

✓ AF-C (continuous autofocus): In this mode, designed for moving subjects, the cameras focuses continuously for the entire time you hold the shutter button halfway down.

Remember these little tidbits:

- In AF-C mode, the camera is supposed to release the shutter even if focusing isn't fully achieved. But your mileage may vary, as they say. Just suffice it to say that if the shutter won't release, it's likely that the camera wants too badly to focus first.
- To lock focus at a certain distance while using AF-C mode, use the technique described in the section, "Using autofocus lock," later in this chapter.
- MF (manual focus): Choose this setting if you want to focus manually. See the upcoming section so cleverly titled "Focusing Manually" for details on how to get the job done.

For Nikon 1 lenses, how you adjust the setting depends on which camera you use:

✓ J1: Make the call via the Focus mode option on the Shooting menu, as shown in Figure 8-9.

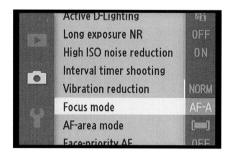

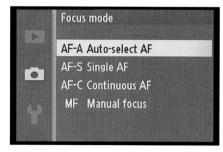

Figure 8-9: On the J1, select the Focus mode via the Shooting menu.

✓ V1: Press the Multi Selector down — in other words, press the button marked AF — to display a selection screen, as shown in Figure 8-10. Press the Multi Selector up or down to highlight a choice and then press OK to close the selection screen.

Either way, if you enable Detailed display mode, you see a symbol representing the selected Focus mode in the upper-right corner of the display, as shown in Figure 8-11. Remember: Just press the Disp button to cycle through the available display modes. And note that you see the Focus

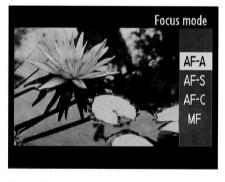

Figure 8-10: On the V1, press the AF button (down button on Multi Selector) to access the selection screen.

 $mode, AF-area\ mode, and\ Face-priority\ AF\ symbols\ in\ the\ display\ only\ in\ the\ P,\ S,\ A,\ and\ M\ modes;\ in\ Scene\ Auto\ Selector\ mode,\ they're\ hidden.$

Choosing the right autofocus combo

You get the best autofocus results if you pair your chosen Focus mode with the most appropriate AF-Area mode because the two settings work in tandem. Here are the combinations that I suggest for the maximum autofocus control:

- For still subjects, use Single Point as the AF-Area mode and AF-S as the Focus mode. You then select a specific focus point, and the camera locks focus on that point when you press the shutter button halfway.
 - Focus remains locked on your subject even if you reframe the shot after you press the button halfway. (It helps to remember the *s* factor: for still subjects, *S*ingle Point, and AF-*S*.)
- For moving subjects, set the Focus mode to AF-C and try using Subject Tracking as the AF-Area mode. You still begin by selecting a general focusing area, but then the camera tracks your subject as it moves through the frame. After you press the shutter button halfway to establish the initial focusing distance,

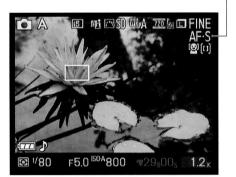

Focus mode setting

Figure 8-11: You can view the current Focus mode in the display.

the camera continues adjusting focus as needed until you press the button the rest of the way to record the picture.

If Subject Tracking fails, I usually switch the AF-Area mode to Single Point. I select my focus point, press halfway to set focus, and then if my subject moves, I reframe as needed to keep the subject under the focus point. As long as the subject remains within the focus point, focus should be properly adjusted as your subject moves.

However, if you're shooting a subject that's set against a relatively empty background and is the closest object to the camera, Auto Area can also work well with continuous autofocusing. The camera won't be confused as to which subject you want to focus on — it's got only one potential target — and it can take care of selecting the focus point for you.

Again, though, you get full control over the Focus mode and AF-Area mode only in the P, S, A, and M exposure modes and only if the Electronic (Hi) shutter release mode is not used. In Scene Auto Selector, you're locked into Auto Area as the AF-Area mode and AF-A as the Focus mode. Remember, too, that when you use lenses other than Nikon 1 lenses, all focusing options may not be supported.

Using autofocus lock

When you set your camera's Focus mode to AF-C (continuous autofocus), pressing and holding the shutter button halfway initiates autofocus. But focusing is continually adjusted while you hold the shutter button halfway,

so the focusing distance may change if the subject moves or you reframe the shot before you take the picture. The same is true if you use AF-A mode (auto-select autofocus) and the camera senses movement in front of the lens, in which case it shifts to AF-C mode and operates as I just described. Either way, the upshot is that you can't control the exact focusing distance the camera ultimately uses.

Should you want to lock focus at a specific distance, you have a couple options:

- Focus manually.
- Change the Focus mode to AF-S (single autofocus). In this mode, focus is locked when you press and hold the shutter button halfway.
- Lock focus with the AE-L/AF-L button. First set focus by pressing the shutter button halfway. When the focus is established at the distance you want, press and hold the AE-L/AF-L button the up button on the Multi Selector. Focus remains set as long as you hold down the button, even if you release the shutter button.

Keep in mind, though, that by default, pressing the AE-L/AF-L button also locks in autoexposure. (Chapter 7 explains.) You can change this behavior, however, setting the button to lock just one or the other. Chapter 11 explains this option.

Focusing Manually

Some subjects confuse even the most sophisticated autofocusing systems, causing the camera's autofocus motor to spend a long time "hunting" for its focus point. Animals behind fences, reflective objects, water, and low-contrast subjects are just some of the autofocus troublemakers. Autofocus systems also struggle in dim lighting, although that difficulty is often offset on Nikon 1 cameras by the AF-assist lamp, which shoots out a beam of light to help the camera find its focusing target. Finally, if you're trying to pick out a small target amid lots of clutter, it can be difficult to get the camera to focus on just the right spot.

When you encounter situations that cause an autofocus hang-up, you can try adjusting the autofocus options discussed earlier in this chapter. But often it's simply easier and faster to switch to manual focusing. Note, though, that you must set the Exposure Mode to P, S, A, or M and use a shutter release option other than Electronic (Hi) to have this option.

If you're using a Nikon 1 lens, follow these steps to focus manually:

1. If you're using the V1 viewfinder to compose the shot, adjust the viewfinder to your eyesight.

Chapter 1 shows you how to take this critical step. If you don't adjust the viewfinder, scenes that are in focus may appear blurry and vice versa.

2. Set the Focus mode to MF (manual focus).

Here's a quick reminder how to do it:

- *J1*: Set the option via the Shooting menu.
- V1: Press the Multi Selector down (the AF button) to display the Focus mode selection screen. Highlight your choice and press OK.

After you select the option, the words OK MF appear briefly on the display, offering a hint about what you need to do in Step 3.

3. Press OK.

Now the display offers a magnified view of the scene, along with a vertical focus-distance scale, as shown in Figure 8-12. In the lower-right corner, you see a thumbnail view of the entire scene, with a yellow box that indicates the magnified area.

Adjust the magnified display as needed.

You can use these tricks:

- To display a different area of the scene: Use the Multi Selector to move the yellow box over that area.
- To adjust the magnification level: Press the Zoom lever up to zoom in further on the subject; press down to reduce the magnification.

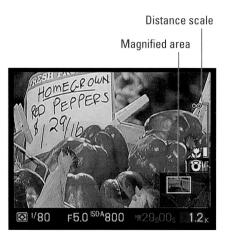

Figure 8-12: Press OK to display the focusing scale; then rotate the Multi Selector to adjust focus.

5. To adjust focus, rotate the Multi Selector.

Just keep rotating until the scene comes into focus. As you do, the focusdistance bar on the right updates, showing you whether you're focusing farther away (the bar climbs toward the infinity symbol at the top) or closer (the bar falls toward the flower, which has become the universal symbol for *macro*, or close-up photography).

See the little circle topped by arrows and labeled MF, at the bottom of the distance scale? That circle-y arrow thing is supposed to remind you to spin the Multi Selector to adjust focus.

At any time, you can adjust the magnified display as outlined in Step 4. If the magnified display disappears — as it does after a few seconds of inactivity — just press OK again to bring it back to life.

6. When focus is set, press OK to exit the magnified view.

The OK MF alert on the display disappears after a few seconds. But you can still press OK to readjust focus as needed.

If you are using the FT-1 lens mount adapter to mount a lens, see your lens manual and the adapter manual for instructions on how to focus manually.

Manipulating Depth of Field

Getting familiar with the concept of *depth of field* is one of the biggest steps you can take to becoming a more artful photographer. I introduce you to depth of field in Chapters 3 and 7; here's a summary in case you missed those pages:

- Depth of field refers to the distance over which the appearance of sharp focus is maintained.
- With a shallow, or small, depth of field, your subject appears sharp but objects located nearer to or farther from the lens appear softly focused.
- With a large depth of field, the zone of sharp focus extends to include objects at a distance from your subject.

Which arrangement works best depends entirely on your creative vision and your subject. In portraits, for example, a classic technique is to use a shallow depth of field, as shown in Figure 8-13. This approach increases emphasis on the subject while diminishing the impact of the background. But for the photo in Figure 8-14, I wanted to emphasize that the foreground figures were in St. Peter's Square, at the Vatican, so I used a large depth of field, which kept both the foreground and the background sharply focused, giving them equal weight in the scene.

So exactly how do you adjust depth of field? You have three points of control: aperture, focal length, and camera-to-subject distance, as follows:

- Aperture setting (f-stop): The aperture is one of three main exposure settings, all explained fully in Chapter 7. Depth of field increases as you stop down the aperture (by choosing a higher f-stop number). For shallow depth of field, open the aperture (by choosing a lower f-stop number). Figure 8-15 offers an example; in the f/5.6 version, focus softens as the distance from the ear of corn increases; in the f/16 version, the background remains sharp. I snapped both images using the same focal length and camera-to-subject distance, setting focus on the corn.
- Lens focal length: In lay terms, focal length determines what the lens "sees." As you increase focal length, measured in millimeters, the angle of view narrows, objects appear larger in the frame, and the important point for this discussion depth of field decreases. Additionally, the spatial relationship of objects changes as you adjust focal length. As an example, Figure 8.16 seems

Shallow depth of field

Figure 8-13: A shallow depth of field blurs the background and draws added attention to the subject.

length. As an example, Figure 8-16 compares the same scene shot at a focal length of 138mm and 225mm. I used the same aperture and camerato-subject distance for both examples.

Whether you have any focal length flexibility depends on your lens: If you have a zoom lens, you can adjust the focal length — just zoom in or out. If you don't have a zoom lens, the focal length is fixed, so scratch this means of manipulating depth of field.

For more technical details about focal length and your camera, see the sidebar "Fun facts about focal length," later in this chapter.

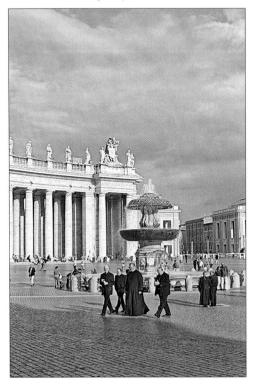

Figure 8-14: A large depth of field keeps both foreground and background subjects in focus.

✓ Camera-to-subject distance: As you move the lens closer to your subject, depth of field decreases. This assumes that you don't zoom in or out to reframe the picture, thereby changing the focal length. If you do, depth of field is affected by both the camera position and focal length.

Together, these three factors determine the maximum and minimum depth of field that you can achieve, as illustrated by my clever artwork in Figure 8-17 and summed up in the following list:

✓ To produce the shallowest depth of field: Open the aperture as wide as possible (the lowest f-stop number), zoom in to the maximum focal length of your lens, and get as close as possible to your subject.

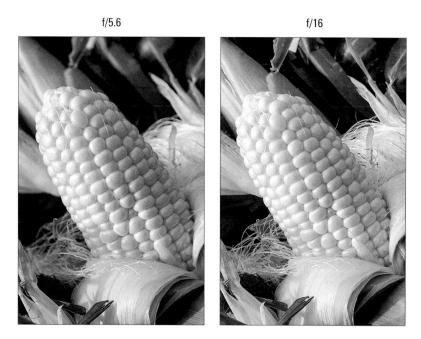

Figure 8-15: A lower f-stop number (wider aperture) decreases depth of field.

One note with regard to shifting depth of field with the aperture setting: If you're coming to the Nikon 1 from the world of dSLR (digital single-lens reflex) photography, you may notice that you get a larger depth of field at any given aperture on the Nikon 1 than you do with a dSLR lens. Without going into technical details, the difference is due to the fact that the Nikon 1 has a smaller image sensor than is used in digital SLR cameras. The greater depth of field is great for landscape photography, but if you mainly shoot portraits and other shots where a very shallow depth of field is desired, you may find this fact of life a little frustrating, especially if you use the 10–30mm lens. You may want to step up to the 30–110mm or 10–100mm zoom, so that you can take advantage of the longer focal length or try the 10mm lens, which lets you open the aperture to f/2.8. Another alternative is to purchase the FT1 lens-mount adapter and work with a lens that offers a longer focal length and larger maximum aperture than is currently available in the Nikon 1 lens lineup.

✓ To produce maximum depth of field: Stop down the aperture to the highest possible f-stop number, zoom out to the shortest focal length your lens offers, and move farther from your subject.

225mm 138mm

Figure 8-16: Zooming to a longer focal length also reduces depth of field.

Greater depth of field: Select higher f-stop Decrease focal length (zoom out)

Move farther from subject

Shorter depth of field:

Select lower f-stop Increase focal length (zoom in) Move closer to subject

Figure 8-17: Your f-stop, focal length, and shooting distance determine depth of field.

Focal length and the crop factor

The angle of view that a lens can capture is determined by its *focal length*, or in the case of a zoom lens, the range of focal lengths it offers. Focal length is measured in millimeters.

According to photography tradition, a focal length of 50mm is described as a "normal" lens. Most point-and-shoot cameras feature this focal length, which is a medium-range lens that works well for the type of snapshots that users of those kinds of cameras are likely to shoot.

A lens with a focal length under 35mm is characterized as a wide-angle lens because at that focal length, the camera has a wide angle of view, making it good for landscape photography. A short focal length also has the effect of making objects seem smaller and farther away. At the other end of the spectrum, a lens with a focal length longer than 80mm is considered a telephoto lens and often referred to as a long lens. With a long lens, angle of view narrows, and faraway subjects appear closer and larger, which is ideal for wildlife and sports photographers.

Note, however, that the focal lengths stated here and elsewhere in the book are so-called 35mm-equivalent focal lengths. Here's the deal: For reasons that aren't really important, when you put a standard lens on most digital cameras, including your Nikon 1 model, the angle of view is reduced, as if you took a picture on a camera that uses 35mm film negatives and then cropped it.

This so-called *crop factor* varies depending on the camera, which is why the photo industry adopted the 35mm-equivalent measuring stick as a standard. With the Nikon 1, the crop factor is roughly 2.7. So the 10–30mm lens featured in this book, for example, captures the approximate area you would get from a 48–81mm lens on a 35mm film camera. (Multiply the crop factor by the actual focal length to get the actual angle of view.) When shopping for a lens, it's important to remember this crop factor to make sure that you get a lens with the focal length designed for the type of pictures you want to take.

Just to avoid a possible point of confusion that has arisen in some of the classes I teach: When I say *zoom in*, some students think that I mean to twist the zoom barrel so that it moves *in* toward the camera body. But in fact, the phrase *zoom in* means to zoom to a longer focal length, which produces the visual effect of bringing your subject closer. This requires twisting the zoom barrel of the lens so that it extends farther *out* from the camera. And the phrase *zoom out* refers to the opposite maneuver: I'm talking about widening your view of the subject by zooming to a shorter focal length, which requires moving the lens barrel *in* toward the camera body.

Here are a few additional tips and tricks related to depth of field:

Aperture-priority autoexposure (A) mode enables you to easily control depth of field. In this mode, detailed fully in Chapter 7, you set the f-stop, and the camera selects the appropriate shutter speed to produce a good exposure. The range of aperture settings you can access depends on your lens.

Even in aperture-priority mode, keep an eye on shutter speed as well. To maintain the same exposure, shutter speed must change in tandem with aperture, and you may encounter a situation where the shutter speed is too slow to permit hand-holding of the camera. Vibration Reduction enables most people to use a slower shutter speed than normal, but double-check your results just to be sure. Or use a tripod for extra security. Of course, all this assumes that you have dialed in a specific ISO Sensitivity setting; if you instead are using Auto ISO adjustment, the camera may adjust the ISO setting instead of shutter speed. (Chapter 7 explores the whole aperture/shutter speed/ISO relationship; see Chapter 2 for more about Vibration Reduction.)

- ✓ Some Scene modes that Scene Auto Selector mode chooses are designed to produce a particular depth of field. Portrait and Close Up modes are designed to produce shallow depth of field, for example, and Landscape mode is designed for large depth of field. (Chapter 3 offers a list of all the available Scene modes.) You can't adjust aperture in these modes, however, so you're limited to the setting the camera chooses. In addition, the extent to which the camera can select an appropriate f-stop depends on the lighting conditions. If you're shooting in Landscape mode at dusk, for example, the camera may have to open the aperture to a wide setting to produce a good exposure.
- ✓ For greater background blurring, move the subject farther from the background. The extent to which background focus shifts as you adjust depth of field also is affected by the distance between the subject and the background. For increased background blurring, move the subject farther in front of the background.

Controlling Color

Compared with understanding some aspects of digital photography — resolution, aperture and shutter speed, depth of field, and so on — making sense of your camera's color options is easy-breezy. First, color problems aren't all that common, and when they are, they're usually simple to fix with a quick shift of your camera's White Balance control. And getting a grip on color

requires learning only a couple new terms, an unusual state of affairs for an endeavor that often seems more like high-tech science than art.

The rest of this chapter explains the aforementioned White Balance control. plus a couple options that enable you to fine-tune the way your camera renders colors. For information on a few additional color options, including one that lets you choose the color space of your photos, see Chapter 11.

Correcting colors with white balance

Every light source emits a particular color cast. The old-fashioned fluorescent lights found in most public restrooms, for example, put out a bluish-greenish light, which is why we all look so sickly when we view our reflections in the mirrors in those restrooms. And if you think that your beloved looks especially attractive by candlelight, you aren't imagining things: Candlelight casts a warm, yellow-red glow that is flattering to the skin.

Science-y types measure the color of light, officially known as color temperature, on the Kelvin scale, which is named after its creator. You can see the Kelvin scale in Figure 8-18.

When photographers talk about "warm light" and "cool light," though, they aren't referring to the position on the Kelvin scale — or at least not in the way most people think of temperatures, with a higher number meaning hotter. Instead, the terms describe the visual appearance of the light. Warm light, produced by candles and incandescent lights, falls in the red-yellow spectrum you see at the bottom of the Kelvin scale in Figure 8-18; cool light, in the blue spectrum, appears in the upper part of the Kelvin scale.

At any rate, most people don't notice these fluctuating colors of light because human eyes automatically compensate for them. Except in very extreme lighting conditions, we perceive a white tablecloth as white no matter whether it's lit by candlelight, fluorescent light, or regular houselights.

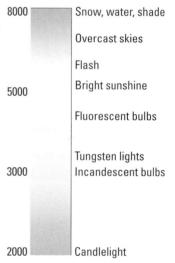

Figure 8-18: Each light source emits a specific color.

Similarly, a digital camera compensates for different colors of light through white balancing. Simply put, *white balancing* neutralizes light so that whites are always white, which in turn ensures that other colors are rendered accurately. If the camera senses warm light, it shifts colors slightly to the cool side of the color spectrum; in cool light, the camera shifts colors the opposite direction.

The good news is that, as with your eyes, your camera's Auto White Balance setting tackles this process remarkably well in most situations, which means that you can usually ignore it and concentrate on other aspects of your picture. But if your scene is lit by two or more light sources that cast different colors, the white balance sensor can get confused, producing an unwanted color cast like the one you see in the left image in Figure 8-19.

Figure 8-19: Multiple light sources resulted in a yellow color cast in Auto White Balance mode (left); switching to the Incandescent setting solved the problem (right).

I shot this product image in my home studio using tungsten photo lights, which produce light with a color temperature similar to regular household incandescent bulbs. The problem is that the windows in that room also permit some pretty strong daylight to filter through. In Auto White Balance mode, the camera reacted to that daylight — which has a cool color cast — and applied too much warming, giving my original image a yellow tint. No problem. I just switched the White Balance mode from Auto to the Incandescent setting. The image at right in Figure 8-19 shows the corrected colors.

There's one little problem with white balancing as it's implemented on your camera, though. You can make this kind of manual white balance selection only in the P, S, A, or M exposure mode. Chapter 7 details all four modes, which you can choose in Still Image photography mode (green camera on the Mode dial) or in Movie mode. Your White Balance setting affects both still photos and movies.

The next section explains precisely how to make a simple white balance correction; following that, you can explore some advanced white balance options.

Changing the White Balance setting

In Detailed display mode, the current White Balance setting appears at the top of the screen, in the area labeled in Figure 8-20. The A represents Auto mode; settings other than Auto are represented by the icons you see in Table 8-1. Keep in mind that the setting appears only in the P, S, A, and M exposure modes — the only ones that give you any control over the White Balance option.

White Balance symbol

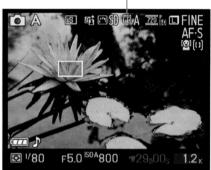

Figure 8-20: This icon represents the current White Balance setting.

Table 8-1	Manual White Balance Settings
Symbol	Light Source
*	Incandescent
\\\\\\\\\\\\\\\\\\\\\\\\\\\\\\\\\\\\\\	Fluorescent
*	Direct sunlight
4	Flash
2	Cloudy
_ //.	Shade
PRE	Preset

The first six settings relate to specific types of lighting, and the Preset (PRE) option enables you to create and store a precise, customized White Balance setting, as explained in the upcoming "Creating a white balance preset" section, later in this chapter. This setting is the fastest way to achieve accurate colors when your scene is lit by multiple light sources that have differing color temperatures.

Whatever setting you prefer, you select it via the White Balance option on the Shooting menu, as shown in Figure 8-21. After selecting an option, press OK. You're then taken to a screen where you can fine-tune the setting if desired, as outlined in the next section. If you don't want to go that route, just press OK again to exit the screen and lock in your White Balance choice.

Your selected White Balance setting remains in force for the P, S, A, and M exposure modes until you change it. So you may want to get in the habit of resetting the option to the Auto setting after you finish shooting whatever subject it was that caused you to switch to manual White Balance mode.

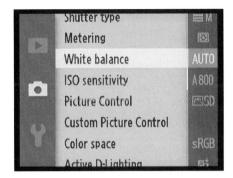

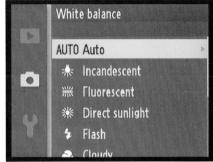

Figure 8-21: Control white-balancing through the Shooting menu.

Fine-tuning White Balance settings

You can fine-tune any White Balance setting except a custom preset that you create through the PRE option. Make the adjustment as spelled out in these steps:

- 1. Display the Shooting menu, highlight White Balance, and press OK.
- 2. Highlight the White Balance setting you want to adjust, as shown on the left in Figure 8-22, and press the Multi Selector right.

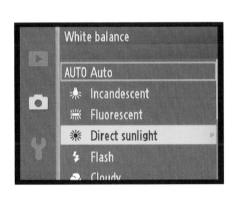

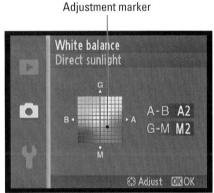

Figure 8-22: Press the Multi Selector right to get to the fine-tuning screen.

You're taken to a screen where you can do your fine-tuning, as shown on the right in Figure 8-22.

3. Fine-tune the setting by using the Multi Selector to move the white balance adjustment marker in the color grid.

The grid is set up around two color pairs: Green and Magenta, represented by G and M; and Blue and Amber, represented by B and A. By pressing the Multi Selector, you can move the adjustment marker — that little black box labeled in Figure 8-22 — around the grid.

As you move the marker, the A–B and G–M boxes on the right side of the screen show you the current amount of color shift. A value of 0 indicates the default amount of color compensation applied by the selected White

Balance setting. In Figure 8-22, for example, I moved the marker two levels toward amber and two levels toward magenta to specify that I wanted colors to be a tad warmer.

4. Press OK to complete the adjustment and return to the Shooting menu.

After you adjust a White Balance setting, an asterisk appears next to the icon representing the setting on the Shooting menu, as shown in Figure 8-23. You see an asterisk next to the White Balance setting symbol at the top of the display as well.

Figure 8-23: The asterisk indicates that you applied a fine-tuning adjustment to the White Balance setting.

Creating a white balance preset

If none of the standard White Balance settings do the trick and you don't want to fool with fine-tuning them, take advantage of the PRE (Preset Manual) feature. This option enables you to do base white balance on a direct measurement of the actual lighting conditions.

To use this technique, you need a piece of card stock that's either neutral gray or absolute white — not eggshell white, sand white, or any other close-but-not-perfect white. (You can buy reference cards made just for this purpose in many camera stores for less than \$20.)

Position the reference card so that it receives the same lighting you'll use for your photo. Then take these steps:

1. Set the camera to the P, S, A, or M exposure mode.

Make sure that your exposure settings are on target — if not, the camera can't create your custom white balance preset. Chapter 7 explains how to adjust exposure settings.

- 2. Frame your shot so that the reference card completely fills the viewfinder.
- 3. From the Shooting menu, select White Balance, press OK, and select the PRE Preset Manual setting, as shown in Figure 8-24.

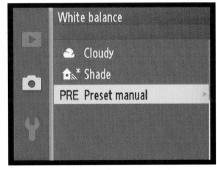

Figure 8-24: Select these options to set White Balance by taking a direct measurement of the light.

4. Press the Multi Selector right.

A warning appears, asking you whether you want to overwrite existing data.

5. Select Yes and press OK.

You see another message, this time telling you to take your picture. You have about six seconds to do so. The letters PRE flash in the lower-right corner of the display to let you know the camera's ready to record your white balance reference image.

6. Take the reference shot.

If the camera is successful at recording the white balance data, you see a message indicating success. If the camera couldn't set the custom white balance, you instead see the message to that effect. Try adjusting your lighting and then try retaking your reference shot.

After you complete the process, the camera automatically sets the White Balance option to PRE so you can begin using your preset. Any time you want to select and use the preset, just switch to the PRE White Balance setting via the Shooting menu. Your custom setting is stored in the camera until you override it with a new preset.

Taking a Look at Picture Controls

A feature that Nikon calls *Picture Controls* offers a way to tweak image sharpening, color, and contrast when you shoot in the P, S, A, and M exposure modes and choose one of the JPEG options for the Image Quality setting. (Chapter 2 explains the Image Quality setting.)

Sharpening, in case you're new to the digital meaning of the term, refers to a software process that adjusts contrast in a way that creates the illusion of slightly sharper focus. I emphasize, "slightly sharper focus." Sharpening produces a subtle *tweak*, and it's not a fix for poor focus.

When you shoot in the advanced exposure modes — P, S, A, and M — you can choose from the following Picture Controls, represented in the menus and in the Detailed display by the two-letter codes in parentheses. (Figure 8-25 shows you where to find the two-letter code in the display.) In the other exposure modes, the camera selects the Picture Control setting for you.

✓ Standard (SD): The default setting, this option captures the image normally — that is, using the characteristics that Nikon offers up as suitable for the majority of subjects.

Picture Control symbol

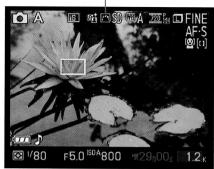

Figure 8-25: This two-letter code represents the Picture Control setting.

▶ Neutral (NL): At this setting, the camera doesn't enhance color, contrast, and sharpening as much as in the other modes. The setting is designed for people who want to precisely manipulate these picture characteristics in a photo editor. By not

- overworking colors, sharpening, and so on when producing your original file, the camera delivers an original that gives you more latitude in the digital darkroom.
- ✓ Vivid (VI): In this mode, the camera amps up color saturation, contrast, and sharpening.
- Monochrome (MC): This setting produces black-and-white photos. Only in the digital world, they're called grayscale images because a true blackand-white image contains only black and white, with no shades of gray.

- ✓ Portrait (PT): This mode tweaks colors and sharpening in a way that is designed to produce nice skin texture and pleasing skin tones. (If you shoot in Scene Auto Selector mode and the camera chooses the Portrait or Night Portrait Scene mode, this Picture Control is automatically selected.)
- Landscape (LS): This mode emphasizes blues and greens. As you might expect, it's the mode used by Scene Auto Selector mode's Landscape Scene mode.

The extent to which Picture Controls affect your image depends on the subject as well as the exposure settings you choose and the lighting conditions. But Figure 8-26 gives you a general idea of what to expect. As you can see, the differences between the Picture Controls are pretty subtle, with the exception of the Monochrome setting. But if you want to give Picture Controls a try, you can adjust the setting via the Shooting menu, as shown in Figure 8-27.

At least while you're new to the camera, I recommend that you stick with the default Picture Control setting (Standard), for two reasons. First, you have way more important camera settings to worry about — aperture, shutter speed, autofocus, and all the rest. Why add one more setting to your list, especially when the impact of changing it is minimal?

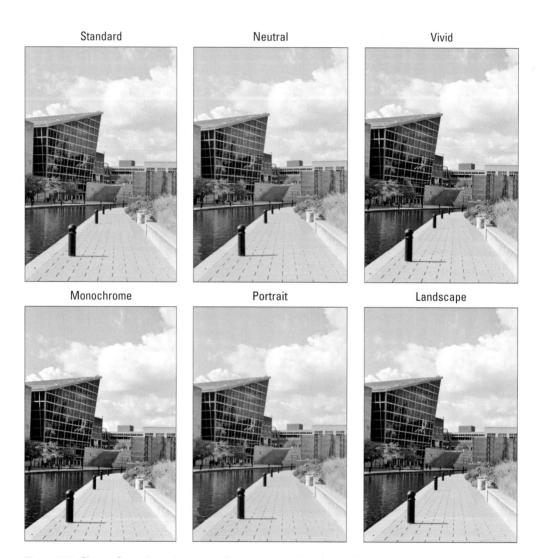

Figure 8-26: Picture Controls apply preset adjustments to color, sharpening, and other photo characteristics to images you shoot in the JPEG file format.

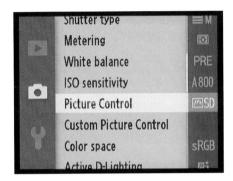

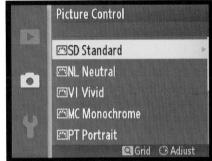

Figure 8-27: Select a Picture Control through the Shooting menu.

Second, if you really want to mess with the characteristics that the Picture Control options affect, you're much better off shooting in the Raw (NEF) format and then making those adjustments on a picture-by-picture basis in your Raw converter. In Nikon ViewNX 2, you can even assign any of the existing Picture Controls to your Raw files and then compare how each one affects the image. The camera does tag your Raw file with whatever Picture Control is active when you take the shot, but the image adjustments are in no way set in stone, or even in sand — you can tweak your photo at will. (The selected Picture Control does affect the JPEG preview that's used to display the Raw image on the camera monitor as well as in ViewNX 2 and other photo browsers.)

However, in the interest of full disclosure, I should alert you to a feature that may make Picture Controls a little more useful to some people: You can modify any Picture Control to more closely render a scene the way you envision it. So, for example, if you like the bold colors of Landscape mode but don't think the effect goes far enough, you can adjust the setting to amp up colors even more. You can even create and store your own, custom Picture Controls. Chapter 11 shows you how to tackle both projects. (The Adjust and Grid options shown at the bottom of the right screen in Figure 8-27 are related to these features.)

Putting It All Together

In This Chapter

- ▶ Reviewing the best all-around picture-taking settings
- Adjusting the camera for portrait photography
- Discovering the keys to super action shots
- Dialing in the right settings to capture landscapes and other scenic vistas
- Capturing close-up views of your subject

arlier chapters of this book break down each and every picture-taking feature on your camera, describing in detail how the various controls affect exposure, picture quality, focus, color, and the like. This chapter pulls together all that information to help you set up your camera for specific types of photography.

Keep in mind, though, that there are no hard-and-fast rules as to the "right way" to shoot a portrait, a landscape, or whatever. So feel free to wander off on your own, tweaking this exposure setting or adjusting that focus control, to discover your own creative vision. Experimentation is part of the fun of photography, after all — and thanks to your camera monitor and the Delete button, it's an easy, completely free proposition.

Recapping Basic Picture Settings

Your subject, creative goals, and lighting conditions determine which settings you should use for some picture-taking options, such as aperture and shutter speed. I offer my take on those options throughout this chapter. But for many basic options, I recommend the same settings for almost every shooting scenario. Table 9-1 shows you those recommendations and also lists the chapter where you can find details about each setting.

One key point: Instructions in this chapter assume that you use Still Image photography mode and set the exposure mode to P, S, A, or M, as indicated in the table. These modes, detailed in Chapter 7, are the only ones that give you access to the entire cadre of camera features. In most cases, I recommend using S (shutter-priority autoexposure) when controlling motion blur is important, and A (aperture-priority autoexposure) when controlling depth of field is important. These two modes let you concentrate on one side of the exposure equation and let the camera handle the other. Of course, if you're comfortable making both the aperture and shutter speed decisions, you may prefer to work in M (manual) exposure mode instead. P (programmed autoexposure) is my last choice because it makes choosing a specific aperture or shutter speed more cumbersome.

I don't recommend Scene Auto Selector or Smart Photo Selector modes because they don't permit you to access certain settings that can be critical to capturing good shots of certain subjects. For help using these automated modes, visit Chapter 3.

Also note that this chapter discusses choices for normal, still photography; Chapter 4 guides you through the options available for movie recording and Motion Snapshot mode. Finally, instructions assume that you're using a Nikon 1 lens. If you attach another lens via the FT1 adapter, see the adapter and lens instruction manuals for details on focusing as well as information on other options that may be unavailable with the attached lens.

Table 9-1 Option	All-Purpose Picture-Taking Settings	
	Recommended Setting	Chapter
Exposure mode	P, S, A, or M	7
mage Quality	JPEG Fine or Raw (NEF)	2
mage Size	Large or medium	2
Vhite Balance	Auto	8
SO Sensitivity	100	7
ocus mode	For autofocusing: still subjects, AF-S; moving subjects, AF-C. For manual focus, MF	8
F-Area mode	Still subjects, Single Point; moving subjects, Subject Tracking or Single Point	8
elease mode	Action photos: Continuous; all others: Single Frame	2
etering	Matrix	7
ctive D-Lighting	On	7

Shooting Still Portraits

By *still portrait*, I mean that your subject isn't moving. For subjects who aren't keen on sitting still long enough to have their picture taken, skip to the next section and use the techniques given for action photography instead. Assuming that you do have a subject willing to pose, the classic portraiture approach is to keep the subject sharply focused while throwing the background Into soft focus. This artistic choice emphasizes the subject and helps diminish the impact of any distracting background objects in cases where you can't control the setting. The following steps show you how to achieve this look:

1. Set the Exposure Mode option (Shooting menu) to A (aperture-priority autoexposure) and select the lowest f-stop value possible.

As Chapter 7 explains, a low f-stop setting opens the aperture, which not only allows more light to enter the camera but also shortens *depth of field*, or the range of sharp focus. So dialing in a low f-stop value is the first step in softening your portrait background. Just press the Zoom lever up or down to adjust the aperture setting.

I recommend aperture-priority mode when depth of field is a primary concern because you can control the f-stop while relying on the camera to select the shutter speed that will properly expose the image. You do need to pay attention to shutter speed as well, however, to make sure that it's not so slow that any movement of the subject or camera will blur the image.

You can monitor the current f-stop and shutter speed at the bottom of the display, as shown in Figure 9-1. If Face-priority AF Assist is enabled, as it is by default, yellow frames appear around detected faces, as shown in the figure. The box with the inside corner markings indicate the face that will be used to establish focus.

2. To further soften the background, zoom in, get closer, and put more distance between the subject and background.

As covered in Chapter 8, zooming in to a longer focal length also reduces depth of field, as does moving physically closer

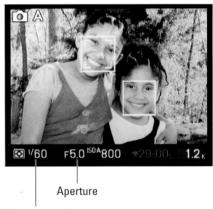

Shutter speed

Figure 9-1: You can monitor aperture (f-stop) and shutter-speed settings in the display.

to your subject. And the greater the distance between the subject and background, the more the background blurs. (A good rule is to place the subject at least an arm's length away from the background.)

A lens with a focal length of 85–120mm is ideal for a classic head and shoulders portrait. You should avoid using a much shorter focal length (a wider-angle lens) for portraits. They can cause features to appear distorted — sort of like the way people look when you view them through a security peephole in a door. See Chapter 8 for more about focal length, including how to calculate the effective focal length of a lens mounted on your Nikon 1 camera.

3. For indoor portraits, shoot flashfree if possible.

Shooting by available light rather than flash produces softer illumination and avoids the problem of red-eye. To get enough light to go flashfree, turn on room lights or, during daylight, pose your subject next to a sunny window, as I did for the image in Figure 9-2.

If flash is unavoidable, see my list of flash tips at the end of the steps to get better results.

4. For outdoor portraits, use a flash if possible.

Even in daylight, a flash adds a beneficial pop of light to subjects' faces, as illustrated in Figure 9-3. A flash is especially important when the background is brighter than the subjects, as in this example.

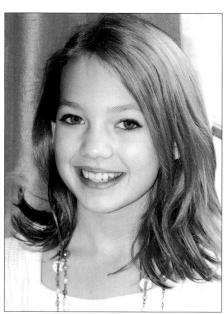

Figure 9-2: For more pleasing indoor portraits, shoot by available light instead of using flash.

For daytime portraits, use the Fill Flash setting. (That's the regular, basic Flash mode.) For nighttime images, try red-eye reduction or slow-sync flash; again, see the flash tips at the end of these steps to use either mode most effectively.

The top shutter speed for flash photography on the J1 is 1/60 second, as it is on the V1 when you use the electronic shutter. With the mechanical shutter, the V1 shutter speed tops out at 1/250 second when you use flash. Either way, if you're shooting in bright light, you may need to stop down the aperture to avoid overexposing the photo. Doing so, of course, brings the background into sharper focus. So try to move the subject into a shaded area instead.

Press and hold the shutter button halfway to initiate exposure metering and autofocusing. If the camera has trouble finding the correct focusing distance, simply focus manually. See Chapter 8 for help with focusing.

6. Press the shutter button the rest of the way to capture the image.

Fill flash

Figure 9-3: To properly illuminate the face in outdoor portraits, use fill flash.

Again, these steps just give you a starting point for taking better portraits. A few other tips can also improve your people pics:

Pay attention to the background. Scan the entire frame looking for intrusive objects that may distract the eye from the subject. If necessary, reposition the subject against a more flattering backdrop. Inside, a softly textured wall works well; outdoors, trees and shrubs can provide nice backdrops as long as they aren't so ornate or colorful that they diminish the subject (for example, a magnolia tree laden with blooms).

- Pay attention to white balance if your subject is lit by both flash and ambient light. Any time you shoot in mixed lighting, the result may be colors that are slightly warmer or cooler (bluer) than neutral. A warming effect typically looks nice in portraits, giving the skin a subtle glow. But if you aren't happy with the result, see Chapter 8 to find out how to fine-tune white balance.
- When flash is unavoidable, try these tricks to produce better results. The following techniques can help solve flash-related issues:
 - Indoors, turn on as many room lights as possible. With more ambient light, you reduce the flash power that's needed to expose the picture. This step also causes the pupils to constrict, further reducing the chances of red-eye. (Pay heed to my white balance warning, however.) As an added benefit, the smaller pupil allows more of the subject's iris to be visible in the portrait, so you see more eye color.
 - Try using a Flash mode that enables red-eye reduction or slow-sync flash. If you choose the first option, warn your subject to expect both a preliminary pop of light from the AF-assist lamp, which constricts pupils, and the flash. And remember that slow-sync flash modes use a slower-than-normal shutter speed, which produces softer lighting and brighter backgrounds than normal flash. (Chapter 7 explains the various Flash modes.)

Take a look at Figure 9-4 for an example of how slow-sync flash can really improve an indoor portrait. When I used regular flash, the shutter speed was 1/60 second. At that speed, the camera has little time to soak up any ambient light. As a result, the scene is lit primarily by the flash. That caused two problems: The strong flash created some "hot spots" on the subject's skin, and the window frame is much more prominent because of the contrast between it and the darker bushes outside the window. Although it was daylight when I took the picture, the skies were overcast, and the reach of the flash wasn't great enough to illuminate the bushes. So at 1/60 second, the exterior appears dark.

In the slow-sync example, shot at 1/4 second, the exposure time was long enough to permit the ambient light to brighten the exteriors to the point that the window frame almost blends into the background. And because much less flash power was needed to expose the subject, the lighting is much more flattering. In this case, the bright background also helps to set the subject apart because of her dark hair and shirt. If the subject had been a pale blonde, this setup wouldn't have worked as well, of course. Again, too, note the warming effect that can occur when you use Auto White Balance and shoot in a combination of flash and daylight.

Regular fill flash, 1/60 second

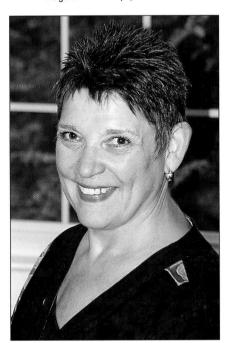

Slow-sync flash, 1/4 second

Figure 9-4: Slow-sync flash produces softer, more even lighting and brighter backgrounds.

Don't forget that a slower-than-normal shutter speed means an increased risk of blur due to camera shake. So use a tripod or otherwise steady the camera. Remind your subjects to stay absolutely still, too, because they'll appear blurry if they move during the exposure. I was fortunate to have both a tripod and a cooperative subject for my examples, but I probably wouldn't try slow-sync for portraits of young children or pets.

• For better portrait results with the V1 flash, try using bounce flash. In other words, aim the flash head upward so that the flash light bounces off the ceiling and falls softly down onto the subject. Compare the two portraits in Figure 9-5 for an illustration. In the first example, aiming the flash directly at the subject resulted in strong shadowing behind the subject and harsh, concentrated light. To produce the better result on the right, I bounced the light off the ceiling. I also moved the subject a few feet farther in front of the background to create more background blur.

Make sure that the ceiling or other surface you use to bounce the light is white; otherwise, the flash light will pick up the color of the surface and influence the color of your subject.

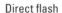

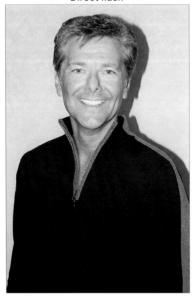

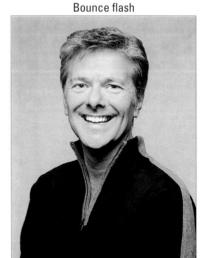

Figure 9-5: To eliminate harsh lighting and strong shadows (left), I used bounce flash and moved the subject farther from the background (right).

Frame the subject loosely to allow for later cropping to a variety of frame sizes. Your camera produces images that have an aspect ratio of 3:2. That means that your portrait perfectly fits a 4-x-6-inch print size but will require cropping to print at any other proportions, such as 5 x 7 or 8 x 10. The Chapter 3 section related to composition talks more about this issue.

Capturing action

A fast shutter speed is the key to capturing a blur-free shot of any moving subject, whether it's a flower in the breeze, a spinning Ferris wheel, or (as in the case of Figure 9-6) a racing cyclist.

Along with the basic capture settings outlined in Table 9-1, try the techniques in the following steps to photograph a subject in motion:

1. Set the Exposure Mode option on the Shooting menu to S (shutter-priority autoexposure).

In this mode, you control the shutter speed, and the camera takes care of choosing an aperture setting that will produce a good exposure.

2. Press the Zoom lever up or down to select the shutter speed.

(Refer to Figure 9-1 to locate shutter speed in the display.) After you select the shutter speed, the camera selects an aperture (f-stop) to match.

What shutter speed should you choose? Well, it depends on the speed at which your subject is moving, so you need to experiment. But generally speaking, 1/320 second should be plenty for all but the fastest subjects (race cars, boats, and so on). For very slow subjects, you can even go as low as 1/250 or 1/125 second. My subject in Figure 9-6 was zipping along at a pretty fast pace, so I set the shutter speed to 1/500 second. Remember, though, that when you increase shutter speed in S

Figure 9-6: Use a high shutter speed to freeze motion.

mode, the camera opens the aperture to maintain the same exposure. At low f-stop numbers, depth of field becomes shorter, so you have to be more careful to keep your subject within the sharp-focus zone as you compose and focus the shot. Increasing ISO will enable you to use a higher f-stop setting and extend depth of field.

You also can take an entirely different approach to capturing action: Instead of choosing a fast shutter speed, select a speed slow enough to blur the moving objects, which can create a heightened sense of motion and, in scenes that feature very colorful subjects, cool abstract images. I took this approach when shooting the carnival ride featured in Figure 9-7, for example. For the left image, I set the shutter speed to 1/30 second; for the right version, I slowed things down to 1/5 second. In both cases, I used a tripod, but because nearly everything in the frame was moving, the entirety of both photos is blurry — the 1/5 second version is simply more blurry because of the slower shutter.

3. In dim lighting, raise the ISO setting if necessary to allow a fast shutter speed.

Unless you're shooting in bright daylight, you may not be able to use a fast shutter speed at a low ISO, even if the camera opens the aperture as

far as possible. If you use one of the three Auto ISO settings, ISO may go up automatically when you increase the shutter speed — Chapter 7 has details on that feature. Raising the ISO does increase the possibility of noise, but a noisy shot is better than a blurry shot.

Why not add flash to brighten the scene? Well, remember that the top shutter speed on the J1 is 1/60 second when you use flash. The same holds true for the V1 when you use the electronic shutter; use the mechanical shutter, and the top shutter speed is 1/250 second. A shutter speed of 1/60 second will rarely be fast enough to capture a moving subject without blur; even 1/250 may not be high enough for fast-moving subjects. In addition, the flash needs time to recycle between shots, slowing your shot-to-shot capture time.

1/30 second

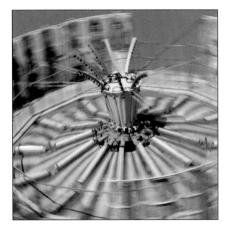

Figure 9-7: Using a shutter speed slow enough to blur moving objects can be a fun creative choice, too.

4. For rapid-fire shooting, use the Continuous shutter-release option.

In that mode, you can capture multiple images with a single press of the shutter button. As long as you hold down the button, the camera continues to record images, at a rate of up to five frames per second. Here again, though, you need to go flash-free; you can't use this Release mode with flash.

Look for the shutter-release mode setting on the Shooting menu; the menu item is called Continuous. You can also consider the Electronic (Hi) release option for an even faster capture rate, but this setting has some drawbacks. See Chapter 2 for details.

5. Select speed-oriented autofocusing options.

Try these two autofocus settings for best performance:

- Set the AF-Area mode to Subject Tracking.
- Set the Focus mode to AF-C (continuous autofocus).

At these settings, the camera tracks your subject as it moves through the frame, and adjusts focus continuously until you take the shot. Do note that Subject Tracking doesn't work well for all subjects, however. If you can't get good results with that AF-Area mode, try Auto Area if you're shooting a subject against a relatively empty background, which makes it easier for the camera to select the correct focus point. For subjects in a crowd, Single Point often works better. Either way, be sure to turn off Face-priority AF, on the Shooting menu, if your subject is surrounded by other people, or the camera may mistakenly set focus on the wrong face. Chapter 8 has details on these autofocus settings.

6. Compose the subject to allow for movement across the frame.

Frame your shot a little wider than you normally might so that you lessen the risk that your subject will move out of the frame before you record the image. You can always crop to a tighter composition later. (I used this approach for my cyclist image — the original shot includes a lot of background that I later cropped away.) It's also a good idea to leave more room in front of the subject than behind it. This makes it obvious that your subject is going somewhere.

Using these techniques should give you a better chance of capturing any fast-moving subject. But action-shooting strategies also are helpful for shooting candid portraits of kids and pets. Even if they aren't currently running, leaping, or otherwise cavorting, snapping a shot before they do move is often tough. So if an interaction catches your eye, set your camera into action mode and fire off a series of shots as fast as you can.

Capturing scenic vistas

Providing specific capture settings for landscape photography is tricky because there's no single best approach to capturing a beautiful stretch of countryside, a city skyline, or other vast subject. Take depth of field, for example: One person's idea of a super cityscape might be to keep all buildings in the scene sharply focused. But another photographer might prefer to shoot the same scene so that a foreground building is sharply focused while the others are less so, thus drawing the eye to that first building.

That said, I can offer a few tips to help you photograph a landscape the way *you* see it:

Shoot in aperture-priority autoexposure mode (A) so that you can control depth of field. If you want extreme depth of field so that both near and distant objects are sharply focused, as in Figure 9-8, select a high f-stop value. For short depth of field, use a low value. Remember that depth of field is also affected by focal length and camera-to-subject distance: For short depth of field, use a long focal length and get close to your subject; for large depth of field, do the opposite. (Chapter 8 offers more information on depth of field.)

Figure 9-8: Use a high f-stop value to keep foreground and background sharply focused.

If the exposure requires a slow shutter, use a tripod to avoid blurring.

The downside to a high f-stop is that you need a slower shutter speed to produce a good exposure. If the shutter speed drops below what you can comfortably handhold, use a tripod to avoid picture-blurring camera shake. Remember that when you use a tripod, Nikon recommends that you turn off Vibration Reduction when using one of the Nikon 1 lenses. Make the change via the Vibration Reduction option on the Shooting menu. (For other lenses, check the lens instruction manual.)

No tripod handy? Look for any solid surface on which you can steady the camera. You can increase the ISO Sensitivity setting to allow a faster shutter, too, but that option brings with it the chances of increased image noise. See Chapter 7 for details.

✓ For dramatic waterfall shots, consider using a slow shutter to create that "misty" look. The slow shutter blurs the water, giving it a soft, romantic appearance, as shown in Figure 9-9. Shutter speed for this

image was 1/5 second. Again, use a tripod to ensure that the rest of the scene doesn't also blur due to camera shake.

In very bright light, you may overexpose the image at a very slow shutter, even if you stop the aperture all the way down and select the camera's lowest ISO setting. As a solution, consider investing in a *neutral-density filter* for your lens. This type of filter works something like sunglasses for your camera: It simply reduces the amount of light that passes through the lens, without affecting image colors, so that you can use a slower shutter than would otherwise be possible.

At sunrise or sunset, base exposure on the sky. The foreground will be dark, but you can usually brighten it in a photo editor if needed. If you base exposure on the foreground, on the other hand, the sky will become so

Figure 9-9: For misty waterfalls, use a slow shutter speed and a tripod.

bright that all the color will be washed out — a problem you usually can't fix after the fact. You can also invest in a *graduated* neutral density filter, which is a filter that's clear on one side and dark on the other. You orient the filter so that the dark half falls over the sky and the clear side over the dimly lit portion of the scene. This setup enables you to better expose the foreground without blowing out the sky colors.

Experiment with turning Active D-Lighting on and off as well. When enabled, this feature makes it possible to create an image that contains a greater range of brightness values than is normally possible. Chapter 7 explains this feature. You also can apply D-Lighting after the fact by using the D-Lighting option on Playback menu; Chapter 11 has details.

For cool nighttime city pics, experiment with slow shutter. Assuming that cars or other vehicles are moving through the scene, the result is neon trails of light like those you see in the foreground of the image in Figure 9-10. Shutter speed for this image was about ten seconds.

Instead of changing the shutter speed manually between each shot, try *bulb* mode. Available only in M (manual) exposure mode, this option records an image for as long as you hold down the shutter button, up to a maximum exposure time of two minutes. So just take a series of images, holding down the button for different lengths of time for each shot.

For the best lighting, shoot during the magic hours. That's the term photographers use for early morning and late afternoon, when the light cast by the sun is soft and warm, giving everything that beautiful, gently warmed look.

Can't wait for the perfect light? Tweak your camera's White Balance setting, using the instructions laid out in Chapter 8, to simulate the color of magic-hour light.

✓ In tricky light, bracket exposures.

Bracketing simply means to take the same picture at several different exposure settings to increase the odds that at least one of them will capture the

Figure 9-10: A slow shutter also creates neon light trails in city-street scenes.

scene the way you envision. Bracketing is especially a good idea in difficult lighting situations, such as sunrise and sunset. In the P, S, and A exposure modes, you can achieve different exposures by using Exposure Compensation, a feature I cover in Chapter 7.

When shooting fireworks, use manual exposure, manual focus, and a tripod. Fireworks require a long exposure, and trying to handhold your camera simply isn't going to work. If using a zoom lens, zoom out to the shortest focal length (widest angle). Switch to manual focusing and set focus at infinity (the top position on the focus-distance scale that appears when you use manual focusing with a Nikon 1 lens). Set the exposure mode to manual, choose a high f-stop setting ─ say, f/16 or so ─ and start at a shutter speed of one to five seconds. From there, it's simply a matter of experimenting with different shutter speeds. Also play with the timing of the shutter release, starting some exposures at the moment the fireworks are shot up, some at the moment they burst

open, and so on. For the example featured in Figure 9-11, I used a shutter speed of about five seconds and began the exposure as the rocket was going up — that's what creates the "corkscrew" of light that rises up through the frame.

Again, for an easy way to vary exposure time between shots, try using the Bulb shutter speed. This technique enables you to experiment with shutter speed more easily because you don't have to use the Zoom lever to adjust the setting between each shot. Remember that this option is available only in the M (manual) exposure mode; it's the setting one step below the slowest shutter speed (30 seconds).

Figure 9-11: I used a shutter speed of five seconds to capture this fireworks shot.

Capturing dynamic close-ups

For great close-up shots, try these techniques:

- Check your lens manual to find out its minimum close-focusing distance. How "up close and personal" you can get to your subject depends on your lens, not the camera body.
- Take control over depth of field by setting the exposure mode to A (aperture-priority autoexposure) **mode.** Whether you want a shallow. medium, or extreme depth of field depends on the point of your photo. In classic nature photography, for example, the artistic tradition is a very shallow depth of field, as shown in Figure 9-12, and requires an open aperture (low f-stop value). But if you want the viewer to be able to see all details clearly, throughout the frame — for example, if you're shooting a product shot for your company's sales catalog — you need to go the other direction, stopping down the aperture as far as possible.

Figure 9-12: Shallow depth of field is a classic technique for close-up floral images.

- Remember that zooming in and getting close to your subject both decrease depth of field. So back to that product shot: If you need depth of field beyond what you can achieve with the aperture setting, you may need to back away, zoom out, or both. (You can always crop your image to show just the parts of the subject that you want to feature.)
- When shooting flowers and other nature scenes outdoors, pay attention to shutter speed, too. Even a slight breeze may cause your subject to move, causing blurring at slow shutter speeds.
- ✓ Use flash for better outdoor lighting. Just as with portraits, a tiny bit of flash typically improves close-ups when the sun is your primary light source. Again, though, keep in mind that the maximum shutter speed possible when you use the built-in flash on the J1 is 1/60 second, as it is for the V1 when the electronic shutter is used. When you use the V1's mechanical shutter, top shutter speed with flash is 1/250 second. So in very bright light, you may need to use a high f-stop setting to avoid overexposing the picture. You can also adjust the flash output via the Flash Compensation control. Chapter 7 offers details.
- When shooting indoors, try not to use flash as your primary light source. Because you're shooting at close range, the light from your flash may be too harsh even at a low Flash Compensation setting. If flash is inevitable, turn on as many room lights as possible to reduce the flash power that's needed even a hardware-store shop light can do in a pinch as a lighting source. (Remember that if you have multiple light sources, you may need to tweak the White Balance setting.)

Part IV The Part of Tens

In this part . . .

n time-honored *For Dummies* tradition, this part of the book contains additional tidbits of information presented in the always popular "Top Ten" list format. Chapter 10 offers ten cameramaintenance tips and emergency repair tips, and Chapter 11 introduces you to ten camera functions that I consider specialty tools — bonus options that, although not at the top of the list of the features I suggest you study, are nonetheless interesting to explore when you have a free moment or two.

Top Ten Maintenance and Emergency Care Tips

In This Chapter

- Preserving battery juice
- Keeping firmware up to date
- Safeguarding your camera from dirt, heat, cold, and other dangers
- Dealing with unsightly image spots
- Protecting your picture files
- Recovering accidentally deleted photos

he old Boy Scout motto, "Be prepared," applies in spades when it comes to digital photography. Although you can't foresee all potential incidents that might snag your photo shoot, you can keep your camera in tip-top condition and practice some basic preventive measures to ensure that your equipment stays safe and in good working order. This chapter provides strategies to help you do just that — and, for times when your best efforts aren't enough, some tips for dealing with unexpected emergencies.

Extend Battery Life

Digital cameras are hungry for battery power, and the Nikon 1 is no exception. To avoid missing important photographic opportunities, you may want to invest in a spare battery so that you don't waste precious time waiting for your battery to recharge when you could be taking pictures.

The amount of time and number of photos that you can shoot before replacing your battery varies depending on how you use your camera. If you start to run low on battery power, try these energy-conservation tips:

✓ **Use the shortest possible auto-off timing.** By default, your camera turns the monitor off automatically after 30 seconds of inactivity. You can reduce the wait time to 15 seconds via the Auto Power Off option on the Setup menu, shown in Figure 10-1. To bring the display back to life, just press any camera button.

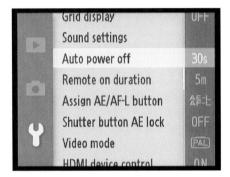

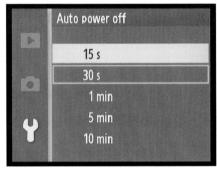

Figure 10-1: Reducing the wait time for the automatic monitor shutoff can help preserve battery power.

On the V1, you also can press the Disp button to turn the monitor off. Depending on the current display mode, you may need to press the button once or twice. Press again to turn the display back on. See Chapter 1 for more information about the available display modes on both the V1 and J1.

- ✓ **Go flash-free.** Whether you're using the J1's built-in flash or the V1's accessory flash, the flash consumes lots of battery juice. When the flash recycle time starts to slow down, that's a clue that your batteries are fading.
- Don't use the GPS accessory. This accessory also requires battery power, so doing without can help you get a few more pictures per battery charge.
- ✓ Turn off Vibration Reduction. You also can save battery power by setting the Vibration Reduction option on the Shooting menu to Off. Of course, you then have to be careful to avoid camera shake when taking pictures, or you can wind up with blurry photos. See Chapter 2 for details about Vibration Reduction.
- ✓ Select JPEG, not NEF (Raw) as the file type. The camera needs a bit more battery power to record Raw images. Make your choice via the Image Quality option on the Shooting menu; see Chapter 2 for help understanding this setting.

- Avoid keeping the shutter button pressed halfway for extended periods. While the button is pressed halfway, the exposure system is working and, if you're using continuous autofocusing, the focusing system is also tracking focus. So wait until you're ready to shoot before you press that button halfway to initiate exposure metering and focusing.
- **Keep the camera (and spare batteries) warm.** Batteries deplete faster when they get cold, so in cold weather, try to find a way to keep the camera warm between shots. If you have a spare battery, tuck it into a shirt pocket to keep the chill off.

Clean the Lens and LCD with Care

Is there anything more annoying than a dirty lens? Let's face it: Fingerprints, raindrops, and dust happen, and they all get in the way of the perfect image. And LCD monitors also can get gunked up pretty easily.

To clean your lens and monitor, stick with these tools:

- ✓ A **microfiber cloth** (like the ones used for cleaning eyeglasses). It works either with or without lens-cleaning fluid, depending on the cloth.
- Any **cotton product**, such as a t-shirt or dishtowel, is usually okay as long as it's clean and lint-free.
- A manually operated bulb blower commonly available in any camera store. Some come with a little natural-fiber brush, which is also okay. It's a good idea to use this type of tool *before* wiping your lens if it's especially dirty you want to ensure that bigger particles of dirt aren't rubbed into the lens.

Do not use any of the following to clean the lens or monitor:

- ✓ The same microfiber cloth you use for your glasses. It may have oily residue from your face.
- Facial tissue, newspaper, napkins, or toilet paper. These are made from wood products and can scratch glass and plastic and can harm a lens coating.
- Household cleaning products (window cleaner, detergent, toothpaste, and the like).
- Compressed air. These cans contain a chemical propellant that can coat your lens or LCD with a permanent residue. Even more scary, compressed air can actually crack the monitor.
- Synthetic materials (like polyester). They usually don't clean well anyway.
- Any cloth that's dirty or has been washed with a fabric softener.

Update Your Firmware

Firmware is the internal software that lives permanently on your camera, telling it how to operate and function — in essence, it's your camera's gray matter.

Every now and then, camera manufacturers update firmware to fix problems and bugs, enhance features, and generally do housekeeping that makes your camera operate better. Sometimes these changes are minor, but occasionally they fix pretty serious problems and errors.

To benefit from these updates, you have to download the new firmware files from the Nikon website and install them on your camera. If you registered your camera (you *did* do that, right?), Nikon should inform you of updates when they occur. But it's a good idea to also simply check the Nikon support page every three months or so to make sure that you don't miss an important firmware update. You'll find instructions on how to download and install the updates on the site.

You can see what firmware versions are currently installed on your camera by selecting the Firmware Version option on the Setup menu, as shown in Figure 10-2. On the V1, the A and B software relates to camera operation; L, to lens operation; and S, to the SB-N5 accessory flash. The J1 firmware is the same but doesn't have the flash-firmware item. Note that the lens firmware is specific to the Nikon 1 lens you use.

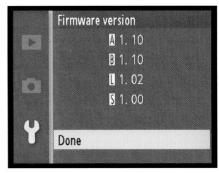

Figure 10-2: Choose this menu option to see what versions of the camera firmware are installed.

Protect Your Camera from the Elements

Remember that a digital camera is pretty much a computer with a lens — and (like any electronic device) your camera isn't designed to cope with weather extremes. So take these safety steps:

- Don't let your camera catch a cold. Extreme cold can cause various mechanical functions in your camera to freeze; it can stop your lens from zooming or your shutter release button from operating. Your monitor may stop functioning as well, and your battery power may drop so much that your camera won't even turn on. If you must take your camera into the cold, keep it in a camera case under your jacket until you're ready to use it.
- Don't let it get heat stroke, either. Extreme heat can damage your camera as well and can be especially hard on your monitor, which can "go dark" if it gets too hot. If this happens, simply get your camera to a cooler place. Typically, it will return to a normal viewing state. Although heat generally doesn't cause as many problems as cold, leaving your camera in direct sunlight (such as in a car) isn't a good idea. If you can at least cover it with a towel or t-shirt, your camera will be happier.
- **Don't focus on the sun.** When shooting in strong sunlight, avoid composing pictures with the sun shining directly into the lens. That direct sunlight can damage the camera and even cause it to catch fire.

Additionally, never look at the sun through the V1 viewfinder; doing so can harm your eyes.

- ✓ Avoid rapid changes in temperature. Changing temperature extremes, such as going from a warm room into sub-freezing weather, are especially bad for your camera. Condensation forms on the camera parts and lens elements, which can (at best) obstruct your ability to take good photos and (at worst) cause permanent moisture damage.
- ✓ Keep it dry. Digital cameras, like most other electronic devices, don't do well if they get wet. Water especially salt water can short-circuit important camera circuitry and corrode metal parts. A few raindrops probably won't cause any big problems, but exposure to enough water, even momentarily, can result in a death sentence for a camera.

If you do accidentally leave your camera on the picnic table during a downpour or drop it in the swimming pool, all may not be lost — but act fast: Remove the batteries and memory card, wipe the camera with a clean, dry cloth — try not to push any camera buttons in the process — and set it in a warm place where it can dry out as much and as quickly as possible. You can even try sealing it in a plastic bag along with some uncooked rice — the rice grains will absorb some of the moisture. With luck, the camera will come back to life after it's had time to dry out. If not, it's off to the repair shop to see whether anything more can be done.

Reduce Display Flickering or Banding

The operating frequency of some types of lights, including fluorescent and mercury-vapor lamps, can create electronic interference that causes the monitor display to flicker or exhibit odd color banding.

You may be able to resolve this issue by changing the Flicker Reduction option on the Setup menu, shown in Figure 10-3. You're supposed to match the setting to the frequency of the electrical current being used by the lights, but if you're not sure what that frequency is and an electrical engineer isn't handy, just try changing the setting and see which one works best. You can choose from two options, 50Hz and 60Hz. (In the U.S. and Canada, the standard frequency is 60 Hz, and in Europe, it's 50 Hz.)

Either way, the interference affects only the monitor display; the flicker or banding doesn't show in your pictures or movies.

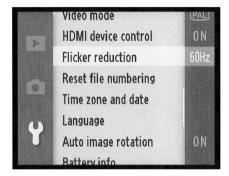

Figure 10-3: To reduce display flickering that can occur when you shoot by fluorescent light, try changing the Flicker Reduction setting.

Clean the Image Sensor

The *image sensor* is the part of your camera that absorbs light and converts it into a digital image. If dust, hair, or dirt gets on the sensor, it can show up as small spots on your photos. Image-sensor spots are often most visible in the sky or in bright, clear areas of your image, but can be seen just about anywhere.

If you notice sensor dirt, take your camera to a repair shop to have the sensor cleaned manually. Although you can find products designed to help you do this job yourself, you do so at your peril. This job is a delicate one, and really should be done only by a trained technician. Call your local

camera store to find out the best place in town to have the cleaning done. (Some camera stores offer free cleaning for cameras purchased from them.)

You can help limit the amount of dust and dirt that finds its way to your image sensor by keeping the camera stored in a case or camera bag when not in use and being cautious when shooting in dicey environmental situations — windy days on the beach, for example. Be especially careful when changing lenses, because that's a prime occasion for dirt to sneak into the camera. Also try to point the camera slightly downward when you attach the lens; doing so can help prevent dust from being sucked into the camera by gravity.

Run the Pixel Mapping Tool

If you notice weird bright spots on all your photos, it may be a sign that you need to run the camera's Pixel Mapping tool. This feature optimizes the image sensor and the internal image-processing functions.

Note that if you bought one of the first V1 or J1 cameras to hit the market, you probably need to update the camera's firmware in order to install this feature in the camera. The update in question upgraded the A and B firmware items to version 1.10.

To run the tool, follow these steps:

- 1. Place the lens cap on your lens.
- 2. Turn the camera on.
- 3. Display the Setup menu, choose Pixel Mapping, as shown in Figure 10-4, and press OK.

You see a confirmation screen that asks permission to map the pixels.

4. Highlight Yes and press OK.

The camera displays a message telling you that it's mapping pixels and warning you not to turn the camera off. The process takes a little while, so be patient.

Figure 10-4: Pixel mapping is designed to optimize the sensor and the camera's image-processing functions.

5. When the pixel mapping is complete, turn the camera off.

If you still see image defects after running the Pixel Mapping tool, your sensor may need cleaning. See the preceding section for tips on that task.

Safeguard Your Picture Files

To make sure that your digital photos enjoy a long, healthy life, follow these storage guidelines:

- ✓ Don't rely on your computer's hard drive for long-term, archival storage. Hard drives occasionally fail, wiping out all files in the process. This warning applies to both internal and external hard drives. At the very least, having a dual-drive backup is in order you might keep one copy of your photos on your computer's internal drive and another on an external drive. If one breaks, you still have all your goodies on the other one.
- Camera memory cards, flash memory keys, and other portable storage devices, such as one of those wallet-sized media players, are similarly risky. All are easily damaged if dropped or otherwise mishandled. And because of their diminutive stature, these portable storage options also are easily lost.
- ✓ The best way to store important files is to copy them to nonrewritable DVDs. (The label should say DVD-R, not DVD-RW or DVD+RW.) Look for quality, brand-name, archival DVDs that have a gold coating, which offer a higher level of security than other coatings and boast a longer life than your garden-variety DVDs.
 - Do be aware, though, that the DVDs you create on one computer may not be playable on another because multiple recording formats and disc types exist: DVD minus, DVD plus, dual-layer DVD, and so on. So if you upgrade computers, be sure that your old DVDs are readable by your new DVD player; if not, make new backups using the new drive.
- For a double backup, check into online storage services. A few popular services are Mozy (www.mozy.com), IDrive (www.idrive.com), and Carbonite (www.carbonite.com). You pay a monthly subscription fee to back up your important files to the site's servers.

Note the critical phrase here: *double backup*. Online storage sites have a troubling history of closing down suddenly, taking all their customers' data with them. (One extremely alarming case was the closure of a photography-oriented storage site called Digital Railroad, which gave clients a mere 24-hours' notice before destroying their files.) So anything you store online should be also stored on DVD or CD and kept in your home or office. Also note that photo-sharing sites such as Shutterfly, Picasa, and the like *aren't* designed to be long-term storage tanks for your images. Usually, you get access to only a small amount of file storage space, and the site may require you to purchase prints or other photo products periodically to maintain your account.

Use Image-Recovery Software to Rescue Lost Photos

It happens to everyone sooner or later: You accidentally erase an important picture — or worse, an entire folder full of images. Don't panic yet — you may be able to get those pictures back.

The first step: *Stop shooting*. If you take another picture, you may not be able to rescue the deleted files. If you must keep shooting, and you have another memory card, replace the one that has the accidental erasure with the other card. You can work with the problem card later.

For pictures that you erased using the camera's delete function, go online or to your local computer store to buy a file-recovery program such as Lexar Image Rescue (\$34; www.lexar.com) or SanDisk RescuePro (\$39 for one-year subscription; www.sandisk.com). For these programs to work, your computer must be able to access the camera's memory card as if the card were a regular drive on the system. So if your camera doesn't show up as a drive when you connect it to the computer (as is the case with Apple computers running some versions of the Mac operating software), you need to buy a card reader.

If you erased pictures on the computer, you may not need any special software. In Windows, deleted files go to the Recycle Bin and stay there until you empty the Bin. Assuming that you haven't taken that step, just use Windows Explorer to open the Bin, click an erased file, and then choose FileDRestore to "un-erase" the picture. On a Mac, deleted files linger in the Trash folder until you choose the Empty Trash command. Until you do, you can open the Trash folder and move the deleted file to another folder on your hard drive.

Already emptied the Recycle Bin or Trash? You also can buy programs to recover files that were dumped in the process; start your software search at the two aforementioned websites.

Use the Strap!

Take the time to attach the nifty Nikon 1 neck strap that ships with your camera. Should you stumble while shooting, that strap could prevent the camera from hitting the pavement.

Once you have the strap attached, though, you still have to pay attention. I see too many photographers with cameras slung over their shoulders instead

of around the neck, strolling casually down the street, the camera swaying this way and that, perilously close to walls, doors, and other objects that could damage the lens with one sharp bump.

One other word of caution: When you set your camera on a table, desk, or whatever, don't leave the strap hanging down off the side. It's too easy for someone passing by to inadvertently brush against the strap and send the whole camera crashing to the ground. Sadly, I learned this very expensive lesson the hard way — in my case, that "someone" was my four-footed furry friend. Fortunately (for him), he is so darned cute that I couldn't stay mad for long, but I still miss the lens that got broken in the process.

Ten Special-Purpose Features to Explore on a Rainy Day

In This Chapter

- > Trimming excess background from a shot
- Improving exposure with D-Lighting
- ▶ Changing the function of some controls
- Automating time-lapse photography
- Switching from sRGB to Adobe RGB
- Creating custom Picture Controls
- Printing without a computer
- Getting help from Nikon

onsider this chapter the literary equivalent of the end of one of those late-night infomercial offers — the part where the host exclaims, "But wait! There's more!"

The ten features covered in these pages fit the category of "interesting bonus." They aren't the sort of features that drive people to choose one camera over another, and they may come in handy only for certain users, on certain occasions. Still, they're included at no extra charge with your camera purchase, so check 'em out when you have a few spare moments. Who knows — you may discover that one of these bonus features is actually a hidden gem that provides just the solution you need for one of your photography problems.

Cropping Your Picture in the Camera

To *crop* a photo simply means to trim away some of its perimeter. Cropping away excess background can often improve an image, as illustrated by Figures 11-1 and 11-2. When shooting this scene, I couldn't get close enough to the ducks to fill the frame with them, so I simply cropped it after the fact to achieve the desired composition.

Figure 11-1: The original contains too much extraneous background.

Figure 11-2: Cropping creates a better composition and eliminates background clutter.

With the Crop function on the Playback menu, you can crop a photo right in the camera. Note a few things about this feature:

- You can crop your photo to four different aspect ratios: 3:2, which maintains the original proportions and matches that of a 4-x-6-inch print; 4:3, the proportions of a standard computer monitor or television (that is, not a wide-screen model); 1:1, which results in a square photo; and 16:9, which is the same aspect ratio as a wide-screen monitor or television. If your purpose for cropping is to prepare your image for a frame size that doesn't match any of these aspect ratios, crop in your photo software instead.
- ✓ For each aspect ratio, you can choose from a variety of crop sizes, which depend on the size of your original. The sizes are stated in pixel terms, such as 3424 x 2280. If you're cropping in advance of printing the image, remember to aim for at least 200 pixels per linear inch of the print 800 x 1200 pixels for a 4-x-6-inch print, for example. See Chapter 6 for more details about printing.
- ✓ If you captured the original photo using the Raw or Raw+JPEG Fine Image Quality setting, the cropped version is saved as a JPEG Fine image. For other JPEG images, the crop version has the same Image Quality level as the original (Fine, Normal, or Basic).
- After you apply the Crop function, you can't apply the other retouching option on the Playback menu, the D-Lighting filter (explained next). So apply that filter first if you want to use it. You also can't crop a resized copy of an original picture (I cover the Resize function in Chapter 6).

Keeping those caveats in mind, crop your image as follows:

- 1. Display the Playback menu and select Crop, as shown in Figure 11-3.
- 2. Press OK to display thumbnails of your photos.
- Use the Multi Selector to highlight the photo you want to crop and then press OK.

You see the screen shown in Figure 11-4. The yellow highlight box indicates the current cropping frame. Anything outside the frame is set to be trimmed away.

Figure 11-3: The Crop function on the Playback menu creates a trimmed copy of your original image.

4. Rotate the Multi Selector to change the crop aspect ratio.

The selected aspect ratio appears in the upper-right corner of the screen, as shown in Figure 11-4.

Adjust the size and placement of the cropping frame size as needed.

The current crop size appears in the upper-left corner of the screen. You can adjust the size and placement of the cropping frame like so:

> • Reduce the size of the cropping frame. Press the Zoom lever down. Each press further reduces the crop size.

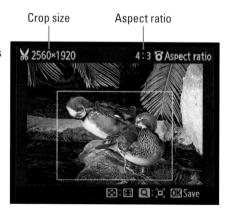

Figure 11-4: Rotate the Multi Selector to change the aspect ratio; press the Zoom lever up and down to adjust the crop-box size.

- Enlarge the cropping frame. Press the Zoom lever up to expand the crop boundary and leave more of your image intact.
- *Reposition the cropping frame*. Press the Multi Selector up, down, right, and left to shift the frame position.

6. Press OK to create a cropped copy of the original image.

The filename of the new image begins with CSC instead of the normal DSC to let you know that you're looking at an edited photo. In the Detailed Photo Information playback display, you also see a Retouch icon in the upper-right corner of the screen; see Chapter 5 for a look at the symbol and more about picture playback.

Shadow Recovery with D-Lighting

Chapter 7 introduces you to a feature called Active D-Lighting. If you turn on this option when you shoot a picture, the camera captures the image in a way that brightens the darkest parts of the image while leaving highlight details intact. It's a great trick for dealing with high-contrast scenes or subjects that are backlit.

You also can apply a similar adjustment after you take a picture by choosing the D-Lighting option on the Playback menu. I did just that for the photo in Figure 11-5, where strong backlighting left the balloon underexposed in the original image.

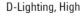

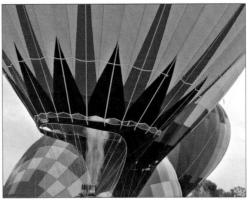

Figure 11-5: An underexposed photo (left) gets help from the D-Lighting filter (right).

Here's how to apply the filter:

- 1. Display the Playback menu and choose D-Lighting, as shown in Figure 11-6.
- 2. Press OK to display thumbnails of your photos.
- 3. Use the Multi Selector to vhighlight the picture and then press OK.

Now you see a screen like the one in Figure 11-7, showing before and after views of your picture.

 Select the level of adjustment by pressing the Multi Selector up or down.

You get three levels: Low, Normal, and High. I used High for the repair to my balloon image.

To see a magnified view of the adjusted photo, press and hold the Zoom lever up. Release the lever to return to the two-thumbnail display.

5. To go forward with the correction, press OK.

Figure 11-6: Apply the D-Lighting filter via the Playback menu.

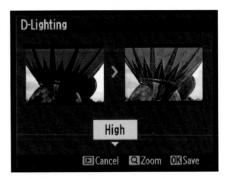

Figure 11-7: Press the Multi Selector up and down to change the amount of the correction.

The camera creates your retouched copy, using a filename that begins with the letters CSC instead of the usual DSC. As with cropped photos, you also see a Retouch icon in the upper-right corner of the screen if you set the Playback display mode to Detailed Photo Information mode.

Note that you can't apply D-Lighting to an image if you captured the photo with the Picture Control feature set to Monochrome. (See Chapter 8 for details on Picture Controls.) Nor does D-Lighting work on pictures you created by using the Crop tool, explained in the preceding section, or the Resize tool, covered in Chapter 6.

Changing the Function of the AE-L/AF-L Button

With the AE-L/AF-L button — the up button on the Multi Selector — you can lock focus and exposure settings when you shoot in the P, S, and A exposure modes, as explored in Chapters 7 and 8.

Normally, autofocus and autoexposure are locked when you press the button, and they remain locked as long as you keep your finger on the button. But you can change the button's behavior. To access the available options, open the Setup menu and highlight Assign AE/AF-L button, as shown on the left in Figure 11-8. Press OK to display the three button options, as shown on the right in the figure.

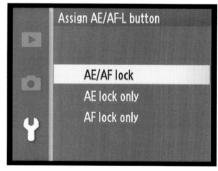

Figure 11-8: You can set the AE-L/AF-L button to lock autoexposure only if you prefer.

The options produce these results:

✓ **AE/AF Lock:** This is the default setting. Focus and exposure remain locked as long as you press the button.

- ✓ AE Lock Only: Autoexposure is locked as long as you press the button; autofocus isn't affected. (You can still lock focus by pressing the shutter button halfway, assuming that you set the Focus mode to AF-S or, if you use AF-A mode, the camera doesn't detect a moving subject.)
- AF Lock Only: Focus remains locked as long as you press the button. Exposure isn't affected.

After highlighting the option you want to use, press OK.

The information that I give in this book with regard to using autofocus and autoexposure assumes that you stick with the default setting. So if you change the button's function, remember to amend my instructions accordingly.

Using the Shutter Button to Lock Exposure and Focus

The Setup menu offers another button tweak called Shutter Button AE Lock, as shown in Figure 11-9. This option, which affects the camera only when you use the P, S, or A exposure mode, determines whether pressing the shutter button halfway locks focus only or locks both focus and exposure.

At the default setting, Off, you lock focus only when you press the shutter button halfway. (Again, this result assumes that you're not using the AF-C Focus mode, which adjusts focus continuously until you capture the

Figure 11-9: If you turn on this option, pressing the shutter button halfway locks exposure and focus.

picture.) Exposure is adjusted continually up to the time you take the shot. If you change the setting to On, your half-press of the shutter button locks both focus and exposure.

As with the AE-L/AF-L button adjustment described in the preceding section, I recommend that you leave this option set to the default while you're working with this book. Otherwise, your camera won't behave as described here (or in the camera manual, for that matter). If you encounter a situation that calls for locking exposure and focus together, you can always use the AE-L/AF-L button. Chapter 7 provides details.

Trying Automated Time-Lapse Photography

With the Interval Timer Shooting option on the Shooting menu, you can set the camera to release the shutter automatically at intervals ranging from seconds to hours apart. This feature enables you to capture a subject as it changes over time — a technique commonly known as *timelapse photography* — without having to stand around pressing the shutter button the whole time.

You can take advantage of this feature only when using the P, S, A, or M exposure mode. See Chapter 7 for an introduction to these modes, which you select via the Exposure Mode option on the Shooting menu.

After setting the exposure mode to one of the aforementioned four settings, follow these steps:

1. Set the Release mode to Single Frame.

You can also use the Continuous mode, but the camera still takes one shot at a time, just as if you had selected Single Frame. The Self-Timer and remote-control modes aren't compatible with Interval Timer Shooting. Select the Single Frame setting via the Continuous option on the Shooting menu. (See Chapter 2 for details.)

2. Display the Shooting menu, highlight Interval Timer Shooting, as shown on the left in Figure 11-10, and press OK.

The screen on the right in Figure 11-10 appears.

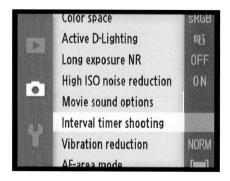

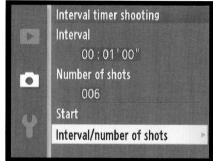

Figure 11-10: The Interval Timer Shooting feature enables you to do automated time-lapse photography.

3. To begin setting up your capture session, highlight Interval/ Number of Shots and press the Multi Selector right.

You see the screen shown in Figure 11-11.

4. Set up your recording session.

You get two options: Interval (time between shots), and Number of Shots (total number of images recorded).

For each option, little value boxes appear. The highlighted box is the active option. For

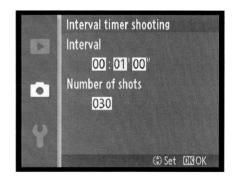

Figure 11-11: Set the time between shots (Interval) and the total number of shots for your time-lapse photography session.

example, in the figure, the minute box for the Interval setting is active. (The box to the left is for hours; the box to the right, seconds.) Press the Multi Selector right or left to cycle through the value boxes; to change the value in a box, press the Multi Selector up or down. Note that the Interval option is based on a 24-hour clock.

5. When you're done setting up the capture options, press OK.

You're returned to the initial Interval Timer Shooting screen (the right screen in Figure 11-10.)

6. Highlight Start and press OK.

The first shot is recorded about three seconds later.

A few final factoids:

- ✓ To interrupt Interval Timer Shooting, turn off the camera. Or move the Mode dial to a different setting or press the Menu or Playback button.
- Menus are disabled while the interval sequence is in progress. Again, if you press the Menu button, you cancel Interval Timer Shooting. You can't adjust any settings that are controlled via the external buttons, either.
- If you're using autofocusing, be sure that the camera can focus on your subject. It will initiate focusing before each shot. See Chapter 8 for details about autofocusing.
- ✓ When the interval sequence is complete, the Interval Timer Shooting menu option is reset to Off. The card access light on the back of the camera stops blinking shortly after the final image is recorded to the memory card.

Changing the Color Space

By default, your camera captures images using the *sRGB color space*, which simply refers to an industry-standard spectrum of colors. (The *s* is for *standard*, and the *RGB* is for *red*, *green*, *blue*, which are the primary colors in the digital color world.) The sRGB color space was created to help ensure color consistency as an image moves from camera (or scanner) to monitor and printer; the idea was to create a spectrum of colors that all these devices can reproduce.

However, the sRGB color spectrum leaves out some colors that *can* be reproduced in print and onscreen, at least by some devices. So as an alternative, your camera also enables you to shoot in the Adobe RGB color space, which includes a larger spectrum (or *gamut*) of colors. Figure 11-12 offers an illustration of the two spectrums. You can use the larger color space in Still Image and Smart Photo Selector shooting modes.

Some colors in the Adobe RGB spectrum can't be reproduced in print. (The printer just substitutes the closest printable color, if necessary.) Still, I usually shoot in Adobe RGB mode because I see no reason to limit myself to a smaller spectrum from the get-go.

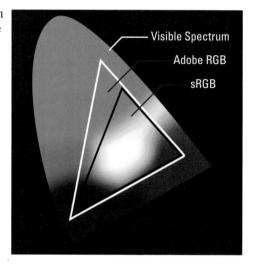

Figure 11-12: Adobe RGB includes some colors not found in the sRGB spectrum but requires some color-management savvy to use to its full advantage.

However, just because I use Adobe RGB doesn't mean that it's right for you. First, if you plan to print and share your photos without making any adjustments in your photo editor, you're usually better off sticking with sRGB because most printers and web browsers are designed around that color space. Second, know that to retain all your original Adobe RGB colors when you work with your photos, your editing software must support that color space — not all programs do. You also must be willing to study the whole topic of digital color a little bit because you need to use some specific settings to avoid really mucking up the color works.

If you want to go with Adobe RGB instead of sRGB, first make sure that the Mode dial is set to either Still Image or Smart Photo Selector mode. Then visit the Shooting menu and highlight the Color Space option, as shown on the

left in Figure 11-13. Press OK to display the screen shown on the right in the figure. Select Adobe RGB and press OK again.

Figure 11-13: Change the Color Space setting via the Shooting menu.

You can tell whether you captured an image in the Adobe RGB space by looking at its filename: Adobe RGB images start with an underscore, as in _DSC0627.jpg. For pictures captured in the sRGB color space, the underscore appears in the middle of the filename, as in DSC_0627.jpg. See Chapter 5 for more tips on decoding picture filenames.

Customizing a Picture Control

When you shoot in the JPEG file format, introduced in Chapter 2, the camera tweaks exposure, color, and sharpness according to the Picture Control setting. For example, the Landscape Picture Control results in more intense blues and greens, whereas the Portrait Picture Control produces softer, warmer skin tones. You can see examples of how each of the six available Picture Controls affect your photo in Chapter 8.

If you decide that none of the Picture Controls suits your needs, you have the option of modifying any of them. For example, if you like the bold colors of Landscape mode but don't think the effect goes far enough, you can adjust the setting to amp up the colors even more.

Here's how to adjust a Picture Control:

1. Set the Mode dial to Still Image or Movie mode and then set the Exposure Mode option to P, S, A, or M.

These are the only modes that let you select a Picture Control.

2. Display the Shooting menu and choose Picture Control, as shown on the left in Figure 11-14.

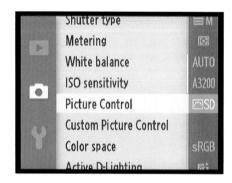

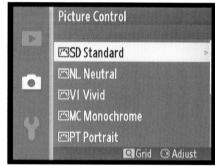

Figure 11-14: Start here to modify a Picture Control.

- 3. Press OK to display the right screen in Figure 11-14.
- 4. Highlight the Picture Control you want to modify.

For example, I highlighted the Standard setting on the right screen in Figure 11-14.

5. Press the Multi Selector right.

You see the screen shown in Figure 11-15, containing sliders that you use to modify the Picture Figure 11-15: Highlight a picture characteristic Control. Which options you can adjust depend on your selected Picture Control.

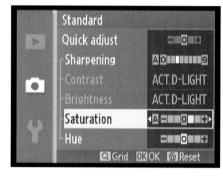

and then press the Multi Selector right or left to adjust the setting.

6. Highlight a picture characteristic and then press the Multi Selector right or left to adjust the setting.

A couple tips:

- Some Picture Controls offer a Quick Adjust setting, which enables you to easily increase or decrease the overall effect of the Picture Control. A positive value produces a more exaggerated effect; set the slider to 0 to return to the default setting.
- The thick vertical bar in the slider bar indicates the current setting for the option.

- Reset all the options to their defaults by pressing the Delete button.
- To display a grid that lets you see how your selected Picture Control compares with the others in terms of color saturation and contrast, as shown in Figure 11-16, press and hold the Zoom lever up. (I vote this screen Most Likely to Confound New Camera Users Who Stumble Across It.) Note that the Standard and Portrait settings are identical in terms of contrast and saturation, so the P for Portrait doesn't appear in the grid unless you selected that Picture Control initially.

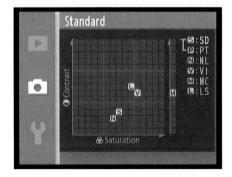

Figure 11-16: Press the Zoom In button to display a grid that ranks each Picture Style according to its level of saturation and contrast.

You can't change any settings via the grid — it's for informational purposes only. However, if you display the grid from the first Picture Control menu (the right screen in Figure 11-14), you can press the Multi Selector up or down to select a different Picture Control. You then can press right to access the Picture Control adjustment screen.

7. Press OK to save your changes and exit the adjustment screen.

An asterisk appears next to the edited Picture Style in the menu to remind you that you've adjusted it.

To restore the original Picture Control settings, follow Steps 1 through 4, press the Delete button, and then press OK.

Saving a Custom Picture Control

In addition to modifying one of the six preset Picture Controls, you can create and save your very own, custom Picture Control. In fact, you can create as many as nine custom Picture Controls. Here's how to do it:

1. Set the Mode dial to any setting but Smart Photo Selector.

Oddly, you can create a Custom Picture Control in all the other modes as well as when Scene Auto Selector is chosen for the Still Image exposure mode. However, you can select and apply your custom Picture Control only in the P, S, A, and M Still Image and Movie exposure modes.

2. Open the Shooting menu and select Custom Picture Control, as shown on the left in Figure 11-17.

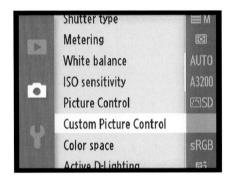

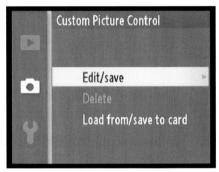

Figure 11-17: Use this option to create and save your very own Picture Control.

- 3. Press OK to display the screen shown on the right in Figure 11-17.
- 4. Highlight Edit/Save and press the Multi Selector right to display the screen shown on the left in Figure 11-18.

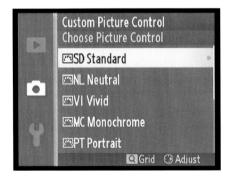

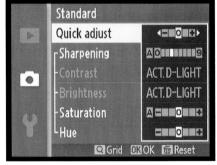

Figure 11-18: Select a Picture Control, press the Multi Selector right, and modify the settings as desired.

Select the Picture Control that's closest to the kind of custom Picture Control you want to create. Then press the Multi Selector right.

Now you see the same screen you use to modify an existing Picture Control, as shown on the right in Figure 11-18.

6. Set the Picture Control characteristics and press OK to display the screen shown in Figure 11-19.

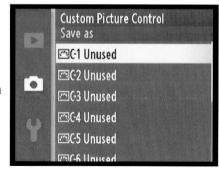

Figure 11-19: Save your Picture Control in any of the nine available storage slots.

The screen lists nine available Picture Control storage slots, labeled C1 through C9.

7. Choose a slot (C1 through C9) to hold your Picture Control and press OK.

You're returned to the Shooting menu. If you call up the Picture Control option on that menu, you should see your new Picture Control at the bottom of the list of menu options. (Remember that you can select the Picture Control option only in Still Image or Movie mode, and only when you select P, S, A, or M as the Exposure Mode setting.)

To delete a custom Picture Control, choose the Delete command instead of Edit/Save in Step 4. Highlight the Picture Control you want to trash and press OK. When the confirmation screen appears, highlight Yes and press OK. You can also simply overwrite an existing Picture Control with a new one; just choose the number (C1 through C9) of the existing control in Step 7.

Printing Directly from Your Camera or Memory Card

Nikon 1 cameras offer two features that enable you to print directly from your camera or a memory card, assuming that your printer offers the required options:

✓ DPOF (Digital Print Order Format): With this option, accessed via the DPOF Print Order option on the Playback menu, you select pictures from your memory card to print and then specify how many copies you want of each image. You also can choose to print the shooting

data and print date with the photo. Then, if your photo printer has a Secure Digital (SD) memory card slot (or SDHC/SDXC slots, if you use these new, high-capacity cards) and supports DPOF, you just pop the memory card into that slot. The printer reads your "print order" and outputs just the requested copies of your selected images. (You use the printer's own controls to set paper size, print orientation, and other print settings.)

✓ PictBridge: This direct-printing feature works a little differently. If you have a PictBridge-enabled photo printer, you can connect the camera to the printer by using a USB cable. (You use the same cable as for picture downloads.) A PictBridge interface appears on the camera monitor, and you use the camera controls to select the pictures you want to print. With PictBridge, you specify additional print options from the camera, such as page size and whether to print a border around the photo.

Both DPOF and PictBridge are especially useful when you need fast printing. For example, if you shoot pictures at a party and want to deliver prints to guests before they go home, DPOF and PictBridge offer quicker options than firing up your computer, downloading pictures, and so on. And, if you invest in one of the tiny portable photo printers on the market today, you can easily make prints away from your home or office. You can take both your portable printer and camera along to your regional sales meeting, for example.

If you're interested in exploring either printing feature, look for details in the electronic version of your camera manual, provided on one of the two CDs that shipped with the camera.

Getting Free Help and Creative Ideas

Okay, so this last one's a bit of a cheat: It isn't actually found on your camera, but it will help you better understand the features that are. I speak of the Nikon website, which you can access at www.nikonusa.com.

If you haven't yet visited the site, I encourage you to do so. In the Service and Support section of the site, you can get free technical support for camera problems, download an electronic copy of your camera manual (should you happen to misplace the one that shipped in the camera box), and get updates to Nikon software. Most importantly, check periodically to make sure that your camera is running the latest firmware, which is the geekspeak term for the camera's internal software. (Chapter 10 offers some additional information about firmware.)

Additionally, check out the Learn and Explore link, which leads you to all kinds of photography tips, tutorials, and other goodies, including the online version of Nikon World magazine. For even more fun, scroll down to the very bottom of the page and look for a link to my Picturetown, which is Nikon's free online photo sharing site. (You can also go there directly via www. mypicturetown.com.) You get 2GB of free photo storage or can upgrade to a pald subscription for additional storage space. If you use the free Nikon ViewNX 2 software that shipped with your camera, you can upload photos directly from that program to your online albums.

If you're based outside the United States, by the way, you may prefer to start your exploration at the global Nikon site, www.nikon.com; just know that not all the features available at the U.S. site are provided at sites oriented to other parts of the world.

Index

Numerics Adobe RGB color space, 282–283 advanced exposure modes, 182-184 advanced flash options 1-mount lenses, 7-9 about, 201 35mm-equivalent focal lengths, 231 adjusting flash output, 208-210 720/60p setting, 86 choosing Flash modes, 201-208 1080/30p setting, 86 controlling manually, 210-211 1080/60i setting, 86 Advanced Shooting menu options, 71–72 AE Lock (autoexposure lock), 90, 197–198 • A • AE-L/AF-L button, changing function of, 278-279 A (Aperture-priority autoexposure) mode AF Lock (autofocus lock), 223-224 about, 34, 188-189 AF-A (auto-select autofocus) mode, for action shots, 256 220-221 controlling depth of field with, 232 AF-Area mode for landscape shots, 256 about, 214 reading exposure meter, 183-184 in Movie mode, 91–92 action shots, 252-256 settings, 218–220, 246 Active D-Lighting AF-assist lamp, 19–20 expanding tonal range with, 198-201 AF-C (continuous autofocus) mode, 221 recommended settings, 246 AF-F focus, 90-91 recovering shadows with, 276-278 AF-S focus, 91 adding AF-S (single autofocus) mode, 8, 221 fade in/fade out transitions in Movie angles, 50-61 mode, 92 aperture SB-N5 flash, 25-27 about, 173-174 adjusting adjusting, 187-189 aperture, 187-189 controls in Movie mode, 89-90 audio settings, 87-89 effect on depth of field, 175-176, 227 color space, 282-283 settings, 181-182, 186-190 flash head, 27 Aperture (Apple), 140 flash output, 208-210 Aperture-priority auto-exposure (A) mode Focus mode setting, 220–222 about, 34, 188-189 playback timing, 106-107 for action shots, 256 shutter speed, 187–189 controlling depth of field with, 232 viewfinder, 11 for landscape shots, 256 White Balance settings, 235–238 reading exposure meter, 183-184 Adobe (website), 139, 140, 142 Apple (website), 139, 140

Apple Aperture, 140

applying Exposure Compensation, 194–197

Apple iPhoto, 139

Adobe Photoshop, 142

Adobe Photoshop Elements, 139–140

Adobe Photoshop Lightroom, 140

aspect ratio in Movie mode, 82 printing, 159 for slow-motion movies in Movie mode, 93 of still pictures in Movie mode, 93 attaching flash, 26 lenses, 7–10 audio adjusting settings, 87–89 disabling effects, 29 settings, 28–29 for slow-motion movies in Movie mode, 94 Auto Area mode, 218 about, 214 in Movie mode, 91–92 settings, 218-220, 246 Auto Image Rotation, 107–108 Auto mode, 68 Auto Power Off, 29 autoexposure lock (AE Lock), 90, 197–198 autofocus lock (AF Lock), 223–224 autofocusing system about, 214 for action shots, 255 AF-Area mode setting, 218–220, 246 autofocus lock, 223-224 changing Focus mode setting, 220–221 choosing autofocus combos, 222–223 disabling Face-priority AF, 217 using default systems, 214-216 automatic photography about, 57-58 composing images, 58-64, 255 Scene Auto Selector mode, 33, 64-74, 246 Smart Photo Selector mode, 32, 74–79, 246 automatic picture rotation, enabling, 107-108 auto-off timing, 264 auto-select autofocus (AF-A) mode, 220 - 221

• B •

background, for still portraits, 249–250 back-of-the-body controls, 16–19 balancing exposure, 181–182 banding, 268 basic shooting mode, choosing, 32 battery, extending life of, 263–265 Battery Info, 30 Battery Status indicator, 25, 114–115 bit depth, 53 bracketing, 258 brightness histogram, 116, 119 built-in flash, 14-15 bulb blower, 265 buttons AE-L/AF-L, changing function of, 278–279 Delete, 16-18, 123 Disp. 16–18 F (Feature), 16-17, 187 Lens-release, 19-20 Menu, 16-19 Movie-record, 14-15 Multi Selector/OK, 16–18 Playback, 16–18 shutter, 14-15, 35, 265

· C ·

Calendar view, 111
calibration utility, 159–160
cameras
connecting to computers, 142–144
external controls, 14–22
handholding, 179
menus, 22–24
printing directly from, 287–288
protecting from elements, 266–267
camera-to-subject distance, adjusting
depth of field with, 228
Capture Illuminator light, 27
capture settings, in Smart Photo Selector
mode, 75–76
Carbonite (website), 270

care and maintenance color battery life, 263-265 about, 232-233 camera protection, 266–267 changing White Balance setting, 235–238 display flickering/banding, 268 controlling, 232-240 firmware updates, 266 correcting with white balance, 233-235 image sensor, 172, 268-269 creating white balance presets, 238-240 image-recovery software, 271 with Fill Flash mode, 203-204 LCD, 265 fine-tuning White Balance settings. lenses, 265 237-238 Pixel Mapping tool, 269 syncing print and monitor, 159-161 safeguarding picture files, 270 color cast, 45 strap, 271-272 Color Space, 71, 282-283 Center-weighted metering mode, 192-194 color temperature, 233 changing colorimeter, 160 aperture, 187-189 color-management tools, 161 audio settings, 87-89 composition, 58-64, 255 color space, 282–283 compressed air, 265 flash head, 27 computer flash output, 208-210 connecting camera to, 142-144 Focus mode setting, 220–222 sending pictures to, 142-151 playback timing, 106-107 connecting camera and computer, 142-144 shutter speed, 187-189 continuous autofocus (AF-C) mode, 221 viewfinder, 11 Continuous Release mode, 35-37 White Balance settings, 235–238 Continuous shutter-release option, 254 Cheat Sheet, 4 controlling choosing color, 232-240 autofocus combos, 222-223 depth of field, 226-232 basic shooting mode, 32 exposure in Movie mode, 89-90 exposure metering modes, 192-194 flash, 69, 210-211 Flash modes, 201-208 flash manually, 210-211 photo software, 137-142 focus in Movie mode, 90-92 quality settings, 43–55 ISO, 189-190 Release mode, 34-41 memory cards, 13-14 shutter type, 187 cool light, 233 Still Image mode, 33-34 correcting color with white balance, thumbnails, 110 233-235 cleaning creating image sensor, 268-269 digital slide shows, 129–133 LCD, 265 motion snapshots, 96-98 movement through frames, 59 lenses, 265 Close-up mode, 68 white balance presets, 238-240 close-ups crop factor, 231 with Fill Flash mode, 205 cropping in-camera, 274-276 shooting, 259-260 Custom Picture Control, 71 Cloudy White Balance setting, 236 customizing clutter, editing, 62-63 basic playback options, 106-108 collapsing lenses, 9-10 monitor display, 24-25 Picture Controls, 283-285

· D ·

dampening noise, 191 date, in Simple Photo Information display mode, 115 default settings, restoring, 30 Delete button, 16-18, 123 deleting compared with formatting, 123 files, 122-127 photos, 122–127 Smart Photo Selector images, 78–79 depth of field for close-ups, 259, 260 controlling, 232 defined, 175, 226 effect of aperture on, 175-176, 227 manipulating, 226–232 maximum, 229-232 shallow, 228-232 Detailed Photo Information display mode, 116-118, 119 digital movies. See Movie mode Digital Print Order Format (DPOF), 287–288 digital slide shows, 129–133 diopter adjustment control, 11 Direct Sunlight White Balance setting, 236 Face-priority AF, 217 sound effects, 29 Disp button, 16–18 display customizing monitor, 24–25 flickering, 268 in Movie mode, 82 Display Brightness (V1), 28 Display Calibration Assistant, 160 displaying thumbnails, 110 dots per inch (dpi), 156 double backup, 270 downloading. See also printing; sharing choosing photo software, 137–142 planning prints, 155-161 processing Raw (NEF) files, 151-155 sending pictures to computer, 142–151 using Nikon ViewNX 2, 146-151

dpi (dots per inch), 156 DPOF (Digital Print Order Format), 287–288 DVD storage, 270 dynamic range, 199

· E ·

eCheat Sheet, 4 editing clutter, 62-63 Electronic (Hi) Release mode, 38–39 electronic shutter, 172 enabling automatic picture rotation, 107–108 flash, 26 erasing compared with formatting, 123 files, 122–127 photos, 122–127 Smart Photo Selector images, 78–79 expanding tonal range with Active D-Lighting, 198-201 expose for the highlights, 198–199 exposure. See also aperture; ISO; shutter speed about, 171-172 balancing, 181–182 choosing exposure metering modes, 192-194 controlling in Movie mode, 89–90 correction tools, 194–201 for landscape shots, 257 reading exposure meters, 184–186 in Scene Auto Selector mode, 73-74 settings side effects, 175–181 **Exposure Compensation** applying, 194-197 controls in Movie mode, 90 exposure modes for action shots, 252 advanced, 182-184 choosing, 192-194 in Motion Snapshot mode, 97 recommended settings, 246 in Simple Photo Information display mode, 114

exposure time, 172 extending battery life, 263–265 lenses, 9–10 external camera controls, 14–22

• F •

F (Feature) button, 16-17, 187 Face-priority AF (autofocus) about, 92, 214 disabling, 217 fade in/out, adding in Movie mode, 92 Feature (F) button, 16-17, 187 figures, 3 Filename, in Simple Photo Information display mode, 115 files deleting, 122-127 protecting, 127-129, 270 Raw (NEF), 50, 52-55, 151-155, 264 size, 48 Fill Flash mode, 203-205 fine-tuning White Balance settings, 237–238 fireworks, shooting, 258-259 firmware, updating, 266 flash adjusting output, 208–210 advanced options, 201-211 attaching, 26 built-in, 14-15 for close-ups, 260 controlling, 69, 210-211 controlling manually, 210-211 in Motion Snapshot mode, 98 removing, 27 saving battery life, 264 SB-N5, 25-27 in Smart Photo Selector mode, 75 for still portraits, 250–252 turning on, 26 flash head, adjusting, 27 flash memory keys, 270 Flash mode, 69–70, 201–208 Flash White Balance setting, 236 flash-ready light, 27 Fluorescent White Balance setting, 236 focal length, 10, 231

focal plane indicator, 14-16 focus about, 213 autofocusing system, 214-224 for close-ups, 259 controlling in Movie mode, 90-92 manual, 224-226 in Scene Auto Selector mode, 74 on the sun. 267 Focus mode about. 90-91, 214 changing setting, 220-222 recommended settings, 246 formatting compared with deleting, 123 memory cards, 12-13, 127 Frame Number/Total Pictures, in Simple Photo Information display mode, 114 frame rate, in Movie mode, 85-86 frames, creating movement through, 59 frames per second (fps), for slow-motion movies in Movie mode, 94 front controls, 19-20 front-curtain sync, 206 f-stop numbers, 173. See also aperture FT1 adapter, 7-8

• G •

GPS accessory, 264 graduated neutral density filter, 257 grain, 178

• H •

handholding cameras, 179
handling
color, 232–240
depth of field, 226–232
exposure in Movie mode, 89–90
flash, 69, 210–211
flash manually, 210–211
focus in Movie mode, 90–92
ISO, 189–190
memory cards, 13–14
hard drive storage, 270
HDMI CEC TVs, 134

HDMI playback, 134 HDMI port, 21 head room, 64 heat, 267 Hi (Electronic) Release mode, 38–39 hidden connections, 20–22 High ISO NR (Noise Reduction), 71, 191 histogram (brightness), 116, 119 huey PRO, 160

.1.

icons, explained, 2-3 IDrive (website), 270 image noise, effect of ISO on, 178-181 image quality options, 50-55 settings, 55-56, 71, 246 in Simple Photo Information display mode, 115 image sensor, 172, 268–269 image settings about, 31, 245-246 choosing basic shooting mode, 32 choosing quality settings, 43-55 choosing Release mode, 34-41 choosing Still Image mode, 33-34 r24.42 setting image size/quality, 55-56 Vibration Reduction, 42-43 image size about, 46-50 settings, 55-56, 71, 246 in Simple Photo Information display mode, 115 image-recovery software, 271 images composing, 58-64, 255 deleting, 122-127 orientation, 107–108 preparing for e-mail and online sharing, 161 - 167rating, 120-122 resizing from Playback menu, 165–167 rotating, 107-108 safeguarding files, 270 sending to computer, 142-151

Smart Photo Selector, 78-79 viewing data for, 113-118 viewing in Playback mode, 108-113 viewing on television, 133–135 zooming, 111-113 Incandescent White Balance setting, 236 inserting memory cards, 12 installing Nikon ViewNX 2, 141 interlaced video, 85 Internet resources Adobe, 139, 140, 142 Apple, 139, 140 Carbonite, 270 Cheat Sheet, 4 IDrive, 270 Lexar Image Rescue, 271 Mozy, 270 Nikon, 140, 201 Pantone, 160 SanDisk RescuePro, 271 Spyder4Express, 160 Strobist, 201 iPhoto (Apple), 139 ISO about, 173-174 for action shots, 253-254 controlling, 189-190 controls in Movie mode, 90 effect on image noise, 178-181 sensitivity, 246 settings, 181-182, 186-190

adjusting audio settings, 87
adjusting focus settings, 222
Electronic (Hi) Release mode, 38–39
icon, 3
Monitor Brightness, 28
Release mode in, 37
setting Flash mode, 202
shutter speed, 172, 173
JPEG, 51–52, 264
JPEG artifacts, 45

• K • Kelvin scale, 233

• [•

Landscape mode, 67 Landscape (LS) Picture Control. 241–243 landscapes, shooting, 255-259 Language, 30 LCD, cleaning, 265 lens focal length, adjusting depth of field with, 227-228 lenses attaching, 7-10 cleaning, 265 collapsing, 9-10 extending, 9-10 removing, 9 zooming, 10 Lens-release button, 19-20 lens/sensor dirt, 45 Lexar Image Rescue (website), 271 lighting. See also exposure about, 171-172 cool, 233 warm, 233 lighting (Active D-) expanding tonal range with, 198-201 recommended settings, 246 recovering shadows with, 276-278 Live Photo Gallery (Windows), 139 locking memory cards, 14 Long Exposure NR (Noise Reduction), 71, 191 lossy compression, 51–52 LS (Landscape) Picture Control, 241–243

· M ·

M (Manual exposure) mode, 34, 183–184, 189
magic hours, 258
maintenance and care
battery life, 263–265
camera protection, 266–267

display flickering/banding, 268 firmware updates, 266 image sensor, 172, 268-269 image-recovery software, 271 LCD, 265 lenses, 265 Pixel Mapping tool, 269 safeguarding picture files, 270 strap, 271-272 managing color, 232-240 depth of field, 226-232 exposure in Movie mode, 89-90 flash, 69, 210-211 flash manually, 210-211 focus in Movie mode, 90-92 ISO, 189-190 memory cards, 13-14 Manual exposure (M) mode, 34. 183-184, 189 Manual Focus (MF) mode, 91, 221, 224–226 margin art, 3 Matrix metering mode, 192-194 MC (Monochrome) Picture Control, 241-243 megabytes, 12 megapixels, 46 memory buffer, 42 memory card reader, 142 memory cards controlling, 13-14 formatting, 12-13, 127 inserting, 12 locking, 14 printing directly from, 287-288 removing, 13 risks with, 270 Menu button, 16-19 menus, 22-24 metadata, 139, 179 metering, 246. See also exposure MF (Manual focus) mode, 91, 221, 224-226 microfiber cloth, 265 microphone, 19-20 Microphone jack, 21 Microphone setting, 88–89 Mode dial, 16-18

modes Shutter-priority autoexposure (S), A (Aperture-priority autoexposure), 34, 183-184, 188-189 34, 183-184, 188-189, 232, 256 Shutter-release, 70 advanced exposure, 182-184 Simple Photo Information display, AF-A (auto-select autofocus), 220-221 114-116 AF-Area, 91-92, 214, 218-220, 246 single autofocus (AF-S), 8, 221 AF-C (continuous autofocus), 221 Single Frame Release, 35-37 AF-S (single autofocus), 8, 221 Single Point, 218-219 Auto, 68 Slow-Sync Flash, 206–207 Auto Area, 91–92, 214, 218–220, 246 Smart Photo Selector, 32, 74–76, 246 auto-select autofocus (AF-A), 220-221 Spot metering, 192-194 basic shooting, choosing, 32 Still Image, 32, 33-34 Center-weighted metering, 192-194 Subject tracking, 92, 219-220 moisture, 267 Close-up, 68 continuous autofocus (AF-C), 221 Monitor Brightness (J1), 28 Continuous Release, 35-37 monitor profile, 160 Detailed Photo Information display, monitors 116-118, 119 calibrating, 159–160 customizing display, 24–25 Electronic (Hi) Release, 38–39 syncing color with print color, 159–161 exposure, 97, 114, 182–184, 192–194, 246, 252 Monochrome (MC) Picture Control, Fill Flash, 203-205 241-243 Flash, 69-70, 201-208 motion blur, effect of shutter speed on, Focus, 90-91, 214, 220-222, 246 175 - 178Motion Snapshot mode Hi (Electronic) Release, 38-39 Landscape, 67 about, 32 M (Manual exposure), 34, 183–184, 189 creating motion snapshots, 96-98 Matrix metering, 192-194 playing movies, 98–99 MF (Manual focus), 91, 221, 224-226 trimming movies, 99-101, 288-289 Motion Snapshot, 32, 96-101, 288-289 movement Movie, 32, 47, 81–92, 93–96, 98–101, creating through frames, 59 288-289 showing, 63–64 Movie mode Night Portrait, 67–68 about, 32 P (Programmed autoexposure), 33–34, 183-184, 188-189 adding fade in/fade out transitions, 92 Playback, 108-113, 120-135 aperture controls, 89–90 Portrait, 67 aspect ratio, 82 Programmed autoexposure (P), 33–34, controlling exposure, 89–90 183-184, 188-189 controlling focus, 90–92 Rear-Curtain Slow-Sync flash, 208 display in, 82 Rear-Sync Flash, 206, 207-208 frame rate, 85–86 Red-Eye Reduction Flash, 69, 205-206 getting started, 81-83 Red-Eye Slow-Sync flash, 208 image sizes, 47 Release, 34-41, 246 playing movies, 98–99 recording options, 84-92 S (Shutter-priority autoexposure), 34, 183–184, 188–189 recording with default settings, 83–84 Scene, 232 shooting slow-motion movies, 93-96 shooting still pictures, 93 Scene Auto Selector, 33, 64–74, 246

trimming movies, 99–101, 288–289

Movie-record button, 14–15 movies recording in Scene Auto Selector mode, 74 recording in Smart Photo Selector mode, 76 trimming, 288–289 Mozy (website), 270 multi accessory port, 15 Multi Selector/OK button, 16–18

· N ·

navigating menus, 23-24 NEF (Raw) format, 50, 52–55, 151–155, 264 Neutral (NL) Picture Control, 240-243 neutral-density filter, 257 Night Portrait mode, 67-68 Nikon (website), 140, 201 Nikon 1 mount, 7-9 Nikon Capture NX 2, 140 Nikon Electronic Format. See NEF (Raw) format Nikon ViewNX 2 about, 137-139 downloading using, 146-151 installing, 11 preparing online photos using, 163–165 processing Raw (NEF) files, 151-155 NL (Neutral) Picture Control, 240-243 noise (image) about, 45 dampening, 191 effect of ISO on, 178-181

.0.

1-mount lenses, 7–9 1080/30p setting, 86 1080/60i setting, 86 online photos, preparing using Nikon ViewNX 2, 163–165 online storage services, 270 On/Off switch, 14–15 orientation (image), 107–108

· p ·

P (Programmed autoexposure) mode, 33-34, 183-184, 188-189 Pantone (website), 160 photo paper, 161 photo settings about, 31, 245-246 choosing basic shooting mode, 32 choosing quality settings, 43-55 choosing Release mode, 34-41 choosing Still Image mode, 33-34 r24, 42 setting image size/quality, 55-56 Vibration Reduction, 42–43 photo software, choosing, 137-142 photographing action, 252-256 close-ups, 259-260 fireworks, 258-259 landscapes, 255–259 slow-motion movies in Movie mode. 93 - 96in Smart Photo Selector mode, 76-77 still pictures in Movie mode, 93 still portraits, 247-252 photos composing, 58–64, 255 deleting, 122-127 orientation, 107-108 preparing for e-mail and online sharing, 161 - 167rating, 120-122 resizing from Playback menu, 165-167 rotating, 107-108 safeguarding files, 270 sending to computer, 142-151 Smart Photo Selector, 78-79 viewing data for, 113-118 viewing in Playback mode, 108-113 viewing on television, 133-135 zooming, 111-113 Photoshop (Adobe), 142 Photoshop Elements (Adobe), 139-140 Photoshop Lightroom (Adobe), 140 PictBridge, 288

Picture Controls, 240–243
controls in Movie mode, 90
customizing, 283–285
saving custom, 285–287
picture element, 46
picture settings
about, 31, 245–246
choosing basic shooting mode, 32
choosing quality settings, 43–55
choosing Release mode, 34–41
choosing Still Image mode, 33–34
r24, 42
setting image size/quality, 55–56
Vibration Reduction, 42–43
pictures
composing, 58–64
deleting, 122–127
orientation, 107–108
preparing for e-mail and online sharing
161–167
rating, 120–122
resizing from Playback menu, 165–167
rotating, 107–108
safeguarding files, 270
sending to computer, 142–151
Smart Photo Selector, 78–79
viewing data for, 113–118
viewing in Playback mode, 108–113
viewing on television, 133–135
zooming, 111–113
pixel count, checking, 156–158
Pixel Mapping tool, 269
pixelation, 45, 157
planning prints, 155–161
playback
about, 105–106
adjusting timing, 106–107
customizing options, 106–108
Playback button, 16–18
Playback menu, 165–167
Playback mode
creating digital slide shows, 129–133
deleting photos, 122–127
protecting files, 127–129
rating photos, 120–122
viewing images in, 108–113
viewing photos on televisions, 133–135
viewing picture data, 113–118
portable storage devices, 270

Portrait mode, 67 Portrait (PT) Picture Control, 241–243 portraits (still), 247–252 preparing online photos using Nikon ViewNX 2, 163-165 pictures for e-mail and online sharing, 161 - 167Preset White Balance setting, 236 presets (white balance), 238-240 print color, syncing with monitor color, 159-161 printer profiles, 161 printing. See also downloading; sharing aspect ratio, 159 choosing photo software, 137–142 directly from camera/memory card, 287 - 288size, 47, 159 processing Raw (NEF) files, 151–155 profiles monitor, 160 printer, 161 Programmed autoexposure (P) mode, 33-34, 183-184, 188-189 Protected symbol, in Simple Photo Information display mode, 116 protecting camera from elements, 266–267 files, 127-129, 270 PT (Portrait) Picture Control, 241–243

quality settings about, 43–44 choosing, 43–55 image-quality options, 50–55 image size, 46–50 troubleshooting, 44–45

r24, 42 rating photos, 120–122 Rating stars, in Simple Photo Information display mode, 116 Raw converter, 151 Raw (NEF) files, 50, 52-55, 151-155, 264 reading exposure meters, 184–186 Rear-Curtain Slow-Sync flash mode, 208 Rear-Sync Flash mode, 206, 207-208 recording in Movie mode with default settings, 83-84 movies in Scene Auto Selector mode, 74 movies in Smart Photo Selector mode, 76 options in Movie mode, 84-92 Red-Eye Reduction Flash mode, 69, 205-206 Red-Eye Slow-Sync flash mode, 208 reducing display flickering/banding, 268 regular (standard-definition) video playback, 133-134 Release mode about, 34 choosing, 34-41 Continuous, 35-37 Electronic (Hi), 38-39 recommended settings, 246 remote-control shooting, 40-41 self-timer, 40-41 Single Frame, 35–37 troubleshooting shutter button, 35 Remember icon, 3 Remote receiver, 16–17, 19–20 remote-control shooting options, 40–41 removing files, 122-127 flash, 27 lenses, 9 memory cards, 13 photos, 122-127 protection, 129 Smart Photo Selector images, 78-79 resampling, 157 Reset File Numbering, 29 resizing pictures from Playback menu, 165 - 167resolution. See also image size checking, 156-158 picture, 86 of still pictures in Movie mode, 93 restoring default settings, 30 Rotate Tall option, 108

rotating pictures, 107–108 rule of thirds, 58–59 running Pixel Mapping tool, 269

S (Shutter-priority autoexposure) mode, 34, 183-184, 188-189 SanDisk RescuePro (website), 271 saving custom Picture Controls, 285-287 SB-N5 flash, 25-27 Scene Auto Selector mode, 33, 64-74, 246 Scene modes, controlling depth of field with, 232 screen display size, 47-48 scrolling through thumbnails, 110 SD (Secure Digital) card, 11-14 SD (Standard) Picture Control, 240, 242, 243 SDHC (High Capacity) cards, 11 SDXC (eXtended Capacity) cards, 11 Secure Digital (SD) card, 11-14 selecting autofocus combos, 222-223 basic shooting mode, 32 exposure metering modes, 192–194 Flash modes, 201-208 photo software, 137–142 quality settings, 43–55 Release mode, 34-41 shutter type, 187 Still Image mode, 33-34 thumbnails, 110 self-timer options, 40–41 sending pictures to computer, 142-151 setting(s) about, 31 AF-Area mode, 218–220, 246 aperture, 181-182, 186-190 audio, 87-89 autofocusing default, 214–216 choosing basic shooting mode, 32 choosing quality settings, 43-55 choosing Release mode, 34-41 choosing Still Image mode, 33-34 Cloudy White Balance, 36 default, 30

setting(s) (continued)	shutter, 172, 187
Direct Sunlight White Balance, 236	shutter button
Flash White Balance, 236	about, 14–15
Fluorescent White Balance, 236	tips, 265
Focus mode, 220–222	troubleshooting, 35
image quality, 43, 55–56, 71, 246	Shutter Button AE Lock, 279
image size, 55–56, 71	shutter speed
Incandescent White Balance, 236	about, 172–174
ISO, 181–182, 186–190	for action shots, 253
Microphone, 88–89	adjusting, 187–189
Movie mode, 83–84	for close-ups, 260
picture, 245–246	controls in Movie mode, 89–90
Preset White Balance, 236	effect on motion blur, 175–178
r24, 42	with Fill Flash mode, 204–205
recommended exposure, 246	for landscape shots, 256–257, 257–258
recommended Focus mode, 246	relationship with focus, 217
recommended Release mode, 246	settings, 181–182, 186–190
setting image size/quality, 55–56	Shutter-priority autoexposure (S) mode,
Shade White Balance, 236	34, 183–184, 188–189
shutter speed, 186–190	Shutter-release mode, 70
sound, 28–29	Simple Photo Information display mode,
TTL (through-the-lens), 211	114–116
Vibration Reduction, 42–43	single autofocus (AF-S) mode, 8, 221
white balance, 235–238	Single Frame Release mode, 35–37
Wind Noise Reduction, 89	Single Point mode, 218–219
setup	Single point option (AF-Area mode), 91–92
automatic options, 68–72	size (image), 46–50, 55–56, 71, 115, 246
steps, 28–30	slide shows, 129–133
Setup menu, 22	Slot Empty Release Lock, 28
720/60p setting, 86	slow-motion movies, shooting in Movie
Shade White Balance setting, 236	mode, 93–96
sharing. See also downloading; printing	Slow-Sync Flash mode, 206–207
choosing photo software, 137–142	Smart Photo Selector mode, 32, 74–76, 246
planning prints, 155–161	software
preparing pictures for, 161–167	choosing, 137–142
processing Raw (NEF) files, 151–155	image-recovery, 271
shooting	menu commands, 3
action, 252–256	sound
close-ups, 259–260	adjusting settings, 87–89
fireworks, 258–259	disabling effects, 29
landscapes, 255–259	settings, 28–29
slow-motion movies in Movie mode,	for slow-motion movies in Movie
93–96	mode, 94
in Smart Photo Selector mode, 76–77	speaker, 14–15
still pictures in Movie mode, 93	special-purpose features
still portraits, 247–252	Active D-Lighting, 198–201, 246, 276–278
Shooting menu, 22, 187	AE-L/AF-L button, 278–279
Shots remaining, 25	changing color space, 282–283

cropping function, 274–276 customizing Picture Controls, 283-285 printing directly from camera/memory card, 287-288 saving custom Picture Controls, 285–287 Shutter Button AE Lock, 279 time-lapse photography, 280-281 trimming movies, 99-101, 288-289 Spot metering mode, 192-194 Spyder4Express (website), 160 sRGB color space, 282-283 Standard (SD) Picture Control, 240–243 standard-definition (regular) video playback, 133-134 Still Image mode, 32, 33-34 still pictures, shooting in Movie mode, 93. See also pictures still portraits, 247-252 stop (exposure), 186 stopping down the aperture, 175-176 strap (camera), 271-272 Strobist (website), 201 Subject tracking mode, 92, 219–220 switching to Thumbnail view, 109-111 to viewfinder, 11 syncing print and monitor colors, 159–161

• T •

Technical Stuff icon, 3
television, viewing photos on, 133–135
temperature changes, 267
35mm-equivalent focal lengths, 231
through-the-lens (TTL) setting, 211
Thumbnail view, switching to, 109–111
time, in Simple Photo Information display mode, 115
Time Zone and Date, 29
time-lapse photography, 280–281
timing, playback, 106–107
Tip icon, 2
tonal range, expanding with Active
D-Lighting, 198–201

tools
color-management, 161
Pixel Mapping, 269
topside controls, 14–16
transferring pictures from camera to
computer, 144–145
trimming movics, 99 101, 288 289
tripod socket, 22
tripods, using for action shots, 256
troubleshooting
picture transfer, 144–145
print color, 160
quality, 44–45
shutter button, 35
TTL (through-the-lens) setting, 211

• U •

UHS cards, 12 updating firmware, 266 upsampling, 47 USB port, 21, 142

• *U* •

V1 adjusting audio settings, 87 adjusting focus settings, 222 controlling flash manually, 210-211 Display Brightness, 28 Electronic (Hi) Release mode, 39 icon, 3 recording movies in Scene Auto Selector mode, 74 recording movies in Smart Photo Selector mode, 76 Release mode in, 37 setting Flash mode, 202 shutter speed, 173 Smart Photo Selector mode, 75 viewfinder, 10-11 viewing current ISO setting, 190 viewing photos on television, 133-134

304

Nikon 1 J1/V1 For Dummies

VI (Vivid) Picture Control, 241–243 Vibration Reduction (VR), 42–43, 68–69, 92, 179, 264 viewfinder, 10–11 viewing images in Playback mode, 108–113 photos on television, 133–135 picture data, 113–118 Smart Photo Selector images, 78–79 Vivid (VI) Picture Control, 241–243 VR (Vibration Reduction), 42–43, 68–69, 92, 179, 264

waking viewfinder, 11 warm light, 233 Warning! icon, 2 waterfall shots, 256–257 websites Adobe, 139, 140, 142 Apple, 139, 140 Carbonite, 270 Cheat Sheet, 4 IDrive, 270 Lexar Image Rescue, 271

Mozy, 270 Nikon, 140, 201 Pantone, 160 SanDisk RescuePro, 271 Spyder4Express, 160 Strobist, 201 Welcome Screen, 28 white balance changing settings, 235–238 controls in Movie mode, 90 correcting color with, 233-235 creating presets, 238–240 fine-tuning settings, 237–238 recommended settings, 246 for still portraits, 250 wide-angle lens, 231 Wind Noise Reduction setting, 89 Windows Live Photo Gallery, 139

Zoom lever, 16–17 zooming for close-ups, 260 lenses, 10 photos, 111–113

e & Mac

2 For Dummies, Edition 1-118-17679-5

ne 4S For Dummies, Edition 1-118-03671-6

touch For Dummies, Edition

1-118-12960-9 OS X Lion

Jummies 1-118-02205-4

ging & Social Media

ille For Dummies

book For Dummies, dition 1-118-09562-1

Blogging Jummies -118-03843-7

er For Dummies, Edition J-470-76879-2

Press For Dummies, dition -118-07342-1

iess

Flow For Dummies -118-01850-7

ting For Dummies, dition 1-470-90545-6 Job Searching with Social Media For Dummies 978-0-470-93072-4

QuickBooks 2012 For Dummies 978-1-118-09120-3

Resumes For Dummies, 6th Edition 978-0-470-87361-8

Starting an Etsy Business For Dummies 978-0-470-93067-0

Cooking & Entertaining

Cooking Basics For Dummies, 4th Edition 978-0-470-91388-8

Wine For Dummies, 4th Edition 978-0-470-04579-4

Diet & Nutrition

Kettlebells For Dummies 978-0-470-59929-7

Nutrition For Dummies, 5th Edition 978-0-470-93231-5

Restaurant Calorie Counter For Dummies, 2nd Edition 978-0-470-64405-8

Digital Photography

Digital SLR Cameras & Photography For Dummies, 4th Edition 978-1-118-14489-3 Digital SLR Settings & Shortcuts For Dummies 978-0-470-91763-3

Photoshop Elements 10 For Dummies 978-1-118-10742-3

Gardening

Gardening Basics For Dummies 978-0-470-03749-2

Vegetable Gardening For Dummies, 2nd Edition 978-0-470-49870-5

Green/Sustainable

Raising Chickens For Dummies 978-0-470-46544-8

Green Cleaning For Dummies 978-0-470-39106-8

Health

Diabetes For Dummies, 3rd Edition 978-0-470-27086-8

Food Allergies For Dummies 978-0-470-09584-3

Living Gluten-Free For Dummies, 2nd Edition 978-0-470-58589-4

Hobbies

Beekeeping For Dummies, 2nd Edition 978-0-470-43065-1

Chess For Dummies, 3rd Edition 978-1-118-01695-4

Drawing For Dummies, 2nd Edition 978-0-470-61842-4

eBay For Dummies, 7th Edition 978-1-118-09806-6

Knitting For Dummies, 2nd Edition 978-0-470-28747-7

<u>Language &</u> Foreign Language

English Grammar For Dummies, 2nd Edition 978-0-470-54664-2

French For Dummies, 2nd Edition 978-1-118-00464-7

German For Dummies, 2nd Edition 978-0-470-90101-4

Spanish Essentials For Dummies 978-0-470-63751-7

Spanish For Dummies, 2nd Edition 978-0-470-87855-2

ble wherever books are sold. For more information or to order direct: U.S. customers visit www.dummies.com or call 1-877-762-2974. K. customers visit www.wileyeurope.com or call [0] 1243 843291. Canadian customers visit www.wiley.ca or call 1-800-567-4797.

Math & Science

Algebra I For Dummies, 2nd Edition 978-0-470-55964-2

Biology For Dummies, 2nd Edition 978-0-470-59875-7

Chemistry For Dummies, 2nd Edition 978-1-1180-0730-3

Geometry For Dummies, 2nd Edition 978-0-470-08946-0

Pre-Algebra Essentials For Dummies 978-0-470-61838-7

Microsoft Office

Excel 2010 For Dummies 978-0-470-48953-6

Office 2010 All-in-One For Dummies 978-0-470-49748-7

Office 2011 for Mac For Dummies 978-0-470-87869-9

Word 2010 For Dummies 978-0-470-48772-3

Music

Guitar For Dummies, 2nd Edition 978-0-7645-9904-0 Clarinet For Dummies 978-0-470-58477-4

iPod & iTunes For Dummies, 9th Edition 978-1-118-13060-5

Pets

Cats For Dummies, 2nd Edition 978-0-7645-5275-5

Dogs All-in One For Dummies 978-0470-52978-2

Saltwater Aquariums For Dummies 978-0-470-06805-2

Religion & Inspiration

The Bible For Dummies 978-0-7645-5296-0

Catholicism For Dummies, 2nd Edition 978-1-118-07778-8

Spirituality For Dummies, 2nd Edition 978-0-470-19142-2

Self-Help & Relationships

Happiness For Dummies 978-0-470-28171-0

Overcoming Anxiety For Dummies, 2nd Edition 978-0-470-57441-6

Seniors

Crosswords For Seniors For Dummies 978-0-470-49157-7

iPad 2 For Seniors For Dummies, 3rd Edition 978-1-118-17678-8

Laptops & Tablets For Seniors For Dummies, 2nd Edition 978-1-118-09596-6

Smartphones & Tablets

BlackBerry For Dummies, 5th Edition 978-1-118-10035-6

Droid X2 For Dummies 978-1-118-14864-8

HTC ThunderBolt For Dummies 978-1-118-07601-9

MOTOROLA XOOM For Dummies 978-1-118-08835-7

Sports

Basketball For Dummies, 3rd Edition 978-1-118-07374-2

Football For Dummies, 2nd Edition 978-1-118-01261-1

Golf For Dummies, 4th Edition 978-0-470-88279-5

Test Prep

ACT For Dummies, 5th Edition 978-1-118-01259-8

ASVAB For Dummies, 3rd Edition 978-0-470-63760-9

The GRE Test For Dummies, 7th Edition 978-0-470-00919-2

Police Officer Exam For Dummies 978-0-470-88724-0

Series 7 Exam For Dummies 978-0-470-09932-2

Web Development

HTML, CSS, & XHTML For Dummies, 7th Edit 978-0-470-91659-9

Drupal For Dummies, 2nd Edition 978-1-118-08348-2

Windows 7

Windows 7 For Dummies 978-0-470-49743-2

Windows 7 For Dummies, Book + DVD Bundle 978-0-470-52398-8

Windows 7 All-in-One For Dummies 978-0-470-48763-1

Available wherever books are sold. For more information or to order direct: U.S. customers visit www.dummies.com or call 1-877-76.

U.K. customers visit www.wileyeurope.com or call (0) 1243 843291. Canadian customers visit www.wiley.ca or call 1-800-567-479

DUMMIES.COM.

Visit us at Dummies.com and connect with us online at www.facebook.com/fordummies or @fordummies

Dummies product make life easier

- DIY
- Consumer Electronics
- Crafts
- Software
- Cookware

- Hobbies
- Videos
- MusicGames
- •and More!

For more information, go to **Dummies.co** and search the store by category.

Connect with us online at www.facebook.com/fordummies or @fordum